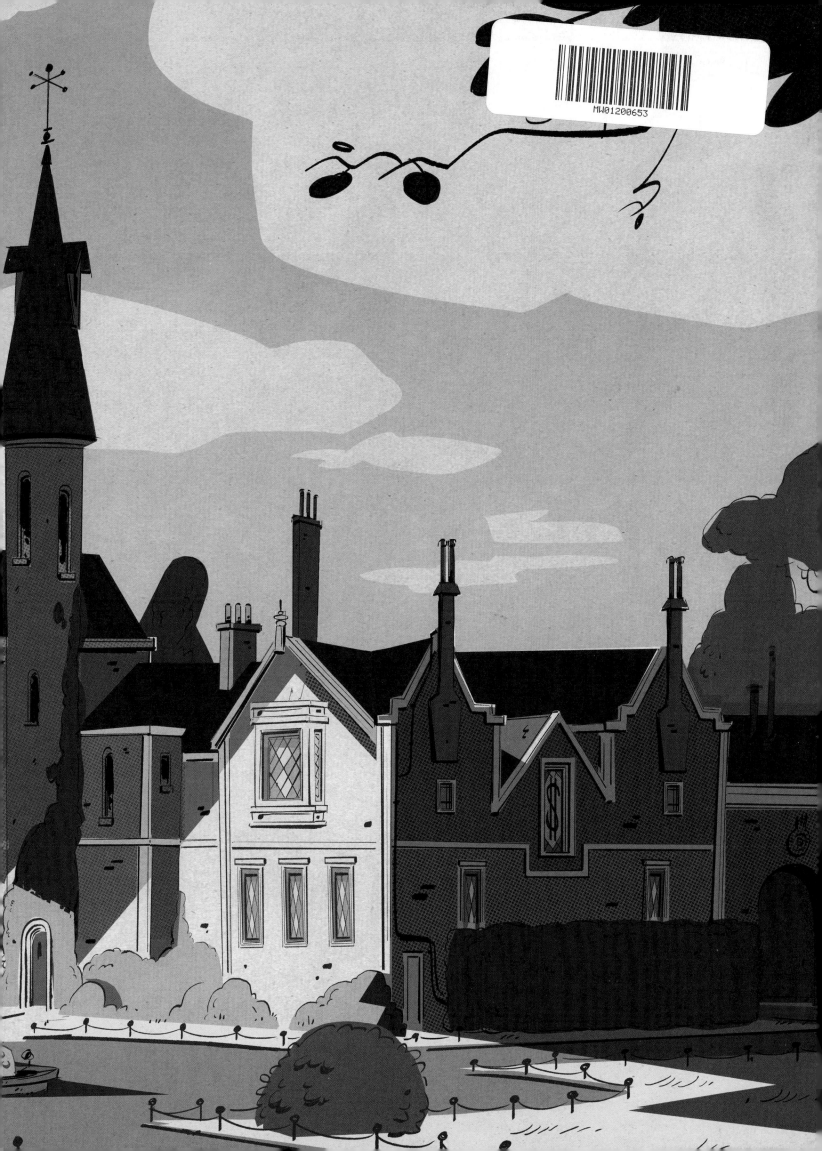

Disney

THE ART
OF

Du

TALES

BY **THE CREW** &
CAST OF *DUCKTALES*
WITH **KEN PLUME**

INTRODUCTION BY
MATT YOUNGBERG &
FRANCISCO ANGONES

DARK HORSE BOOKS

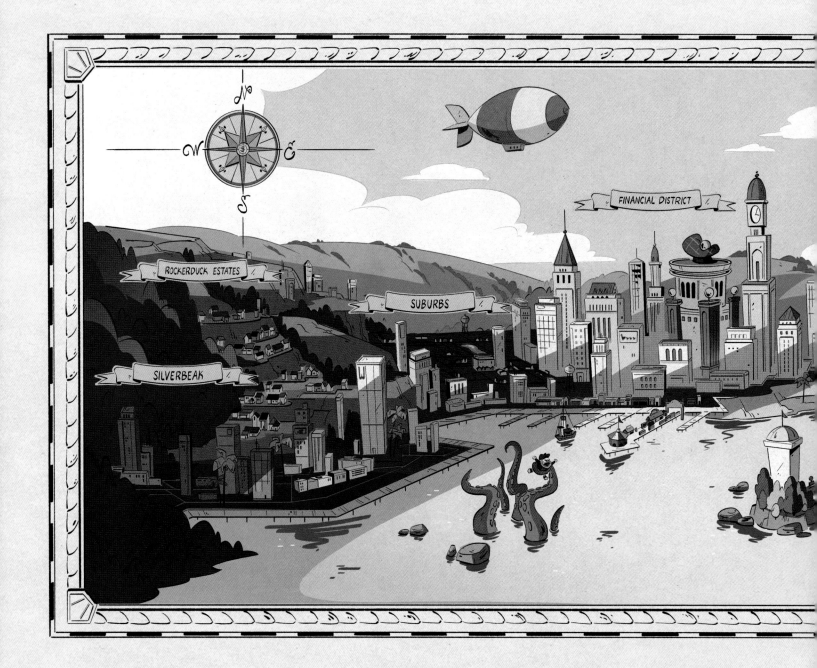

President & Publisher
MIKE RICHARDSON

Editor
PATRICK THORPE

Assistant Editor
ANASTACIA FERRY

Designer
JUSTIN COUCH

Digital Art Technicians
ANN GRAY & ADAM PRUETT

Front cover artwork by
SEAN JIMENEZ

Neil Hankerson, Executive Vice President; Tom Weddle, Chief Financial Officer; Dale LaFountain, Chief Information Officer; Tim Wiesch, Vice President of Licensing; Matt Parkinson, Vice President of Marketing; Vanessa Todd-Holmes, Vice President of Production and Scheduling; Mark Bernardi , Vice President of Book Trade and Digital Sales; Randy Lahrman, Vice President of Product Development and Sales; Ken Lizzi, General Counsel; Dave Marshall, Editor in Chief; Davey Estrada, Editorial Director; Chris Warner, Senior Books Editor; Cary Grazzini, Director of Specialty Projects; Lia Ribacchi, Art Director; Matt Dryer, Director of Digital Art and Prepress; Michael Gombos, Senior Director of Licensed Publications; Kari Yadro, Director of Custom Programs; Kari Torson, Director of International Licensing

Published by Dark Horse Books
A division of Dark Horse Comics LLC
10956 SE Main Street, Milwaukie, OR 97222

DarkHorse.com
Facebook.com/DarkHorseComics
Twitter.com/DarkHorseComics

First Edition: October 2022
Ebook ISBN 978-1-50672-365-5
Hardcover ISBN 978-1-50672-364-8
Deluxe Edition ISBN 978-1-50672-922-0

10 9 8 7 6 5 4 3 2 1
Printed in China

MIX
Paper from
responsible sources
FSC
www.fsc.org FSC® C016973

Library of Congress Cataloging-in-Publication Data

Names: Plume, Ken, author. | Youngberg, Matt, writer of introduction. | Angones, Francisco, writer of introduction.
Title: The art of DuckTales / the crew & cast of DuckTales with Ken Plume ; introduction by Matt Youngberg & Francisco Angones.
Other titles: At head of title: Disney
Description: First edition. | Milwaukie, OR : Dark Horse Books, 2022. | Summary: "Scrooge McDuck and nephews Huey, Dewey, and Louie are back in the 2017 remake of the classic series from Disney Television Animation, DuckTales, and join Donald Duck on adventures-solving mysteries and rewriting history! Like Scrooge into the Money Bin, dive into this beautiful, oversized coffee-table book and read tales of the making of the series from developers Matt Youngberg, Francisco Angones, Suzanna Olson, and others. Join in on the adventure with exclusive interviews with the cast including David Tennant (Scrooge McDuck), Danny Pudi (Huey), Ben Schwartz (Dewey), Bobby Moynihan (Louie), Kate Miccuci (Webby), Don Cheadle (Donald Duck), and many more! Find out what it means to every day be out there making DuckTales! Woo-oo!"– Provided by publisher.
Identifiers: LCCN 2021047118 (print) | LCCN 2021047119 (ebook) | ISBN 9781506723648 (hardcover) | ISBN 9781506723655 (ebook)
Subjects: LCSH: DuckTales (Television program : 2017-) | Animated television programs–United States.
Classification: LCC PN1992.77.D836 A78 2022 (print) | LCC PN1992.77.D836 (ebook) | DDC 791.45/72–dc23
LC record available at https://lccn.loc.gov/2021047118
LC ebook record available at https://lccn.loc.gov/2021047119

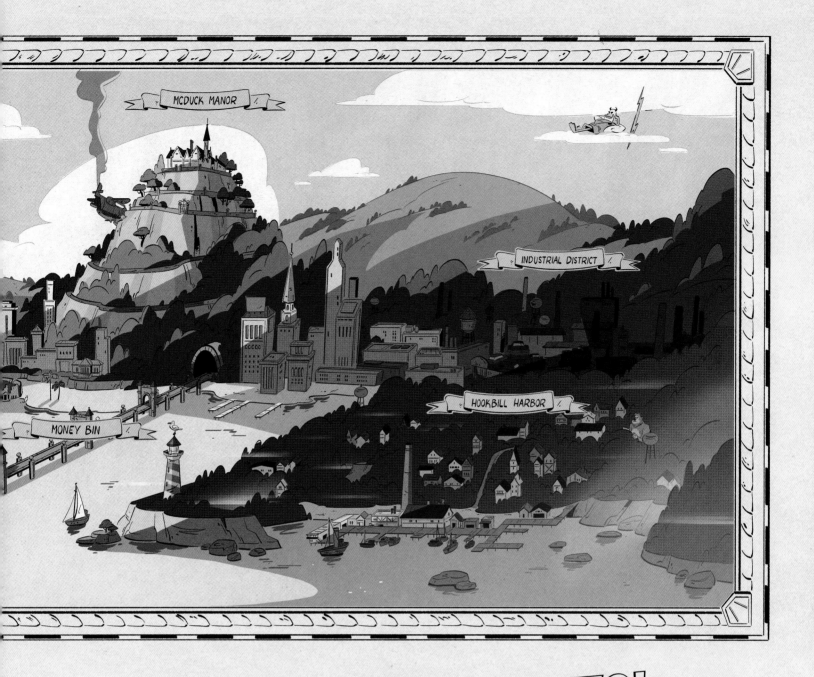

MCDUCK MANOR

INDUSTRIAL DISTRICT

HOOKBILL HARBOR

MONEY BIN

TABLE OF CONTENTS!

ACKNOWLEDGMENTS
KEN PLUME!

Sometimes, an offhand comment turns into a sincere reality. This book began with just such a spark, and the reality is the book you're holding right now. Much like the show it celebrates, *The Art of DuckTales* has been a labor of love, from the first notion I shared with Frank Angones in November of 2019 through over a year of interviews, admin, organizing, and editing. A common refrain throughout the process was "It would be so much easier if I didn't care so much," but I did care. Tremendously so. I wanted this book to capture the same level of care poured into the show by the incredibly gifted folks who made it. Producing seventy-five episodes of an animated television show is no small feat, and producing one as beautifully crafted and exceptionally heartfelt as *DuckTales* requires immense talent and dedication from a team devoted to the work and, more importantly, to each other. I hope this book reflects just how much care and talent went into realizing *DuckTales*. More than just a rollicking adventure, *DuckTales* is a show about family—and the making of *DuckTales* is also about family. To that end, I want to thank my book family, without whom none of this could have happened. First, to my ever-patient if ever-exasperated editor, Patrick, thank you for believing that we could make this book, and then making it happen. Also, cheers to Justin for an absolutely cracking design that perfectly captures the spirit of the show. To my adoptive *DuckTales* family—Frank, Matt, Sean, Suzanna, and Laura—thank you for accepting me, with open arms and open hearts, into the fold. I hope I've done you proud. While we're on the subject of family, I would certainly be remiss if I didn't thank my parents, sister, nephews (Cameron and Jonny!), extended family, and friends for their continued support in all the ways that matter most. Thanks also to Mike Phirman, Hal Lublin, Mark Gagliardi, Molly Lewis, Ben Soileau, Mark Wheaton, Lauren Kisilevsky, Rowan & Wyatt, Zane Jensch, Jason Scott Read, Kelsey Ann Brady, Calvin Lester, Nate Beagle, James Wojtal Jr., Kirk Thatcher, Wendell W., Kelly Sue DeConnick, Matt Fraction, Karen Fritchman, HL & T, Paul Dini, Misty Lee, Caissie St. Onge, Matt Debenham, Lincoln & Eli, Dan Edwards, Kelly Thompson, Karla Pacheco, Aaron Fever, Kevin Smith, Christopher McCulloch, Doc Hammer, Bill Corbett, Amy Mebberson, James Silvani, Abiskibita, Joel Watson, Q Fortier, Edward Mejia, Owen Panettieri, Kathryn Maughan, Emma Liegler, Erin King, Luiz Augusto Buff, and Nigel Griffin. Finally, my deepest gratitude goes to the crew and cast of *DuckTales*, who were very accommodating and gracious in speaking with me and shared my enthusiasm for honoring a show they also hold dear. I hope fans enjoy this glimpse behind the scenes and appreciate the artistry of everyone who worked on the show. This book is dedicated to the artists of *DuckTales*—every single one of them. *DuckTales* was a gift, and I thank you for it. Woo-oo!

KEN PLUME
SOMEWHERE IN DUCKBURG
SEPTEMBER 2021

INTRODUCTION
MATT YOUNGBERG AND FRANCISCO ANGONES!

Dear Reader,

The book in your hand is a labor of love that represents a ton of passion for a show . . .
that was a labor of love that represented a ton of passion for *another* show . . .
that was a labor of love that represented a ton of passion for a series of works . . .
that were a labor of love that represented a ton of passion for a family of ducks.
This got real meta, real fast. But of course it did.

In the summer of 2015, an impossibly talented and handsome individual met some guy that was pretty okay. *[This is Matt. Frank won't tell me which one of us was "the handsome one." But I think we both know.]* These two set off on a fantastical and dangerous adventure to uncover the greatest treasure of all: a reboot of a beloved childhood favorite that didn't mess things up too bad.

Along that adventure, they gained trusted allies (and a few enemies who I don't think were named in this book). And that team of adventurers became a bit of a family. And what started out as two dummies on an ill-advised quest became a grand adventure we all shared together.

We always said that these characters, and these stories, belong to everyone. Well, the work in this book belongs to the impossibly talented, endlessly warm, ceaselessly resourceful, sometimes dysfunctional, but always collaborative creatives those two dummies had the good fortune to work with.

This tome, lovingly excavated by Ken Plume, is a treasure map. It details the painstaking path of this family that gave their all to make a weird little show about a family of ducks.

How did we Dewey it? Soon you'll know.

Bless Your Bagpipes,
And Blathering Blatherskite,
And H'boy,
And Aw Phooey,
And Clop Clop Clop,
And, now and forever, Woo-oo,

MATT YOUNGBERG AND
FRANCISCO ANGONES

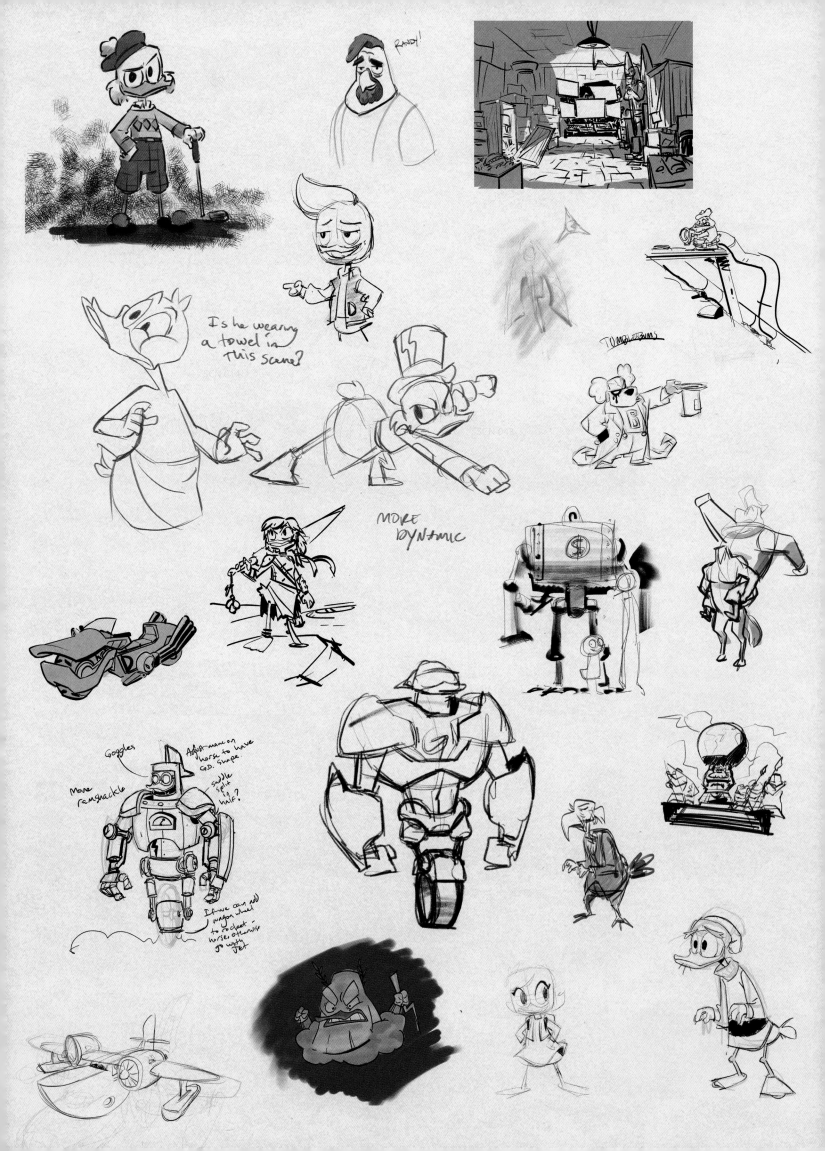

PREPRODUCTION!

AN *EPIC, GLOBE-TROTTING ADVENTURE COMEDY.* ABOUT A FAMILY OF DUCKS.

WOO-OO!

IN THE FINE FAMILY ADVENTURE TRADITION OF *THE INCREDIBLES* AND *INDIANA JONES,* AND ENSEMBLE FAMILY COMEDIES LIKE *"MODERN FAMILY,"* AND *"ARRESTED DEVELOPMENT,"* *THESE ARE THE TALES OF THE DUCK FAMILY OF DUCKBURG*

AND...

HOW A TRIO OF *TROUBLEMAKING TRIPLETS* MANAGED TO MAKE THE RICHEST DUCK IN THE WORLD *EVEN RICHER* BY GIVING HIM A *FAMILY.*

LIFE IS LIKE A HURRICANE: THE STORY

TEN YEARS AGO...

TRILLIONAIRE ENTREPRENEUR AND PROFESSIONAL ADVENTURER *SCROOGE MCDUCK,* WENT ON DANGEROUS, STUPID, GLORIOUS ADVENTURES WITH HIS NEPHEW *DONALD* AND NIECE *DELLA,* AND EVERYTHING WAS AMAZING.

THEN...

...FOR REASONS UNKNOWN TO THE REST OF THE FAMILY...

...IT ALL STOPPED.

TODAY...

DELLA'S KIDS, HUEY, DEWEY, AND LOUIE, LIVE WITH THEIR *OVERPROTECTIVE, RISK-AVERSE* UNCLE DONALD.

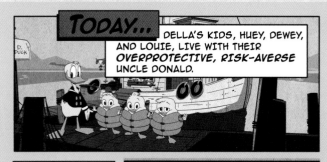

THEY DON'T BOTHER HIM WITH QUESTIONS ABOUT THE OLD DAYS, OR THEIR MOM, OR THEIR FAMILY. BUT AFTER DONALD GOES TO BED, THEY SHARE RUMORS THEY'VE HEARD ABOUT THE INSANE ACTS OF DERRING-DO THAT CRAZY OLD RICH MAN UP ON THE HILL HAS PERFORMED, COMPLETELY UNAWARE THAT THEY'RE THE *HEIRS TO A LEGACY OF ADVENTURE.*

THE BOYS ARE ITCHING FOR EXCITEMENT, BUT ARE CONSTANTLY UNDER THE WATCHFUL EYE OF "HELICOPTER PARENT" DONALD, WHO DOES HIS BEST TO KEEP CLOSE TABS ON THEM AT ALL TIMES BOTH IN AND OUT OF THE HOUSE.

EVER SINCE SCROOGE AND DONALD'S FALLING OUT, SCROOGE HAS HUNG UP HIS ADVENTURING TOP HAT AND DONNED THE SPATS OF CORPORATE RESPONSIBILITY.

A DUCK OF HIS AGE AND STATURE CAN'T GO TRAIPSING ABOUT GETTING INTO TROUBLE AND SWIMMING IN HIS SWEET, SWEET MONEY BIN. AT LEAST THAT'S WHAT HE (AND HIS BOARD OF DIRECTORS) KEEPS TELLING HIMSELF. HE'S GOT INVESTORS TO REPORT TO AND MEETINGS TO ATTEND AND CONTRACTS TO REVIEW AND...

 CURSE ME KILTS IS SCROOGE BORED.

SCROOGE IS IN A RUT AND HIS STANDOFFISH NATURE HAS EARNED HIM A REPUTATION AS A BIT OF A MISER, EVEN WITH HIS FAITHFUL HOUSEKEEPER *MRS. BEAKLEY* AND HER EVER-EAGER, STUDIOUS GRANDDAUGHTER *WEBBY.* SCROOGE NEEDS SOMETHING, SOMEONE, *SOMEONES,* TO SHAKE HIM OUT OF HIS FUNK AND HELP HIM TURN EVERY DAY INTO AN ADVENTURE!

I MEAN, THEY'RE JUST A COUPLE OF KIDS AND AN OLD MAN.

HOW MUCH TROUBLE COULD THEY POSSIBLY GET INTO?

...RIGHT?

SO... WHEN A LAST-MINUTE EMERGENCY FORCES DONALD TO LEAVE THE BOYS WITH THEIR UNCLE SCROOGE - HIS *ABSOLUTELY, POSITIVELY, LASTEST OF THE LAST-DITCH* BABYSITTING OPTION - A GOLDEN OPPORTUNITY SEEMS TO PRESENT ITSELF FOR SCROOGE AND HIS CLAN. BUT DONALD CONVINCES HIMSELF NOT TO WORRY.

THE BEGINNING!

MATT YOUNGBERG (Executive Producer): I started working in animation back in 1999. I was going to CalArts at the time and had just finished my freshman year. My first job was doing freelance storyboards for *Batman Beyond*. From there, I just kept working on big franchise-type properties, from *Batman Beyond* to *X-Men: Evolution*, and then I did *Teen Titans*, which is where I directed for the first time. After that, I took over the *Transformers: Animated* franchise, which was my first showrunning experience. After that, I took over *Ben 10: Ultimate Alien*, after which I refreshed the franchise with *Ben 10: Omniverse*, giving it a whole new look and style of storytelling. Once that was wrapped, I was looking for my next thing, and that's when *DuckTales* fell into my lap. I had always wanted to do *DuckTales*. It was my white whale. I lucked out that it was available at the same time I was.

FRANCISCO "FRANK" ANGONES (Co–Executive Producer, Story Editor): I started off as a live-action TV writer and had sold a couple of things in the comedy space, both hourlong and half-hour. While I was going out to staff on other things, I heard about a show that Craig McCracken was working on. I had been a huge fan of Craig's from *Powerpuff Girls* and *Foster's Home for Imaginary Friends*, and his new show, *Wander Over Yonder*, was described to me as "*Hitchhiker's Guide to the Galaxy* meets *Looney Tunes*, with Jack McBrayer." I had the good luck to do a day of freelance on that, and it was my first day in animation. It was one of the best creative days of my life. It felt freeing, and I had the ability to really play and cut loose. Over the course of that one day freelancing, I really fell in love with the process. Off of that freelancing, I was able to join the writing staff of the show, and then went on to become the head writer in its second season. As we were working on the end of *Wander Over Yonder*, I'd heard that certain Disney executives had been talking about trying to bring back *DuckTales* in some way, shape, or form. I was a massive *DuckTales* fan, and just a huge Disney Afternoon fan in general. So I tried to make it known to the universe that I was really interested in doing something with that.

I went to my garage, pulled out all of my old *DuckTales* posters and toys, and conveniently set them up by the exit of my office. And then I would invite executives to coffee, telling them to meet in my office so that as they went out, they would see the posters and the small *DuckTales* shrine, and they'd be like, "Oh, do you like *DuckTales*? We're actually talking about trying to make a reboot of that." That led to my very first meeting with Matt, and we were off to the races from there.

SEAN JIMENEZ (Art Director): I started out in clean-up at Disney Feature Animation and worked on *Pocahontas*, *The Hunchback of Notre Dame*, *Hercules*, and *Mulan*. After that, I left and worked on *The Iron Giant* as an inbetweener before going to Imagineering as an audio animatronics animator. It was on *Iron Giant* that I got to work more closely with the director, Brad Bird. I was inspired by that experience and wanted to get more into either story or development, so I decided to go to CalArts at age twenty-seven. At CalArts, I met a whole bunch of people who then started taking over television animation, like Alex Hirsch, Pen Ward, and J. G. Quintel. They inspired me to get into TV, because they all wanted to get into TV. I fell in love with the short form at CalArts, so when I graduated, I got a boarding and writing position on the first season of *Adventure Time*. That was a pivotal moment in my career. With TV, it's a smaller chunk of story to tell, so it was easier to wrap your brain around it, and it was just a small group of people putting it together. Whereas when I was doing features, it was hundreds and hundreds of people, and you felt like you're just a little cog.

After the first season of *Adventure Time*, I had an opportunity to go to Disney Television Animation, because Alex Hirsch was in development, and a show that he directed the pilot for, *Fish Hooks*, got picked up. I went to Disney as a background designer, because that was the position that was open, and I fell in love with background design. After that, Alex got *Gravity Falls*, and I was on that from the beginning. Working in the trenches of *Gravity Falls* is where I met Suzanna Olson. In its second season, I got to art direct some projects in development. Not long after that, I got a call from Shane Prigmore, and he asked if I was interested in *DuckTales*, and would I meet with Matt, Frank, and Suzanna about it.

SUZANNA OLSON (Producer): I didn't have the traditional eye towards animation. When I started out into school, I was more on the art history / art conservation / fine arts track, so I thought I would do museum curatorship or art conservation. As I went forward in that, I realized it was going to be a lot more organic chemistry than my skill set or interest could handle, so I took some tangents and some soul searching and realized that animation production had the best of both worlds. I could talk about art with artists every day but also use my organizational projec-management side, as well as have a finished product at the end of all the hard work. So animation seemed perfect. I got my foot in the door as a production assistant at Disney, and during that time, I worked on a show for Disney XD called *Kick Buttowski*. I had the good fortune to go into *Gravity Falls* as a production coordinator,

SOLVING MYSTERIES: THE THEMES

PART. 1

RISK VS REWARDS...

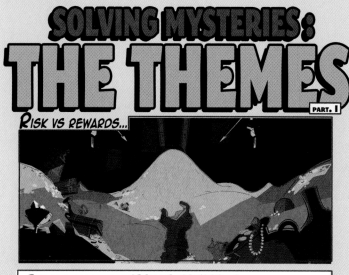

THIS IS A SHOW ABOUT **RISK VS. REWARD.** ABOUT THE AMAZING THINGS THAT CAN HAPPEN WHEN YOU'RE WILLING TO TAKE A CHANCE. ABOUT LEARNING WHAT THINGS ARE REALLY VALUABLE TO YOU. IN THE END, THIS IS THE STORY OF A FAMILY BEING PUSHED BY THE WORLD'S RISKIEST DUCK TO TAKE BIG, CRAZY, WILD CHANCES WHILE DISCOVERING THE THINGS THEY'RE NOT WILLING TO RISK.

SCROOGE, A MULTI-MULTI-TRILLIONAIRE MANY TIMES OVER, IS OUR VEHICLE TO GO ON ANY ADVENTURE WE CHOOSE. HE'S GOT THE CURIOSITY, THE LIMITLESS RESOURCES AND THE UNMATCHED SENSE OF BRAVADO TO GO ANYWHERE AND TRY ANYTHING.

ULTIMATELY, WHAT WE'D LIKE TO CAPTURE WITH DUCKTALES IS THE NOTION THAT THE WORLD IS AN EXCITING PLACE, FILLED WITH MYSTERIES, SECRETS, AND REWARDS IF YOU HAVE THE OPTIMISTIC, CAN-DO CHUTZPAH TO GO OUT AND SEEK THEM. THROUGH THEIR ESCAPADES OUR HEROES WILL ALSO FIND HIDDEN VALUE IN THEIR FAMILY AND IN THE WORLD AT LARGE. THEY WILL LEARN WHAT SCROOGE KNOWS INNATELY: WITH GREAT RISK THERE IS GREAT REWARD, AND WITH WILL-POWER THERE IS GROWTH.

AS SUCH... EACH CHARACTER HAS A UNIQUE RELATIONSHIP TO THAT NOTION OF RISK.

- THE BOYS AND WEBBY ARE **HUNGRY FOR IT** BECAUSE THEY'VE NEVER TRULY EXPERIENCED IT AND ARE UNAWARE OF THE DANGER IT MIGHT BRING.

- DONALD **AVOIDS RISK** AT ALL COSTS BECAUSE HE KNOWS THE TROUBLE IT CAN CAUSE WHEN IT BLOWS UP IN YOUR FACE (AS IT SO OFTEN DOES FOR DONALD), BUT THAT'S PREVENTED HIM FROM LIVING HIS LIFE TO THE FULLEST.

- LAUNCHPAD FACES RISK SO OFTEN THAT HE'S **OBLIVIOUS** TO IT.

- GLOMGOLD WILL NEVER BEAT SCROOGE BECAUSE HE'S ALWAYS WAITING FOR HIS RIVAL TO TAKE THE FIRST RISK AND THEN ATTEMPT TO **COPY** HIS SUCCESS.

- AND SCROOGE'S FORTUNE WAS BORN OF HIS WILLINGNESS TO **RISK EVERYTHING** FOR THE SAKE OF THE BIGGEST REWARD POSSIBLE. BUT THAT EXTREME DEVIL-MAY-CARE ATTITUDE HAS A TENDENCY TO CAUSE FRICTION BETWEEN SCROOGE AND THE INVESTORS, EMPLOYEES, AND FAMILY. SCROOGE IS GOING TO HAVE TO LEARN THAT THERE ARE SOME THINGS IN LIFE EVEN HE'S NOT WILLING TO RISK.

AS THEY GO ON DARING, RIDICULOUS ADVENTURES TOGETHER, THE DUCK FAMILY DISCOVERS THAT THERE ARE **THINGS MORE VALUABLE THAN TREASURE**

(YES, EVEN THE STOLEN TREASURE OF COLLIE BABA. YES, EVEN THE SELF-REPLICATING INFINITY DIAMONDS OF SIR FRANCIS DRAKE. YES, EVEN THE— YES, ALL TREASURE.)

EACH MEMBER OF THE FAMILY HAS TO LEARN TO EMBRACE THAT ELEMENT OF RISK THAT PUSHES THEM OUT OF THEIR COMFORT ZONE WHILE ALSO **DISCOVERING THE THINGS MOST IMPORTANT TO THEM.** IT'S NOT ENOUGH TO BE WILLING TO RISK EVERYTHING; YOU ALSO HAVE TO KNOW **WHO** YOU'RE WILLING TO RISK EVERYTHING FOR.

WHICH LEADS TO OUR OTHER MAIN THEME...

and through a series of events, Alex Hirsch asked for me to be line producer in the second season. So I got to finish off that series with Alex and Sean.

Towards the end of *Gravity Falls*, Disney gave me the lay of the land and asked if any of the next shows coming up were of any interest. The one that really popped up for me that I really wanted was *DuckTales*. I remember the interview that I had with Matt Youngberg. We chatted in his office. Not only was *DuckTales* iconic—it was very formative for me. Matt seemed like an incredible leader, and luckily, Matt liked me, too. Then we were off to the races. I got to meet Frank shortly thereafter. As we were getting into the art of it all, it was hard facing the question of "How do you take an iconic property and reboot it and its art style?" Having known Sean from *Gravity Falls*, I knew that he had such a respect for art history, art, artists, and where things came from, but he's also a tastemaker and can look ahead. So I called him, and I convinced him. I told him, "You don't have to commit, but just come in and do a couple of pieces and meet the guys." Sure enough, when he met Matt and Frank, that's when the really fun conversations took off.

MATT YOUNGBERG: There were rumors of rebooting *DuckTales* for years, and when I was done with *Ben 10*, I called up Disney and asked what was going on with it. At that point, they still had not figured out what they were doing with *DuckTales*, so they brought me in for a few meetings. They had a team on it in development, and I was on the outside. I assume that they really liked my take that I was bringing in. I was focusing on the family. I really wanted to make sure that the stories were coming from family, and that's what was pushing the adventure. It was focusing a lot on the heart, and the comedy and the adventure were the cool things in an episode, but they weren't the reason for the episode. The reason for the episode was interpersonal relationships and how they played off of each other and pushed the story forward. It was at that point when they had me meet Frank.

FRANK ANGONES: I was told by Disney, "This is the guy that we're going with." The breadth of this property and these iconic characters that are beloved— going back to the Carl Barks comics, to their appearances in various shorts, TV, and film projects, the original show, the video game—is overwhelming. If you try to embrace all of it, it'll crush the production. The thing that the original series very wisely did in making it a twenty-two-minute family adventure for children is to focus on that family element and focus on the relationships and the relatable family problems. We always said that *DuckTales* was a family sitcom where the family just happens to be a family of the world's greatest adventurers. Because Scrooge has had a long and storied adventure history, we were able to use that phrase as a base to pull in material from the European and Latin American comics, from the video game, from the original series, as well as those Carl Barks stories that started it all. It was a really great way to be able to pull from the toy box while still staying focused on that central core theme of family being the greatest adventure of all.

Our first meeting was at Disney TVA in 2015. The thing that Matt and I really bonded on was Chris Claremont *X-Men* comics. In the eighties, they had these huge, sprawling story arcs with complicated narratives. But the way comic books were written at that time, even in the middle of a long arc, you'd still be able to pick up any random issue of *X-Men* and feel like you had gotten your money's worth. That became the basis for the structure of our show, where each individual episode stands on its own as its own fun adventure, which you can watch in any order. But if you do happen to watch the whole series, then you have more of the context, and you get this larger adventure.

One of the big things that we agreed on right off the bat was to take this opportunity to differentiate Huey, Dewey, and Louie.

I had a two-page manifesto laying out my idea for the series, which is: something bad happened before the start of the show, and when Scrooge risked something that he couldn't get back, it alienated him from Donald

SOLVING MYSTERIES: THE THEMES

PART. 2

FAMILY IS THE GREATEST ADVENTURE

At its core, our version of DuckTales is a show about a remarkably unique family. And like every family, they have their own history, rivalries, alliances, inside jokes, weird eccentricities, and secrets...sometimes really big secrets...but at the end of the day, they love each other and will always have each other's quacks. Er... "backs." Have each other's backs. Sorry. No more duck puns.

Huey, Dewey, Louie, and Webby provide our access to the grand, storied, mysterious, and exciting world of the Duck Family/Clan McDuck. Like all kids their age, they're just starting to figure out that the grown-ups around them are people too. They pour over little hints and details of past relationships and events and press their ears to the door to uncover new clues. The kids are eager not only to uncover the details of the family's swashbuckling past (and for Scrooge, that's A LOT of past), but also to take their place as the next generation of adventurers. While Scrooge may be the charismatic vehicle for adventure, the kids are the protagonists.

And the one thing that is abundantly clear to the kids is that THIS FAMILY NEEDS EACH OTHER.

Whatever arguing, danger, or personal space violations they may face (how can such a big mansion have so few working bathrooms?!), they're way better off together than they ever were apart. Without each other, Scrooge would be stuck up in his musty old bin with all the money in the world and no one to share it with. And Donald would still be struggling to busily raise the boys by himself, hold down a job, and keep his little family afloat (literally. They lived on a houseboat.) This family— including Webby, Mrs. Beakley, and Launchpad—fills in each other's gaps to become a finely-honed adventuring team. If they stick together, there's no rival (personal, professional, or mythological) these ducks can't face.

Our goal is to take these iconic figures and turn them into real, relatable, three-dimensional characters, with an identifiable family dynamic that will speak to modern viewers. Sure, not everyone knows a trillionaire adventurer, trouble-making triplets, or an MI-6 trained nanny, but that relatability will come from the emotions and specificity of the characters. And that specificity is going to be crucial to juggling and differentiating a sizable main and recurring cast we want to build up around the Duck family.

AN IMPORTANT CAVEAT: We will never, EVER get so schmaltzy as to flat-out say "Family is the Greatest Adventure of All." We have, however, toyed with the idea of Launchpad constantly trying to say it before being cut off by a crash or an ambush or a blow dart to the neck. While our show is incredibly sincere, we should avoid sappiness at all costs.

In our desire to create such a dynamic, we're looking for inspiration not only from such family adventure stories as The Incredibles, the Indiana Jones films, and the Tintin comics, but also "Modern Family," "Arrested Development," and "30 Rock" to help strike a unique balance between **THRILLING ADVENTURE AND OFF-BEAT ENSEMBLE COMEDY.**

and locked Donald into being completely risk averse. We always tried to tie Scrooge's riches and treasure hunting to the notion of adventure and it being this epic thing. That allowed us to make the heart of these characters, the heart of the conflict, and the heart of the show to be about family and dealing with family. All families have rivalries and secrets and things that aren't talked about anymore, and that became an interesting way to ground the show.

The big question coming out of that meeting for us was not "How do we make more *DuckTales*?" It was "How do we recapture the feeling that *DuckTales* gave us when we were kids but do that for a contemporary audience?" The audience has changed, and kids have a different expectation from their shows. We really wanted to make sure that the focus was on doing a full family show, because it made sense for us that when we were kids, we would identify with Huey, Dewey, Louie, and Webby. Then, as adults, we would identify with Scrooge, Donald, or Beakley. We wanted something that the whole family could watch together. And it made sense with this property, which was so beloved by our generation, to make something our generation would be able to watch with the kids.

A big part of the appeal of the show is the big, quirky family ensemble cast. Once we were able to actually start separating those characters out in individual adventures and then bring them back together, when they came back together, it really did start to feel more like a full family experience, with people coming at each other from all different ways. Our initial pitch to Disney was that we wanted to do *Modern Family* meets *Arrested Development* meets *Indiana Jones*. It was all about that snappy chemistry that happens when all of the characters are in the room that you don't necessarily get in a lot of other sitcoms, where it's not a full family of interesting characters.

SUZANNA OLSON: Matt has such great instincts about that stuff and keeps the kids, the parents, and the original fans in mind as he's making each of

these decisions. Before we'd go too far in one crazy direction, Matt would keep us on task.

MATT YOUNGBERG: I always loved the crazy direction, even if I didn't agree with it and was like, "Okay, well, what does that get us? Is there a different way of doing that kind of thing?" As the show went on, it got crazier, and a lot of those crazy suggestions become more and more "Well, yeah. Okay, that sounds good. Let's do it." But the most important thing at the beginning was getting that really solid base for storytelling, and then you can expand into the crazy territory once you're invested in those characters.

FRANK ANGONES: After our initial meeting, we had two internal meetings, and they were a joy. We had never met before, and it was like being in a room with one of your buddies, riffing on this cool thing. If *DuckTales* works at all, it's because of the chemistry that sparked out of that meeting and how that specific type of chemistry filtered out to all elements of the crew.

SUZANNA OLSON: Frank and Matt visually showed those interpersonal relationships with a crazy-cool whiteboard, and that turned it around for the execs. They saw their vision of the family and the family stories that were possible, and it was the beginning of them starting to get Matt and Frank's vision.

SEAN JIMENEZ: Having been in development, I could see that a lot of the other takes on the material were more focused on just the epic, sweeping adventures, and that didn't feel right. When I met Matt and Frank, they pitched their version, and I thought there was an immense thoughtfulness and seriousness towards the material that I loved and responded to. I understood during that meeting exactly why this version was being made, because Matt and Frank actually figured out how to make it work.

THE STYLE OF DUCKTALES!

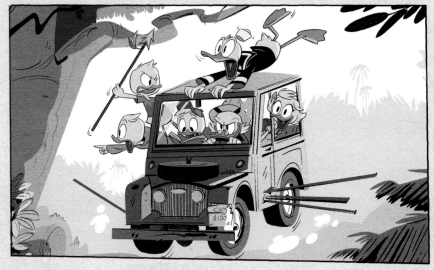

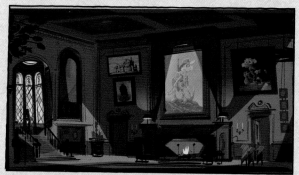

MATT YOUNGBERG: Ultimately, the visual style of the show that we talked about in that first meeting with Sean is pretty close to what eventually wound up onscreen. Since we were updating the stories, we really wanted to find a way to tell those modern stories that felt fresh and new to a modern audience. Visually, I was really in love with the idea of bringing in some of the old inked quality of things from the original Carl Barks comics but then modernizing it a bit. I was also looking at French comics and manga and all of this really cool stuff that a modern audience is very familiar with. So it was all about taking the old and marrying it with the new. Sean and I really connected, and he got what I was saying in my initial pitch to him, which was "What if there was an artist in the world of *DuckTales*, walking around through the cities and towns, and he had a sketchbook, and he was inking the scenery that he was seeing?" I wanted to have this grounded feeling, where it felt like you were in a place that existed, but it had more of an artistic, inked quality to it, instead of a photographic quality. Sean got it immediately, and then he went away and sketched up a few examples of what he was thinking, based on that idea. As soon as that artwork came in, I knew that was the direction that we needed to go.

SUZANNA OLSON: Sean was the only art director that came in with pencils and paper and laid out a bunch of ideas.

FRANK ANGONES: The thing that was exciting when I first met Sean is that Sean was coming to this project with the same big-idea thinking that Matt and I

were talking about, really trying to figure out a way to embrace and honor the original stories and show and these characters, while also finding ways to use those elements to recontextualize it for a modern audience. Sean sparked on those references and came up with tons of interesting ideas. Part of the joy of working on this show was that I learned so much working with Sean, Matt, Suzanna, and our whole team. I am not an artist, but I connect with the way that Sean talks about connecting art and design to character and theme.

SEAN JIMENEZ: What clicked for me is when Matt mentioned Carl Barks, and then we talked about Hergé's clean line, with Carl Barks's comic feel—so, what if the duck who was walking around chronicling the series was Hergé, with his clean, reductive quality? That felt like a new territory that we were entering into. In Photoshop, you can import a piece of texture instead of trying to render it. In the original series, they painted those backgrounds by hand. Now we could really make it feel more like a comic book.

FRANK ANGONES: We wanted the show to feel pulpy, like an old pulp novel or comic book, so Sean went and purchased these giant reams of old newsprint, with all of that pulp texture in them.

SUZANNA OLSON: And then I had to figure out how to get them photographed at Imagineering, with the same camera type that Ansel Adams used, and then that high-resolution image was the underlying texture of our show.

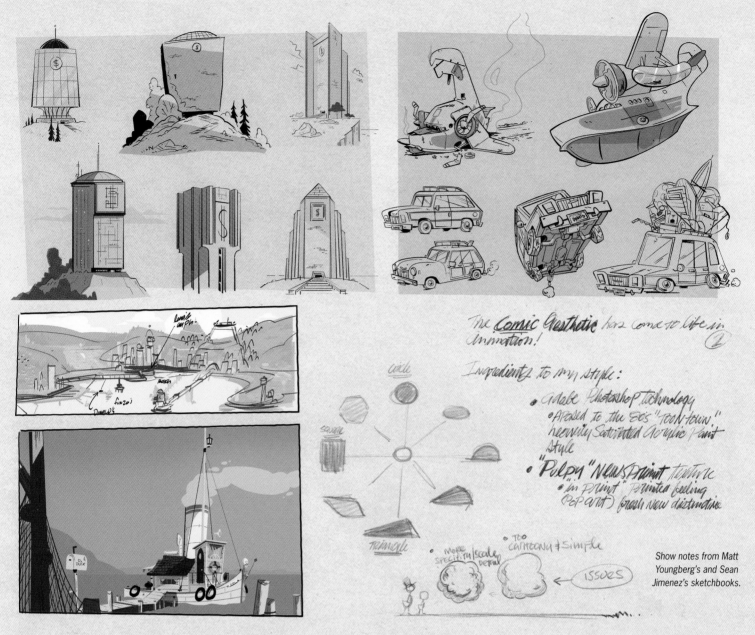

Show notes from Matt Youngberg's and Sean Jimenez's sketchbooks.

FRANK ANGONES: In the background of every single frame of *DuckTales*, you see that pulp texture, and that's not a thing that leaps out, but it is something that inherently shows how much Sean cares and how big his ideas can be while still honoring tradition.

MATT YOUNGBERG: No one else had cracked it like Sean. He cracked what was in my brain but brought in new things, and that's the whole point. I don't want to hire people who are just going to do exactly what's in my brain, because I'm not as good as some other people. I'm not as good as Sean as an art director. So I want Sean to be able to crack something that I'm not seeing, and that's what he did. Having that clear vision helped so much as we moved forward, and it went super smoothly from there. I'm someone who has a hard time sitting in development, because I like decisions being made that matter. My production brain is: if it works, and we like it, let's make it work, and let's make it the show. Having that means that when you're talking to anyone about the show, you

have something to point to and say, "This is our direction. This is our guiding light."

Photographing the paper texture used throughout the series (and this book).

SUZANNA OLSON: During this process is also when the Ben Day dots were brought in to be used in the shadows. That was another revelation.

SEAN JIMENEZ: At the time, no one was really using them, so I ended up building our own brush, so that we could control the scale and diameter. Many of the challenges of art direction have to do with scale. When audiences are watching a TV screen, the size of the Ben Day dot has to be carefully controlled. The bigger they get, the more they become patterns that overpower the background and get in the way, but too small, and they compile and matrix in movement. There are all of these really strange optical issues that come from introducing Ben Day dots into the equation. It was worth figuring out, because it ended up adding an interesting freshness to the style.

PARALAX/MULTIPLANING EXAMPLE

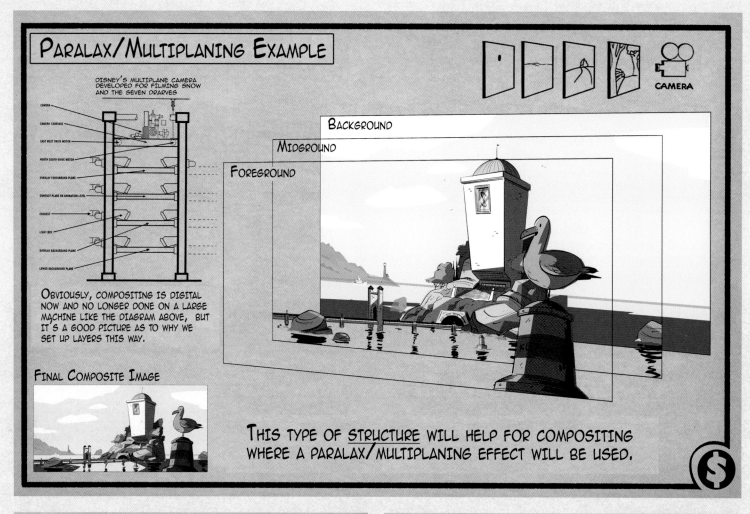

DISNEY'S MULTIPLANE CAMERA DEVELOPED FOR FILMING SNOW AND THE SEVEN DWARVES

CAMERA
CAMERA CARRIAGE
EAST WEST DRIVE MOTOR
NORTH SOUTH DRIVE MOTOR
OVERLAY FOREGROUND PLANE
CONTACT PLANE OR ANIMATION LEVEL
EXHAUST
LIGHT BOX
OVERLAY BACKGROUND PLANE
LOWER BACKGROUND PLANE

OBVIOUSLY, COMPOSITING IS DIGITAL NOW AND NO LONGER DONE ON A LARGE MACHINE LIKE THE DIAGRAM ABOVE, BUT IT'S A GOOD PICTURE AS TO WHY WE SET UP LAYERS THIS WAY.

BACKGROUND
MIDGROUND
FOREGROUND

CAMERA

FINAL COMPOSITE IMAGE

THIS TYPE OF <u>STRUCTURE</u> WILL HELP FOR COMPOSITING WHERE A PARALAX/MULTIPLANING EFFECT WILL BE USED.

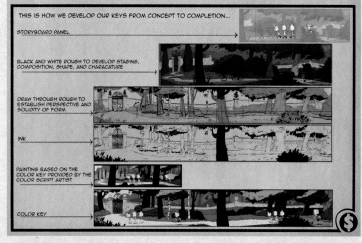

THIS IS HOW WE DEVELOP OUR KEYS FROM CONCEPT TO COMPLETION...

STORYBOARD PANEL

BLACK AND WHITE ROUGH TO DEVELOP STAGING, COMPOSITION, SHAPE, AND CHARACATURE

DRAW THROUGH ROUGH TO ESTABLISH PERSPECTIVE AND SOLIDITY OF FORM

INK

PAINTING BASED ON THE COLOR KEY PROVIDED BY THE COLOR SCRIPT ARTIST

COLOR KEY

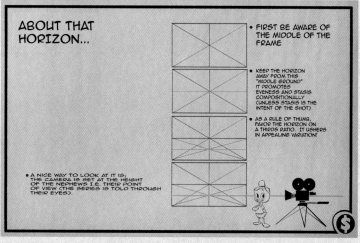

ABOUT THAT HORIZON...

- FIRST BE AWARE OF THE MIDDLE OF THE FRAME

- KEEP THE HORIZON AWAY FROM THIS "MIDDLE GROUND" IT PROMOTES EVENESS AND STASIS COMPOSITIONALLY (UNLESS STASIS IS THE INTENT OF THE SHOT)

- AS A RULE OF THUMB, FAVOR THE HORIZON ON A THIRDS RATIO. IT USHERS IN APPEALING VARIATION!

- A NICE WAY TO LOOK AT IT IS; THE CAMERA IS SET AT THE HEIGHT OF THE NEPHEWS I.E. THEIR POINT OF VIEW (THE SERIES IS TOLD THROUGH THEIR EYES).

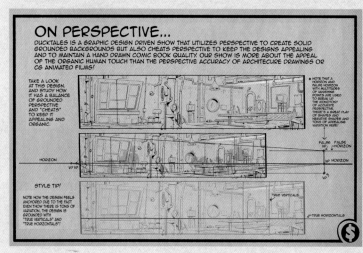

ON PERSPECTIVE...

DUCKTALES IS A GRAPHIC DESIGN DRIVEN SHOW THAT UTILIZES PERSPECTIVE TO CREATE SOLID GROUNDED BACKGROUNDS BUT ALSO CHEATS PERSPECTIVE TO KEEP THE DESIGNS APPEALING AND TO MAINTAIN A HAND DRAWN COMIC BOOK QUALITY. OUR SHOW IS MORE ABOUT THE APPEAL OF THE ORGANIC HUMAN TOUCH THAN THE PERSPECTIVE ACCURACY OF ARCHITECURE DRAWINGS OR CG ANIMATED FILMS!

TAKE A LOOK AT THIS DESIGN, AND STUDY HOW IT HAS A BALANCE OF GROUNDED PERSPECTIVE AND "CHEATS" TO KEEP IT APPEALING AND ORGANIC.

NOTE THAT A HORIZON AND FALSE HORIZON WITH MULTITUDES OF VANISHING POINTS ARE USED TO BREAK UP THE MONOTONY OF ACCURATE PERSPECTIVE. THERE'S A GREAT PLAY OF SHAPES AND NEGATIVE SHAPES AND TONS OF APPEALING VARIATION HERE!

FALSE VP FALSE HORIZON

HORIZON VP HORIZON

STYLE TIP!

NOTE HOW THE DESIGN FEELS ANCHORED DUE TO THE FACT EVEN THOW THERE IS TONS OF VARIATION, THE DESIGN IS GROUNDED WITH "TRUE VERTICALS" AND "TRUE HORIZONTALS!"

TRUE VERTICALS

TRUE HORIZONTALS

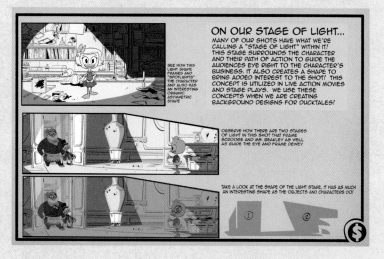

ON OUR STAGE OF LIGHT...

MANY OF OUR SHOTS HAVE WHAT WE'RE CALLING A "STAGE OF LIGHT" WITHIN IT! THIS STAGE SURROUNDS THE CHARACTER AND THEIR PATH OF ACTION TO GUIDE THE AUDIENCES EYE RIGHT TO THE CHARACTER'S BUSINESS. IT ALSO CREATES A SHAPE TO BRING ADDED INTEREST TO THE SHOT! THIS CONCEPT IS UTILIZED IN LIVE ACTION MOVIES AND STAGE PLAYS. WE USE THESE CONCEPTS WHEN WE ARE CREATING BACKGROUND DESIGNS FOR DUCKTALES!

SEE HOW THIS LIGHT SHAPE FRAMES AND "SPOTLIGHTS" THE CHARACTER AND ALSO HAS AN INTERESTING ORGANIC ASYMETRIC SHAPE

OBSERVE HOW THERE ARE TWO STAGES OF LIGHT IN THIS SHOT THAT FRAME SCROOGE AND MS. BEAKLEY AS WELL AS GUIDE THE EYE AND FRAME DEWEY

TAKE A LOOK AT THE SHAPE OF THE LIGHT STAGE, IT HAS AS MUCH AN INTERESTING SHAPE AS THE OBJECTS AND CHARACTERS DO!

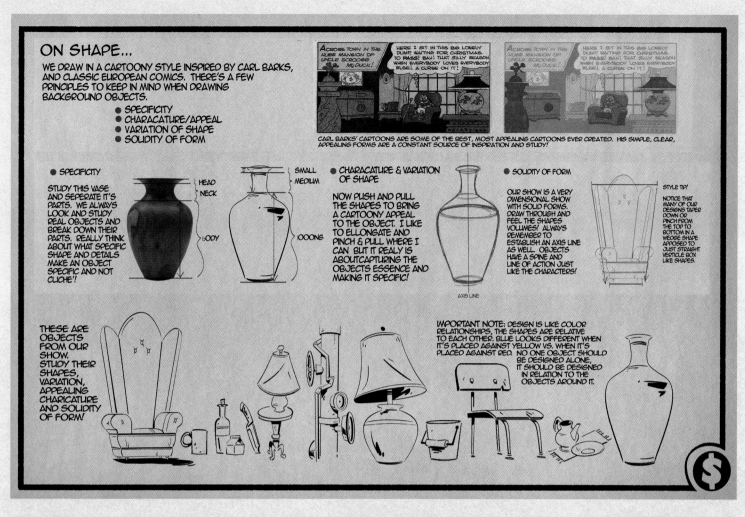

ON SHAPE...

WE DRAW IN A CARTOONY STYLE INSPIRED BY CARL BARKS, AND CLASSIC EUROPEAN COMICS. THERE'S A FEW PRINCIPLES TO KEEP IN MIND WHEN DRAWING BACKGROUND OBJECTS.

- SPECIFICITY
- CHARACATURE/APPEAL
- VARIATION OF SHAPE
- SOLIDITY OF FORM

CARL BARKS' CARTOONS ARE SOME OF THE BEST, MOST APPEALING CARTOONS EVER CREATED. HIS SIMPLE, CLEAR, APPEALING FORMS ARE A CONSTANT SOURCE OF INSPIRATION AND STUDY!

- SPECIFICITY

STUDY THIS VASE AND SEPERATE IT'S PARTS. WE ALWAYS LOOK AND STUDY REAL OBJECTS AND BREAK DOWN THEIR PARTS. REALLY THINK ABOUT WHAT SPECIFIC SHAPE AND DETAILS MAKE AN OBJECT SPECIFIC AND NOT CLICHE'!

HEAD / NECK / BODY

SMALL / MEDIUM / LOOONG

- CHARACATURE & VARIATION OF SHAPE

NOW PUSH AND PULL THE SHAPES TO BRING A CARTOONY APPEAL TO THE OBJECT. I LIKE TO ELLONGATE AND PINCH & PULL WHERE I CAN BUT IT REALY IS ABOUT CAPTURING THE OBJECTS ESSENCE AND MAKING IT SPECIFIC!

- SOLIDITY OF FORM

OUR SHOW IS A VERY DIMENSIONAL SHOW WITH SOLID FORMS. DRAW THROUGH AND FEEL THE SHAPES VOLUMES! ALWAYS REMEMBER TO ESTABLISH AN AXIS LINE AS WELL. OBJECTS HAVE A SPINE AND LINE OF ACTION JUST LIKE THE CHARACTERS!

AXIS LINE

STYLE TIP! NOTICE THAT MANY OF OUR DESIGNS TAPER DOWN OR PINCH FROM THE TOP TO BOTTOM IN A WEDGE SHAPE APPOSED TO JUST STRAIGHT VERTICLE BOX LIKE SHAPES.

THESE ARE OBJECTS FROM OUR SHOW. STUDY THEIR SHAPES, VARIATION, APPEALING CHARICATURE AND SOLIDITY OF FORM!

IMPORTANT NOTE: DESIGN IS LIKE COLOR RELATIONSHIPS, THE SHAPES ARE RELATIVE TO EACH OTHER. BLUE LOOKS DIFFERENT WHEN IT'S PLACED AGAINST YELLOW VS. WHEN IT'S PLACED AGAINST RED. NO ONE OBJECT SHOULD BE DESIGNED ALONE, IT SHOULD BE DESIGNED IN RELATION TO THE OBJECTS AROUND IT.

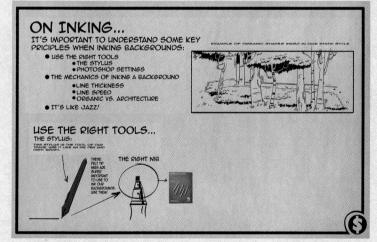

ON INKING...

IT'S IMPORTANT TO UNDERSTAND SOME KEY PRICIPLES WHEN INKING BACKGROUNDS:

- USE THE RIGHT TOOLS
 - THE STYLUS
 - PHOTOSHOP SETTINGS
- THE MECHANICS OF INKING A BACKGROUND
 - LINE THICKNESS
 - LINE SPEED
 - ORGANIC VS. ARCHITECTURE
- IT'S LIKE JAZZ!

EXAMPLE OF ORGANIC SHAPES INKED IN OUR SHOW STYLE

USE THE RIGHT TOOLS...

THE STYLUS:
THE STYLUS IS THE TOOL OF OUR TRADE. USE IT LIKE AN INK PEN AND PAINT BRUSH.

THESE FELT TIP NIBS ARE SUPER IMPORTANT TO USE TO INK OUR BACKGROUNDS. USE THEM!

THE RIGHT NIB

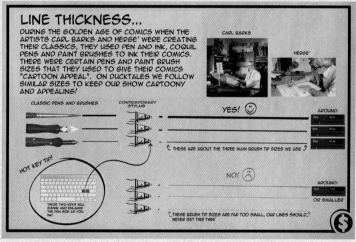

LINE THICKNESS...

DURING THE GOLDEN AGE OF COMICS WHEN THE ARTISTS CARL BARKS AND HERGE' WERE CREATING THEIR CLASSICS, THEY USED PEN AND INK, COQUIL PENS AND PAINT BRUSHES TO INK THEIR COMICS. THERE WERE CERTAIN PENS AND PAINT BRUSH SIZES THAT THEY USED TO GIVE THEIR COMICS "CARTOON APPEAL". ON DUCKTALES WE FOLLOW SIMILAR SIZES TO KEEP OUR SHOW CARTOONY AND APPEALING.

CARL BARKS

HERGE'

CLASSIC PENS AND BRUSHES / CONTEMPORARY STYLUS

YES! ☺

HOT KEY TIP!

↑ THESE ARE ABOUT THE THREE MAIN BRUSH TIP SIZES WE USE

THESE TWO KEYS WILL SHRINK AND ENLARGE THE PEN SIZE AS YOU INK!

NO! ☹

AROUND:

OR SMALLER

↑ THESE BRUSH TIP SIZES ARE FAR TOO SMALL, OUR LINES SHOULD NEVER GET THIS THIN!

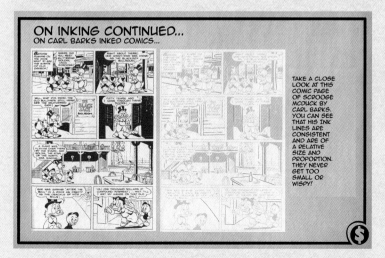

ON INKING CONTINUED...

ON CARL BARKS INKED COMICS...

TAKE A CLOSE LOOK AT THIS COMIC PAGE OF SCROOGE MCDUCK BY CARL BARKS. YOU CAN SEE THAT HIS INK LINES ARE CONSISTENT AND ARE OF A RELATIVE SIZE AND PROPORTION. THEY NEVER GET TOO SMALL OR WISPY!

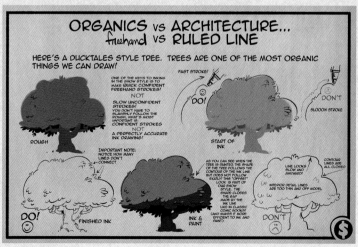

ORGANICS VS ARCHITECTURE...

freehand VS RULED LINE

HERE'S A DUCKTALES STYLE TREE. TREES ARE ONE OF THE MOST ORGANIC THINGS WE CAN DRAW!

ONE OF THE KEYS TO INKING IN THE SHOW STYLE IS TO MAKE QUICK CONFIDENT FREEHAND STROKES! NOT SLOW UNCONFIDENT STROKES! YOU DON'T HAVE TO SLAVISHLY FOLLOW THE ROUGH, WHAT'S MOST IMPORTANT IS CONFIDENT STROKES NOT A PERFECTLY ACCURATE INK DRAWING!

ROUGH

FAST STROKE!
DO!

DON'T
SLOOOW STROKE

START OF INK

IMPORTANT NOTE: NOTICE HOW MANY LINES DON'T CONNECT

AS YOU CAN SEE WHEN THE TREE IS PAINTED THE SHAPE OF THE TREE FOLLOWS THE CONTOUR OF THE INK LINE BUT DOES NOT FOLLOW EXACTLY THIS "OFFSET" LOOK IS PART OF OUR SHOW STYLE. THE SHAPE CLOSES THE GAP OF THE INK LINE.

DO!
FINISHED INK

INK & PAINT

CONTOUR LINES ARE ALL CLOSED

INTERIOR DETAIL LINES ARE TOO THIN AND OFF MODEL

DON'T

CHARACTER DESIGN!

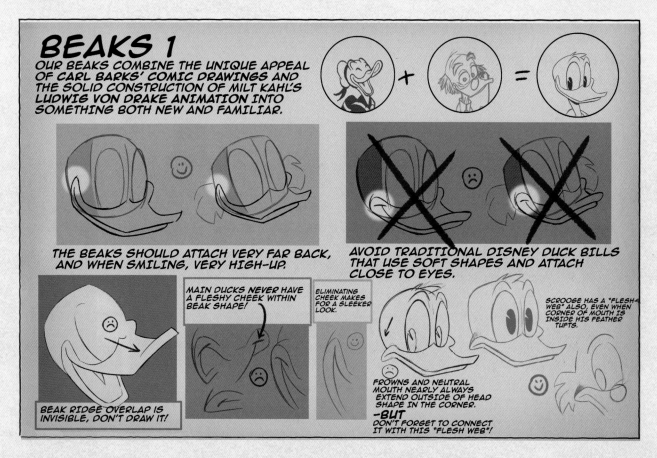

MATT YOUNGBERG: I had started sketching characters, just on my own, trying to figure out what our style would be. We brought in some character designers, and I'd also do tweaks on those. At that point, we had figured out the general style of the show, but the characters were the harder part to nail down in terms of what we were doing. Were we updating them? Doing the same? Are we doing Carl Barks? So we went out to a bunch of different artists, and we had amazing takes coming in. There were little bits and pieces that we liked from different artists, and so we started combining those ideas. Then we brought on Alex Kirwan to help us crack the code, because Alex Kirwan is the Sean Jimenez of character design. He loves digging into the history and figuring out what works and what doesn't.

FRANK ANGONES: A thing that Disney animators have had to contend with for almost one hundred years now is how to handle the beaks. They're hard to draw, they're hard to do standard lip flap, and it's hard to get a range of expression. And then when we're trying to codify this to do what we need them to do, can they be animated?

MATT YOUNGBERG: Because I wanted it to go slightly more dynamic, clean, and sharp than the original series, which was a bit more in the traditional Disney design realm, I hit on Milt Kahl. Looking at all the old duck history, I really connected with Milt Kahl's treatment of the beaks of characters, especially

his Ludwig Von Drake drawings. The beak was a design unto itself. It was clean and sharp and didn't have a lot of overlapping gobbledygook. It was very strong and clear, and I latched on to that. And then Alex hit on the idea of bringing in the Carl Barks cheeks, so the front of the beak was Milt Kahl, and the back of the mouth was Carl Barks, which was very organic and expressive.

SEAN JIMENEZ: I co-conceived the "beak formula" on how to draw the duck beaks for TV production with Alex Kirwan, who was our brilliant character design lead through the development portion of the series. Tim took over when the show went into production. It took a long time to figure out the beaks, because it's really hard to draw them dimensionally.

TIM MOEN: There are a lot of cheats in the beaks. The beaks make zero sense. If you had to 3D sculpt the beaks, it would not look the same as it looks in the different angles on the model sheet. There's nothing literal about it. It's something that all of the Disney ducks have, but you can't mess with it, or else it doesn't look like a Disney duck anymore. Alex and Sean had started to cultivate a style which paid homage to the Carl Barks comics, taking certain elements, such as the way that Barks drew beaks, the pie slice cut out of their pupils, and the way beaks connect with the cheeks. The beaks were a combination of how Barks drew them and the Ludwig Von Drake designs from the early 1960s. The beaks have to be drawn with the cheeks looking

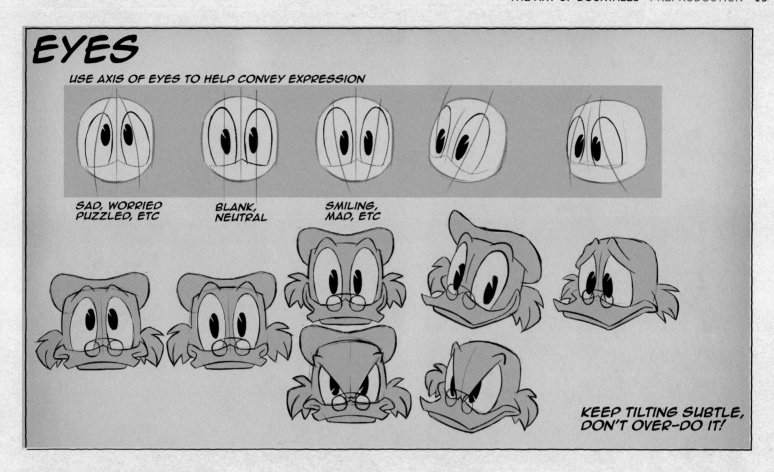

EYES

USE AXIS OF EYES TO HELP CONVEY EXPRESSION

SAD, WORRIED
PUZZLED, ETC

BLANK,
NEUTRAL

SMILING,
MAD, ETC

KEEP TILTING SUBTLE,
DON'T OVER-DO IT!

the way Carl Barks would draw them, but the front of the bill needs to look like how Von Drake was drawn in the sixties.

Another element we took from Carl Barks is that all of our characters' eyes have dark oval pupils with a slice cut out that represents a highlight. Typically, as much as we can control it, the highlight is pointing in the direction that the character is looking.

MATT YOUNGBERG: Tim Moen became an essential team member, as he took all of our wild character design ideas and coalesced them into a specific design language that everyone could speak. For TV production, you need to translate pie-in-the-sky ideas into something simple and understandable enough for an overseas studio to be able to execute. Tim came in and started figuring out the final shape language of our characters to allow for consistency. He was the first to take the development stuff that Alex Kirwan had done and actually do turnarounds.

SEAN JIMENEZ: While I did all the design philosophy, background design, and "stage of light" concept pages for our show style guide codifying the look of the series, I enlisted Tim Moen to head up the character design portion of the pack, with my specific direction on the page layouts.

TIM MOEN: I knew we had to be as specific as possible and have every single bit figured out, so I put the guide together over the summer of 2016. Alex Kirwan did part of it, too. I wanted to make sure that anyone using this guide could understand the structure of the characters, so that if you're drawing it, there are no questions. You can see, structurally, what everything is.

There's a learning curve on a series, where you spend a lot of time getting into the style that someone else has explored in development and then figuring out any deficiencies in that when you need to make it be production ready, where it needs to be drawn by hundreds of animators having to maintain a consistent look. In development, we're just exploring ideas, and we're not worried about the technical aspect. My job was taking those ideas and then making the technical aspect work. It was really just trying to understand how the ducks are constructed and how to codify the cleanup style to make it consistent.

SEAN JIMENEZ: I came up with the "marshmallow" analogy to help the designers and overseas vendors understand the treatment of the dimensional shapes of the characters.

Professor VON DRAKE

PROD. 3101

Milt Kahl's treatment of Professor Von Drake.

TIM MOEN: That helped a lot, because that's how we kept it simple: by treating all the structural elements of a character, as much as we can, with that underlying aesthetic. That's how we got consistency. They're simple shapes like a square, but it's a little puffed out and rounded on the corners. The slight positive air pressure of every character and all of their little facets and features is definitely part of what goes into the look of *DuckTales*, as is the posture and invisible skeletal structure of the ducks.

One of the things that was difficult and different about *DuckTales* is Matt was like, "We're making an action show." *DuckTales* is an action-comedy adventure, and so the characters needed to walk and behave a little bit more humanoid than they had in the past. If you look at the traditional Disney duck design, they lean forward more, and the

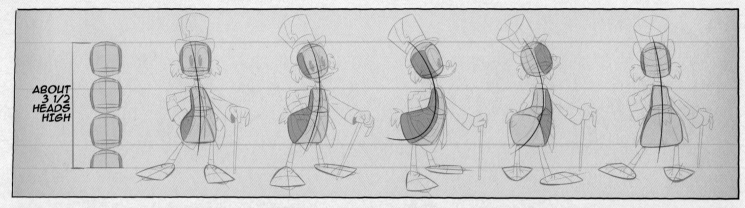

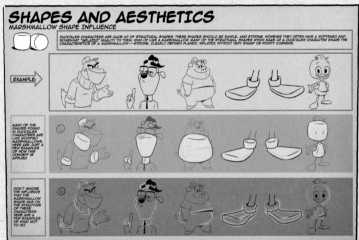

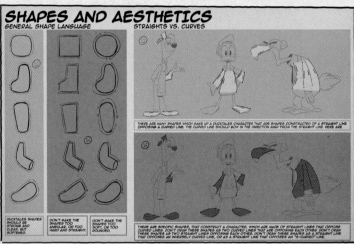

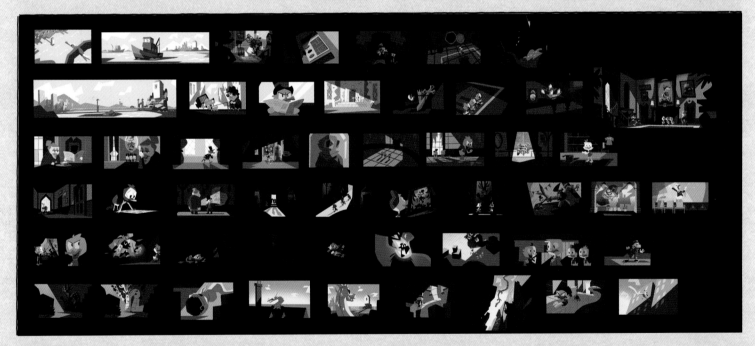

legs are a little bit more under and back, like regular ducks. The posture is not quite as erect as you'd draw a proper human being. Sean drew a skeletal structure of how he viewed the duck mechanic working, and we ended up attaching the legs closer to the front of the pelvis, so that they weren't behind the ducks, and they just had kind of a big tail sticking out. That way, they can really act and kind of go nuts.

The shapes need to have some kind of strength to them, usually straights and curves. You'll see it in how the arms, torsos, and sometimes even the feet are drawn. And in cleanup, the ink lines have to taper into one another. Where there are turns or where lines converge, they taper—but not too thin or too thick.

Sean and Matt wanted the cleanup to have a flowy ink stroke with tapered ends. It was hard to learn how to do that, but fortunately our cleanup artist, Jeremiah Alcorn, figured that style out before I came on. I learned a lot from him by dissecting his work and figuring out a way to

implement that style in our cleanup process. The lines had to flow into each other, and we couldn't have overshoots that weren't intended, or it would look sloppy. Everything had to be meticulous, or it falls apart rather quickly. We needed something to send overseas to make it feel consistent.

It was impressed upon me to really hit the 1950s Carl Barks aspect of the designs, but when Tapan Gandhi came on as a character designer, he was really able to lock in to an aspect of the style of the show that none of us were even talking about, which was the Disney Afternoon aspect. He was able to look at Darkwing Duck or Goofy in *Goof Troop* and do an updated version of how that would look in our show style. Hybridizing those ideas with what Matt, Frank, and Sean were thinking put us over the edge with what we needed for the series. The key aspect of a final character design, when you're looking at it, is whether or not it looks like it fits within our world.

BUILDING THE PRODUCTION TEAM!

MATT YOUNGBERG: Building out our team at the beginning, it was pretty key to get some directors involved. Initially, we brought in Dana Terrace, John Aoshima, and Tom Owens. Tom left within the first few episodes, and when he left, we replaced him with Matt Humphreys, who was one of our storyboard artists. Sarah Craig also arrived fairly early to do prop design as part of the core team.

SUZANNA OLSON: When we started the show, Matt and each director had a few storyboarders in mind to set the tone of the show, but we had a lot of positions to fill. So I used the anonymous testing process that we did on *Gravity Falls*, which was to take names and identifying information off of the tests, and we submitted them to Matt and the directors. That way, they got to judge the work just on the technical and creative boarding abilities. Then, on the second round, share the name and their résumé, and talk about the person. There were some young, up-and-coming board artists, right out of school, and there were veterans who'd already been doing it. It allowed us to be open and take away any implicit bias that might sometimes exist. It was important to Matt to have a diverse team and have new voices. He wanted talented people and was always promoting growth from within. So we had a lot of people who grew into supervisory roles within our crew who started from that anonymous casting process.

SEAN JIMENEZ: We implemented the color-script process, which was a big thing for the show. It's an artist who's focusing creatively on color harmonies, right from the beginning of the process on an episode. We used the color script as part of the creative process. We showed it to everyone upfront so they could get a snapshot view of what the colors guiding the show would be. We approached it cinematically, since color represents mood and the emotion of a character. It was the first time I was able to get color-script positions implemented into the production pipeline, which usually isn't the case. *DuckTales* was one of the first shows to really codify color scripting into the preproduction process of the show and not just do it willy-nilly. Usually, it's a job that's multitasked by another position within a show, like an art director or a background painter. I felt we needed somebody to focus on it full time. I had worked with Josh Parpan on *Gravity Falls* and really loved his colors.

SUZANNA OLSON: Sean always came in with a great blue-sky vision, but he was also production minded, so he'd come to me with diagrams and "Here's how I think it could work," which was great. He would always put some thought into how it could possibly be implemented. It always made it so

Sign on the writers' room door.

much easier to pitch the vision upwards and get that buy-in. The studio was really excited about *DuckTales*, and they let us experiment in a lot of different ways. Matt introduced the "board-o-matic" to Disney TV Animation.

MATT YOUNGBERG: An animatic is taking the final storyboards from an episode and matching them to an episode's recorded dialogue. A board-o-matic was a rough animatic, taking the first-pass storyboards and doing that. In the past, I had seen both a really good board get pitched and die because the person pitching isn't very good, and horrible boards get by because someone's really good at pitching. I wanted to take that risk out of it. I knew our scripts were strong and our actors were strong, and I'm hiring board artists because their skills are strong, and not that they're great at getting up in front of someone and pitching them. So my philosophy was to get it in animatic form as quickly as possible to see if it's working.

MATT YOUNGBERG: We were collaborative not just on the art side but the writing side, as well. Usually on a show, you don't bring an art director into a story break. Traditionally, the last thing that happens is an art director gets to come in and start putting things together. But from very early on, we had Sean sitting in at the story breaks. When we had the broad story beats, Sean would be there hearing them, so he would already be getting ideas for visuals.

FRANK ANGONES: The key to the process of making the show was collaboration. The way that the writing would work is that we would come up with general ideas, like, "This is the type of story we want to tell." But then there was a template it had to pass, which was "What makes this a story worth telling?" and "What makes this an episode of *DuckTales*?" Because there are stories worth telling that aren't necessarily an episode of *DuckTales*.

There are a couple of things that we codified pretty early on in this show that cemented collaboration as the order of the day, across the board. One of them was involving the art director and the directors in the story break. Along with collaboration, I think it's important that people feel engaged, because then you feel ownership of a thing. And if you feel ownership of a thing, you're going to put in more of yourself and your heart. It's a testament to Matt as a showrunner that he always encouraged that. He hired well, and he brought in these people because he wanted to hear their opinions and because he wanted to collaborate with them and knew they could do something that maybe wasn't his strong suit. And Matt has many strong suits, and it would be very easy for Matt to not be that type of dude, but we were all very lucky that he was.

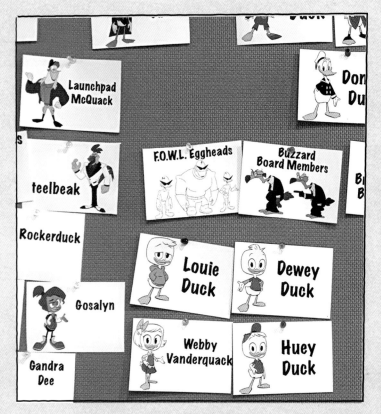

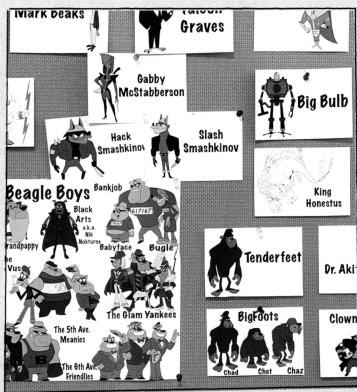

Notes pinned to a wall capture plot ideas and character bios for the show's writers.

SUZANNA OLSON: Speaking to hiring well, I would go to bat for the ideas, but a lot of times the implementation and execution was really a collaboration with Laura Reynolds. It was her amazing experience, coming from the feature side and twelve years at Pixar. She brought all that to the table and really helped smooth the road for the entire crew.

MATT YOUNGBERG: Laura was a really special hire. I remember Suzanna was reading Ed Catmull's book, *Creativity, Inc.*, and she read a story about an implementation of some kind of production method that was really intriguing. And the person behind it was Laura.

SUZANNA OLSON: It was a story about *The Incredibles* and Brad Bird, and keeping the production running when it came to the character animation, and I was like, "The way this woman thinks is incredible. I want her on *DuckTales*." So I looked her up, we went out to lunch, and when I had a position finally available, she accepted.

SEAN JIMENEZ: Laura was key in the production process as the person trying to figure out how to implement everything everyone needed within the production schedule.

MATT YOUNGBERG: Suzanna has a great eye for production people, as well as their talent, and everyone she hired was always a home run. Around that point is also when we had to crew up the writing team.

FRANK ANGONES: I wrote up a loose ten-page document that served as a writing guide, outlining what we were doing with the show, the characters, how the relationships work, and a list of the things that we were referencing. We also developed this thing called the "no mine cart" rule, which was a huge thing for us in the early days. At one point, a mine cart chase was a revelation in pulp storytelling. It's like, "Oh my gosh, it's like a car chase, but it's on rails! And it's through a mine, so there are all these specific obstacles!" And then it just got done to death. Everyone just did versions of it, and it became an old saw that you've seen a million times before. Our goal was: "All right, we never want to do something that feels like you've seen it

a hundred times before on an adventure show. What's the variation, but with an idea that you haven't necessarily seen before?" It's just trying to shake up those tropes. So when we met with writers, we always impressed that it's a family story first, the stories and adventures come from family, and that would inform what the action set pieces would be.

Colleen Evanson had submitted a sample idea that was a family road trip to Atlantis and just playing up the family aspect. That was perfect, because you got all of the family road trip stuff, and all of the adventure stuff, and it grounds things. We used her idea in the second half of our pilot. We were able to bring in Colleen, and it was her first big staff writing gig, but she just had such a great brain for comedy. I was able to bring on Bob Snow and Christian Magalhaes, because I knew they both had great adventure story brains. Madison Bateman had a long history with franchise animated shows and animated shows in general. The thing that all of the writers shared was that they were all hungry to do something really interesting and different with *DuckTales*, and wanted to form a writers' room, and to form that kind of bond. I firmly believe that nobody really knows how a TV show is written and understands that this is a collaborative effort, especially the way that we would break stories, bringing in all these other people and really hammering it out. To foster that sense of collaboration amongst the writers, I said, "Hey, if you're in the writers' room for a story break, your name is on that episode as a 'story by' credit, because you contributed." It's that thing of getting people invested by providing them ownership and involvement, so they're not just focusing on their episodes, they're focused on everything.

MATT YOUNGBERG: Up to this point in my career, it was rare to even have a writers' room. I've had writers, but everything was on a freelance basis, where we'd bring people in and break stories together, and then the writers would just disappear. This was the first time where I had a writers' room, they were all in-house, and they were all sitting in offices right near mine. It was an opportunity to pick their brains all the time and to bring them into things that they traditionally hadn't been a part of. It was this really great opportunity to really make a show cohesive, from the start to the finish. I never was able to do that before. We were doing something that was really special, and everyone could feel it.

THE MUSIC OF DUCKTALES!

Scrooge/Adventure

MATT YOUNGBERG: Our approach to music on the show was guided by the adventure and sense of grandness we wanted to bring to it. We wanted to make it feel as big as it should be, and so we wanted some really cinematic music. We wanted to make sure each character had their own theme. We also needed versatility, because we knew we weren't going to be doing the same stories every time, in the same locations, but rather would be going on different adventures around the world. If we're going to a country, we needed music that embraced that culture. It was a real challenge to find the right composer, because it was a big ask to do all of that stuff. Then we found Dominic Lewis, and Dom could do it all.

DOMINIC LEWIS: As a child, I fell in love with *DuckTales* and the theme song. So when I got the offer to score *DuckTales*, it was like a dream come true. Tackling the pilot, I relied on my emotional memories of the original show, and then wanted to bring what I was going to bring to this new show. Frank and Matt told me, "We want to create the show that you think you remember," and that was how I approached the score, because I remembered it being awesome. I threw caution to the wind and went, "Well, how about a huge orchestra and loads of cool band elements, and just throw everything at it and see what happens?" And amazingly *DuckTales* can hold anything. And that's a huge credit to Matt and Frank and the whole team.

MATT YOUNGBERG: There was never a challenge that we threw at him that he couldn't pull off. It's crazy how versatile he was, because he could do a perfect pop song, but then he could also do a perfect cultural theme for any country we went to.

FRANK ANGONES: Dom was able to not only shift in terms of world music but also shift in terms of tropes and tones. He could deliver a superhero theme that was as strong as a spy theme that was as strong as a mystical theme. One of the times I was the most blown away by Dom's work was when we were sitting in the mix for the series one finale, "Shadow War," and I realized that over the course of the season, Dom had developed individual themes for Webby, the boys, Scrooge, Donald, Magica, Gizmoduck, and Della, and he managed to weave them all together as each of these characters had their

big moments. We never wanted wall-to-wall music or music to punctuate jokes. I think Dom was also the only person who submitted a theme for Scrooge McDuck that didn't involve bagpipes.

DOMINIC LEWIS: Because of the adventure aspect of the show, I wanted to tackle the "adventure Scrooge" theme first. I sat at the piano, and I remembered a theme that I'd written while in college in London. I never finished it, because I could never use it, because it was a very 1980s adventure kind of thing. There was nothing I was working on that warranted it, because everyone was always looking for cool and fresh and modern and electronics. But then starting *DuckTales*, I remembered that piece and developed it into a swashbuckling adventure thing. Then I worked on the theme for Huey, Dewey, and Louie, and I wanted to go the other way and use more band instruments and have it be something a little younger and simpler and more of a motif than a "theme" theme.

And there were so many other themes throughout the show. Because of the images and because of how great the show was, it was very easy for me to write themes and for them to work, because the characters were so strong. We were all on the same page. It's very rare to get the chance to be able to sit down at a piano every week and go, "Oh, I need a new theme today." That's awesome. And then by the end of the series, I've got seventy-plus episodes of development and play with those themes. I made a very conscious effort not to do what they did on the original *DuckTales* and reuse stuff. I wanted every episode to have its own feel, avoiding that sort of needle-drop aspect, which they did for budgetary reasons. With modern-day samples, I was able to create different sound worlds for different episodes.

FRANK ANGONES: Matt was not a big fan of musical numbers, but one of the things that turned him around was just how good Dom was at writing funny pastiche songs. Dom really helped our case, when no one else really did, when it came to musical numbers.

DOMINIC LEWIS: When I was hired, they didn't realize what a closeted songwriter I am, but that's how I started: with big dreams of being a rock star. They eventually started throwing it to me to write songs, and requests kept

Huey, Dewey, and Louie

Webby

Gizmo Duck

Magica De Spell

happening as the seasons went along, which was great. I just adored writing the songs on the show, from Beaks's dubstep song to Lena's training-montage song, as well as Double-O-Duck and the song that Donald sings to Daisy.

FRANK ANGONES: Dom was also the person who demanded that we put some horns back into the theme song, because how dare we remove the horns.

MATT YOUNGBERG: We had done our updated version of the theme song with Michael "Smidi" Smith, a music producer and composer, and he did an amazing job. Felicia Barton did the vocals for it. And then when we hired Dom, we had Dom come in, and we played him the theme song. He was like, "I love it, but it's got to have the horns. Can I do a little pass?"

Writers' "mystery board" illustrating character relationships.

DOMINIC LEWIS: I said, "You can't change the chords in the bridge. You have to keep the same chords, because the changes are great. You've got to get them in there." They had changed them because they thought it might feel dated, but I managed to get my way. And then they brought me on to do string arrangements and the orchestral side of the new main theme. I pushed so hard to get horns in it, but I didn't get them. I did get the lines in on strings, and that was the compromise. When the series started, the original composer of the theme, Mark Mueller, came up to me and said, "I heard that you were the one that kept the chords in the bridge. Thank you so much!"

MATT YOUNGBERG: And he was right. It sounded great with just a little tweak. And he did that because he's a huge fan. It's the same reason we all fit into the show: because we loved *DuckTales* and we wanted it to be awesome.

DOMINIC LEWIS: I wanted to come at it fresh every episode and create something cool and different each time, having the themes and orchestrations as our grounding pegs. I think that's why it's so successful, because it was treated on a per-episode basis. Television series generally do not get that amount of music. Working on *DuckTales* was like working on a movie.

THE CAST AND CHARACTERS!

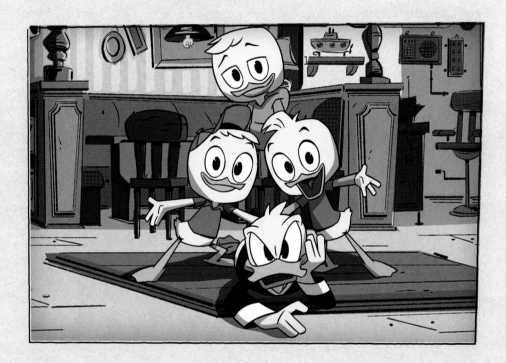

FRANK ANGONES: When it came to casting, we wanted to audition everybody, because we were building a family sitcom. We auditioned traditional voice actors, kids, teens, and actors who could sound like kids. With the exception of David Tennant, all of our main cast auditioned. The one advantage that we always had in casting the show was that everybody loved *DuckTales*, was super excited, and was willing to audition to be a part of it. We wanted a big cast who could jump off of each other's vibe. The issue with trying to achieve that in animation is that most animated shows don't record all together anymore. There's not a lot of opportunity for the cast to feel improvisatory or like everyone's in the same room. So our big priority going in was casting people who could feel spontaneous bouncing off of our voice director, Sam Riegel, feeding them lines. We wanted people that felt like they could bounce off of each other really well if they were actually together. Naturally, we ended up with a lot of improv actors.

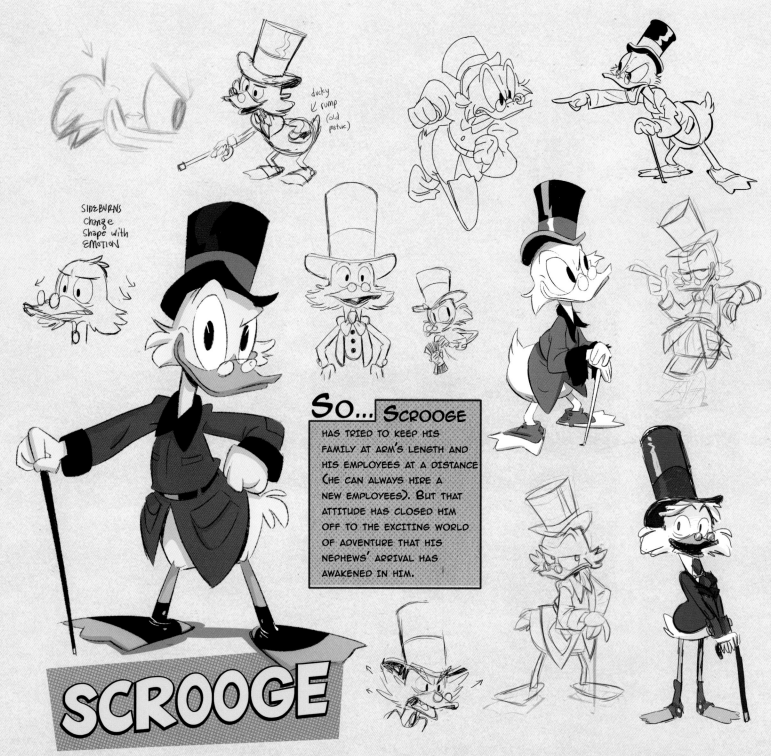

SIDEBURNS change shape with EMOTION

ducky rump (old posture)

So... SCROOGE

HAS TRIED TO KEEP HIS FAMILY AT ARM'S LENGTH AND HIS EMPLOYEES AT A DISTANCE (HE CAN ALWAYS HIRE A NEW EMPLOYEES). BUT THAT ATTITUDE HAS CLOSED HIM OFF TO THE EXCITING WORLD OF ADVENTURE THAT HIS NEPHEWS' ARRIVAL HAS AWAKENED IN HIM.

SCROOGE

FRANK ANGONES: One of the central themes of *DuckTales* is risk versus reward. It was getting to the core of what we know as Scrooge from not just the original series but also the Carl Barks comics, and very much from Don Rosa's seminal work, *The Life and Times of Scrooge McDuck*. It's the idea that Scrooge can succeed because he's willing to risk anything, because he's so hyperconfident in his abilities that he knows that if he lost all his money tomorrow, he could roll up his sleeves and start again from scratch and figure out a way to get it back. So the interesting thing to do with a character like that is figure out the one time that he sacrificed something he couldn't earn back. And then we needed to put that in context to his relationship with Donald, because we knew we wanted Scrooge and Donald to have a contentious relationship. It's fun to have Donald be contentious. That's what he does.

We knew we wanted a Scottish actor to play Scrooge. That was our big thing. We didn't want to have someone doing a Scottish accent. We wanted an authentically Scottish actor. David Tennant was our first choice for Scrooge. And he was as amazing as we all thought he would be.

DAVID TENNANT: Scrooge McDuck is part of the cultural furniture of our lives, but I just knew him as one of the ensemble of characters in the Disney universe, specifically in the Donald Duck corner of it. I was aware that he was a Scottish character—the clue's in the name and the slight stereotyping of Scottish people being mean. And I'd been aware that he had been portrayed with a Scottish accent before, and that they had come to me because I had that accent for free. This wasn't just another voice-over gig. This was something that people were very excited about and was going to have an impact. I'd done animated characters before, but there's something about performing one of those heritage characters that does feel a little bit special.

FRANK ANGONES: We had listened to a lot of different actors and a lot of different voices. Casting David as Scrooge was not only a performance thing, because we knew he would hand in a tremendous performance, but it felt like we were planting a flag. We thought that when people heard David Tennant was playing Scrooge McDuck, people would know what that meant.

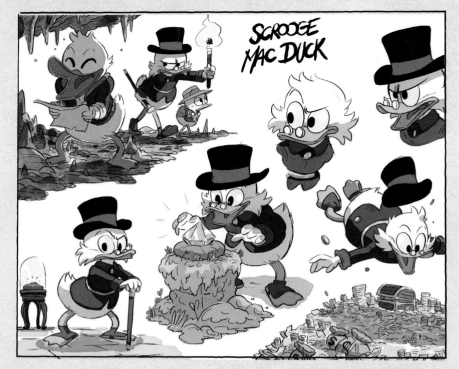

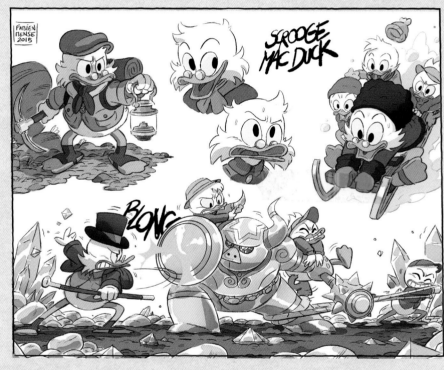

"Oh, that's what they're doing. This is a quirky, smart adventure show." The idea was to bring some of that pathos and comedy and likability to this traditionally cantankerous character.

One of the big moves we made with the Scrooge character, which we pulled from the Don Rosa comics, was that the reason he cares so much about the money and his treasures was because each one reminded him of a life experience and an adventure. In our show, Scrooge is a treasure hunter, inasmuch as experiences are a treasure, and he delights in finding new and impossible challenges that no one has ever found or discovered before. And David just immediately embodied that. Luckily, he was game to come in and play.

DAVID TENNANT: The first time I read a full script, I realized that the writing had layers and depth to it and was clearly written with an enthusiasm which you can just taste. The jokes were really clever, and the plotting was much more complex and exciting and thrilling than it needed to be, if it just wanted to be written off as a nice, diverting kid show. The writers treated it as a serious piece of work—and I use the word *serious* advisedly, because of course it's shot through with silliness and fun and imagination and creativity. Even before I spoke to Frank or Matt, or anyone who was involved in it, just in that reading of the first script, I thought it was a quality piece of work and something that people had invested a bit of their blood in. You could get that sense from the page.

With everything, it's script based for me. It's that first episode, where he has to go on a bit of a journey from an impenetrable, inscrutable Ebenezer Scrooge type to something that can be punctured. The nephews come, and they puncture this carapace. They never completely scratched it away, but he was definitely someone who was very steady, stoic, and entrenched in his worldview, who had to reexamine what that was. That was very much the character that I got from that first episode, and that was the character that consistently went through it. I think he softened as the years went on, as that was the journey that the character went on. The Scrooge of the end of the series is a more accessible character than the rather flinty, difficult character that appeared in episode one. He went on a journey alongside his nephews and Webby, and they allowed him to find a warmth and sensitivity.

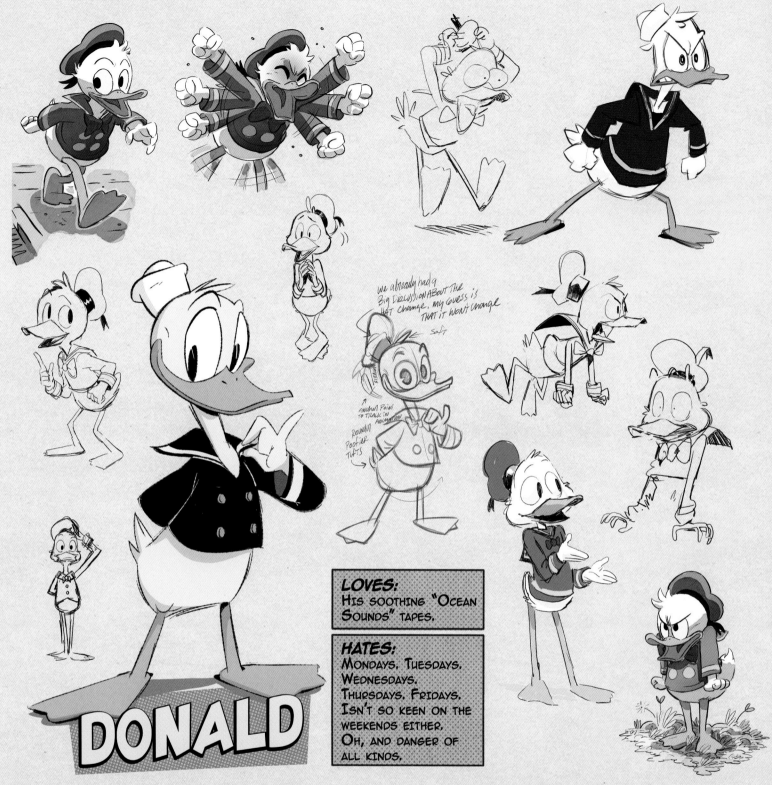

LOVES:
HIS SOOTHING "OCEAN SOUNDS" TAPES.

HATES:
MONDAYS. TUESDAYS. WEDNESDAYS. THURSDAYS. FRIDAYS. ISN'T SO KEEN ON THE WEEKENDS EITHER. OH, AND DANGER OF ALL KINDS.

DONALD

FRANK ANGONES: Donald is the caretaker for Huey, Dewey, and Louie, and he doesn't want to take any risks, because who gets stuck with all the bad luck? No one but Donald Duck. The world has treated him terribly, and he wants to protect these kids from something else bad happening.

We brought back Tony Anselmo as Donald Duck, and he had a new set of challenges in this show. The gold standard of humanizing Disney's classic big five characters was *A Goofy Movie*, the spinoff of *Goof Troop*, and what Bill Farmer did with Goofy. He made the silliest character of the main five into the most compassionate, relatable, heartwarming dad character and was incredible. We wanted to do that for Donald Duck.

MATT YOUNGBERG: The deepening of Donald's character came through his interactions with the other characters. I think that was a really important part of evolving Donald for the show. Bringing as much emotional depth out of that very specific performance as possible was the goal. Donald is an icon,

and the inspiration for our take came from the comics. Donald in the comics is a different character, and our goal was to hew closer to the tone and the relationships in the comics.

It's funny, but one of the hardest character design nuts to crack, even though it feels like he shouldn't have been the hardest, was Donald Duck. When you look at our lineup, Donald is probably closest to what he looks like throughout the years, but when you have a character as iconic as Donald Duck, you can't go too far from his original design, or it's the uncanny valley. As you're trying to change Donald Duck, if he's not still Donald in some way, he's broken. He doesn't look like Donald Duck anymore. And so that was one of the big challenges. The whole idea was how to make it a little bit more dynamic for an action-adventure series. That's when his legs got a little bit longer and straighter, and his shapes got a little bit more dynamic. But at the end, he was still Donald Duck.

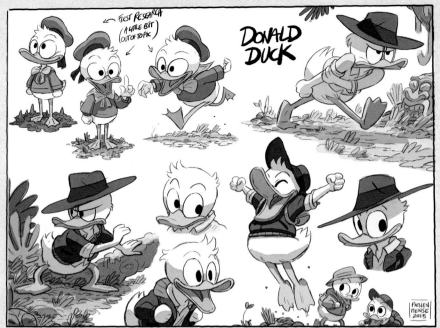

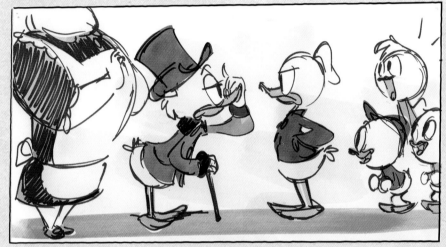

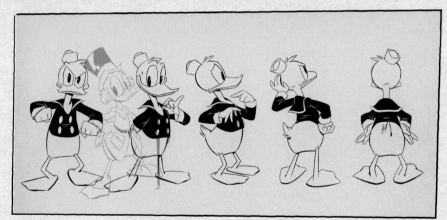

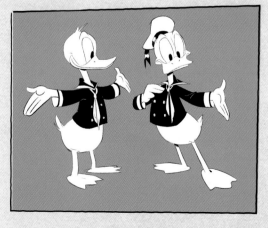

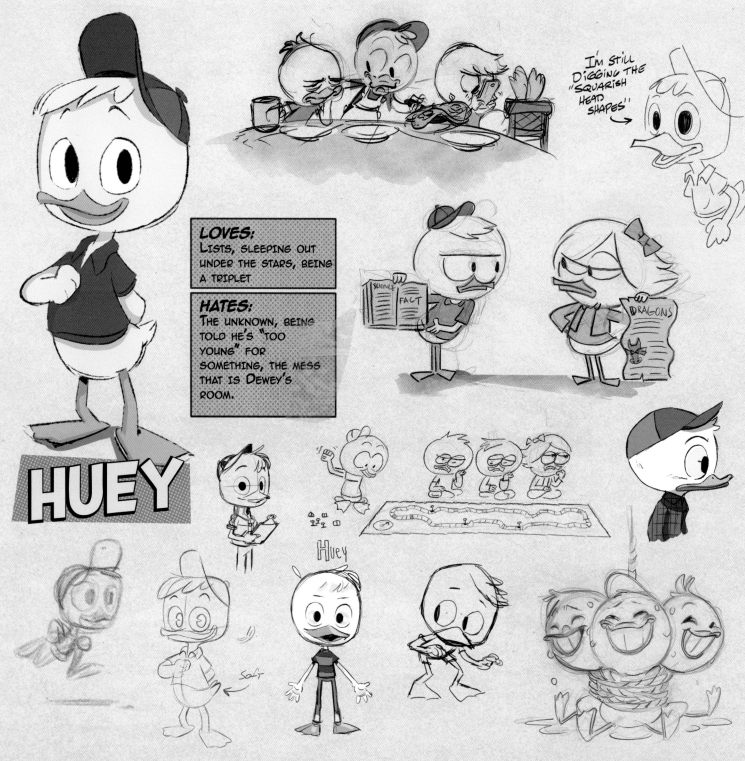

LOVES:
Lists, sleeping out under the stars, being a triplet

HATES:
The unknown, being told he's "too young" for something, the mess that is Dewey's room.

I'm still digging the "squarish head shapes"

HUEY

FRANK ANGONES: Huey, Dewey, Louie, and Webby, in the original show, were all voiced by the incomparable Russi Taylor. Traditionally, they had been interchangeable, and Russi had done slight vocal variations for them, so you could tell which were which, but they weren't as defined vocally as far apart as we needed them to be. And so that became a big part of the casting of the boys. In terms of performance, we were always most concerned with who could make the lines the funniest, naturally, and who could carry the emotion of the scenes. And for Huey, Dewey, and Louie, that was Danny Pudi, Ben Schwartz, and Bobby Moynihan.

Danny Pudi was just naturally Huey. From *Community*, we knew that he could do the nerdy thing. But he did the opposite of what he did on *Community*, which was amp it up to eleven, as opposed to being super dry, and he really let Huey's neuroses spin out, which was super fun.

DANNY PUDI: When I heard that there was a reboot, I was very excited. I actually watched the show as a kid, with my siblings, was a big fan of it, and the Disney Afternoon meant something to me. I remember meeting with Frank and Matt, and I loved their script. I thought it was so fun and smart. I think it kept the spirit of the original series, but it was doing its own thing. This was the first voice-over that I had auditioned for and got, and so that felt so exciting to me. The character itself, Hubert, definitely spoke to my soul—his spirit and his love of adventure, family, maps, schematics, a good plan, and sugar. I can relate to all of that.

There's a frenzied nature to Huey. He's very excitable. He has a thirst for knowledge and adventure, he loves a plan, but uncertainty is definitely his biggest fear. I was really excited to play this character who definitely can be an expert and can be the one that is the most mature—by less than one minute. He's the oldest, and he uses that to be in charge. But he also carries a Junior Woodchuck guidebook in his hat, and without that, he's in serious trouble. I love that messiness of Huey. He's really tightly wound, and he can spin out very quickly if things don't go according to plan. And his brothers don't make it easy for him. The fun thing is that they're constantly trying to differentiate themselves and figure out who they are individually, as well as within the group.

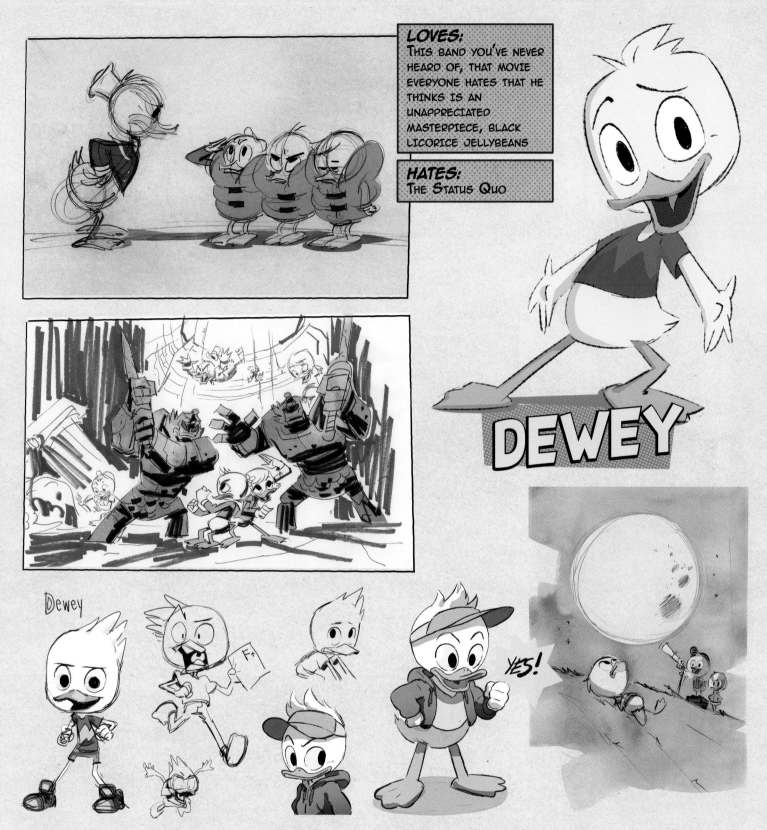

LOVES: This band you've never heard of, that movie everyone hates that he thinks is an unappreciated masterpiece, black licorice jellybeans

HATES: The Status Quo

DEWEY

Dewey

YES!

MATT YOUNGBERG: With Huey and Louie, we had a very clear path on how we wanted them to sound. But with Dewey, there's this real challenge: if you don't get the right actor, he's going to come across as just the "cool guy" and not somebody with more depth to the character than that. He's someone who desperately wants to be the cool guy but isn't. When we had Ben Schwartz audition, we had him try all three of the kids. When he did Dewey, it was a different take than even we were expecting, but in a good way.

BEN SCHWARTZ: When I saw the email about auditioning for *DuckTales*, I immediately wanted to do anything I could to be a part of it, because it meant so much to me as a kid. The Disney Afternoon was enormous in my life, and this was the crowning jewel in it. I wanted to be able to usher that in for a different generation.

FRANK ANGONES: We had already written the two-part pilot before we did any of the casting. Originally, Dewey had way more of a chip on his shoulder, because he had the arc of the first season feeling like he didn't fit in and then confronting Scrooge about the truth about his mother, Della. So he ended up feeling a little bit more like the bad boy and didn't have that much of a comedic angle. But then we heard Ben's take on it. I think the script said, "Dewey sings his own adventure music," and Ben Schwartz improvised it. Suddenly, everything about it clicked into place. I went back and completely rewrote most of the Dewey stuff in the pilot with that attitude in mind—that he's just a weird cross between a glory hound and a theater kid. Dewey is impossibly insecure, but he'd never admit it.

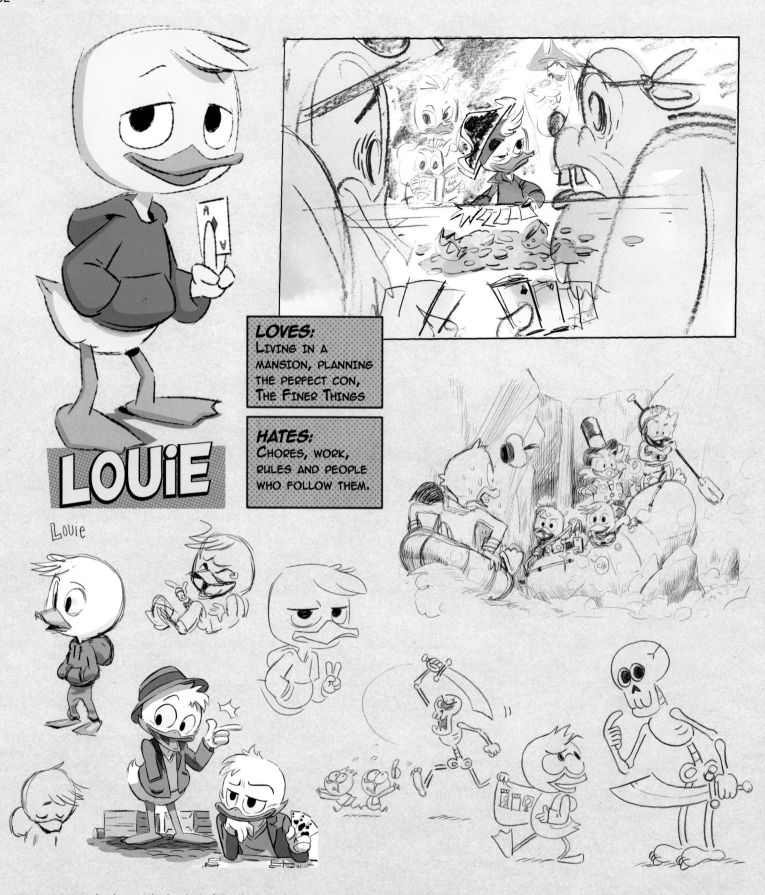

LOVES:
LIVING IN A MANSION, PLANNING THE PERFECT CON, THE FINER THINGS

HATES:
CHORES, WORK, RULES AND PEOPLE WHO FOLLOW THEM.

LOUIE

Louie

FRANK ANGONES: Louie was the hardest of the three nephews to cast, because everyone who auditioned for Louie made him come off as a selfish jerk that you wouldn't like. We brought in Bobby Moynihan, and Bobby was the only person, over hundreds of actors, where I was like, "Now he's a stinker." He wasn't a jerk. He's fun, and a little bit of a con, but he's charming about it. There's just something so inherently likable in Bobby's voice. Louie's the car salesman always trying to pitch you on a bad idea, or the guy who would try to talk his way out of a mummy attack—and that became an episode.

BOBBY MOYNIHAN: I often get cast as sweet characters. The first drawing I saw of Louie, at the audition, was him in the hoodie, with the card in his hand, and I remember thinking, "Oh, that's me." When I saw that picture, I thought, "Oh, he doesn't have a care in the world. Huey's the adventurous one, Dewey's the cool one that people like, and Louie is just like, 'I don't care, I'm gonna be rich someday . . .'" To me, he was less a jerk, or even greedy, but more just "I don't have to worry, because why should I? I've got it made." That was super freeing, because I never get cast as anything like that. Louie had that confidence but almost didn't care, because the confidence came from not knowing that he actually needed it. He was very street smart but heart stupid. It was fun to play.

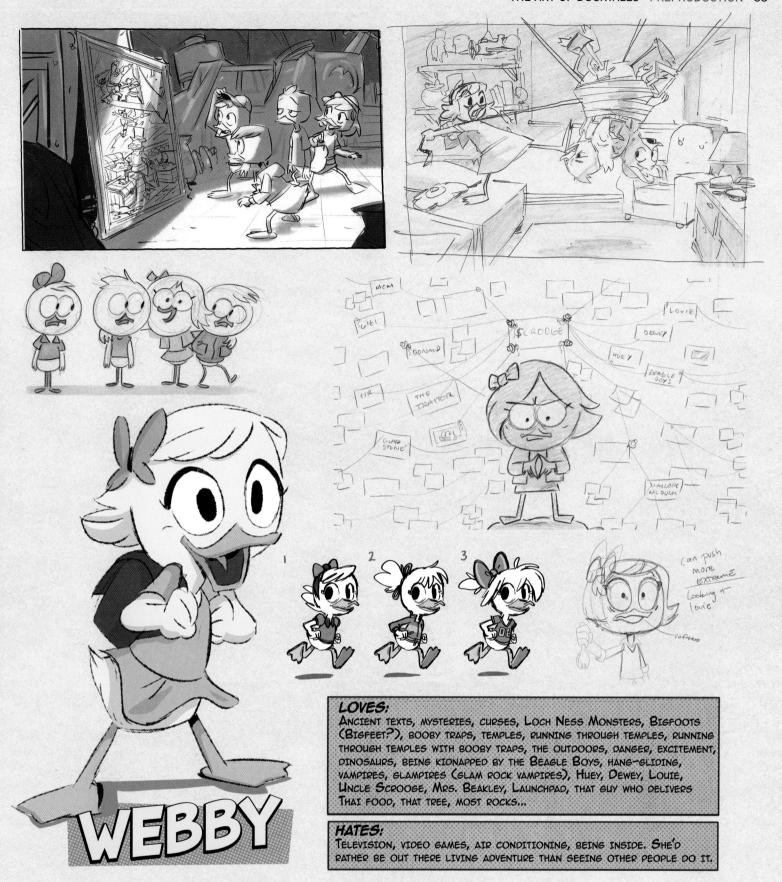

LOVES:
ANCIENT TEXTS, MYSTERIES, CURSES, LOCH NESS MONSTERS, BIGFOOTS (BIGFEET?), BOOBY TRAPS, TEMPLES, RUNNING THROUGH TEMPLES, RUNNING THROUGH TEMPLES WITH BOOBY TRAPS, THE OUTDOORS, DANGER, EXCITEMENT, DINOSAURS, BEING KIDNAPPED BY THE BEAGLE BOYS, HANG-GLIDING, VAMPIRES, GLAMPIRES (GLAM ROCK VAMPIRES), HUEY, DEWEY, LOUIE, UNCLE SCROOGE, MRS. BEAKLEY, LAUNCHPAD, THAT GUY WHO DELIVERS THAI FOOD, THAT TREE, MOST ROCKS...

HATES:
TELEVISION, VIDEO GAMES, AIR CONDITIONING, BEING INSIDE. SHE'D RATHER BE OUT THERE LIVING ADVENTURE THAN SEEING OTHER PEOPLE DO IT.

FRANK ANGONES: I really wanted to incorporate Webby as one of the triplets—making her the "fourth triplet," so to speak—to have an awesome entry point for girls to the property. Casting Kate Micucci came very naturally. Kate had that level of enthusiasm, but she brought a warmth to it, because we didn't want Webby to just be the super-excited girl all the time. Kate brought a natural sense of self-consciousness and insecurity to this girl who had spent her whole life in a mansion and knew everything about history, Scrooge, and adventuring but knew absolutely nothing about social norms. Webby wasn't shameless or awkward about it—she just really wanted to fit in. Kate brought that vulnerability.

KATE MICUCCI: When I read the copy for the audition, I knew exactly what I wanted to do with it. It was such a funny and cool character, and I knew in my gut that it was special. Webby is amped. I would never in a million years record her while sitting down. I had to be standing up and moving, and my arms were flailing, because she's just pure energy and enthusiasm. She wants to be a part of what the guys have going on, but she's also got real interesting stuff happening in her own life. She's earnest and means only good things, is the most highly skilled and trained, and is just excited about everything.

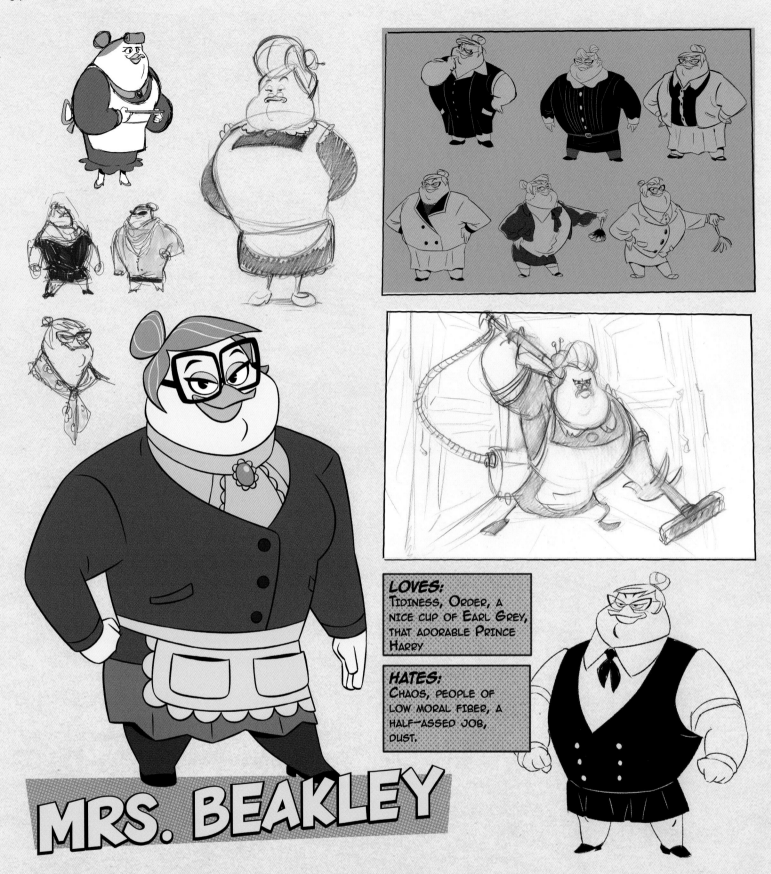

LOVES:
TIDINESS, ORDER, A NICE CUP OF EARL GREY, THAT ADORABLE PRINCE HARRY

HATES:
CHAOS, PEOPLE OF LOW MORAL FIBER, A HALF-ASSED JOB, DUST.

MRS. BEAKLEY

FRANK ANGONES: Toks Olagundoye as Mrs. Beakley just floored us. She was a suggestion from casting, and she perfectly captured our need to have someone who was fun, insanely stern, and could kill you with a word or a look. Toks came in and just leveled that recording booth. She had that character in her pocket, ready to go.

TOKS OLAGUNDOYE: I'm glad that's what it seemed like! I'm a bit of an introvert, and I tend to be a little stoic when I first meet people, which I think lends itself to an image—which is not always accurate—that I absolutely know what I'm doing. I'm just really silent because I have no idea! When I auditioned, I remember thinking it would be nice to be in a Disney cartoon,

and that the description of the character had Helen Mirren in it. I think I brought a lot of my grandmother into it, because that's who I pictured. My grandmother was a formidable Norwegian woman who was very strong, very capable, and was in the Resistance during World War II. That, to me, fit the description of Mrs. Beakley. And so the posture and depth of voice that I gave her was my grandmother's.

I loved any of the times that Beakley had to get out there and be physical and save people. That always gave me my own little personal thrill. Webby is my favorite character, so I always was very touched by their interactions and by how she tries to take care of her and how she doesn't want Webby to be like her, but Webby's just going to be anyway.

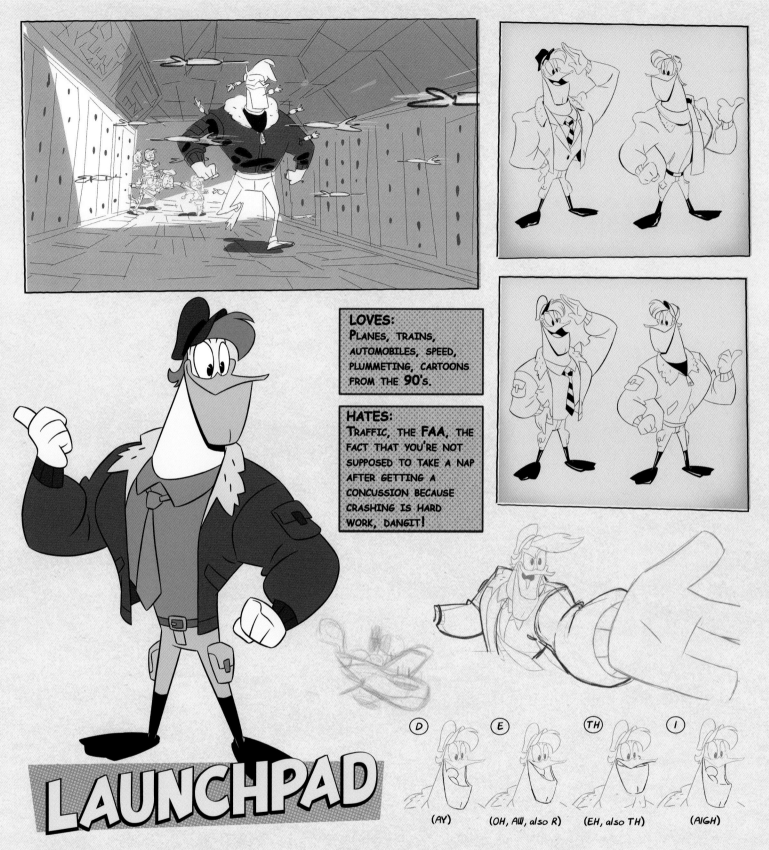

LOVES: Planes, trains, automobiles, speed, plummeting, cartoons from the 90's.

HATES: Traffic, the FAA, the fact that you're not supposed to take a nap after getting a concussion because crashing is hard work, dangit!

LAUNCHPAD

(D) (AY) (E) (OH, AW, also R) (TH) (EH, also TH) (I) (AIGH)

FRANK ANGONES: The biggest challenge that we had, at least in terms of defining the character, was Launchpad. We were clueless. And the funny thing was, everybody wanted to audition for Launchpad. Anybody who we called in for anything else said, "Can I also audition for Launchpad?" The only thing that we knew we wanted is that we didn't want it to sound exactly like the original Terry McGovern voice, because we wanted to provide some kind of evolution. But that character is so indelible that everybody came in and just did that version. There were a couple of people who brought an interesting take to it. But there were two people who came in and totally nailed it—Beck Bennett, who we went with, and Bobby Moynihan. What a great problem to have, because we had Beck to put in for Launchpad and knew he'd nail it, one hundred percent, but we needed Bobby to play Louie.

BECK BENNETT: The voice kind of came to me. I had watched *DuckTales* growing up, and I had an impression in my mind of the attitude. I picked a voice that I could easily go into with full enthusiasm, which works for Launchpad. He's just such a puppy dog.

FRANK ANGONES: In our series, Launchpad is not the swaggering Launchpad of the original series who wants to be a hero. Launchpad is the guy who is a hero and inspires other heroes. There's the family element of *DuckTales*, and then there's the adventure element of *DuckTales*. Launchpad is the beating heart and soul of the adventure element of *DuckTales*.

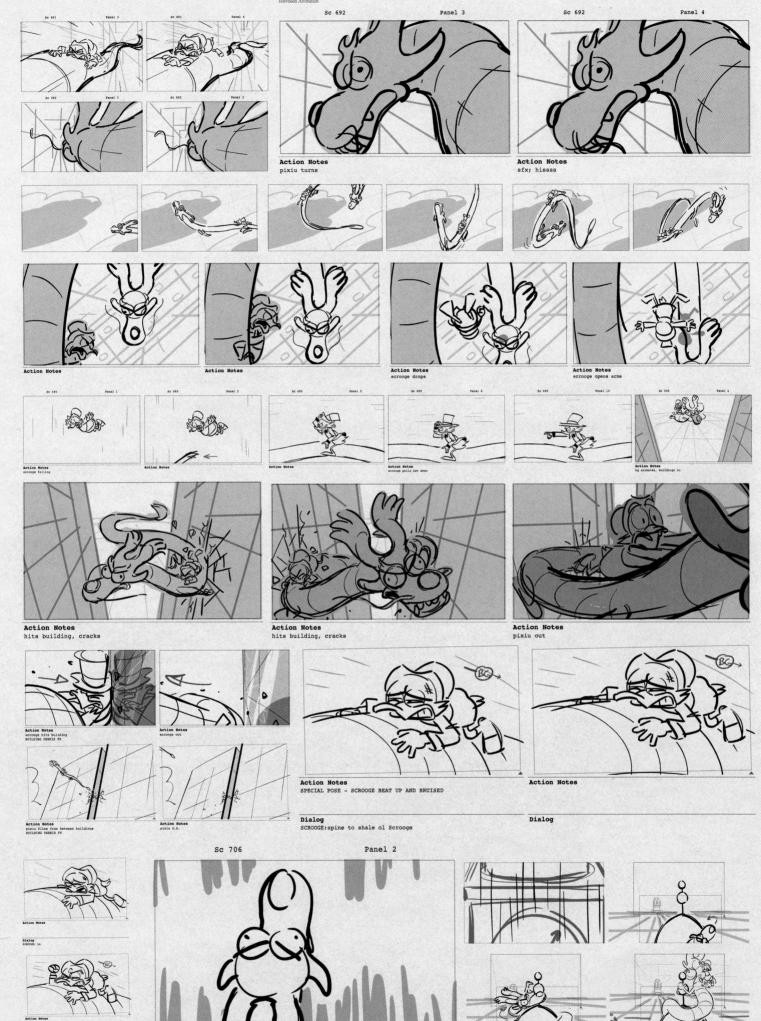

THE EPISODES!

SEASON 1 "WOO-OO!"
EPISODE 1

MATT YOUNGBERG: What we needed to do with the pilot—not just storywise, but legacywise—was to say why we were *DuckTales*. Not only what makes this *DuckTales*, but also what makes this "new *DuckTales*." We had to be able to do both of those things. By the end of the pilot, we had to be able to say, "That's a *DuckTales* episode!" but it had to feel fresh and new and different than what the original series was. That was the big challenge of the overall approach. But the challenge as an episode is that it was a million characters, doing big things, and fitting all of that into an episode.

FRANK ANGONES: This was our thesis statement on "This is what *DuckTales* would feel like if *DuckTales* was made today." So it's taking all of the things from the Carl Barks stories, using the original series as a guidepost in terms of what that adventure would feel like on television, and updating it for a modern audience. And also introducing a frankly insane concept for a show if you have no previous knowledge of Scrooge, or the kids, or Donald. Maybe we don't have to introduce everything about the setup to our show, but instead use some of that as backstory and mysteries that we can solve later. And then also the big thing, aside from being an adventure show, was having it be a family comedy, explaining not just the circumstances but also the character dynamics. It was a lot of plates to spin while still being a rollicking *DuckTales* adventure. This is my favorite episode of the show.

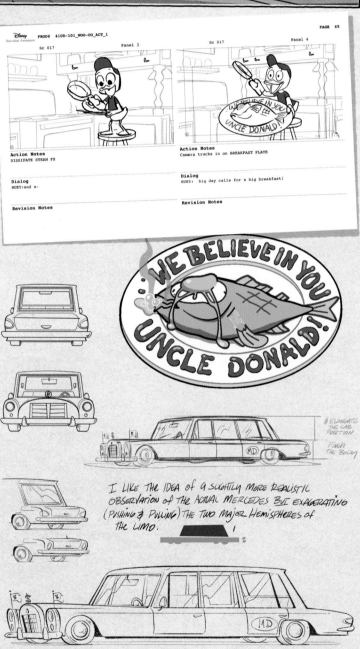

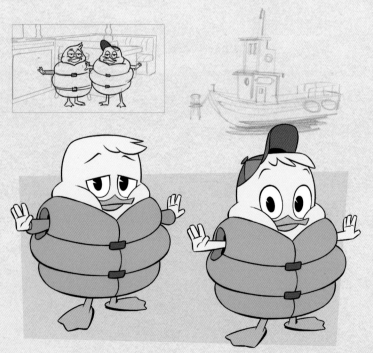

SEAN JIMENEZ: I'm a car buff. One of the exciting things to me is that I had a chance to do cartoon versions of really specific cars from Europe, because it's justified and validated in terms of story. It goes back to the Hergé influence, where you reference something from real life.

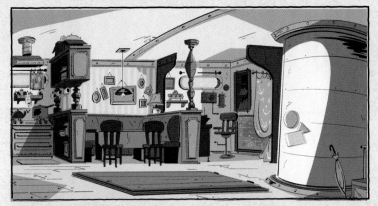

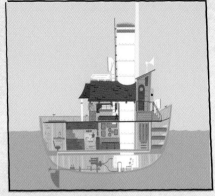

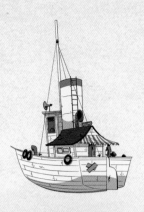

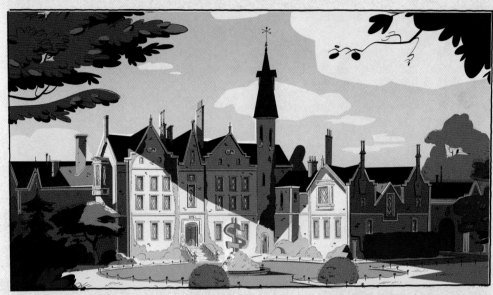

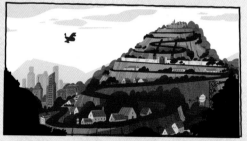

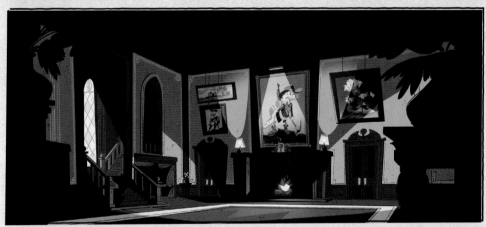

SEAN JIMENEZ: Matt really wanted to make sure that Scrooge's mansion was not ostentatious, so it was like, how do you do that? And so the scale of it on Killmotor Hill is based on Hearst Castle. The exterior of the mansion is based on Schloss Roxburghe, in Scotland.

SEAN JIMENEZ: The interior of the mansion is based on Skibo Castle, which was Andrew Carnegie's vacation home in Scotland.

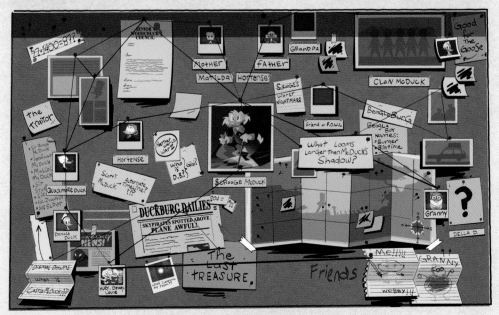

FRANK ANGONES: We seeded the entire series on Webby's "mystery board," as we affectionately called it. It's the first time you see our design for Gladstone Gander. There's "Who is D.B.?"—which is the Duke Baloney episode from season 2, and the "GiGi" is for Goldie O'Gilt, to say there's some connection between Glomgold and Goldie. As for the "22 + 1400 = 87?" equation, 22 is Agent 22, which is Beakley. The Roman numeral for 1,400 is MCD, which is Scrooge McDuck. And then all of that equals 87—which is Project 87, which turns out to be Webby. So, Webby is the sum of Beakley and Scrooge.

"ESCAPE TO/FROM ATLANTIS!"

EPISODE 2

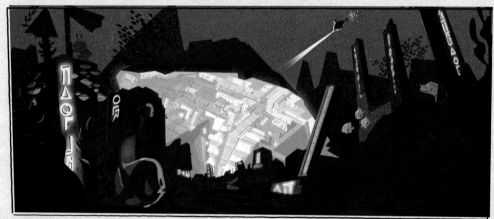

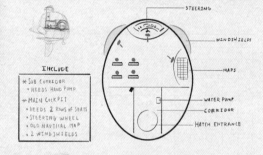

INCLUDE
- SUB CORRIDOR
- NEEDS HAND PUMP
- MAIN COCKPIT
- NEEDS 2 ROWS OF SEATS
- STEERING WHEEL
- OLD NAUTICAL MAP
- 2 WINDSHIELDS

STEERING
WINDSHIELDS
MAPS
WATER PUMP
CORRIDOR
HATCH ENTRANCE

FRANK ANGONES: I'm always very thankful that we were able to do the two-part premiere, where "Escape to/from Atlantis!" was also a part of the premiere, because it gave us a little bit more room to breathe and define the globetrotting side of the show. "Woo-oo!" was always meant to introduce the Duckburg side of the show, and then this was our thesis for the globetrotting part.

We love our booby traps on *DuckTales*, so this was us doing a classic booby-trap, temple-treasure adventure. And our twist on it was, well, the temple is upside down. All of the buzz saws are on the ceiling, so it's the easiest adventure of all time. And that really got our brains thinking. One of the most fun ideas to crack was the upside-down-bridge room, and figuring out the mechanics of how those right-side-up traps would work upside down. It was finding the ways to execute these off-the-wall ideas in service of story. All Dewey wants is to go have a huge, crazy adventure, and all he gets is a lame, weird adventure.

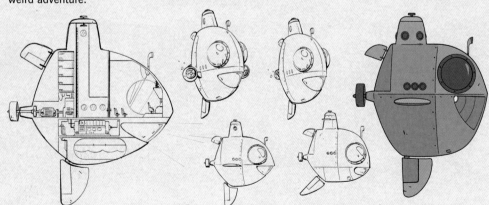

MATT YOUNGBERG: The idea behind the sub was that if Gyro was creating vehicles, a lot of times they'd have an animal theme. So if you're in a sub, and if Gyro's designing it, it would probably be a fish.

SEAN JIMENEZ: And if it's going to be a fish, what kind of fish would it be? And being a Disney nerd, this is actually referencing a ride vehicle from Tokyo DisneySea, where you get into a sunfish, and it has the porthole.

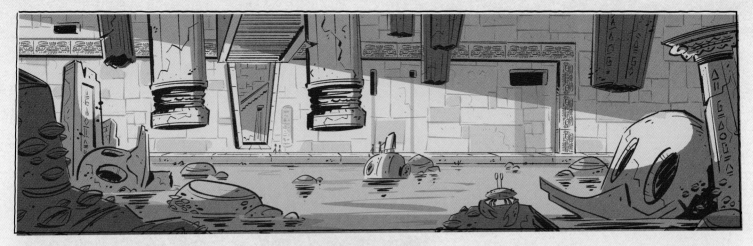

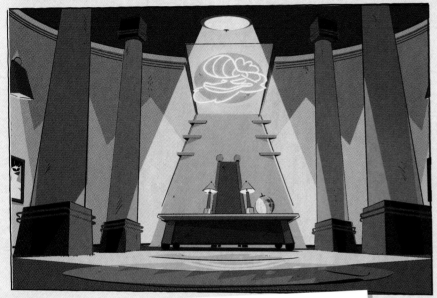

SEAN JIMENEZ: For the Glomgold architecture, we landed on the idea that he's stuck in the eighties, so I immediately thought of Michael Graves. For Glomgold's general aesthetic, I actually had a mood board of Swatch designs, which informed the look for anything Glomgold. And when we were working on Scrooge's office building in the downtown district, it's reminiscent of the dawn of the Industrial Revolution. It has very beautiful architecture.

SEAN JIMENEZ: The boards for this scene of Dewey dancing across the bridge were awesome. Matt did draw-overs, and Dana Terrace animated it.

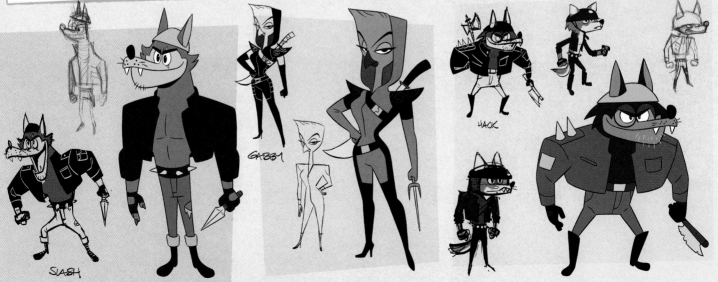

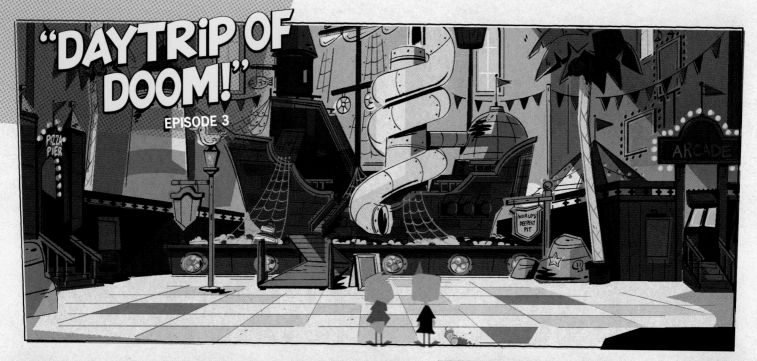

"DAYTRIP OF DOOM!"
EPISODE 3

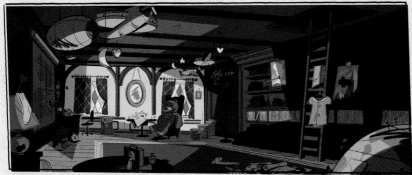

MATT YOUNGBERG: In the pilot, we set up the family, we set up all the back-story, we had a big adventure—all the things that we needed to pack into the pilot to sell it as "This is *DuckTales*." And now that we've established that, and the family is together, what is the new normal for this family that just came together? What's the regular day-to-day feeling going to be? And that's where this episode came from.

This story was our chance to feature Webby. What is her life like now, and who is Webby? We got into it a bit in the pilot, but this was her chance to really show what she could do.

We also used this episode to establish what Donald's superpower is in the show, in terms of why he was such a great adventurer. We saw glimpses in the pilot, but in this episode, we see Donald fight for the first time. The reason Donald is such a great adventurer is his berserker rage, where if he got mad enough, no bad guy could go toe to toe with him.

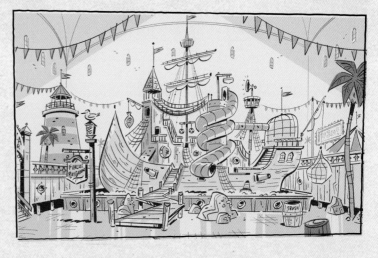

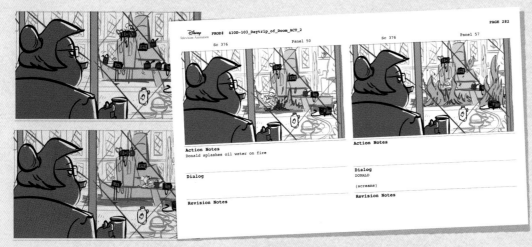

SUZANNA OLSON: Donald putting out the fire, by storyboard artist Jason Reicher, is one of the greatest board sequences in *DuckTales* history. It put him on the map for being our go-to Donald guy.

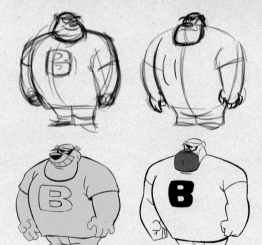

SEAN JIMENEZ: When we were looking at the original Beagle Boys from the Carl Barks comics, they were all exactly the same. For our show, it was just like our approach to Glomgold—you want to really push the silhouette of the group. That's even more reason for the big, medium, and small.

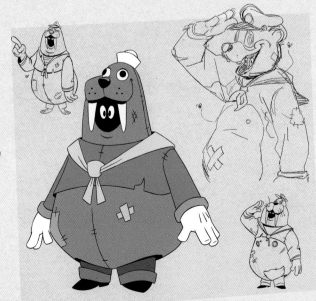

FRANK ANGONES: This is an Emmy Cicierega storyboard. We mentioned Jason Reicher, and I think, in an interesting way, those two board artists provide the farthest edges of the types of comedy that we do on *DuckTales*. Reicher does the classic physical comedy, and Emmy brings this very contemporary feel. You always know when Emmy has done a pass on a board.

"THE IMPOSSIBLE SUMMIT OF MT. NEVERREST!"
EPISODE 4

FRANK ANGONES: Outside of the pilot, this was our first chance to show what a globetrotting adventure episode would be. It was an idea we had as early as the pitch, which relates to our famous "no mine cart" rule: if we're going to do a type of episode with a classic adventure trope that you have seen, we want to find a twist on it that you haven't seen. So we decided to do a mountain-climbing episode—but the reason that no one has ever made it to the top is that the mountain is full of portals. And that became the through line for a lot of the types of adventures we told. This episode was important in showing not just how Scrooge was taking these kids on adventures, but how these kids were changing Scrooge and getting him to become a better person.

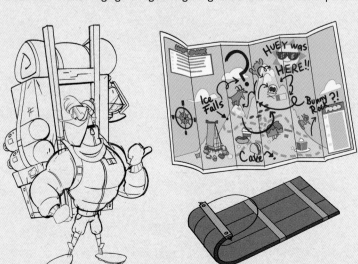

SEAN JIMENEZ: From a design perspective, when it comes to snow, you have this opportunity to make it very graphic, because it's really just two values. You have the light of the snow and the dark of the stone. I was looking at pictures of Mt. Everest and, especially when you're up high, it's a weird, otherworldly landscape where it's just two values. And I really love that idea.

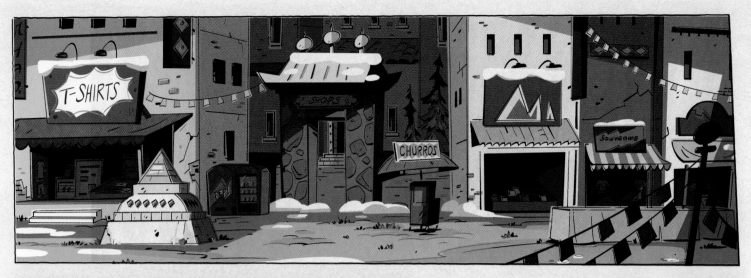

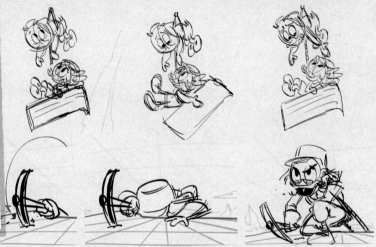

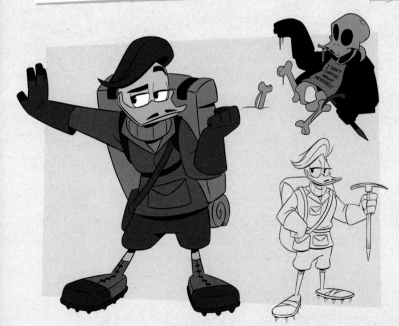

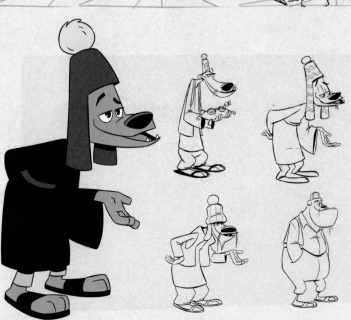

"THE GREAT DIME CHASE!"

EPISODE 5

FRANK ANGONES: We wanted to establish all the major locations, and for Scrooge, the Money Bin is a huge location. We'd been doing character-focused episodes, and this was our chance to focus on Louie, and so it would make sense that it would focus on the money. It was also our opportunity to do our version of the Scrooge origin myth of him cleaning Burt the Ditchdigger's shoes, which is from Carl Barks. I really liked the idea of having this kind of slamming-doors farce with Scrooge and his people, Louie trying to get the dime, and Gyro kind of wandering through. It was an opportunity to introduce some major Barks characters.

SEAN JIMENEZ: The diagram of the Money Bin was a huge undertaking. We really wanted it to make sense. And it's iconic.

FRANK ANGONES: This is another great example of Sean's team and the writing team working very closely together to figure out the practical needs for the episode, with Louie running around, and we knew the lab would be part of the bin. We looked up any existing blueprints of previous bins to see how they worked, and there was Don Rosa's blueprint of the classic Barks cube, where all of the offices were on one side, and we're like, "Well, that's an interesting solution."

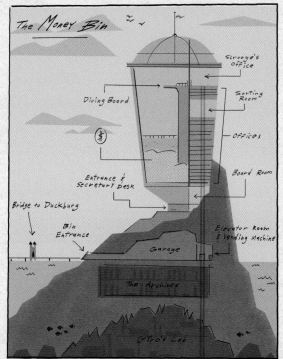

SEAN JIMENEZ: I asked our background designer Valerie Schwarz to include a Scrooge painting that's an homage to Steve Zissou from *The Life Aquatic*. I pushed a lot of little pop culture references into the backgrounds. That's one of the things I love about being an art director—I can get these dorky little things in there.

SUZANNA OLSON: There was a lot of back-and-forth to figure out what our version of Carl Barks's oil painting style would be, for flashbacks, and we found an artist named Tim Artz who helped crack it.

SEAN JIMENEZ: He's in the Netherlands and had done cover paintings for the comics there.

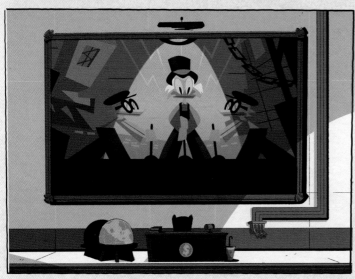

SEAN JIMENEZ: The painting in the office was inspired by Diego Rivera paintings from the early 1930s. It's like the industrial paintings in Rockefeller Center, because the whole idea is that Scrooge represents that kind of old way of becoming rich.

SEAN JIMENEZ: I stick stained glass windows everywhere I possibly can on anything I've ever worked on. It helps add a little bit of interest to something that could be very blank, and it also felt right that it would be in this special library in the Money Bin.

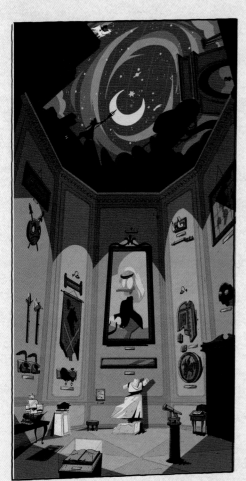

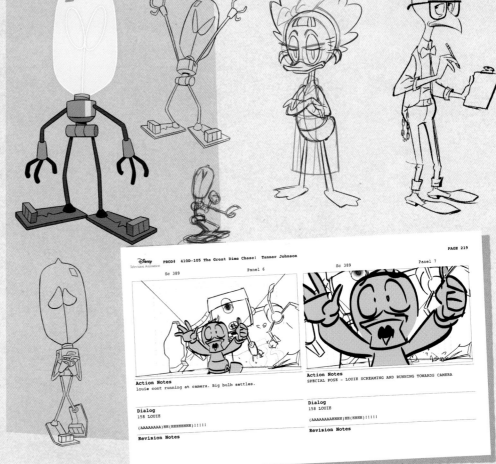

"THE BEAGLE BIRTHDAY MASSACRE!"

EPISODE 6

FRANK ANGONES: This is one of our rare A-story-only episodes, with just one big story, where cutting to another story would damage the feel and the flow of the main story. We knew we wanted to introduce dozens and dozens of Beagle Boys. And, just as the original *DuckTales* pulled in references to movies that they loved, we wanted to pull in an action-movie reference that we hadn't seen a million times before and we all really love: *The Warriors*. What if we did *The Warriors*, but instead of all the different weird, crazy gangs, it was different subsets of the Beagle Boys? And then combining that with a "kids surviving this one crazy night" story, like *Adventures in Babysitting*.

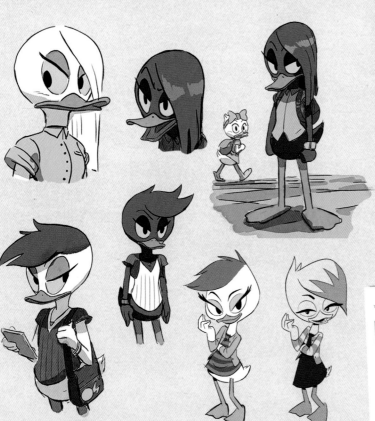

MATT YOUNGBERG: Fabien Mense did the early designs of this cool, hip teen duck, and we all fell in love with them. We gave those to Tim Moen and had him riff off them, but in our show style.

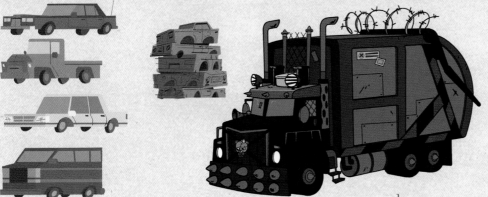

SEAN JIMENEZ: We knew the junkyard was something that was going to come up a lot on the series, so we created these labyrinths and mountains of cars. We designed the cars so that we could reuse them as normal cars throughout the rest of the series. Then we made them junk cars and created modular towers out of them, and built the set that way.

FRANK ANGONES: Writer Bob Snow has a list of hundreds of Beagle Boy names, and a list of forty Beagle Boy gang names, like the Fifth Avenue Meanies, the Sixth Avenue Friendlies, the Longboard Taquitos, the Deja Vus, and the Glam Yankees. Just a broad and weird set of names, and then it was put on the character design team to execute them, and they knocked it out of the park every time.

"THE HOUSE OF THE LUCKY GANDER!"
EPISODE 7

MATT YOUNGBERG: This episode was one of Sean's biggest conceptual swings, and it paid off, perfectly. It's crazy, because it looks so visually complicated, but Sean figured out how to simplify it in a way that was easy to replicate. And the backgrounds just worked.

SEAN JIMENEZ: I knew we were going to go from the casino to some sort of magical realm. And it just dawned on me: What if it's a house of cards, because it's a casino? What if all the walls were made of cards, and then they're hidden in plain sight through the whole episode? And then when Toad Liu Hai creates his magic spell, the house of cards falls, and what's left is just a void. What makes it feasible is the cards are going to be repeated as a modular element. We drew one card, really, really high res, and then built our backgrounds with that one card, repeated. After we created the backgrounds, we added some variation. But throughout the beginning of the episode, in the casino, there's a hint of the void. It feels like dramatic lighting, where you lose the outline of the ceiling, but that's the void. So, hidden in plain sight, they are entering a magical realm. And just overall, all of the colors in the episode were inspired by the John Carpenter movie *Big Trouble in Little China*.

finish line Donald beats Gladstone!

lucky Gladstone

disco wall (level 3)
unlucky Donald

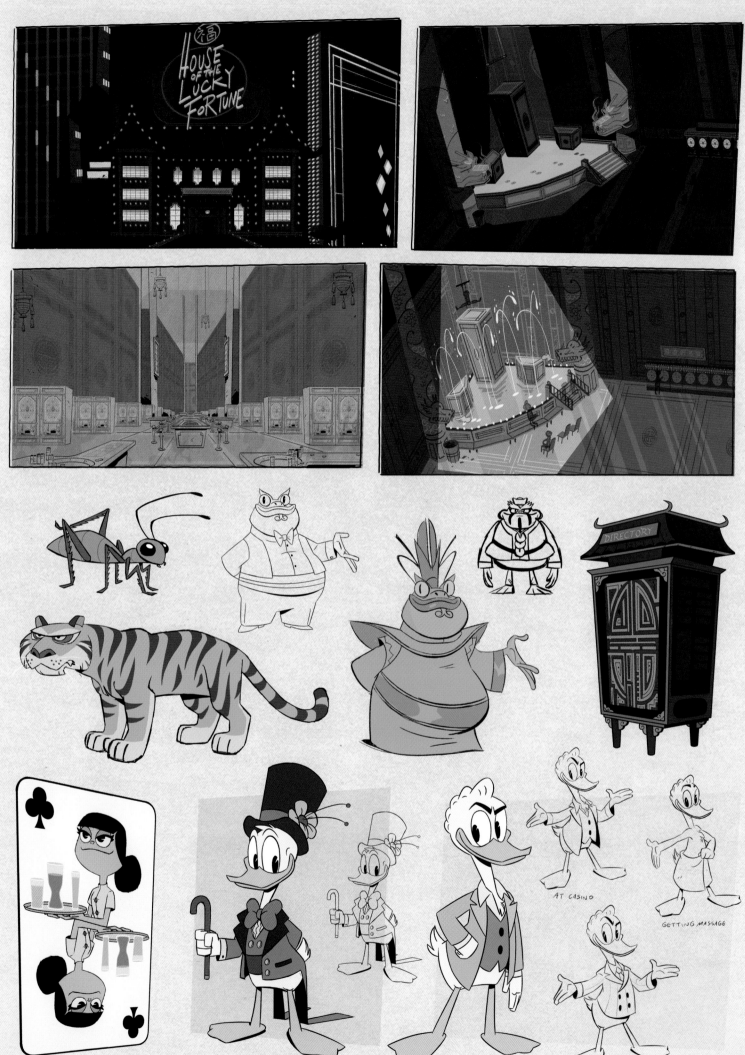

AT CASINO

GETTING MASSAGE

NEW SUIT

"THE iNFERNAL iNTERNSHiP OF MARK BEAKS!"

EPISODE 8

FRANK ANGONES: Scrooge has traditionally had all of these different million-aire and billionaire rivals. We hit on this idea that Scrooge is the constant, but every couple of generations, there is a different billionaire nemesis of Scrooge that reflects the worst parts of the culture at that time. So we set Rockerduck in the early 1900s, and he's this inherited-money land baron. Glomgold was the greed-is-good guy who came to Duckburg in the eighties, who modeled himself on that conception of wealth. And then it felt like we absolutely needed to do a tech-bro billionaire, which would be a thing that Scrooge wouldn't understand, or care to understand, at all. It's the one thing that Scrooge and Glomgold would agree on: they both hate this new guy.

It seemed like there was a lot of fun in doing a version of *Die Hard* where Nakatomi Plaza was this super-cool, chill tech-conglomerate place with beanbags and stuff. This is the first time that we really pitted two of the brothers against each other. It was really important that this internship would be a thing that both Huey and Dewey would want, because there are so few things both of them want, though here it's for entirely different reasons.

MATT YOUNGBERG: Developing Mark Beaks and his world, we thought, as a tech bro, he's got to be in the cool, gentrified part of Duckburg, and that became Silverbeak. It had to contrast with the old-billionaire stuff of the Billionaires Club, so you get the sleek, clean look of Waddle's headquarters.

SEAN JIMENEZ: We were looking at clean, blank, and monolithic modern ar-chitecture. Which makes a cool aesthetic, because it's so minimal.

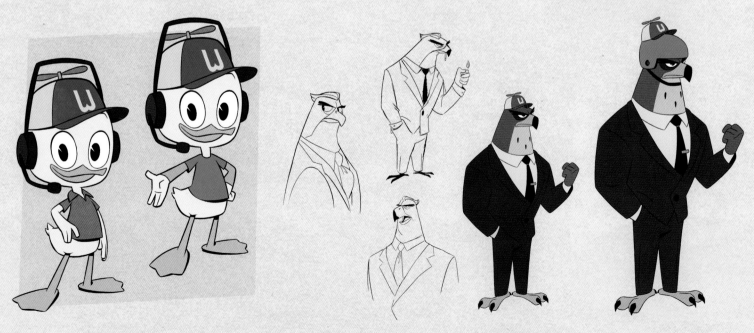

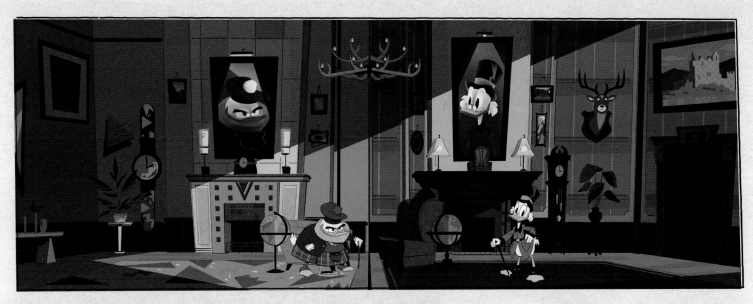

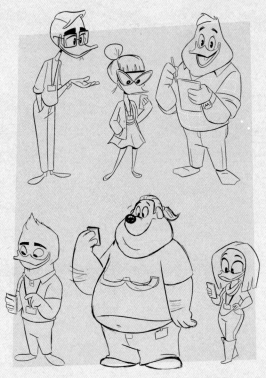

MATT YOUNGBERG: The initial design passes for Mark Beaks were done by Shiyoon Kim, and they really set the tone. The only prompt we gave was that Beaks should be an African gray parrot, because those are the smartest birds in the world. And then Tim Moen took these really cool conceptual designs and honed them into the show style.

MATT YOUNGBERG: A lot of the workers at Waddle were based on people on the crew, including me, Sean, Tapan Gandhi, Cameron Butler, and Jason Evaristo.

SEAN JIMENEZ: And my wife, Brigette Barrager!

"THE LIVING MUMMIES OF TOTH-RA!"

EPISODE 9

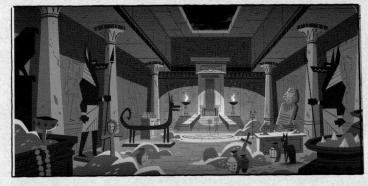

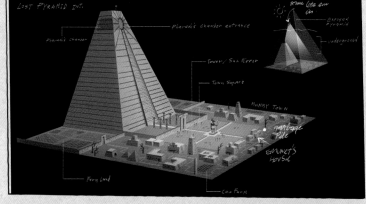

FRANK ANGONES: Going back to the "no mine cart" rule, the idea that you would find a civilization of mummies, and they weren't alive, but they were locked away and worshiped this all-powerful mummy king. More importantly, because it was a con, this was a good opportunity to do a Louie adventure story. A question we always had was: "Okay, how does Louie fit in?" In the pitch bible, for every main character, we had an answer to what they would do when faced with a giant mummy. Louie's was a monologue about trying to represent the mummy as his manager, and promising to make him bigger than Tut. That was the generative thing here—how can Louie talk his way through "Is this a con, or is this real?" It also allows for a lot of great interplay with Louie and Webby—in the early days, we'd take any opportunity to pair off characters ideologically opposed to each other. And Scrooge leads a rebellion.

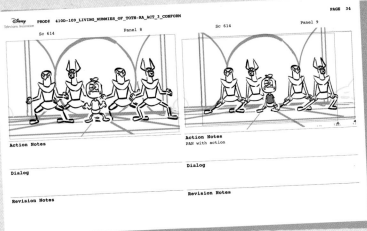

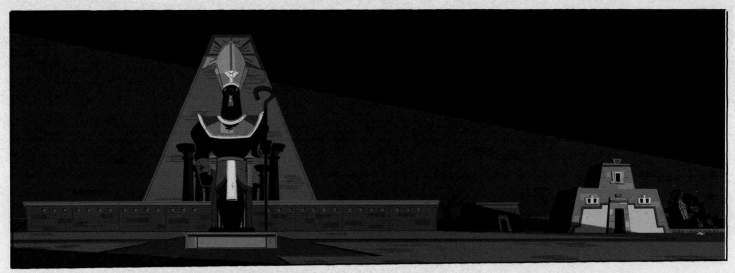

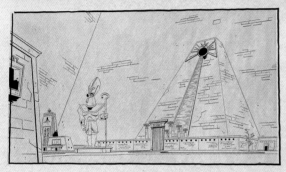
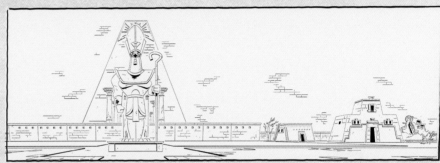

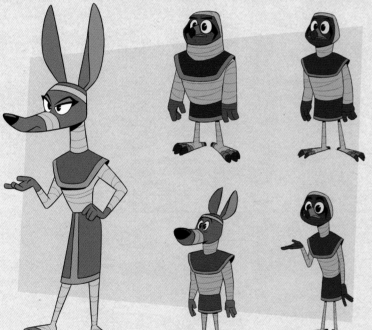

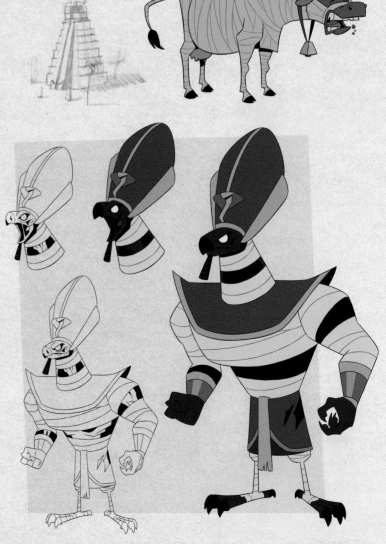

MATT YOUNGBERG: The original idea for this episode was: "What if people were still alive inside of these tombs, and created their own culture, without outside influence?" So, getting inside the pyramid, you discover that there was this huge advanced civilization that had been taken from ancient Egyptian culture but had blossomed from that. And the original idea was that it was a more advanced society, with their own versions of cell phones and hovercraft, so it was going to be this super-advanced society inside. But as we got into it, the story evolved away from that, because we needed to figure out what the challenge was, and the mummies being destitute works for the purposes of the story. It became much more of a cult-worship type of situation.

FRANK ANGONES: It was us wanting to do a real classic *DuckTales*, to the point where we wanted to give everyone their *DuckTales: The Movie* outfits.

"TERROR OF THE TERRA-FIRMIANS!"
EPISODE 10

FRANK ANGONES: We really loved the idea of a runaway-subway story, and trying to find adventurous things to do within Duckburg. And we got to pair Huey's point of view against Webby's, focusing on Huey's type A Junior Woodchuckness. In "Neverrest," it was a positive trait, but here you explore that he does not like the unexplained. Huey wants to find an explanation, while Webby is in awe of the wonder and myth. She loves the lore and the legend of the Terra-firmians, and he believes that there's a rational explanation for everything.

It was also an opportunity to further develop Webby and Lena's friendship, in that this is the first episode where we know that Lena is bad, and is using them. The audience is trying to figure out what Lena's angle is, because you can still see that Lena likes Webby. It was an interesting balance to try to achieve.

SEAN JIMENEZ: This is our first of what I always called our "dark matrix" shows, which means the overall episode is in a really, really low key, lighting-wise. It's a spooky dark ride palette. This is our first big foray into dramatic lighting, and how you can use a dark key to bring the drama, but it's also a way of burying line work. You have to treat it like theatrical lighting to get things to read. The characters are in pools of light. The audience senses that there's something there in the darkness.

MATT YOUNGBERG: It was an interesting episode in terms of our design philosophy, of trying to take something complicated and then simplifying it. The shadows are covering so much that it gave a lot of drama to it.

MATT YOUNGBERG: This subway car was the first time that we really explored the depths of the Glomgold branding. It became a gag throughout the series. I loved the ability of our background designers to find the character of the show within the backgrounds. It wasn't just about giving you a background; it was about a story behind that background, and how our world and characters inform those backgrounds. I'm always a fan of little visual gags that add layers to the visuals and the jokes of the show.

SUZANNA OLSON: Background artist Paul Tsui thought of a lot of the fun subway-poster ideas and slogans. He was very creative when it comes to those.

SEAN JIMENEZ: There's a "Sean's Do's & Donuts" ad that's making fun of me for what is apparently my legendary "do's and don'ts."

SEAN JIMENEZ: This was the introduction of Webby's style of drawing, which was done by Melanie Atwater. We weren't going to add another hat on top of all of Webby's other hats by making her a great artist. She's got to have a more childlike style, but also clean and clear, so that the audience gets everything. Melanie cracked it. It's super charming.

FRANK ANGONES: Webby's adorable little legend of the Terries and the Fermies is the actual Carl Barks story, peppered with the original *DuckTales* episode, "Earth Quack."

MATT YOUNGBERG: I really love these posters so much. I think they're super funny. *Duck House* is a movie I want to make.

MATT YOUNGBERG: The idea of the Terra-firmians looking really scary, but in reality they aren't scary, meant we had to accept that we were seeing them through the eyes of the ducks. So when you see them and they're all lit up and scary, it's the kids' imaginations playing that up, because when they walk into the light, they're these dumpy little cartoony characters.

And they're these rocks, but they act like modeling clay, so they can roll up into balls and roll around so you don't see their faces or their arms. Mobility was something challenging to figure out with them, like how they unfold.

"McMYSTERY AT McDUCK McMANOR!"

EPISODE 11

SUZANNA OLSON: After everything in the previous episode, we were getting to a point where we needed less assets in an episode. So I made the request to Frank to do a "bottle episode," to try to keep it small.

FRANK ANGONES: This episode is where I discovered the myth of the bottle episode in animation. A bottle episode is a television episode that takes place in one location, so it's easy on production. That is a lie in animation. It was very hard to write, because we were juggling all of these different characters, trying to keep it engaging, and doing a locked-room murder mystery.

MATT YOUNGBERG: You think it should be uncomplicated, but now we have to figure out literally every angle of this room. We thought the main hall would be best because that's the biggest and we'll be able to fit everyone in, and it's one that we've kind of worked out already. But when you start shooting every single angle of that room, you realize how little design coverage of that room you have, so the backgrounds become very complicated.

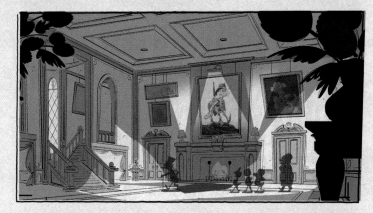

FRANK ANGONES: John Aoshima did an amazing job directing this episode, with Colleen Evanson writing it, and those two did a ton of work. And so did the board team, to make this as dynamic as humanly possible, just figuring out every inch of this one room in the mansion, and figuring out how to be able to stage it so that you can get seclusion while you're still locked in this room.

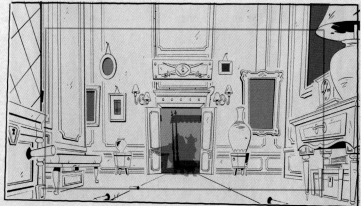

SEAN JIMENEZ: It was a positive, ultimately, for forcing us to dive deeper into the mansion's geography, and adding more reuse locations in order to do it. It seeds the rest of the series, because in development, you don't really have that much time. In an ideal world, you'd be in development for a year, where you're building all this stuff out, but you can't do that. So for the mansion, you have to build it one episode at a time, making sure that the board artists reuse what's there from the previous episodes, and then maybe adding ten percent new material. And then, by the time you get to the second season, you have enough of the mansion figured out that you can reuse it a lot."

MATT YOUNGBERG: It was a fun episode. It turned out really, really good. But there's no such thing as a truly easy episode of animated television. And if it is easy, you're doing your job wrong.

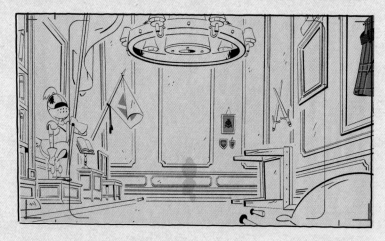

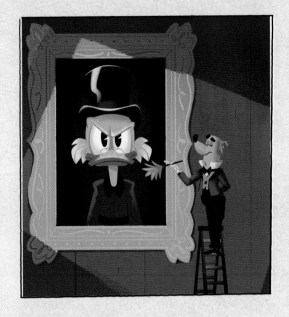

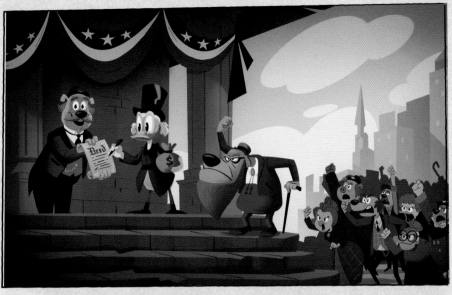

FRANK ANGONES: This was our introduction of Duckworth, who is a classic character from the original series, not from the comics.

MATT YOUNGBERG: We knew from the very beginning what we wanted to do with Duckworth. We knew he was dead, and that we wanted him to come back as a ghost.

FRANK ANGONES: We love the idea of Duckworth being such a dedicated butler that, even in death, he continues to serve, and to know exactly what's right for Scrooge, whether Scrooge wants it or not.

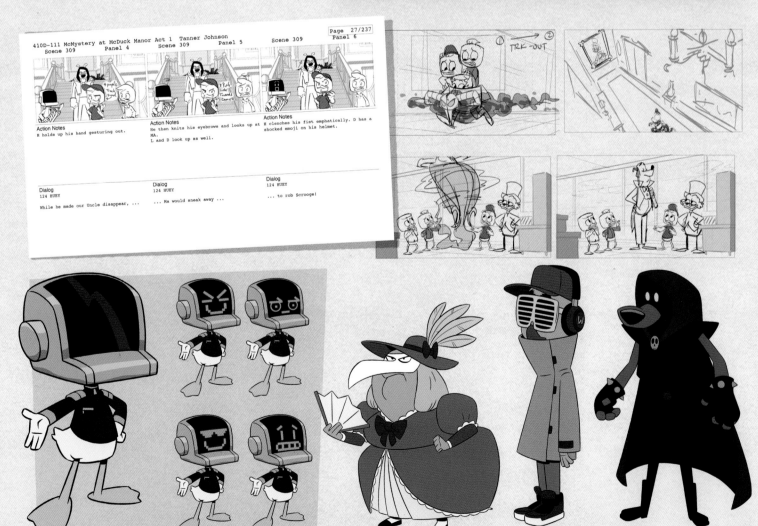

"THE MISSING LINKS OF MOORSHIRE!"

EPISODE 12

FRANK ANGONES: The network thought it would be fun to do a sports episode, and we thought golf would make sense. Particularly the idea of seeing Scrooge not be good at something, and coming off of "Escape to/from Atlantis!," continuing the Dewey/Scrooge mentorship story line. It's the story of a parent playing a game against their kid, and then that one time the kid starts beating them, and how does the parent process that and continue to be supportive? Also, the notion of mystical golf seemed like a lot of fun.

MATT YOUNGBERG: It was Scrooge getting so frustrated at not being good that he becomes more of the selfish Scrooge that is core to his original personality. But then, being true to the core of our *DuckTales*, he had to let go of his selfishness and anger and allow his family to succeed where he can't.

SEAN JIMENEZ: I called my Scottish brother-in-law, Fraser, and told him that we were doing a story where they go to a seaside area of Scotland for a golf tournament, and was there a cool place, maybe ruins, that he could recommend? He suggested Dunnottar Castle, and it was perfect. If you look at the place, it's pretty close to what we did. He also called my attention to the Callanish Stones. It's notable that a lot of this episode comes from research of real places, and then we built our fun, whimsical story around it. We used color to signify that they've moved from the real world and into the weird hyper realm, with heightened purples to offset from the more rich greens of Scotland.

MATT YOUNGBERG: I have a lot of love in my heart for this episode. Visually, I love what we did on this show, using the mists as a way of covering the difficulty of the locations, a little bit, but also as this design element that made it just so gorgeous to look at.

SUZANNA OLSON: Sean's "do's and don'ts" for our show style tried to stay away from atmosphere, like fog and glare, but we broke the rules in this episode, because it felt appropriate. When you add those layers of fog and atmosphere, it adds complexity to the animation, to the retakes, but it was absolutely worth it for this. It needed it. So we broke our typical Barksian comic style to add those effects.

MATT YOUNGBERG: And it was one of the only times we broke our "no atmosphere" rule. The color styling that made this feel so otherworldly was also something super beautiful. This is one where the backgrounds stand on their own as gorgeous pieces of art.

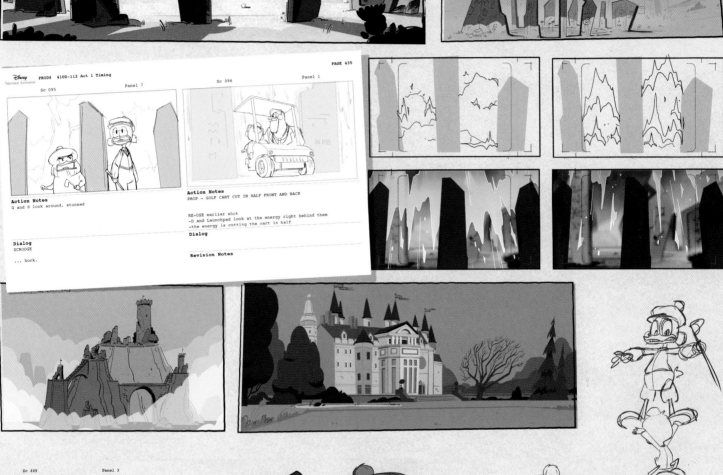

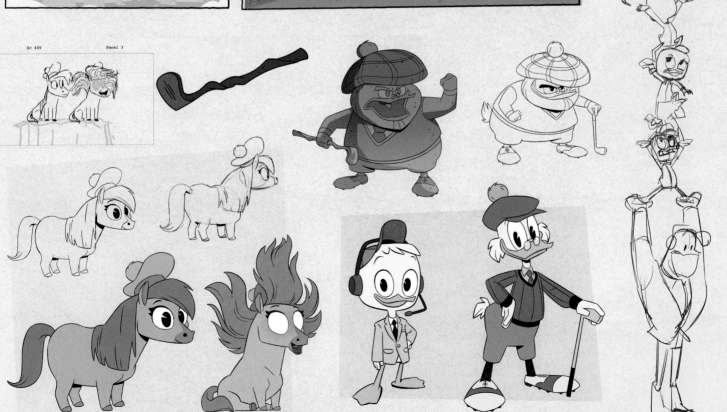

62

"THE SPEAR OF SELENE!"

EPISODE 13

SEAN JIMENEZ: The design of the island is very Carl Barks, in that we tried to have a single element that draws your attention, and that was the temple. When I think of something grand, it's going to be up high. So let's put this temple that they're trying to reach up at the highest peak possible. It's echoing McDuck Manor, on the top of the hill. There's a symmetry.

MATT YOUNGBERG: I love Greece and Greek mythology. I lived in Greece for two years, and I speak Greek, so I loved being able to bring in some of that to this series.

FRANK ANGONES: We love the idea that Scrooge used to vacation on an island full of Greek gods. The island of Ithaquack was a reference to a city from the original *DuckTales* episode "Home Sweet Homer." The two stories of this episode are that this is a place that has history for Scrooge and his family, but it's also a place that Della had visited, and that became a big deal. We established the *Spear of Selene* in "Great Dime Chase," and Dewey thinking that it must be an artifact and that the Temple of Heroes has the spear in it. And by researching his history, he's researching his mom, but also addressing that notion of "you may not like what you find." He has this picture of his mom in his head. But because he's never known her, what if that picture doesn't match up with what the truth was? Did his mom betray Scrooge? Did his mom steal something? Did his mom cause all of these things? And having to reckon with that as they're going through this bizarre temple became a big emotional touch point for the story.

And then on the other side of that story, we wanted to give Donald a history with some characters. Donald is so curmudgeonly and pessimistic, so let's pair him with our single most optimistic character possible, who could also physically damage him all the time. And so the notion of Storkules, Donald Duck's best friend and bosom chum, was born.

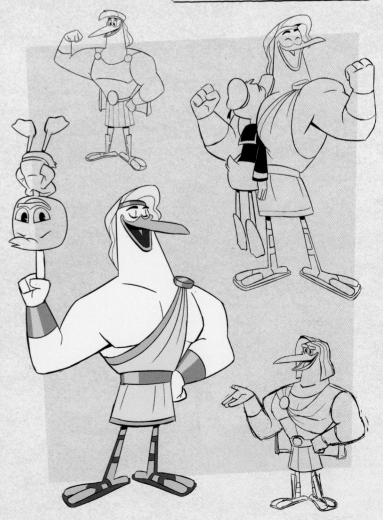

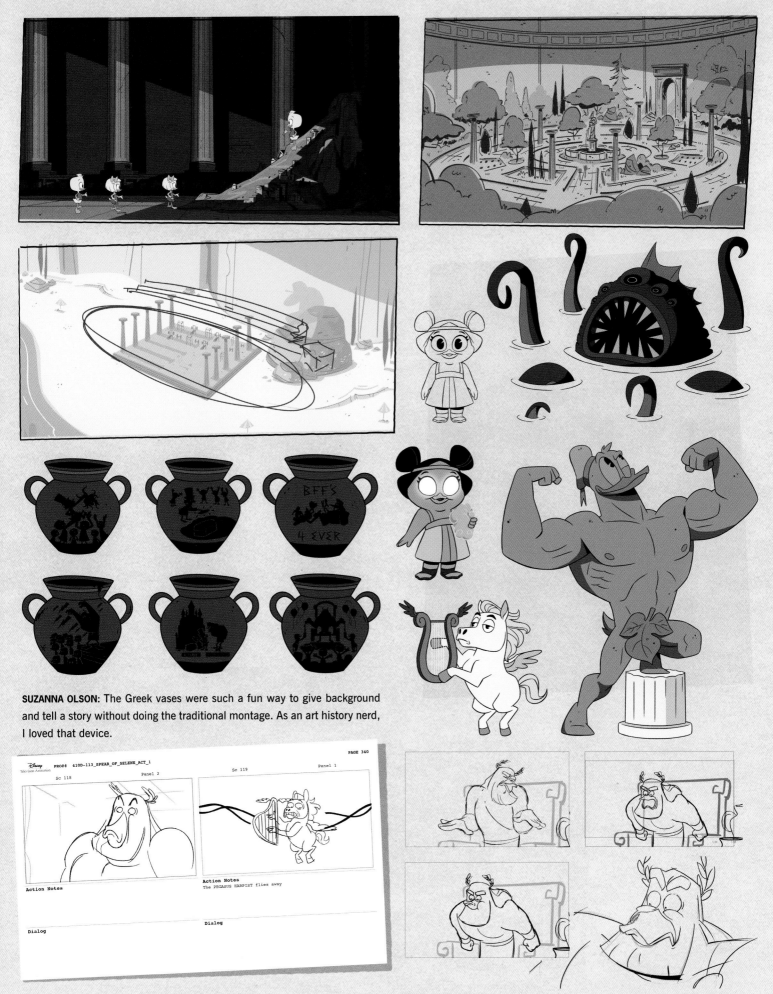

SUZANNA OLSON: The Greek vases were such a fun way to give background and tell a story without doing the traditional montage. As an art history nerd, I loved that device.

MATT YOUNGBERG: One of my favorite things became to try and figure out how to put an Emmy Cicierega storyboard on model, because she would do these faces that break our design completely but are so funny that I've got to figure out how to make them work. This Zeus was so much fun for me because it was like, "How far can we push this? How big can we make these expressions go to make hers match?" Her drawings are so good.

"DAY OF THE ONLY CHILD!"
EPISODE 14

FRANK ANGONES: We've done all these adventures with Huey, Dewey, and Louie being thrown into big adventures, but part of the show was making sure that they were kids. So this episode focused on Huey, Dewey, and Louie. We wanted to give a showcase for each of them. For the Huey story, we really wanted to do a Junior Woodchuck story, which we hadn't done yet. Huey is desperate for brothers, and then two Beagle Boys show up and realize that they had been mistreated by their brothers.

FRANK ANGONES: We loved Doofus. Doofus is so upsetting in all things.

SUZANNA OLSON: Doofus elicits a visceral response, to see just the gross amount of wealth, and to see what a child would do with it.

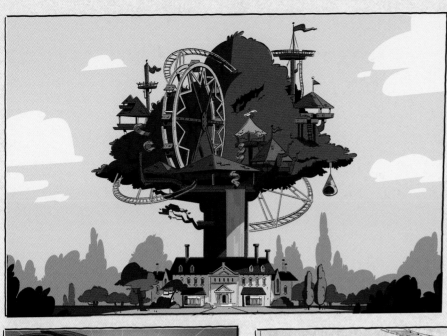

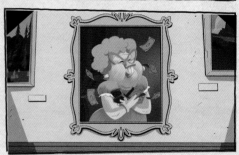

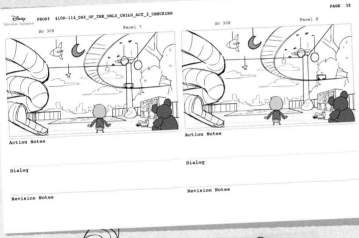

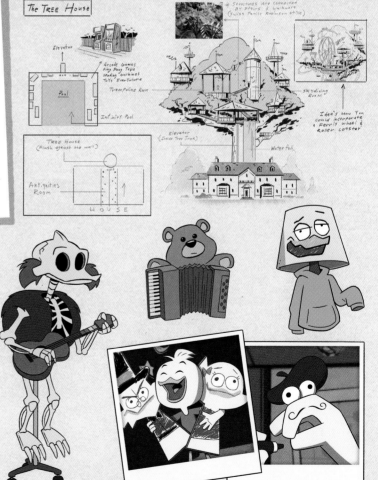

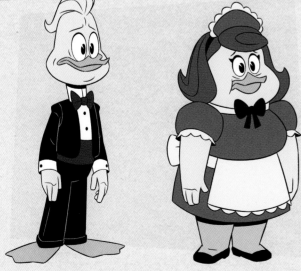

FRANK ANGONES: The reveal that Doofus's butler and maid are his parents is just so weird.

FRANK ANGONES: We loved *Dewey Dew-Night!* so much that it became a conceit that we brought back at least once a season, and we did a whole bunch of shorts about it.

66

"BEWARE THE B.U.D.D.Y. SYSTEM!"
EPISODE 15

MATT YOUNGBERG: While the script came pretty easy, technically this was a very difficult show to pull off. There are a lot of moving pieces and a lot of new things. We had the *Darkwing Duck* opening, as well as the introduction of Gizmoduck, a race, and then a chase. It was hard.

FRANK ANGONES: One of my best friends since college, when this episode came out, said, "At Frank's funeral, there will not be a eulogy. They will show this episode of television, and it will tell you everything you need to know about the man." The advantage of being the head writer of a TV show is you get to pick which episodes interest you and you want to write, and you get a lot of carte blanche to do what you want to do with them. We planned that when we did Gizmoduck, we were going to throw *Darkwing* in there, and it would be a Launchpad-focused story—which was revolutionary, because we hadn't really done an adult-focused story that wasn't ultimately about the kids. I didn't know if we were going to get more than one season, so I knew that we should do this and have faith that we would know how to execute it. And if this wound up being the only season of *DuckTales*, I wanted to be able to say that we did this.

MATT YOUNGBERG: The *Darkwing* opening ended up being not too difficult, because I gave it to Ben Balistreri to design and storyboard.

SEAN JIMENEZ: Ben is one of the best character designers in the industry, and he's also a director at Disney and a hardcore Disney Afternoon fan.

MATT YOUNGBERG: The chase at the end was the big set piece, and we needed to figure out how to manage it and make it something that wasn't going to break the bank in terms of the locations. We figured out a really smart system, because it starts on the track, and then as it becomes the chase, it goes into a ravine. And so, essentially, it became just a couple locations. But within that, the difficulty came from there being a lot of moving pieces—a car chase, a robot chase, all these painted backgrounds, and then you have these giant boulders at the top, toppling into each other. It was one of the hardest sequences we ever had to do, in terms of figuring it all out.

SEAN JIMENEZ: It was about the complexity. For every solution we were trying to make, it presented its own intricate problems, and then we were constantly having to solve those problems. Solving the challenges is always exciting. Background painter David Cole and I were trying to figure out the zip pans, and I was like, "Maybe the zip pan backgrounds just look like abstract paintings? And because they're strips, they almost look like strips of torn paper?" And David Cole got what I was saying and did the zip pan backgrounds like that. Our postproduction artist, Luciano Herrera, made sure it worked like it should in the final episode.

MATT YOUNGBERG: Redesigning Gizmoduck was a huge deal. Gizmoduck was a real key component of our show's design philosophy. How do you update it to make it this cool action hero–looking suit of armor but still retain the uniqueness of what Gizmoduck is? It was a real challenge and process. One of the things I remember talking about is giving it a little bit more of the superhero proportions, with the big chest and arms, but then balancing it on this one wheel to be truly Gizmoduck.

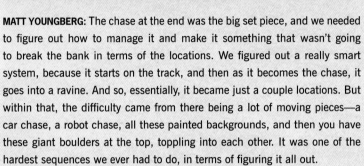

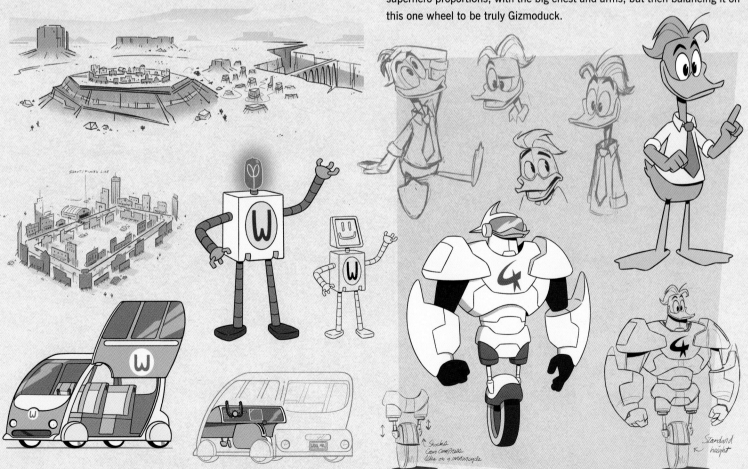

"THE GOLDEN LAGOON OF WHITE AGONY PLAINS!"
EPISODE 16

FRANK ANGONES: We had to do a Scrooge Klondike episode, given the history of Scrooge, and this was the most interesting way, rather than doing a flashback, which we had seen before. We wanted to do something set in the present day. We also knew we had to do some version of Glittering Goldie. This was a great opportunity to do a story exploring what Scrooge felt like he lost, and building the exact right person for Scrooge McDuck to fall in love with—which was, of course, the exact wrong person for Scrooge McDuck to be in love with, but he just can't help himself. We liked the idea of having her be the one person who can get one up on Scrooge McDuck pretty reliably. She is every bit the adventurer that he is, and she is the definition of being sharper than the sharpies. She is the only sharpie who is sharper than Scrooge McDuck. There was a little bit of *Dirty Rotten Scoundrels* in this, too, with the Scrooge-Glomgold-Goldie love triangle.

SUZANNA OLSON: Goldie was a great evolution of the character, and one that we had a lot of fun with.

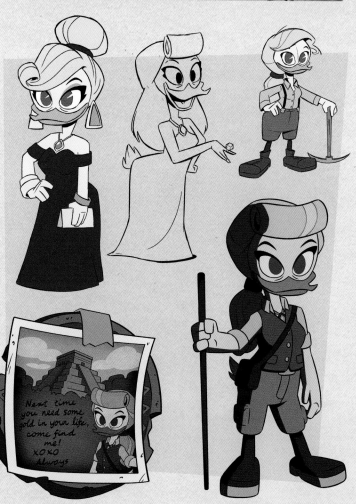

FRANK ANGONES: We knew we wanted to set an episode in Dawson. Anytime we were hard up for an adventure location, Sean had reference of something he had always wanted to explore and do. And so that was the inspiration for this.

SEAN JIMENEZ: There was a lot of love thrown at this episode, and it turned out beautiful. It's one of my all-time favorites. It's so gorgeous, and there's really great emotion in it.

SEAN JIMENEZ: When they're in the cavern, I was pulling reference from an old Disneyland ride, Rainbow Caverns.

FRANK ANGONES: The Glomgold flashback sequences were everyone's favorite part of this episode. We thought that if all of Scrooge's flashbacks would be done in this Carl Barks painting style, then Glomgold's should be done in this awful, cheesy eighties pop-art style. It allowed us to see how Glomgold sees himself. The flashbacks were all designed by Tanner Johnson, who became a director on the show.

"JAW$!"

EPISODE 17

FRANK ANGONES: This episode, written by Colleen Evanson, was originally called "The Beast beneath the Bin." Prior to this episode, Magica had just been a silhouette, gaining power. But as the eclipse neared, her powers grew and got more impressive, allowing her to finally talk. Colleen became the go-to Magica writer, as she could really capture Magica's pettiness and hatred. There is no amount of revenge that Magica De Spell could get on Scrooge that she wouldn't revel in. She loves being malicious and is gleeful in how evil she is.

"What happens if some kind of mystical shark gets loose in the Money Bin?" is one of the original story premises we developed for the show. It forced us to reckon with what the dimensions of the bin were like. How big of a "high seas adventure" is this?

This is also the introduction of the dynamic between Lena and Magica, and how Lena is a prisoner of Magica and is connected to her shadow, which is a play on the original *DuckTales* episode "Magica's Shadow War." The design of Shadow Magica is very similar to the black silhouette with red eyes from that episode. But we twisted it so the shadow is actually the person, and Magica is the shadow.

MATT YOUNGBERG: Lena is having second thoughts about Magica's plan, and what Magica expects from her, and how selfish Magica is. She doesn't really care about Lena or how things happen, as long as her ends are met.

FRANK ANGONES: This is very much the turning point for Lena, where she realizes, "Oh, I may actually like Webby."

medium far

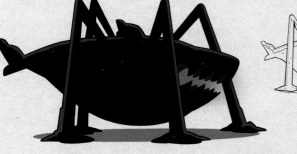

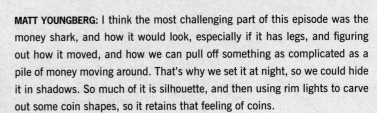

MATT YOUNGBERG: I think the most challenging part of this episode was the money shark, and how it would look, especially if it has legs, and figuring out how it moved, and how we can pull off something as complicated as a pile of money moving around. That's why we set it at night, so we could hide it in shadows. So much of it is silhouette, and then using rim lights to carve out some coin shapes, so it retains that feeling of coins.

SEAN JIMENEZ: It was supposed to be a real scary monster, but everyone was struggling to make it scary.

MATT YOUNGBERG: The answer was the silhouette and how it moved on the land, being low to the ground and the spindly legs propelling it forward. We had Sarah Craig do some animation for it. She was one of our prop and character designers, but also an all-around amazing artist, and she figured out how to make this thing move really well. She became essential to the production of this episode. We definitely couldn't have pulled it off to the level we did without her.

"FROM THE CONFIDENTIAL CASEFILES OF AGENT 22!"

EPISODE 18

MATT YOUNGBERG: This was our big spy episode. *DuckTales*, as a story machine, can basically fit any genre. A spy genre episode was a given, especially since some of my favorite episodes from the original series were spy ones. But this one is different than just James Bond, and more of an old-school British 1960s spy show. That was a lot of fun to play with.

FRANK ANGONES: One of the interesting things about working with Matt Youngberg, who has a big history in action-adventure cartoons, is if you're going to pitch him something with robots or spies, he is going to have opinions and demand that it be different than every other version of that he's already done. So there wasn't a lot of James Bond to be had in this. Instead, we went for the weird British stuff, like *The Avengers* and *The Prisoner*. In terms of season one, this episode was the prototype for the promise of the show. It balances Scrooge and Beakley's past with a story that is focusing on who Scrooge is now, in the present, with one of the kids. It's a spy story that takes place in the present and the past, and it has the Gummi Bears, a villainous organization from *Darkwing Duck*, and Ludwig Von Drake. It takes things from all elements of this property.

We realized that we had never had a Scrooge and Webby story. We knew what the ultimate story was of Scrooge and Webby, so when you've seen the whole series and then go back and look at this episode, you'll see that we knew what we were doing.

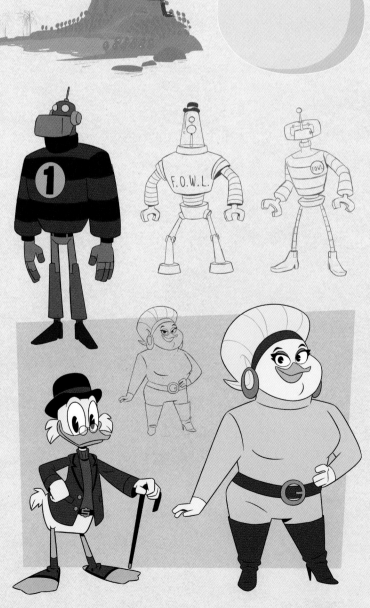

SEAN JIMENEZ: I went to town on this one, because one of my favorite production designers is Ken Adam, who was the production designer for a lot of the James Bond movies. So I was really excited.

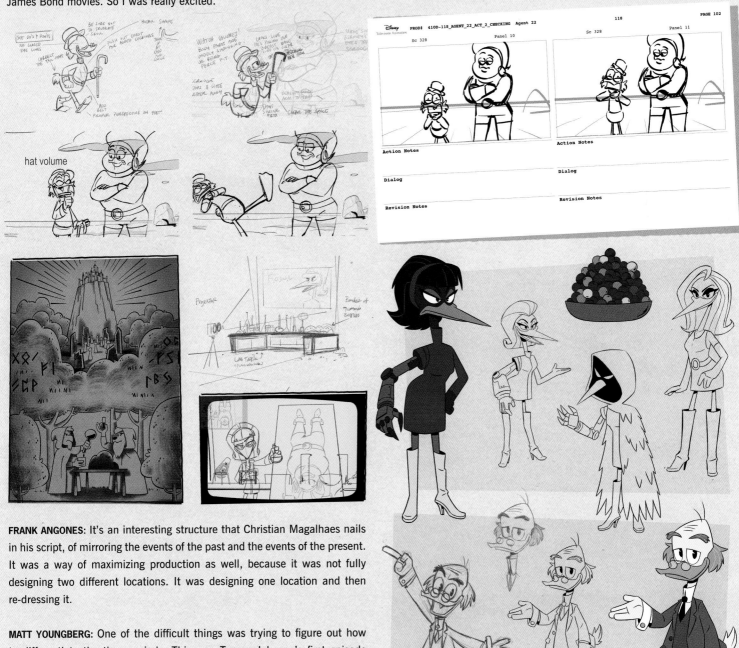

FRANK ANGONES: It's an interesting structure that Christian Magalhaes nails in his script, of mirroring the events of the past and the events of the present. It was a way of maximizing production as well, because it was not fully designing two different locations. It was designing one location and then re-dressing it.

MATT YOUNGBERG: One of the difficult things was trying to figure out how to differentiate the time periods. This was Tanner Johnson's first episode as a director that he got to do on his own. He worked really hard to figure out how to do the transitions into the past. Sean came up with the idea of a color differentiation between the present and the past—bringing in the desaturated look from old films and adding film grain.

SEAN JIMENEZ: And then there's a mini film, which is black and white. So there's three stages—our present-day color palette, a desaturated palette for flashbacks, and then the black-and-white palette of the footage that Black Heron takes. It ended up working really well.

MATT YOUNGBERG: Being able to do Von Drake was awesome. You can see a lot of the Milt Kahl style that we pulled from for our show. We leaned into it with Ludwig, because it was such a core part of cracking the look of our *DuckTales*.

"SKY PIRATES IN THE SKY!"

EPISODE 19

FRANK ANGONES: We had said in the pilot that there were sky pirates over Plain Awful. We knew that if we could crack one *TaleSpin* character, then we would have an inroad to whatever else we wanted to do, and Don Karnage was always the most fun.

It gave us an opportunity to do a story that we had talked about doing from the beginning, which is the idea of Dewey desperately wanting someone to pay attention to him and getting lost in the shuffle of a giant family. Our writers spent a lot of time studying the opening of *Home Alone* to figure out how to believably get Dewey away from the family without anyone noticing.

We had the idea that the sky pirates were actually a traveling theater troupe who couldn't bankroll their shows, so they began plundering. It's essentially if the cast of *Pirates of Penzance* realized they were really bad at one part of that show and really good at the other part. And so they use a big song-and-dance number to stupefy the crowd.

MATT YOUNGBERG: It ended up being a difficult episode to produce, because of the singing and dancing and everything that that brings with it. This was our big swing. We knew these things would be difficult, but the level of difficulty we could tackle with this series became very clear in this episode.

SEAN JIMENEZ: We were doing a musical. That means tons of characters, and most of them can't be reused. And there are planes that are dancing in the sky. It was doubly complex, because Matt Humphreys, who's an incredible director, loves complexity. So you had a complex story and a director who loved complexity making for a very, very big episode.

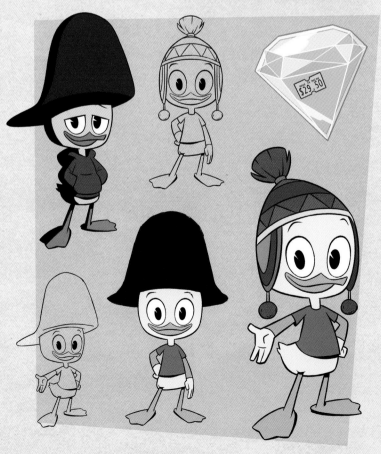

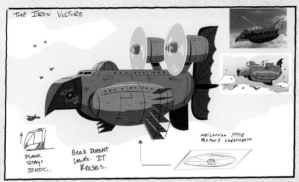

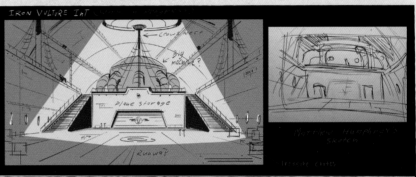

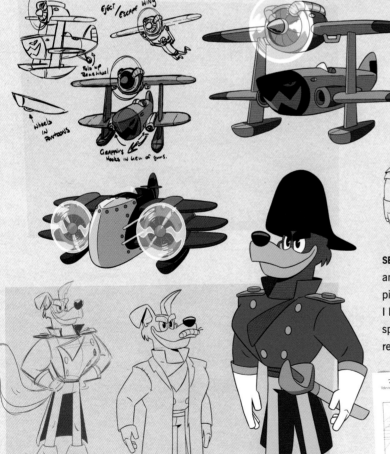

SEAN JIMENEZ: In the third act, when they're trying to trick Don Karnage and the pirates, they disguise themselves. Humphreys had the idea that the pirates are using spotlights to shine a light on a character to track them. So I had the idea to amplify the sequence by going monochromatic red with the spotlights. Those are big, bold swings, and what's great about Matt is he really encouraged me to take big swings like that.

MATT YOUNGBERG: In finalizing the design for Don Karnage, because of the singing and dancing and the showmanship, I wanted to make sure that we elongated him a little bit and made him a little bit more lithe. So we gave him longer legs and puffed out his chest to give him more of a dancer feel.

"THE SECRET(S) OF CASTLE McDUCK!"
EPISODE 20

Scottish Moors

FRANK ANGONES: This was a riff on the Don Rosa story "The Last of the Clan McDuck," with the notion of the various ghosts of Clan McDuck coming to aid their descendants in times of need. This episode has a lot of Carl Barks and Don Rosa McDuck lore.

MATT YOUNGBERG: We were always trying to make sure that we were creating a robust mythology using elements that have come before, like the comic books and the other shows.

FRANK ANGONES: We knew that we wanted to do a real *Goonies*-feeling story for the boys, tied to trying to uncover a mystery. This episode brought to a head that Dewey had been investigating Della and not telling his brothers. I love the emotion in this story, and that we did a story that was about the brothers, where the treasure-hunt mystery is that one brother is trying to prevent you from solving the mystery.

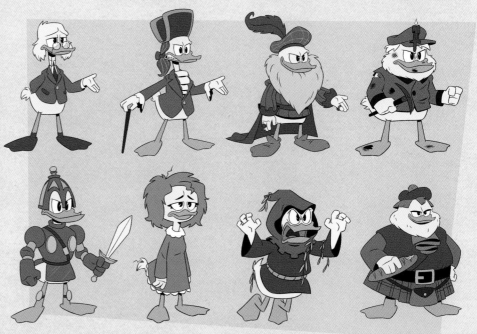

SEAN JIMENEZ: Usually what happens when the show gets pitched out is I'm already trying to think about something tangible to start using as a springboard for the style of that episode, in terms of lighting and mood. We knew that we were going to make Castle McDuck sort of spooky and foggy, as it's full of ghosts. It was all about making it feel like an old sixties B movie, so my design of the castle was trying to capture that gothic movie tone.

MATT YOUNGBERG: The paintings that Tapan Gandhi, Rachel Yung, and Josh Parpan did in this episode are all just gorgeous.

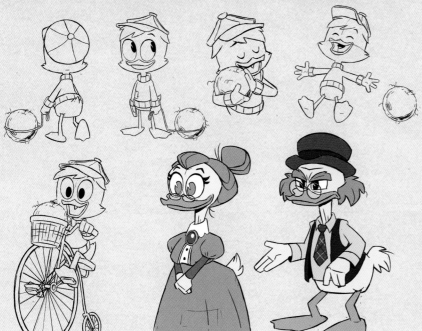

FRANK ANGONES: This episode was the most we've seen of Della until now, and it hints about the design of the *Spear of Selene*. They don't know it's a rocket ship yet. They think it's an artifact. An important design element for the ship is that it had to be believable out of context, that you would think it was an actual spearhead, but then when you turn it a certain way, it looks like a rocket.

"WHO iS GiZMODUCK?!"
EPISODE 21

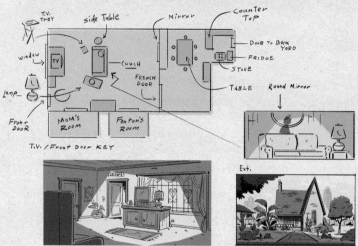

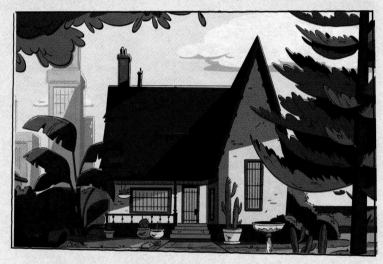

FRANK ANGONES: We had set up Fenton in Launchpad's story in "B.U.D.D.Y. System," but this was our opportunity to do a Fenton story, focused on him, delivering on the promise of everything we said we had wanted him to be—a Latino superhero who was definitely Latino and informed by his background but not solely defined by it.

The big idea that we had for this was "ridesharing, but for superheroes," where you could download an app, and a superhero would come to save you, and how that can be commodified. But the big question is in the title: who is Gizmoduck? At the beginning, he doesn't even know that he's going to be a superhero. He just knows that he has this crazy suit and he believes he could be a superhero. Or he could be a menace. Gyro thinks he's just an intern. Gyro says that the armor was designed to help him reach things on high shelves, and that's it, which is a very Gyro reason to invent a power armor.

At the end of "B.U.D.D.Y. System," we realized that Mark Beaks was more of a Gizmoduck villain than a Scrooge villain, so this was us letting Beaks go full evil. Beaks is the opposite of Fenton. Fenton has a million ideas and he wants to do good for the world, while Beaks has no ideas and only cares about appearances.

And if Beaks was Gizmoduck's Lex Luthor, Huey is Gizmoduck's Jimmy Olsen. Huey is his little sidekick who's always around, in the same way that we knew a Launchpad story would have Dewey.

MATT YOUNGBERG: But because we wanted to lean into the superhero genre, we still had some fun with the tropes, but then deviated as much as we could. The bank robbery is a good example of that, where all superheroes get to stop a bank robbery, but here, everything goes wrong.

SEAN JIMENEZ: This is my grandma Jean's house, in downtown LA. The interior is laid out exactly like her house. That's a fun thing about being an art director: I get to give a shout-out to my grandma's house.

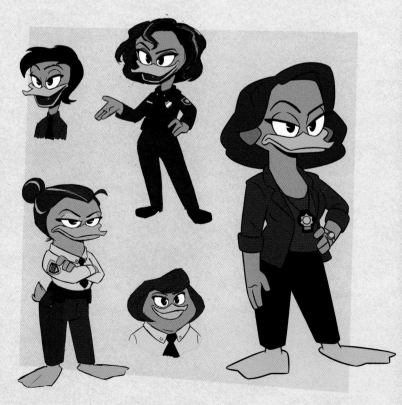

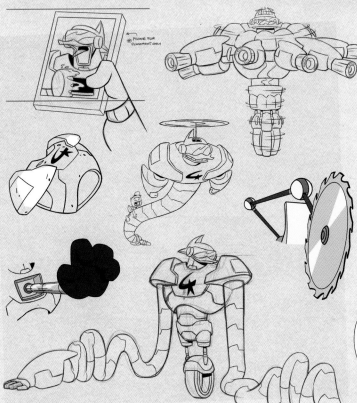

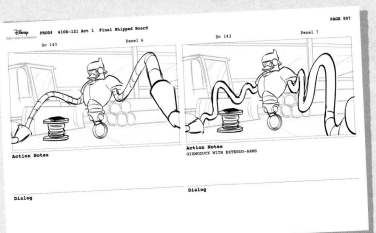

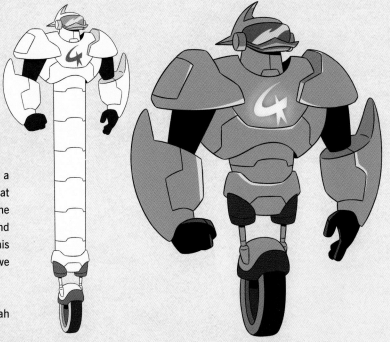

MATT YOUNGBERG: As Gizmoduck evolved, we had to evolve the design a little bit. Even though it doesn't look like he evolved, there was stuff that still needed to get figured out and clarified, and so we continued to hone and push and pull on his design until we figured out more of his abilities and transformations. We had a sheet of all of his abilities that he can do with his armor, and that sheet continued to grow throughout the series anytime we introduced something new.

SEAN JIMENEZ: One of our prop artists (and later, character designer), Sarah Craig, really had to figure out and design all of Gizmoduck's gadgetry.

"THE OTHER BIN OF SCROOGE McDUCK!"
EPISODE 22

FRANK ANGONES: We knew that the A story of this episode was going to be the darkest thing we had done on the show so far, so the B story had to be the most ridiculous thing we had done.

The fun idea became a Louie story like those eighties "kid finds a mythical or sci-fi creature in the woods" movies. In those movies, we'd noted that creature always got a house and a lot of free food out of the deal. It also allowed us to keep track of Scrooge as this great monster hunter, which we used to connect the two stories, as obviously Scrooge would be hunting Gavin—a.k.a. our Sasquatch, Tenderfeet—and that threat of Scrooge being a monster hunter would make Lena worried that if they ever found out the truth about her, she would be next on the list of monsters to be hunted. This is Lena's turning point.

MATT YOUNGBERG: That's why this episode works so well. *DuckTales* is a comedy adventure, so it needs to have comedy. If you lean into just the drama, it could get caught up in it, and it becomes a different show. So when you can add in that B story of such utter silliness, it carries the *DuckTales* of it through in a way that other shows don't really do. We take each of the dramatic beats seriously, but the comedy beats need to be taken just as seriously. I think this episode did a really great job of that.

SEAN JIMENEZ: This is one of those episodes that show what's great about *DuckTales*, because yes, it's a kids' show, but there's such a meta, postmodern approach. This is an example of how dark this show can get.

FRANK ANGONES: This is us setting the pieces for the season finale. Dewey is getting closer to the truth, Magica is getting closer to the dime, and those two things are going to come to a head.

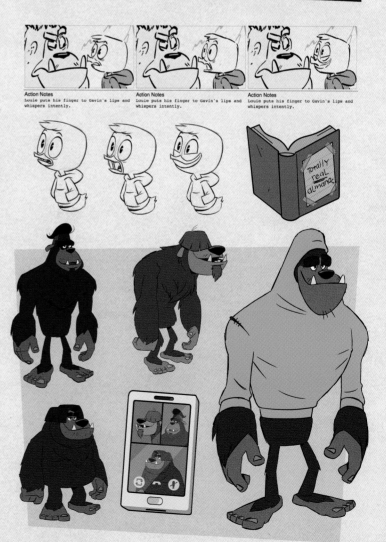

*EFX: MAGIC ENERGY

*EFX: MAGIC BLAST

*EFX: MAGIC BLAST

EFX: MAGIC PARTICLES DISSAPATE

SEAN JIMENEZ: Jean-Sebastien Duclos was the board artist who did the nightmare sequence where Webby transforms into the Quacky Patch doll, and he really swung for the fences with the shadows and posing. It's beautiful work. From my perspective as an art director, when you see work like that, you can feel the board artists living in a sequence and putting so much of themselves into it.

410D 122 Act 2A Scene 444	Panel 8	Scene 445	Panel 1	Scene 445	Page 342/345 Panel 2
Action Notes Doll Webby OUT to O.S.		Action Notes CUT TO: Lena is shocked		Action Notes PUPIL HIGHLIGHT on LENA ONLY (NO SHIMMER FX) THROUGH BALANCE OF SC	
Dialog		Dialog		Dialog 181 LENA Webby!	

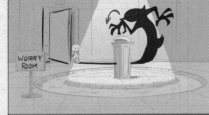

FRANK ANGONES: Some of the most beautiful, wonderful stuff was done with Magica's shadow, like the whole sequence with the shadow overtaking the entirety of the back wall, and the whole back wall of the Worry Room becoming just eyes.

"THE LAST CRASH OF THE SUNCHASER!"

EPISODE 23

MATT YOUNGBERG: This episode is a standout in a standout series. From script to finish, it was everyone firing on all cylinders. Frank's script was amazing and difficult to pull off, given the logistics of being stuck in a plane.

FRANK ANGONES: I wanted there to be a big blowout that had emotional stakes and ramifications, and the only place to do that is right before the finale. Our belief was that the only way that Scrooge could possibly lose to Magica would be if he was at his emotional low point, which meant this was the saddest episode of television I've ever written. There was a lot of concern about the fact that there's an entire act of this children's comedy TV show that only had one joke, and it's when Launchpad asks if they want him to pause the *Darkwing Duck* tape. But the conception of this was that we're going to trap everyone in a locked room and have all the secrets come out, and see how everyone confronts all the things that they've been either hiding or ignoring or avoiding for the entirety of the season. Even though Scrooge is finally to a place where he's starting to feel like he did back when he used to adventure with Donald and Della, you can't allow him to get away with not reckoning with that secret.

MATT YOUNGBERG: This was the dark night of the soul for the family, where all of the things that we had set up and everything that Scrooge had been trying to leave behind catches up with him. It's not a confrontation between a hero and a villain. It's a confrontation between two family members. And it's all deftly handled.

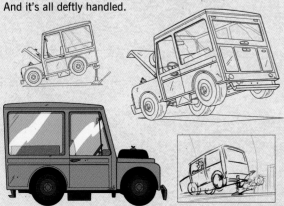

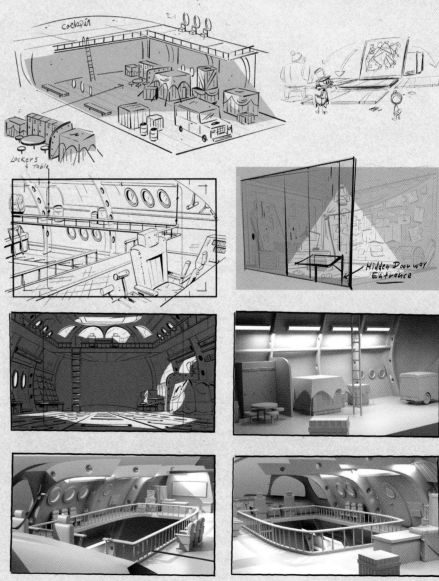

FRANK ANGONES: We hadn't figured out the entire layout of the interior of the *Sunchaser*, but because we were setting an entire episode in it, we did a lot of work building the plane in CG.

MATT YOUNGBERG: David Cole did a rough model of the interior of the plane to help us figure out the angles and the placement of the characters. We knew it was going to be a logistical nightmare to make sure that everything worked. It became very handy for the board artists.

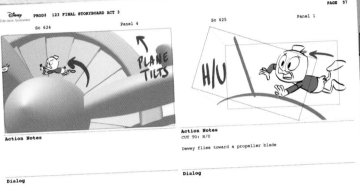

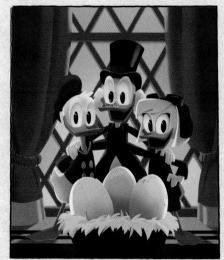

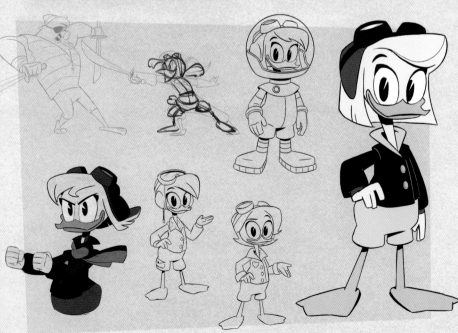

FRANK ANGONES: One of the things that Sean and I both got really excited about was that the last shot of this episode is a mirror of the very first comics appearance of Scrooge McDuck, where he's sitting alone in his study, saying, "Nobody likes me, and I don't like anybody." That's where he is, emotionally, at the end of this episode, so we thought it'd be really cool to mirror that image in the last shot.

MATT YOUNGBERG: It was from the Barks story *Christmas on Bear Mountain*, and it works perfectly for his attitude. We added the tears, because it wasn't just anger but also a sadness that he was alone again, for the first time since the beginning of the series.

"THE SHADOW WAR!" PART ONE
EPISODE 24

MATT YOUNGBERG: What a hard episode to pull off. It was an action finale, but we had to make sure the emotional finale hit as hard as it could. We had to make sure Magica was truly as big of a threat as we had promised she was going to be—so we had an army of shadows in a swirling vortex, the destruction of the Money Bin, and trapping Scrooge in the dime. We had to use all of these things to elevate her, so we could see her at her most powerful. Then at the end, we see her laid low, to her least powerful.

SEAN JIMENEZ: This finale had two forms of ambition. There's the narrative ambition that's in the script, and then there's the cinematic ambition in the visuals. I remember going into the story break and Frank warning me this was going to happen. That they were going to write a big, epic shadow war, where every character that we've seen in the series is going to have a shadow counterpart, and we were going to have Magica exert immense power. And that was difficult to pull off. But we had no choice. We had to pay this off. So we had to go big. Matt Humphreys is an incredible board artist and an incredible director, and in this episode, Humphreys went for it. It was a really hard finale to do, but it turned out great.

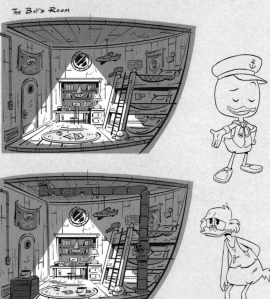

FRANK ANGONES: At some point in the season, we realized we had two major serialized stories, and we could treat the season as if it was one big episode of *DuckTales*. Dewey's Della investigation was an A story, and the Magica revenge plot was a B story, and so we wanted to tie those two things together in a way that was unexpected. This was Scrooge realizing that he really needs his family.

MATT YOUNGBERG: There was a lot of setup, emotionally, throughout the season that we needed to pay off in this finale.

FRANK ANGONES: This episode set the unfair standard of having to top ourselves with every successive finale. First Duckburg is in jeopardy, then the world is in jeopardy, and finally the very concept of adventure is in jeopardy.

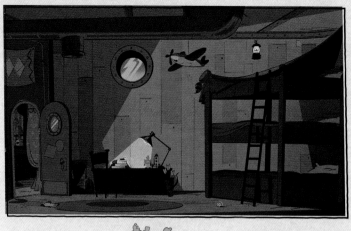

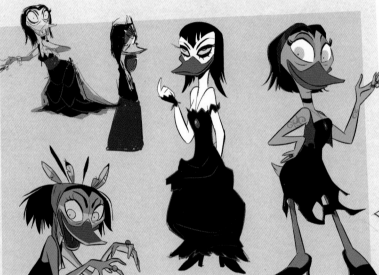

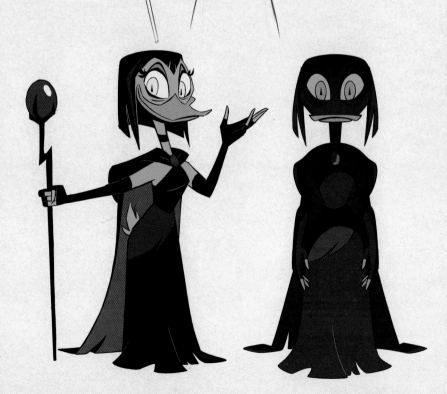

MATT YOUNGBERG: The big thing to figure out for this episode, in terms of visuals, was the design of Magica. It was always our intention to go tall and slender.

FRANK ANGONES: The version that was in the original *DuckTales* was very much the standard duck body shape, whereas Carl Barks's original intention was something between Morticia Addams and Sophia Loren. When she first shows up in the comics, she's very slender, and her proportion is taller than Scrooge, and she has this kind of very alluring danger to her.

MATT YOUNGBERG: Trying to make things more dynamic and pulling her away from the standard duck shape made it look and feel like she was more of a threat to Scrooge.

SEAN JIMENEZ: Alex Kirwan did some of the early designs on Magica, all the way back during development.

FRANK ANGONES: Magica's design is the best. The thing that I like about Magica's crazy reptilian eyes is that, because we've made such a big deal of doing the Barks pie eyes on all the other characters, her eyes are made of the missing slice from everyone else's eyes.

"THE SHADOW WAR!" PART TWO

EPISODE 25

MATT YOUNGBERG: The challenges of this episode were the shadows and the vortex, and the hardest thing about the vortex was trying to figure out how to give it the scale it needed, and then the overall color scheme. We did some explorations and tried to design something that would work, but in the end, it was David Cole figuring out how to use computer graphics animation to enhance the vortex and make it look even bigger and more threatening, more full of these shadows.

SEAN JIMENEZ: We had to do a lot of the vortex during postproduction. I was figuring out the stylistic idea while David was basically kitbashing the vortex together, rotoscoping live-action elements with the drawings, and mixing and matching and putting it all together. David deserves so much credit, because this is something he'd never done before, and it turned out amazing.

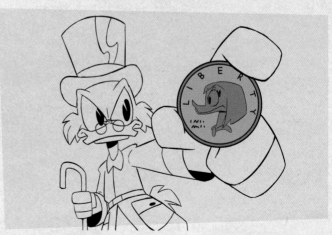

MATT YOUNGBERG: It was really hard to pull off, but to the credit of the team, we figured it out. I love the backdrop of the eclipse, as well. It was a unique opportunity to do something really dramatic, and it gave a really dramatic feel to the finale. I loved it.

MATT YOUNGBERG: To finally reveal Magica's face on the dime was such a big moment that we'd been hiding in plain sight for so long. I don't think anyone ever picked up on the fact that we never showed the face of the dime, so for us to pull it off was awesome.

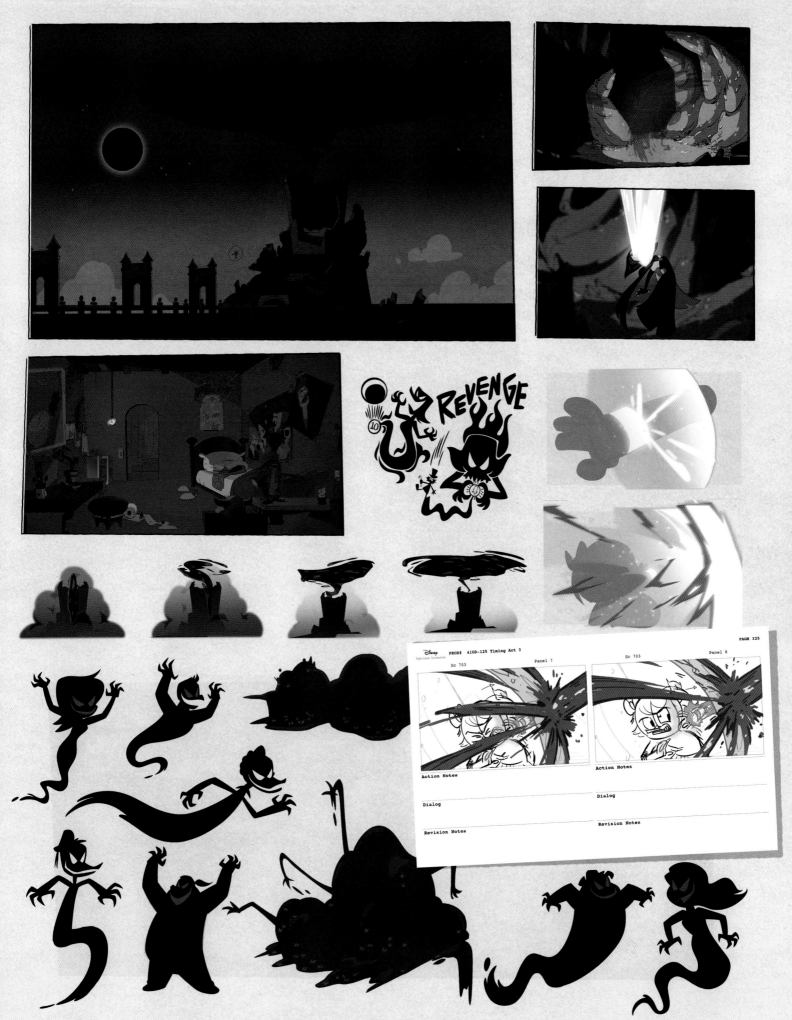

SEAN JIMENEZ: Our character designers had to figure out the shadow creatures. You'd think that silhouettes would be easier to do, because they have no interior lines, but it's still a lot of work to figure all that out.

SEASON 2
"THE MOST DANGEROUS GAME . . . NiGHT!"
EPISODE 1

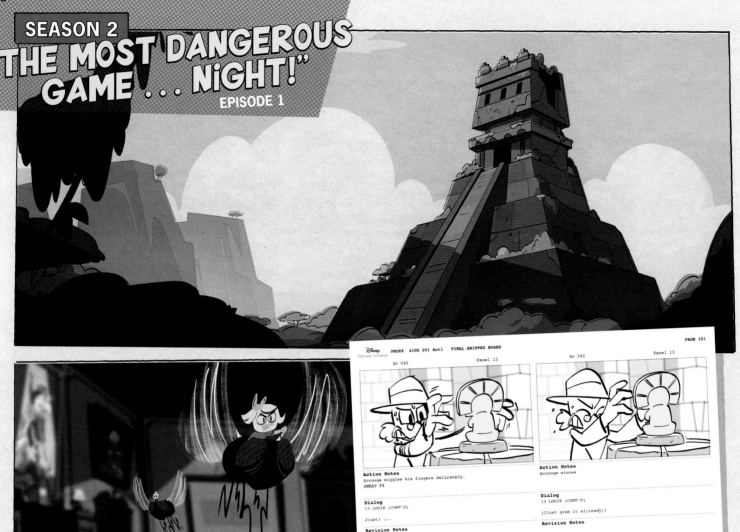

MATT YOUNGBERG: One of the challenges of coming off such a big finale like we had at the end of season one is "Well, where do we go now?" It felt pretty natural to go into what the new status quo is in the family, now that a big adventure has been wrapped up and all the secrets have been revealed. Along with that new status quo, we knew that Louie (and his growth and story) was going to be the focus of season two. So trying to merge those two ideas was the main thrust of this episode.

FRANK ANGONES: The family spent the whole of season one getting to this place of being full-fledged adventurers and a family, so we thought it'd be really interesting to start season two by showing them in this new status quo.

MATT YOUNGBERG: It gave Louie a chance to have some time to be thoughtful and think about his place in this family. It felt like a really great way to table set for the rest of the season. Looking at the trajectory of the second season, you have Della coming back, and then "Moonvasion!," which was our biggest action set piece ever. So it all starts small in their house as a family, building to this big giant thing by the end of the season.

Coming off of the big season one finale, you'd think maybe we should go on a big giant adventure, to show how this adventure family is doing. But lowering the stakes to just a game night and having that be at home—to me, that's more interesting, to see how this family is interacting now.

SEAN JIMENEZ: Doing a smaller episode was a really great gift to us, because that season one finale was super grindy. This was a real easy episode to put together, with the exception of the trickiness of the optical effects we did to make it feel like they were tiny.

TANNER JOHNSON: I storyboarded the cold open, and it was really awesome to be able to storyboard a very straightforward Indiana Jones–style sequence.

SEAN JIMENEZ: The idol is a hybrid of a Carl Barks idol and the one from *Raiders of the Lost Ark*. I originally did a version of it for the original promotional marketing campaign for the series, but there was never a place for it in the show until this opportunity came along.

SEAN JIMENEZ: We needed to figure out the shrinking effect and how to make it feel both aesthetic and plausible. I had the idea to blur the backgrounds, which we don't usually blur.

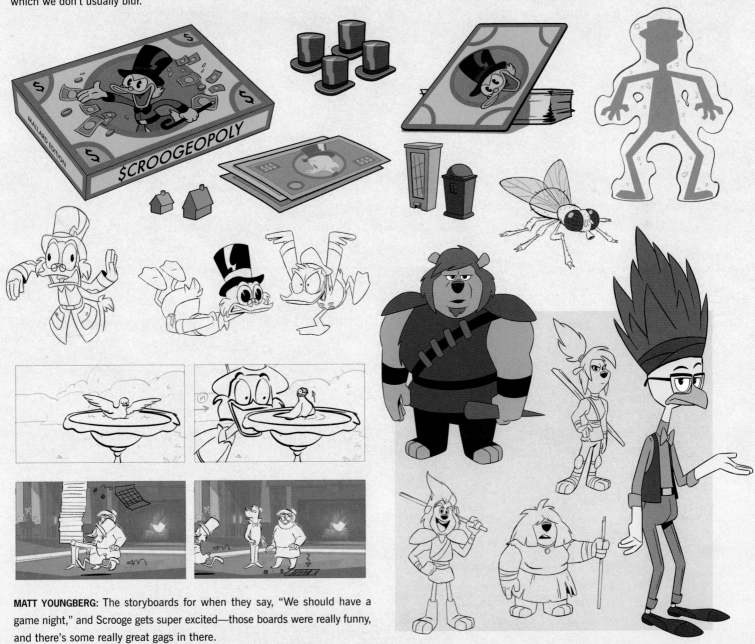

MATT YOUNGBERG: The storyboards for when they say, "We should have a game night," and Scrooge gets super excited—those boards were really funny, and there's some really great gags in there.

"THE DEPTHS OF COUSIN FETHRY!"
EPISODE 2

FRANK ANGONES: There are characters that are huge parts of the European Disney duck comics and have achieved great popularity there, and one of the characters they love is Cousin Fethry. In "House of the Lucky Gander," we played Louie off of Gladstone as what Louie would become if left unchecked. This was an opportunity to pair Huey off with Fethry and have him be what Huey's worried that he looks like to the outside world, which is this obsessive, weird Junior Woodchuck. Fethry's got a very strange, peculiar interest, but he's ultimately a good guy.

MATT YOUNGBERG: I think Fethry is great, and this episode turned out really strong.

FRANK ANGONES: We loved the idea of doing something with deep-sea thermal vents.

MATT YOUNGBERG: We did so much new design for this episode. Sean did this really cool design of the aquavator, and figuring out the logistics of how it worked really helped in the writing.

SEAN JIMENEZ: This was one of the hardest episodes to make, because you're dealing with water, and effects, and the thermal vents are blowing. It was very complicated, and we wanted to get it right, so it became really difficult to produce. But I got to do a lot of really cool art direction on it, and it ended up turning out really awesome.

MATT YOUNGBERG: For the aquavator, we looked at a lot of Jacques Cousteau and older styles of submersibles and sea labs and things like that.

SEAN JIMENEZ: The aquavator is like a strange hybrid version of a Jacques Cousteau submarine and an elevator pod. In my opinion, we're the most imaginative when we're smashing things together. Narrative is driving research, and it's all synthesizing inside of us.

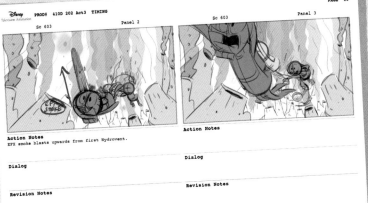

SEAN JIMENEZ: We also had to deal with how to make it feel like we're underwater. So there's no real sign of water until somebody moves, disturbing the water. The water disturbances in this episode are really well done. The scenes where they're swimming, every time they kick their legs, bubbles are trailing, with beautiful follow-through animation.

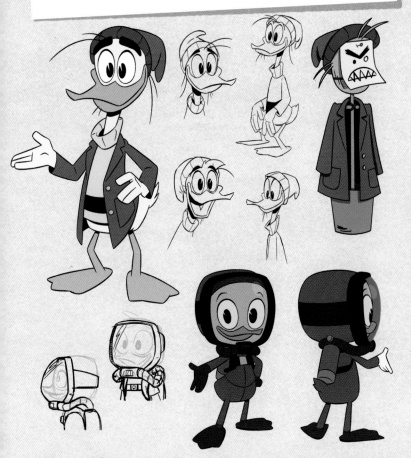

MATT YOUNGBERG: The breathing apparatus was another challenge, when you have ducks with beaks. It was like, "Oh, I guess we have to give them a face shield that can fit their beaks inside," because it's such a unique problem to have. We also had to figure out, "Are they wearing full wetsuits? Are they wearing half wetsuits, like their regular clothes?" They already had flippers, so we didn't need to add longer flippers.

MATT YOUNGBERG: Designing the giant krill was really hard. It's one of those things where you have to play with certain elements of it to get the scale right. If the eyes are too big, the krill feels too small. But if you make the eyes too small, it doesn't feel like a krill. So the process was to find the correct composition to make it feel like a giant krill but also be manageable in animation.

"THE BALLAD OF DUKE BALONEY!"

EPISODE 3

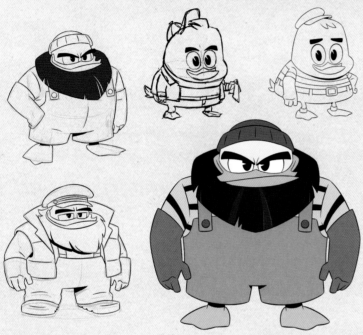

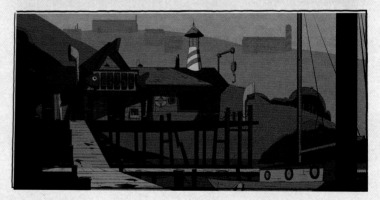

MATT YOUNGBERG: In season one, it's a balancing act and you're still figuring things out, but you're growing more confident in your characters and your stories. In season two, you start really flexing, because the characters are established now, and we get to have fun with them. And this episode is a perfect example of having fun with the characters we've established, like Flintheart Glomgold. We knew from the beginning that we wanted him to be South African, like he was in the original comics, and that as a kid in South Africa, Scrooge kind of screws him over. This was our opportunity to round out Duke Baloney as a character and explain why he acts the way he does.

FRANK ANGONES: Glomgold was one of our favorite villains to write, and we knew we wanted him to be a major villain in season two. But we also knew that we had this whole other thing, and it would be fun to take him on this journey and make him a little weird and a little sympathetic.

In the original *DuckTales*, and pretty much any other appearance of Glomgold, he's just a meaner Scrooge in a different costume. He's that archetype of the villain that's a copy of the hero, but evil. In our conception, Glomgold showed up and saw Scrooge was successful, so he did everything he could to model himself on Scrooge. Glomgold takes an idea, makes it his own, but bigger, faster, and cheaper. So he took the idea of Scrooge McDuck and quite literally made himself the bigger, faster, and cheaper version.

MATT YOUNGBERG: Glomgold was really fun to redesign, because we pushed his chest out to get more of a barrel chest instead of being an egg. Now, he's just this block of muscle. I love his bushy real beard.

MATT YOUNGBERG: Hookbill Harbor was a whole new area of Duckburg, and we really pushed the design of it to be much more foggy, and the color palette was very different. We wanted it to feel like a big harbor and a place where things could happen but ultimately focus in on one little area, which was around Chums and the ships. These kinds of maps became super helpful in the show to be able to say, "This is where this is happening."

SEAN JIMENEZ: My take on it was to make it feel briny and dilapidated from the sea.

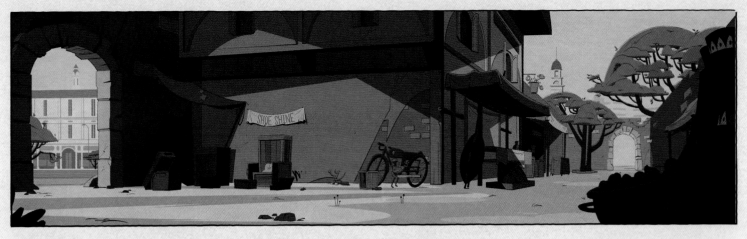

MATT YOUNGBERG: We kept the design for South Africa in the flashback simple by putting it in this shopping alley, so that we didn't have to see a whole ton of the city. Glomgold's in this little alcove.

FRANK ANGONES: The dream sequence in this episode is one of the most perfect things we've ever done. The genius conception that Sean came up with was not to make it a dream sequence the way you would see it in a cartoon—make it a dream sequence that you would have seen in a film from 1950.

SEAN JIMENEZ: It was so fun to stylize it, to go black and white and lean into the early surrealistic film quality of it. We obviously wanted to make it absolutely feel like a parody of an arthouse movie, and it was so cool that everyone understood the tone and vibe of it.

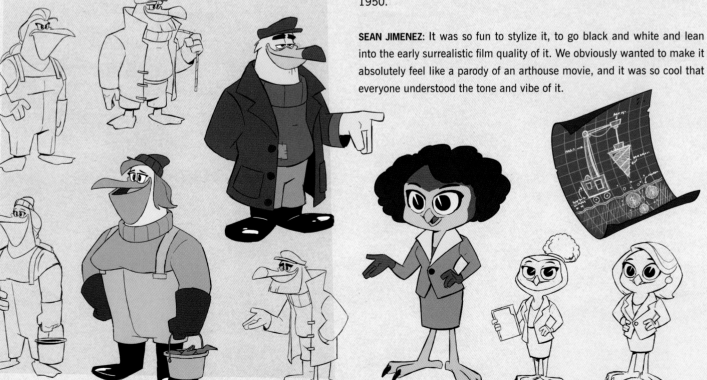

"THE TOWN WHERE EVERYONE WAS NICE!"
EPISODE 4

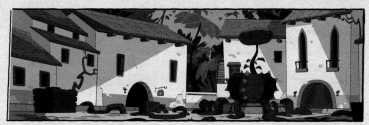

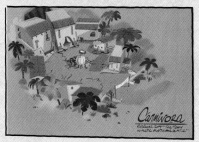

SEAN JIMENEZ: The action is within a single location with multiple camera points of view, so you have all the characters working within that area, in the town square. We built it like a movie set, so we knew all of the positioning of the buildings in advance of the storyboards. We wanted it to feel organic, so I offset the buildings so that they were a little catawampus to each other, giving us interesting angles.

FRANK ANGONES: The general idea of this episode was Donald's impostor syndrome and that we knew we wanted to incorporate the Three Caballeros as part of Donald's past. Donald has a lot of nostalgia for his past, and that he thinks he was so cool is really funny. This episode also established that he was some kind of musician, which helped set up the reveal of his childhood grunge phase in the Christmas episode. I like any time we can tell a story where people talk about how cool Donald used to be, which we did with Storkules, and do again here.

SEAN JIMENEZ: Visually, the most important thing about this episode was the color. This was our homage to *Saludos Amigos*, *The Three Caballeros*, and the artist Mary Blair. The color in this episode is really cool. This is very personal, because my wife, Brigette Barrager, did the color script for this. She's a children's book illustrator, and she had illustrated a book about Mary Blair. Brigette is considered a person who understands Mary Blair and her use of color. So when this episode came down the pike, I wanted to bring her on to help design it. Brigette specifically wanted to hark back to *Saludos Amigos*, because there's some trippy sequences in there that aren't in *The Three Caballeros*.

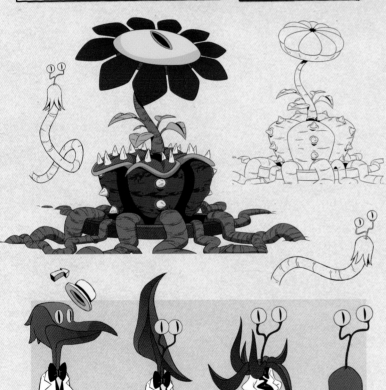

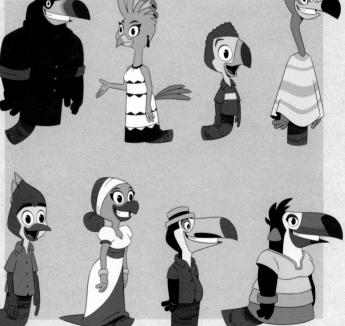

MATT YOUNGBERG: It was very difficult to stage this episode in a way that you don't reveal that the villagers are plant monsters. We figured out a really gross transformation for the people into the flowers, with the eyeballs and stuff. They're the flowers of this plant.

SEAN JIMENEZ: There's a little bit of cartoon magic, to get the townspeople to peel open to reveal that the eyes were also seeds of the plant.

"STORKULES iN DUCKBERG!"

EPISODE 5

MATT YOUNGBERG: Continuing our arc for the season, Louie is feeling confident that he knows his place, so he's going to start trying to make his way in the world and create something of his own. He has the right business brain but doesn't have the best ideas, and his selfishness can get in the way.

FRANK ANGONES: We knew that Louie Inc. was a big part of Louie's arc. The fundamental thing about Louie is that he wants to be very rich, but he doesn't realize that being rich takes a lot of work. So he's going to try to be sharper than the sharpies: his way to business success. Then it's that issue of when you create a problem that only you can solve, but if you do too good a job of solving that problem, you put yourself out of business. We were trying to map this onto something, so we used *Ghostbusters* as a template, which is why we have a big montage in the middle of all of the crazy success going on. "Hey, there are Harpies loose, and we're the only people who can take care of them!" And then we had the Storkules B story, which we could justify by having him be the reason the Harpies are in Duckburg.

MATT YOUNGBERG: As usual, we were trying to balance a season (especially when we know we're going to the moon) to give a mix of big globetrotting adventures and these smaller Duckburg stories. It's much more of a character exploration with Louie than it is a big adventure, but being *DuckTales*, the adventure has to come in at the end.

MATT YOUNGBERG: The one challenge with the Harpies was how to approach them visually, as representations of them usually have human characteristics. Just giving the Harpies beaks made them birds, so it was making sure that we blended the human and the bird to make it this really weird thing that still reads as a Harpy. Carl Barks did Harpies that were much more humanoid, and they had big noses. We gave them beaks that fit that shape but put our spin on it.

MATT YOUNGBERG: The cover of *Harpies Bazaar* is one of Frank's favorite visual gags in the series.

FRANK ANGONES: The cover of *Harpies Bazaar* is the only thing that matters in this book. It is, hands down, my absolute favorite visual gag we have ever done. The cover copy "Niche Publication Vindicated!" is a joke that implies an entire backstory.

MATT YOUNGBERG: The boat being pulled by the flying Harpies was a logistical nightmare to figure out.

MATT YOUNGBERG: The urns were one of those things where our artists figured something out, and it worked so well that we obviously had to use that idea again.

"LAST CHRISTMAS!"
EPISODE 6

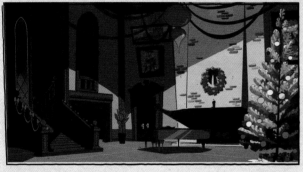

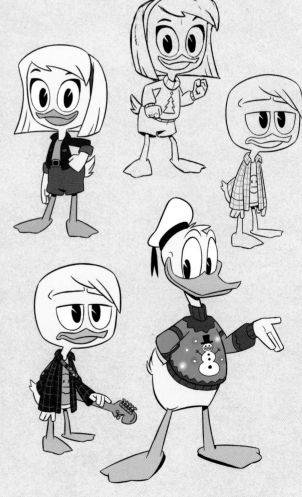

FRANK ANGONES: This was an episode that was originally slated to be in the first season and was going to be part of the Della mystery, where in his investigation Dewey would go back in time to try to find answers, but he went back too far and met Della as a kid. But it was decided that it didn't make sense to do a Christmas special so early in the series—which ultimately ended up being a blessing, because I think it works much better as an introduction to Della, right before you actually meet her in the present day. Having had a season that built up the mystery of Della but then to meet her as a kid first, I thought, was a really interesting way to approach it.

MATT YOUNGBERG: This was an opportunity to set her up a little bit more. At her core, she's this very daring duck who's a driven, capable, and enthusiastic adventurer.

FRANK ANGONES: We liked this riff on *A Christmas Carol* with Scrooge going the other way than you would expect. So he had met these three ghosts, who went to the wrong guy named Scrooge first. Rather than having to spend time with family, Scrooge built up this mythos around him not liking Christmas as an excuse, so he could take a night off and go party.

MATT YOUNGBERG: Scrooge doesn't hate Christmas. He hates Santa Claus, but he doesn't hate the actual holiday. Christmas is his time to get together with his ghost buddies and drink and have fun, and they go through time and go to different Christmas parties.

FRANK ANGONES: The Dewey story gave us a chance to remind the audience of the stakes of Della for her kids, because we knew that the next episode wasn't going to have any of the kids in it, so it was important for us to get a family perspective on her before we introduced her properly into the show.

FRANK ANGONES: As part of the shifting timeline, Donald would have been Dewey's age in the nineties. And we know that at some point, he started a band, so he would have had some kind of musical interest. And it made all the sense in the world for Donald Duck, if he grew up in the nineties, to be very into grunge, and be very emo.

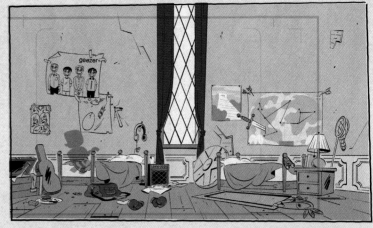

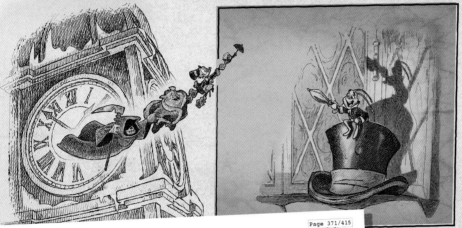

SEAN JIMENEZ: Getting Mike Peraza to do the end credits art was such a cool idea. He's done a lot for us over the three seasons, but these pieces were probably the biggest and most meaningful contribution. To a large extent, Mike defined the art style of the original *DuckTales*. Mike's style has been an influence to so many people, including me. And because he also did the title illustrations for *Mickey's Christmas Carol*, having him do an homage to those for us was mind blowing to me.

SUZANNA OLSON: He did a great job of merging our show's style and the new designs with the classic *Mickey's Christmas Carol* cards that he designed. That's the original parchment that he used in *Mickey's Christmas Carol*. He still had it, so we digitally scanned it.

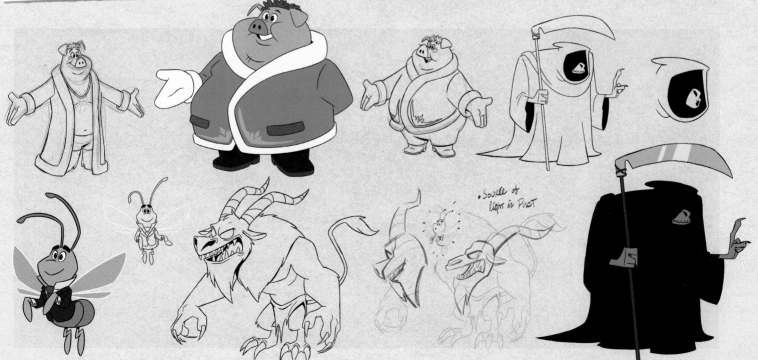

"WHAT EVER HAPPENED TO DELLA DUCK?!"
EPISODE 7

● = living area
● = cockpit

FRANK ANGONES: We had been building to this episode since the pilot. We knew that we had to do an episode just to catch up with Della. When we first pitched the idea of Della being this mystery, and then that Della would come back, we knew that we couldn't have it where suddenly she's there and everything's fine. We had to vividly portray what a character would actually go through in this process. We knew that, once she was introduced in season two, Della would become a new main character in the cast—but she would not have the benefit of having had a full season's worth of character development. And she had also been built up as this impossible, legendary thing. So we knew that we really wanted to do an entire episode just focused on her. The idea of her attempting to send these videos home was a way of giving just pure, unfiltered Della.

MATT YOUNGBERG: This episode was a beast, but we knew it was going to be a beast. There was so much challenging stuff to figure out from the writing side alone, but then all of the stuff that we had to do visually in order to make that work was an incredible challenge. If you have one character that you're following the whole episode on a very barren-looking wasteland, there's a danger you're going to run into having it feel samey, and just repeating actions. But to everyone's credit, everybody did an amazing job of pulling it together into this really cinematic episode.

SUZANNA OLSON: The series, and Matt and Frank, always tried to be inclusive and representative. So, as we always do when we try to be inclusive and representative, we worked with Disney and we partnered with consultants, particularly the Amputee Coalition. The Amputee Coalition reviewed character designs and Della's animation cycles for when she's walking and running—both on the moon and on Earth. The walking and running cycles were done by Kat Kosmala. We had to be specific about tracking which side was her prosthetic leg. We did all of that research to try to make it as authentic as possible.

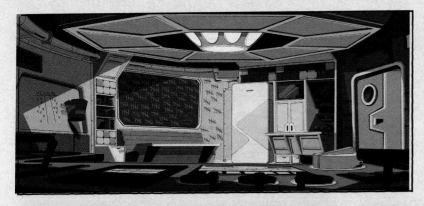

SEAN JIMENEZ: As I was developing the shape language, most of this episode was going to be the moon rocks. I was doing these sort of swoopy lines to help indicate movement and have a calligraphic feeling that's the essence of French comics, which is part of my influence. But as I was doing those, I was thinking about the episode and the Moonlanders' use of gold, and I thought that maybe the swoopy lines are colored in a way that indicates that they're veins of gold, inherently part of any moon-rock work. And if the Moonlanders are going to build a city, they would quarry this moon rock to build it, and they'd polish the stone in order to get the veins to show through.

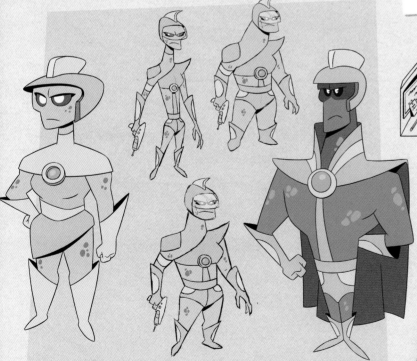

MATT YOUNGBERG: Figuring out the look of the Moonlanders was a challenge. In a world of ducks and pigs and dogs, the weirdest-looking thing would be something more humanoid. And so we kind of leaned more towards something that was a little bit more human looking, but taking away the nose to make sure they still felt alien.

"FRIENDSHIP HATES MAGIC!"

EPISODE 8

MATT YOUNGBERG: After the events of the first season, the big question was "What happened to Lena?" We always knew we wanted to bring her back, free of Magica, as a full, sentient being of her own. With Huey, Dewey, and Louie, we had three great male leads, but we wanted to also have three great female leads. And so this was our opportunity to do that by bringing Lena back and introducing Violet Sabrewing.

FRANK ANGONES: This episode was very much about bringing Lena back and continuing her arc of coming to terms with the fact that she is made of dark magic. If the first season was about her trying to be bad enough to be a bad guy, this is her trying to prove that she could be good enough to be a good guy, even with all the bad stuff in her.

MATT YOUNGBERG: It also reinforces the theme of our show, which is that family are the people that you choose to have in your life. Webby coming out of this with two new best friends that are like sisters was pretty great. And we touch on it briefly later, but, needing a place to live, Lena ends up going and living with Violet and her two dads, and so she and Violet develop a sisterly bond.

MATT YOUNGBERG: We were always trying to find a diverse variety of looks for the show. Visually, we landed on the idea that she was a hummingbird, and that's where her last name came from—sabrewing is a type of hummingbird. And hummingbirds are very distinct. They definitely don't look like ducks. And the beaks are much harder, especially if you have to have a character talking, but it turned out great.

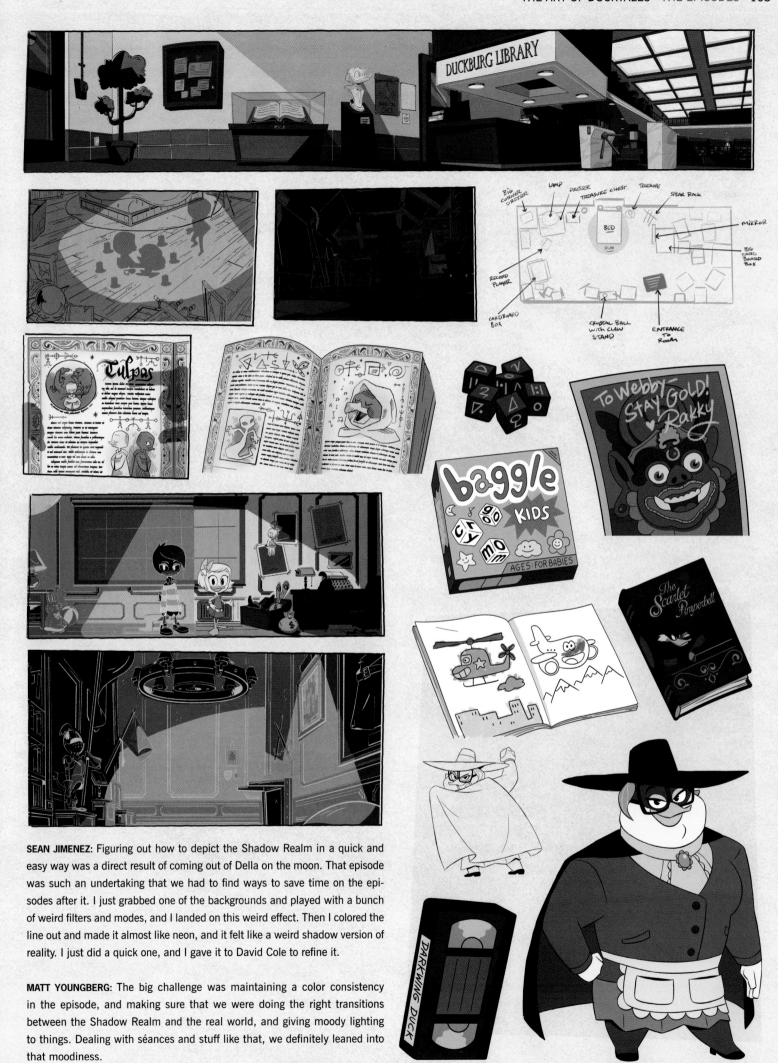

SEAN JIMENEZ: Figuring out how to depict the Shadow Realm in a quick and easy way was a direct result of coming out of Della on the moon. That episode was such an undertaking that we had to find ways to save time on the episodes after it. I just grabbed one of the backgrounds and played with a bunch of weird filters and modes, and I landed on this weird effect. Then I colored the line out and made it almost like neon, and it felt like a weird shadow version of reality. I just did a quick one, and I gave it to David Cole to refine it.

MATT YOUNGBERG: The big challenge was maintaining a color consistency in the episode, and making sure that we were doing the right transitions between the Shadow Realm and the real world, and giving moody lighting to things. Dealing with séances and stuff like that, we definitely leaned into that moodiness.

104

"TREASURE OF THE FOUND LAMP!"
EPISODE 9

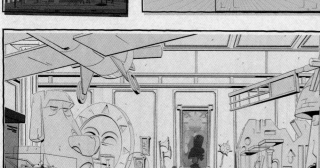
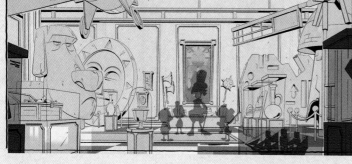
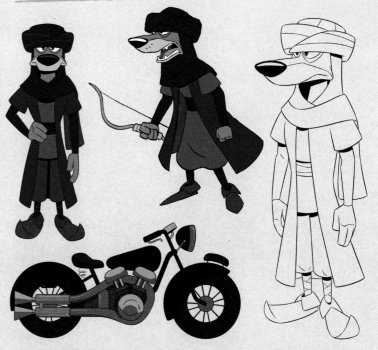

FRANK ANGONES: We were always toying with the idea of a different treasure hunter who comes to take a treasure that Scrooge had already found, and doing an adventure on the adventure.

MATT YOUNGBERG: You have to do a magic-lamp episode of *DuckTales*. It feels like that's a requirement. It's a classic treasure-hunting story. But we wanted to flip things a little bit, and we didn't want it to be about finding the genie and then making three wishes. You already know how that story is going to play out. If you have a genie show up and the wishes end up going wrong, then you have to fix it. But in this episode, it's the hunt for the lamp, but at the end, the magic of the lamp is not the genie—the magic is the story of the adventure that they went on. It's about the power and the importance of story and what it means to people.

FRANK ANGONES: By the end of this episode, you start to track the through line that ends in the finale, of Scrooge valuing stories and adventure over treasure. I always like to say that season one of a show is world building and season two is world exploring, so we had a lot of options to go back and deepen characters and reuse characters.

MATT YOUNGBERG: We wanted to take the character of D'jinn, who in *DuckTales the Movie* was Dijon and was portrayed as a thief and a coward, and instead make him a well-rounded, heroic character. He's the driver of our story. He's not a villain—he's just this driven, focused character who doesn't seem to have a lot of humor in him, which made him very fun and funny to play off of our characters. And then to have the whole thing at the end be the reveal that the lamp wasn't magic but instead represented something very important to him personally, and that was why he was looking for it—I thought that brought a whole new level of depth and interest to the character.

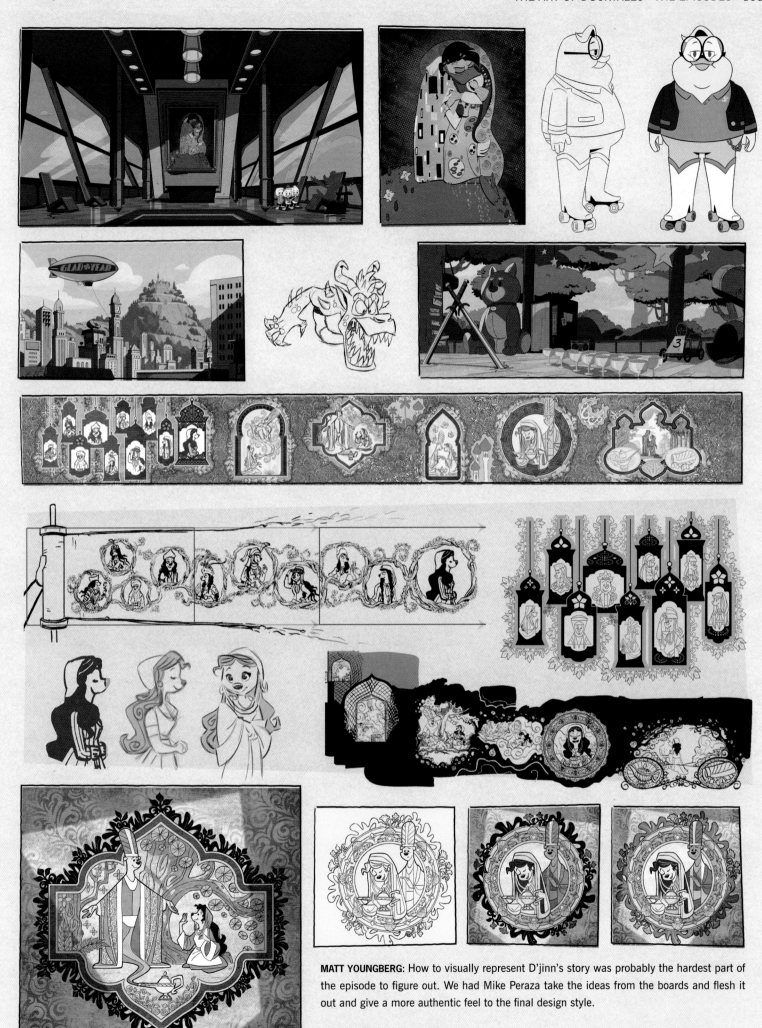

MATT YOUNGBERG: How to visually represent D'jinn's story was probably the hardest part of the episode to figure out. We had Mike Peraza take the ideas from the boards and flesh it out and give a more authentic feel to the final design style.

SEAN JIMENEZ: He wanted it to feel like Eyvind Earle—which was great, because I'm a huge fan of that style.

"THE OUTLAW SCROOGE McDUCK!"

EPISODE 10

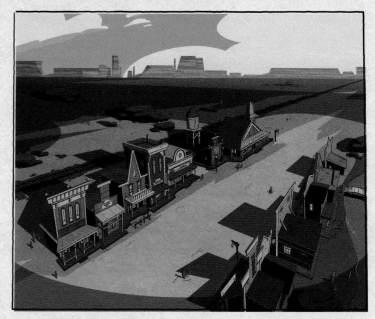

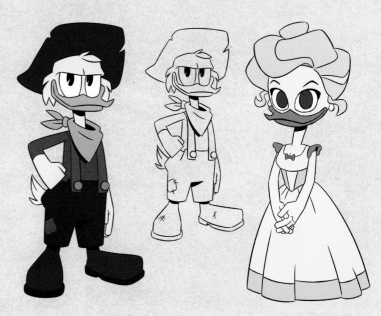

FRANK ANGONES: We knew we wanted to do an Old West train heist flashback episode.

TANNER JOHNSON: A lot of our show was about subverting a lot of traditional adventures. I love the subversions, but it was also nice to just do a pretty straightforward adventure, like a train robbery involving a giant nugget of gold. Now, we did kind of subvert it by having the framing device of it be a story that Scrooge is telling Louie and having Louie's commentary bleeding into it.

FRANK ANGONES: It's writer catnip to be able to say, "Hey, we're doing an Old West episode, and we need Scrooge's gang that he uses to rob this train." So you get Goldie, obviously. We also hadn't used Gizmoduck yet this season, so we brought in Marshall Cabrera, who was a sheriff. In the comics, Scrooge does meet Ratchet Gearloose in the past, who is Gyro's ancestor. But rather than have just a bunch of ancestors on the team, we said, "What if it's just Gyro?" There's an establishing shot where, in the background on a roof, you can see Gyro getting back into his time tub and going back into the future.

A lot of Louie's arc for this season was based on the idea of having him recognize that he can't con his way to ultimate success, and having him realize that it took Scrooge, through hard work and gumption, over a century to achieve what Louie would like to achieve very quickly.

SEAN JIMENEZ: We emulated old western movies and TV shows, right down to designing the town to feel like back-lot sets, including flats on the fronts of the buildings. Part of the fun of *DuckTales* is to emulate genres. But in order for the comedy to come through, you have to lean into the iconic trope of it, so the design has the grounding in which the joke can come through.

SEAN JIMENEZ: Designing the desert buttes for this episode was my opportunity to emulate one of my heroes, Maurice Noble.

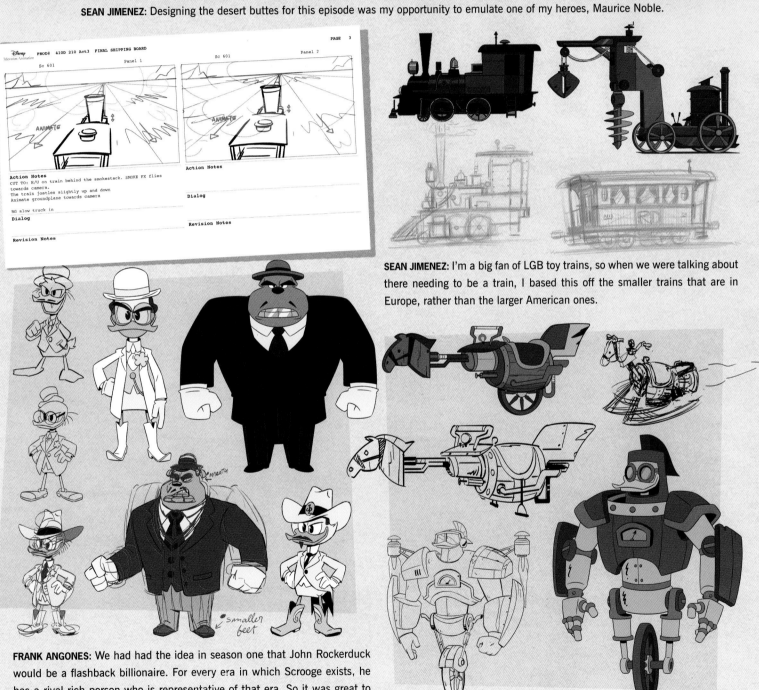

SEAN JIMENEZ: I'm a big fan of LGB toy trains, so when we were talking about there needing to be a train, I based this off the smaller trains that are in Europe, rather than the larger American ones.

FRANK ANGONES: We had had the idea in season one that John Rockerduck would be a flashback billionaire. For every era in which Scrooge exists, he has a rival rich person who is representative of that era. So it was great to have this kind of lily-white robber baron.

MATT YOUNGBERG: Designwise, we had the original Rockerduck that we wanted to reference, because that's always how we approach things first, and then we put our own spin on it. There's nothing more impractical than a white suit in the Old West, but he's all about showing his wealth and showing off how fancy he is.

MATT YOUNGBERG: The hardest thing in this episode, visually, was the rocket bikes and turning the rocket bikes into Gizmoduck. There were some pretty difficult logistical issues to deal with there. We were toying with the idea of giving them just a rocket, but we put wagon wheels on them because we needed Gizmoduck to have his unicycle wheel. At one point, we were feeling that the bikes looked too cool, so we had to jank it up a notch.

"THE 87 CENT SOLUTION!"

EPISODE 11

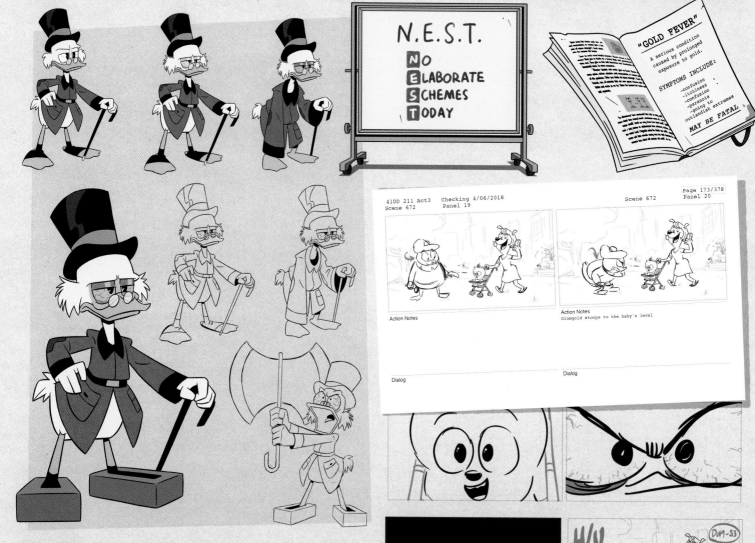

MATT YOUNGBERG: One of the more classic kind of things to do with Scrooge is give him an obsession with gold, so this episode came closer to the classic Scrooge than some other stories we might do. His obsession with his money got out of control. The logistics of this episode were very hard. It was very intricate to figure out how all of the puzzle pieces fit together, and to do it in a way where everything happens in normal time, and then you flash back to see how it all kicked off and keeps happening. We had to make sure that all the stuff we did to the present matches up just right with all the stuff that Glomgold was doing.

FRANK ANGONES: I really like that, in the end, it all came down, emotionally, to Scrooge recognizing that maybe he needs to trust his family.

MATT YOUNGBERG: A great example of Glomgold's insanity and pettiness is the scene where he's first trapped in time and doesn't realize it, and he spends a year in a staring contest with a baby. It's close in on his face, and then he gets all crusty eyed, but then when it transitions out of that close-up, there's a pile of food and trash next to them that wasn't there before. So he'd take breaks, get food, come back, and continue. He was obsessed about winning, but he would still take a time-out so he could go eat.

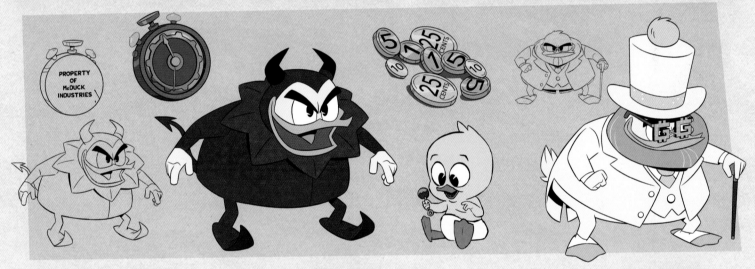

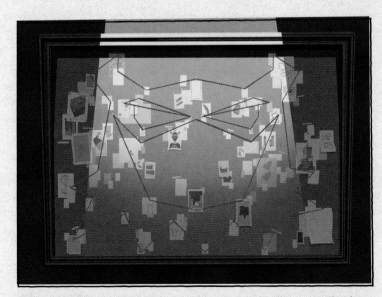

SEAN JIMENEZ: The threads in the board are connecting the events that have been happening to Scrooge, but when you pull out, for a brief moment you see that the threads form a picture of Chester, who's been making Scrooge nuts. It's a cool bit of foreshadowing, because we hadn't yet been introduced to that guy—who's just Glomgold dressed up in a jester outfit—in the episode yet.

MATT YOUNGBERG: I think that the series as a whole will be very memorable, but the scene that will live on for many years to come is Glomgold arriving at Scrooge's funeral and dancing to DJ Khaled's "All I Do Is Win." When he tries to get up and dance on top of Scrooge's coffin is where his malevolence and evil is so stark and yet shows he's incompetent. But he's also dangerous because of those things. He's pure evil, but in the funniest way possible. I love that scene so much.

"THE GOLDEN SPEAR!"

EPISODE 12

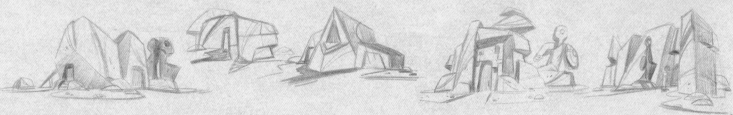

MATT YOUNGBERG: This was reestablishing Della's story and getting back to where she's at with everything. She's moving into the moon city, and we're establishing her relationship with Penumbra and really kind of kicking that off. Then getting her off the moon is what we needed to do to get to the second half of the season. Getting Della back to Earth was the thrust of the season. We had to set up the threat for the season with Lunaris.

FRANK ANGONES: We always tried to have a big bad for the season match part of Scrooge's motto that we were focused on for the season, so in this season, Lunaris is "sharper than the sharpies." Lunaris had been figuring out the angles of this invasion for thirty years, because his father lived in fear, and he didn't want to live in that fear.

MATT YOUNGBERG: This episode sets the table for not just the next episode but the rest of the season. It's setting up the level of malevolence that Lunaris has, that he is this calculating monster underneath his dignified façade, and that he's truly going to be an intellectual match for our heroes.

MATT YOUNGBERG: The city on the moon was a design challenge, because it's got this crescent shape. If you have certain angles of the city, you see the city going up behind them—while with other angles, you wouldn't see that. It was logistically tough to figure out designs that are specific and unique to the moon. They don't have classic geometry and terrestrial imagery. So we built everything out of gold and carved rock. Sean and his design team did an amazing job. I think it's really unique and very cool.

SEAN JIMENEZ: We had to make the neighborhood an extension of the Moonlanders' architecture and technology. I was looking at weird seventies shelter homes, which were these organic houses made out of raw materials from the earth. I thought that these houses would have the same kind of form language, so that it didn't just look like a neighborhood in California or something. That was a really fun exercise, because I was playing with abstract shapes. I was also influenced by a sculptor named Henry Moore, who created these really cool statues that looked like they were otherworldly.

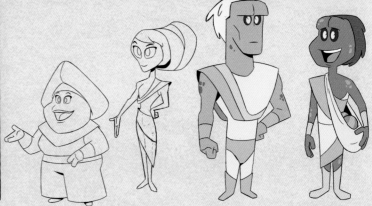

FRANK ANGONES: A lot of people on our crew fell in love with the Moonlanders. The basis for the Moonlanders stuff was very much 1930s pulp stories.

MATT YOUNGBERG: We had a lot of fun designing them, and we had certain ones that we became very fond of, like Gibbous, Palus, and Zenith.

MATT YOUNGBERG: The zombie scene was very fun. Zombies are fun when you use them, because you get to be gruesome and comical at the same time.

SEAN JIMENEZ: We really leaned into the schlocky B movie horror design. We couldn't have blood, so I decided to make the sky blood red and have the lighting be red.

"NOTHING CAN STOP DELLA DUCK!"
EPISODE 13

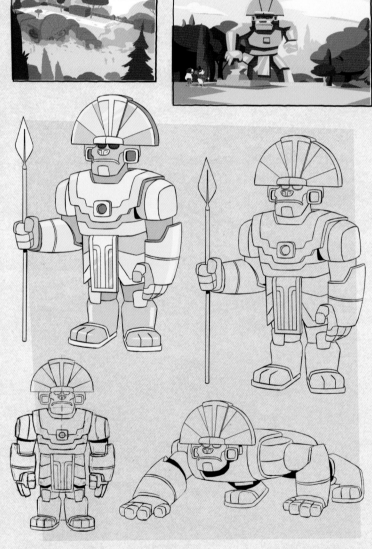

MATT YOUNGBERG: This was the big event. In the arc of the season, Della needed to come back early, because you needed her to be a part of the family so that it could build to the finale, which is the family versus Lunaris. This is our opportunity to bring her in and make her special, to make her a part of this family, and to deliver on the promise of what we wanted to do with the show.

FRANK ANGONES: It was an exciting challenge to make this story work—about a mother, who everyone thought was gone forever, coming back. And then, because it's *DuckTales*, we wanted to attack it from a family perspective. What does her return really mean, emotionally? Della is like, "I'm gonna make up for all the lost time! I am so sorry I did this. I was a fool. I messed up. And now I'm going to make up for ten years of missing mom in twenty-four hours."

It was another opportunity to kick the tires on our characterizations of Huey, Dewey, and Louie, to see exactly how each one would react to her return. Huey would have nothing but questions but still accept it. Dewey is just like, "Yep, everything I thought about my mom was amazing, and it turned out to be true. She's hilarious, and she throws catch phrases, and we're gonna be best friends forever." But I don't think we knew going in how much this season was going to tie Della and Louie together. His first reaction when he sees Della is "This is a trick. What is the con?" And we end this episode having Louie come to a place where he's going to try and accept her, but it's not resolved at all, as we see down the line.

MATT YOUNGBERG: This whole episode is about realizing that there aren't shortcuts. And there were no shortcuts to bringing Della back.

SEAN JIMENEZ: When we were talking about the design of the Gilded Man, it was very blue sky. Matt and I both grew up in and are nerds of the eighties, and as we were sitting there trying to figure out what would make the Gilded Man interesting, my mind hit on an old toy line, which were rocks that transformed into robots. And that's how we cheated that you hadn't seen the Gilded Man in Scrooge's wing of secrets in the pilot—because when transformed, it just looked like a crate and was hiding in plain sight. And then you would get a really cool sequence when it's activated and transforms.

SEAN JIMENEZ: In this story break, the idea came up of Della showing how cool and athletic she is, and someone mentioned skateboarding. I got really excited. I was like, "Yeah, let's do a skating thing, but I'm going to handle it right." I grew up as a skater, and one of my biggest pet peeves in animation is that most of the people who depict skating don't know anything about it. They'll animate it like it's weightless, ignoring the physics of the trick. I did a rough board pass on the sequence. And then we got an animator friend of mine named Eric Fountain, who's also a skater, to animate it.

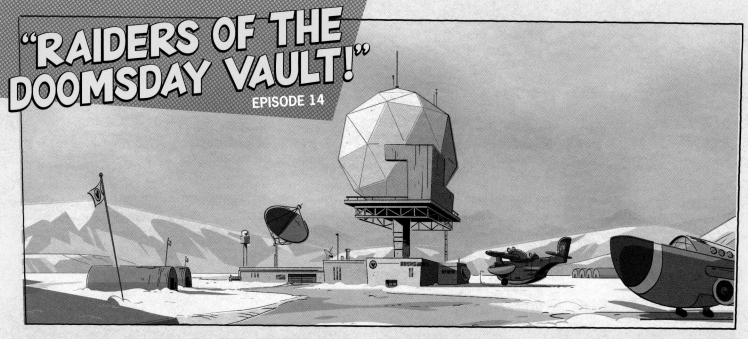

"RAIDERS OF THE DOOMSDAY VAULT!"
EPISODE 14

MATT YOUNGBERG: This was one where, I admit, when it was first brought up—before the episode was pitched or anything—just the idea of a seed vault was like, "How are we going to make this fun and exciting?" I couldn't figure it out. This was one where I relied heavily on the writers to come up with the thing that would get me excited. And they did a great job, because it was not one I anticipated having as much fun with as we did.

FRANK ANGONES: This is the fulfillment of the promise of Dewey's story from season one. This is the reality of Dewey adventuring with his mom versus the fantasy of what he always wished and realizing that there was a lot of pressure to be had there. It was an important bonding episode, and it was always really important for us to try to do one-on-one bonding stories with Della once she was integrated into the cast, so we can explore the texture of these different relationships.

The seed vault is based on an actual vault that contains all the world's seeds, in case of an apocalypse, and making this episode work was about finding the *DuckTales* spin on it, which was that the seed vault also has a tree that grows money—which is a very Barksian idea.

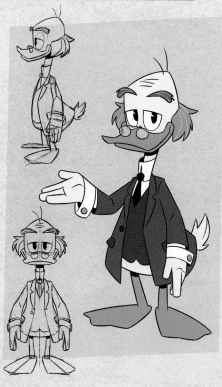

MATT YOUNGBERG: This was an important episode, even though it's wrapped in something that seems to be unimportant. A doomsday vault full of seeds and an adventure to go see it doesn't seem very exciting, but thematically, what was important was Della is now going out on adventures with the family, and this is Dewey's adventure with his mom. It was important to us to make sure that each of the boys had an adventure that tied them to their mom, so that they each got individual attention in the season.

FRANK ANGONES: It allowed for a lot of resolution that we hadn't covered in the previous episode. It's Della and Dewey feeding each other's worst instincts and building each other up to the point where Dewey's not sure if he can live up to it—and not sure if he wants to. There are definitely those times, as a parent, where you're wondering, "Am I being supportive of the right things?" So having Della come around and say, "You don't have to prove yourself to me. I love you, no matter what," was an important thing. It was an important piece of validation that Dewey, of all characters, needed to hear at this point in the series.

MATT YOUNGBERG: And the B story proved once again that you can put Glomgold anywhere, and he'd be great.

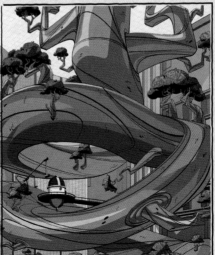
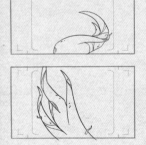

SEAN JIMENEZ: Some of my favorite sketchbook drawings I did were figuring out the seed arm design. The logistics of this were not figured out in the script, outside of there being a thing that sorts out the seeds, and then they fall from a certain height. But then I hit on the idea that it could also be the elevator that gets you to the catwalk. It was a really juicy logistics assignment, and then giving it a cool stylized quality that felt plausible.

SEAN JIMENEZ: We knew that this enormous money tree was going to grow out of the seeds, and I remembered visiting, in Mammoth Lakes, an ancient bristlecone pine forest. So we took the look of those as our jumping-off point.

"THE DANGEROUS CHEMISTRY OF GANDRA DEE!"
EPISODE 15

MATT YOUNGBERG: Now we're really seeing Fenton getting comfortable as Gizmoduck, but it's overwhelming his personal life. It was fun to play with the superhero side of things, like with the weather villain at the beginning and Mega Beaks at the end. As with most Gizmoduck episodes, we brought Huey in. He's to Gizmoduck what Dewey is to Darkwing Duck. Huey and Fenton have a really great chemistry together.

FRANK ANGONES: In his first appearance, we had established Fenton as a guy who just had so many ideas and wanted to do so much that it made sense that he would have a Gizmoduck suit that could do a million things. And his second appearance was him trying to figure out which of these things he was going to do. Is he a hero? A robot? A scientist? And it turns out he's all those things. And so this episode was the natural follow-up to that, where we were saying, "Yeah, but having to be all those things to all those people is exhausting, and he can't handle that all the time." He had to find something personal for himself. And we followed that through line all the way to his resolution in the finale, of Darkwing saying to him, "You don't have to do everything by yourself. You have friends to help." And that being the kind of thing that Fenton can live with.

MATT YOUNGBERG: Since we discovered that Mark Beaks was a natural foil for Gizmoduck, this was going back to him trying to steal something from Gizmoduck and make it his, so that he can be as cool and awesome as Gizmoduck. This time, it goes wrong in the form of nanobots that make him the Hulk, basically.

FRANK ANGONES: If you were getting a Gizmoduck episode, you could always rely on Beaks to do something weird and messed up, and so we got Mega Beaks.

MATT YOUNGBERG: It's just a fun superhero episode. It's the right balance of action and comedy.

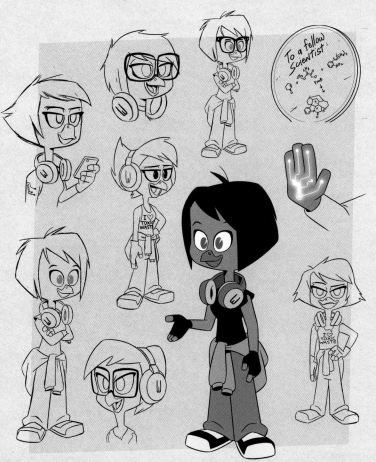

FRANK ANGONES: We knew we wanted to bring in Gandra Dee from the original series, but we wanted to find something more for her and have her be an interesting counterpart for our version of Fenton—so having her be a punk rock scientist, as opposed to a very positive, optimistic scientist. Gandra Dee is all about punk rock garage science.

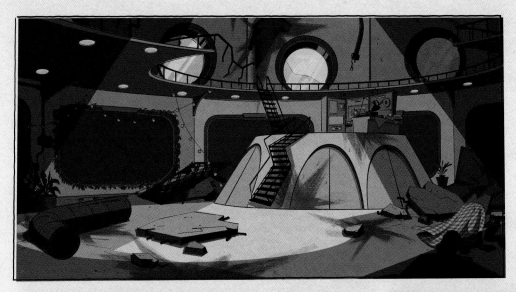

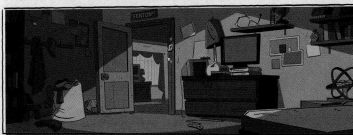

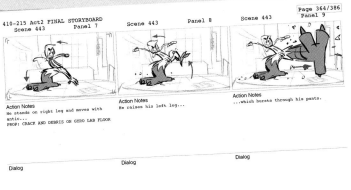

SEAN JIMENEZ: This is the first episode that you see Fenton's room. I indulged myself by including a lot of references to the movie *Real Genius*.

410-215 Act2 FINAL STORYBOARD
Scene 443 Panel 7 Scene 443 Panel 8 Scene 443 Page 364/386 Panel 9

Action Notes
He stands on right leg and moves with antic...
PROP: CRACK AND DEBRIS ON GYRO LAB FLOOR

Action Notes
He raises his left leg...

Action Notes
...which bursts through his pants.

Dialog Dialog Dialog

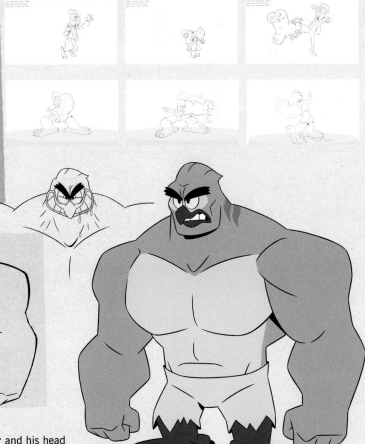

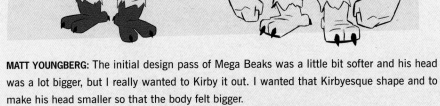

MATT YOUNGBERG: The initial design pass of Mega Beaks was a little bit softer and his head was a lot bigger, but I really wanted to Kirby it out. I wanted that Kirbyesque shape and to make his head smaller so that the body felt bigger.

"THE DUCK KNIGHT RETURNS!"
EPISODE 16

FRANK ANGONES: This episode could have been impossibly daunting, on a personal level, for me. Darkwing Duck was my superhero. I dressed up as Darkwing Duck several times as a kid. I had all the toys. I was just an impossibly massive fan. This episode was my love letter to how much I loved that show and what that show meant to me.

MATT YOUNGBERG: For me, the daunting thing with this episode was making sure that Frank was happy with it. Like, I joke, but I'm also serious, because for this to succeed, Frank needed to feel that it was right. I don't know a bigger fan of *Darkwing Duck* than Frank. It's the same thing we would say about *DuckTales*, too: that there are going to be people who don't agree with our direction on it—that's just a given—but if you do it with the right love and heart behind it, then people are going to respond to it, and there will be fans of what you're doing. It was a big swing to make Darkwing be an actor, because that wasn't what the original series was at all. But it fit so perfectly with the idea of who Darkwing is.

FRANK ANGONES: The original Darkwing was the superhero who carried headshots.

MATT YOUNGBERG: So it made sense, as we were developing the idea for this, that the current Darkwing Duck is a failed actor, because he has that drive to be recognized, and that ego. Even when he has a secret identity, he wants everyone to know who he is at all times. I thought that that fit really well. But Drake has this heart, as well, that it's not just about ego for him. It's also about the love of who this superhero, Darkwing Duck, represents to him. The saving grace of our version of Drake was having Jim Starling, by comparison, be even more shallow.

FRANK ANGONES: Matt summed up perfectly what Darkwing has to be with "You love to see him get hurt, but you want to see him win." And in all these conversations about codifying his tone, we realized he's Jackie Chan. He is the guy who is constantly overwhelmed, but he is always fighting back while trying to look confident. It's the aspirational version of Darkwing that I always loved. Anyone can do the right thing when it's easy. It's what you do when things are hard that makes you a hero. And that is Darkwing.

MATT YOUNGBERG: As we were trying to balance all of the pieces to make the story work, we also had to do the same with the action scenes. It was a real challenge, because if you make it too actiony, then it's what we're trying to make fun of, with the Alistair Boorswan character. It becomes too serious and gritty. But if you go too cartoony, then it breaks the rules of the show. But that's what we were trying to do with Darkwing: find that balance. Why can he get cartoony hurt more than other people? And it's his tenacious attitude and his drive to persevere, no matter what.

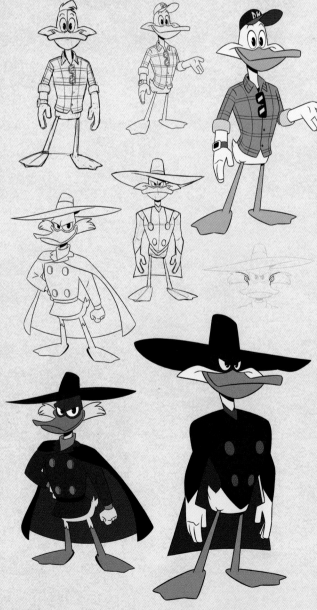

FRANK ANGONES: Tapan Gandhi did a fantastic job reinterpreting the Darkwing design for a modern audience.

PAGE 310

Disney
Television Animation

PROD# 410D-216-Act3 FINAL

Sc 716 Panel 1 Sc 716 Panel 2

Action Notes
CUT TO Wide on Set

The rain puts out the fire

RAIN FX
FIRE FX
Letterbox Overlay

Dialog

Revision Notes

Action Notes

Dialog

Revision Notes

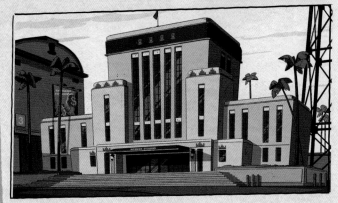

SEAN JIMENEZ: There are elements of the McDuck Studios design that are straight-up MGM Studios in Hollywood's golden age and the Disney sound stages.

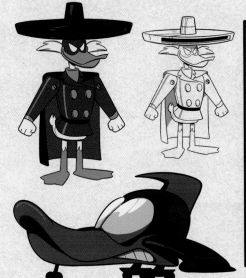

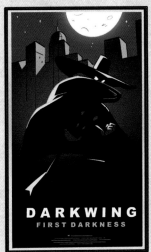

DARKWING
FIRST DARKNESS

SEAN JIMENEZ: For the color of the *Darkwing* film, we leaned into the syrupy purples of the Prince music video for the original *Batman* that aren't actually in the Tim Burton movie.

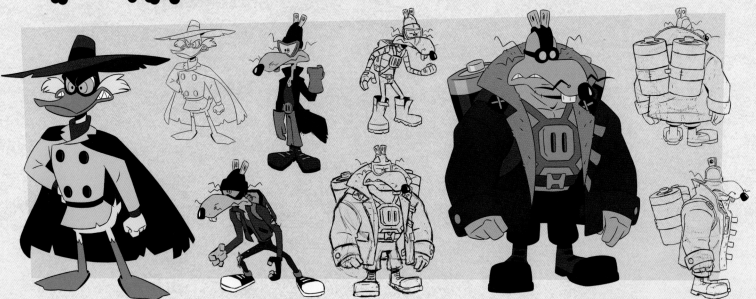

"HAPPY BIRTHDAY, DOOFUS DRAKE!"
EPISODE 17

FRANK ANGONES: We knew that we wanted to do a Goldie and Louie episode, where Louie learned what it was actually like to be a con man and why that wasn't a thing he actually wants to be. He's not built to do the hard work that Scrooge does, but he's also not built to be the kind of amoral con that Goldie is.

We always knew there were a couple of ways to get Matt onboard to approve something. This either could have been Zeus's birthday party or Doofus's birthday party, and ultimately Doofus's birthday party made more sense. Also, we just love doing Doofus stories.

MATT YOUNGBERG: With Doofus, there's no wrong answers when it's like, "How weird can we go?" You can go as weird as possible.

FRANK ANGONES: I was happy to have a "Della bonding with one of the kids" episode that wasn't fraught with trauma. It's just Della trying to figure out what Huey is. And Huey, by his nature, is not an angsty individual. Dewey is drama personified, and Louie carries potential-bad-guy angst, but Huey's whole thing is he's just the sweetest soft boy in the world.

MATT YOUNGBERG: Della and Huey are both nerds about things.

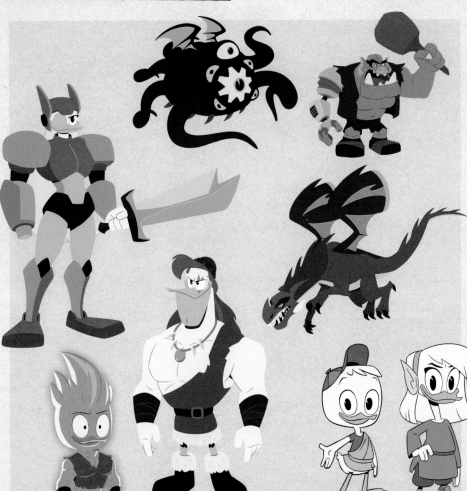

MATT YOUNGBERG: The art style of the video game world was really fun to play with, because coming off of a very big episode, we wanted to make sure it was a manageable thing. So we weren't going to do a CG world.

SEAN JIMENEZ: We wanted to emulate the look of a PC game. We dropped the line weight on the characters to make the designs more shape driven and dropped the lines completely on the backgrounds.

MATT YOUNGBERG: It was fun to play with the different-color lines, because when you went into this world, you wanted to make sure you felt like you were in a video game.

SEAN JIMENEZ: That whole sequence where BOYD is becoming purely a threat robot, with his eyes melting, was setting a little bit of what we were going to do for "Astro B.O.Y.D.!" It's an interesting way to show BOYD's humanity—through the color of his pupils, when they go from blue to red.

"WHAT EVER HAPPENED TO DONALD DUCK?!"
EPISODE 18

MATT YOUNGBERG: This is one of the big arc episodes for the season, but this is also our definitive statement on Donald Duck for the whole series. Our approach to Donald and who he was is built around the ideas that we present in this episode. We wanted it to be his big hero episode, knowing that there were a lot of other things to do in the season. Donald has had hero moments in the show, but he's always been the secondary part of those stories. This is all about Donald Duck, the hero. We also explore why he is the way he is. He cares so much that it overwhelms him a little bit, and that's where his strong emotions come from.

FRANK ANGONES: We said when we started the show that we wanted our version of *DuckTales* to do for Donald what *A Goofy Movie* did for Goofy, which is take all of the traits that you know about him and make him a relatable three-dimensional character. And this was the episode where I felt like, yeah, we can say pretty firmly that this is our statement on that. There's something great about a character who is famously angry, whose most famous trait is he flies off the handle, and him realizing he has to be there for his kids and go to therapy. It was another opportunity to tell a story that you don't necessarily see in kids' cartoons, of him trying to channel his negative feelings into something positive. Whenever you see Donald get mad, from here on out, I'll always think he's mad because he thinks life is unfair, and he feels bad that the people he loves have to deal with that, and that's why he's flying off the handle.

MATT YOUNGBERG: As we were progressing through the season, we needed to show even more of why Lunaris is a threat. So you're seeing that he is a master planner who's got everything figured out, but then at the end of the episode, we're also putting him up against our best fighter, which is Donald Duck. We'd established that when Donald goes into his berserker rages, he can beat anybody. But then when he goes up against Lunaris, and Lunaris can easily deflect him and take him out, we see that Lunaris is also a master fighter. It was elevating his threat a little bit more, so that when we get to the season finale, we feel like this villain is a hugely legitimate threat to our Duck family.

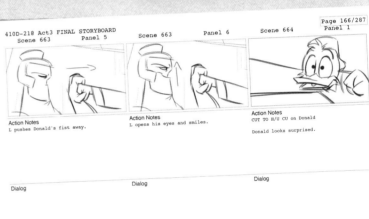

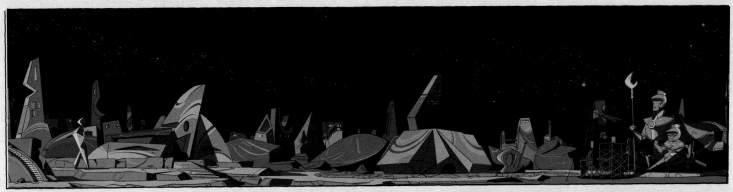

SEAN JIMENEZ: Jason Reicher and I are both fans of Stanley Kubrick's *2001*. It was not written in the script, but while he was storyboarding the sequence of Donald rocketing back to Earth in the capsule, he thought it would be fun to reference the star gate sequence in *2001*. There wasn't much time to do it, but whenever we had a tricky, weird compositing problem, I'd get David Cole on it. My only direction was that I wanted to emulate that sequence as closely as possible, but a slightly more cartoony version of it. And David Cole built out these long pans and composited the sequence.

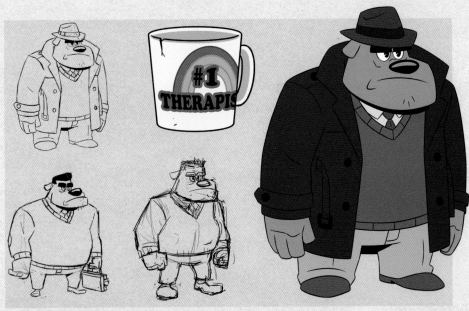

"A NIGHTMARE ON KILLMOTOR HILL!"
EPISODE 19

MATT YOUNGBERG: This was a big experimental episode for us, in a lot of fun ways.

FRANK ANGONES: Emmy Cicierega had done such a fantastic job as a story-board artist, and she had such a distinctive voice in all of her boards. She always added jokes. She had done writing for books and other shows before, and we wanted to give her the opportunity to do a story.

EMMY CICIEREGA: I was asked if I had any interest in writing, and I said, "Yes!" The writers approached me, like, "We know that you love visual comedy, and we know that you love doing the trippy stuff, so whatever this is, we want it to be chock full of that stuff."

FRANK ANGONES: When you have someone like Emmy, you want to give her free rein to do as many weird things as possible, so we came up with the idea to do a *Nightmare on Elm Street: Dream Warriors* thing. Very organically, it grew into a Lena and Magica story. We hadn't said where Magica had been. This seemed like a really interesting and appropriate way to bring back this figure that loomed so large in Lena's head, even after she had freed herself from the shadow dimension, and have her confront Magica and say, "You have no power over me anymore." And then you also had all of the fun of figuring out what everyone's dream lives would be.

EMMY CICIEREGA: I was really hyped for it to be a Lena episode, because then it could turn into a kind of horror story. I wanted it to be a fun, Halloweeny kind of episode. It's a slumber party, you get scary things happening, and reality is warping. Having no adults be around was really, really fun, because you get to spend more time with the kids.

SUZANNA OLSON: This episode has Emmy's DNA baked into it, and it has a tone and a style that fits within the *DuckTales* world, but it's very much her voice and perspective, which is what we wanted to do with our codirectors and our cowriters.

EMMY CICIEREGA: I wanted there to be at least one scene that made me laugh, because that's always my goal for anything. If I can make myself laugh while I'm boarding, then I'm happy. And I wanted it to have as much weird stuff as possible.

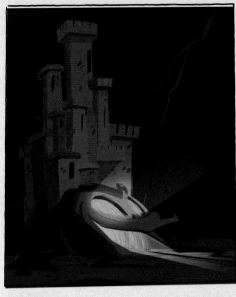

SEAN JIMENEZ: When we were in the dream world, since these were a series of different characters' dream states, I wanted to self-color the lines, so that each dream sequence was relatively monochromatic, assigned to the representative color of whoever's dream it was. You went from dream to dream to dream, and it's all keyed to that character's standard color.

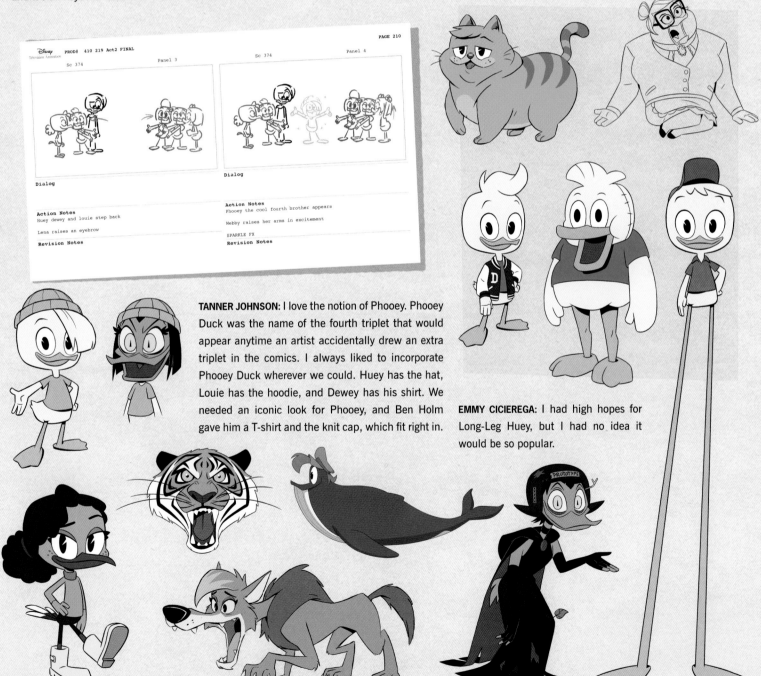

TANNER JOHNSON: I love the notion of Phooey. Phooey Duck was the name of the fourth triplet that would appear anytime an artist accidentally drew an extra triplet in the comics. I always liked to incorporate Phooey Duck wherever we could. Huey has the hat, Louie has the hoodie, and Dewey has his shirt. We needed an iconic look for Phooey, and Ben Holm gave him a T-shirt and the knit cap, which fit right in.

EMMY CICIEREGA: I had high hopes for Long-Leg Huey, but I had no idea it would be so popular.

"THE GOLDEN ARMORY OF CORNELIUS COOT!"
EPISODE 20

 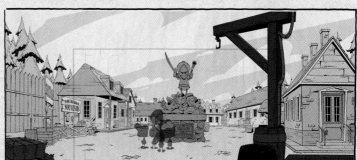

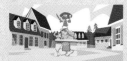

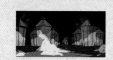 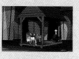

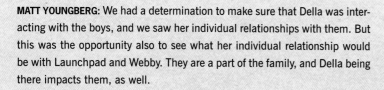

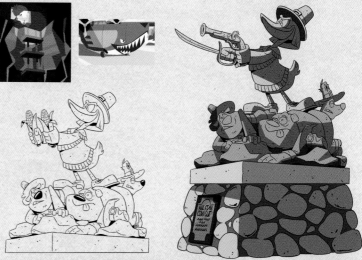

FRANK ANGONES: We wanted to do something with the classic story of Cornelius Coot and the golden corn for Duckburg. This episode is really about Della being back, and now Webby doesn't know where she belongs and feels that she can't live up to Della Duck. It was her finding Della's journal and feeling, "I was the young adventure girl, but Della outpaced me every step of the way, because I was locked in a mansion for ten years."

MATT YOUNGBERG: We had a determination to make sure that Della was interacting with the boys, and we saw her individual relationships with them. But this was the opportunity also to see what her individual relationship would be with Launchpad and Webby. They are a part of the family, and Della being there impacts them, as well.

FRANK ANGONES: And then we also have Launchpad's reaction to Della's return, and how adrift he feels now that there's a competent pilot around. It's just one of those things where you introduce Della, who's a pilot, and it's like, "Well, we already have a pilot. So what does that mean for our pilot? Let's do a story about that." It took a lot of legwork to figure out in what sense Launchpad is a better pilot than Della. Is crashing better than not crashing? I love it whenever Launchpad proves himself to be not just an idiot. He's like, "Oh, I'm holding together that thing with gum because it allows the skywriting thing to vent. I'm not a total idiot." Which sets him up in a place where Della has to admit his way, though it is dangerous and she doesn't care for it, is the right way.

FRANK ANGONES: A statue of Cornelius Coot used to be in Mickey's Toontown, in Walt Disney World, and the engraving on the statue that the kids read is a variation on what the actual text was in the park.

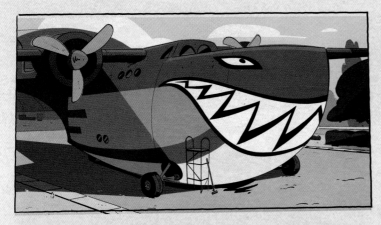

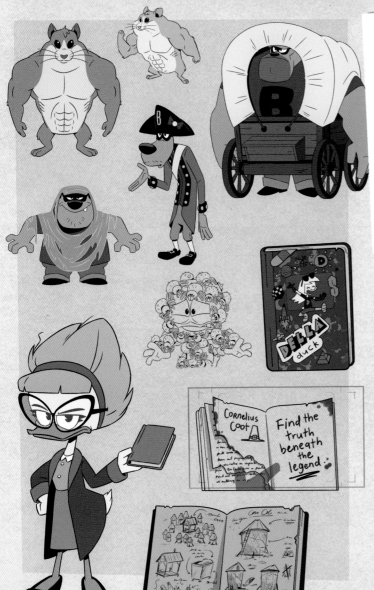

Page 147/271
Panel 6

410D 220 ACT3 FINAL SHIPPING BOARD
Scene 682 Panel 5 Scene 682

Action Notes
The front left Corn Crib's cap blows off
and a stream of Popcorn fires into the
air.

Action Notes

Dialog

Dialog

ADD CRATES
& FARM TOOLS
LAYING
AROUND!

SEAN JIMENEZ: Christian Magalhaes and Bob Snow wrote out a big finale with all of this corn popping, but the script was vague on the logistics of how that worked and how it all tied back to Cornelius Coot. None of that was worked out. It was all abstract. So I went to the WDI library, and I looked up farm equipment related to corn. Poring through a stack of books, I came upon this tiny corn silo called a corncrib. A corncrib is a silo for storing corn that comes to a peak, and there's a hole at the top. So it was perfect for what we needed for the big popping finale in the episode, because I figured you could put them up on a platform, light a fire in that space underneath, and the resulting popcorn would burst out the top. And then it made sense that it would be something Cornelius Coot could have deduced as a means to create the sound of gunfire to scare off the Beagle Boys. And it passed the Matt test, because it felt plausible. Cartoon magic is your last resort.



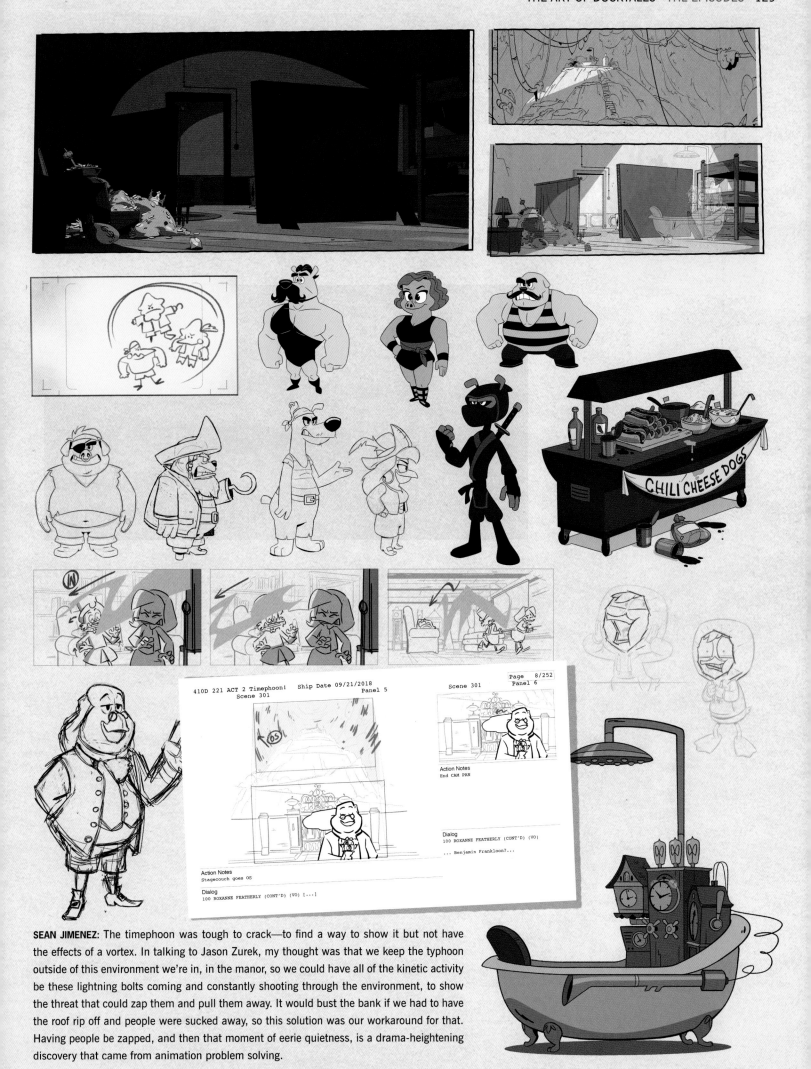

410D 221 ACT 2 Timephoon! Ship Date 09/21/2018
Scene 301 Panel 5

Action Notes
Stagecouch goes OS

Dialog
100 ROXANNE FEATHERLY (CONT'D) (VO) [...]

Scene 301 Page 8/252
Panel 6

Action Notes
End CAM PAN

Dialog
100 ROXANNE FEATHERLY (CONT'D) (VO)

... Benjamin Frankloon?...

CHILI CHEESE DOGS

SEAN JIMENEZ: The timephoon was tough to crack—to find a way to show it but not have the effects of a vortex. In talking to Jason Zurek, my thought was that we keep the typhoon outside of this environment we're in, in the manor, so we could have all of the kinetic activity be these lightning bolts coming and constantly shooting through the environment, to show the threat that could zap them and pull them away. It would bust the bank if we had to have the roof rip off and people were sucked away, so this solution was our workaround for that. Having people be zapped, and then that moment of eerie quietness, is a drama-heightening discovery that came from animation problem solving.

"GLOMTALES!"
EPISODE 22

FRANK ANGONES: There wasn't a lot of opportunity for the classic villains to team up in the first season. It was something that we had talked about doing as an extended back half of this season, of Glomgold trying to recruit each of these members, but it just felt like there was too much story going on. It was a thing that used to happen in the latter half of the original *DuckTales* series, where you would get Glomgold and Magica teaming up, or Glomgold hiring the Beagle Boys. And so we thought it would be fun to smash all of our giant-ego villains together in a delightful mélange. We talked about all of the villains being dark reflections of some aspect of Scrooge and his family, and so we were like, "All right, let's take that dark aspect of Scrooge and his family and actually make them the dark mirror of Scrooge's family." Here are the good guys, and here are their opposite number, and line them up. And it was the "Will Louie turn evil?" story. We had jokingly established Louie in the pilot as being the "evil triplet," and so this was trying to pay off on the promise of that.

MATT YOUNGBERG: And that's all the backdrop of one of the wackiest, craziest episodes. But it's what we do on *DuckTales*. We're balancing. The Louie story line needed to have the right kind of depth and feeling to it, because it was balanced against this cavalcade of comedy characters, and even Louie himself is a funny character. So the message needed to be very clear.

FRANK ANGONES: Neither Louie nor Della is in the right. Della is just trying to figure out how to be a mom. There was a lot of hemming and hawing about the exact wording of the message that Della was sending to Louie that set him off. We knew it had to reiterate his fear of being on the outside, from "Most Dangerous Game . . . Night." I think we did a pretty good job of threading that needle, because you had to believe it was enough to get Louie to turn evil and join Glomgold's gang, but you also had to believe that it was something that could spur Louie to want to use his abilities to prove to his family that he was capable of being a part of the family. He used his scheming skills to be a part of the family. This is the proof of Louie's ultimate skill: he defeated all of Scrooge McDuck's greatest villains with a pen stroke, which is the true mark of him being sharper than the sharpies.

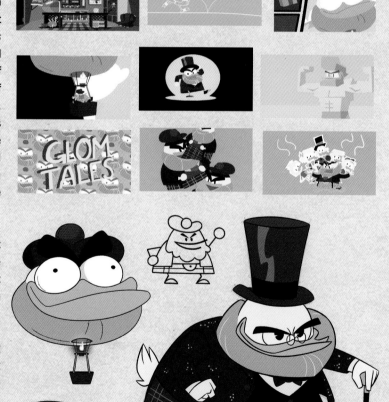

MATT YOUNGBERG: The Shorts department were doing these "Theme Song Takeovers," and we were like, "Well, what we want to do is have Glomgold actually take over the theme song for the episode, so let's work together on it."

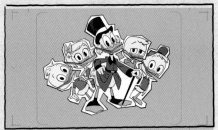

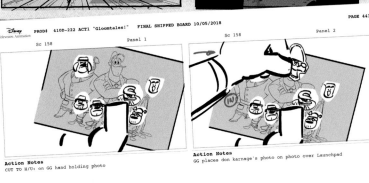

Disney
Televison Animation

PROD# 410D-222 ACT1 "Gloomtales!" FINAL SHIPPED BOARD 10/05/2018

PAGE 443

Sc 158 Panel 1 Sc 158 Panel 2

Action Notes
CUT TO H/U: on GG hand holding photo

Action Notes
GG places don karnage's photo on photo over Launchpad

Dialog
105 GLOMGOLD (CONT'D)

"Now w(e're)..."

Dialog
105 GLOMGOLD (CONT'D)

"...(w)e're ready."

"THE RICHEST DUCK IN THE WORLD!"

EPISODE 23

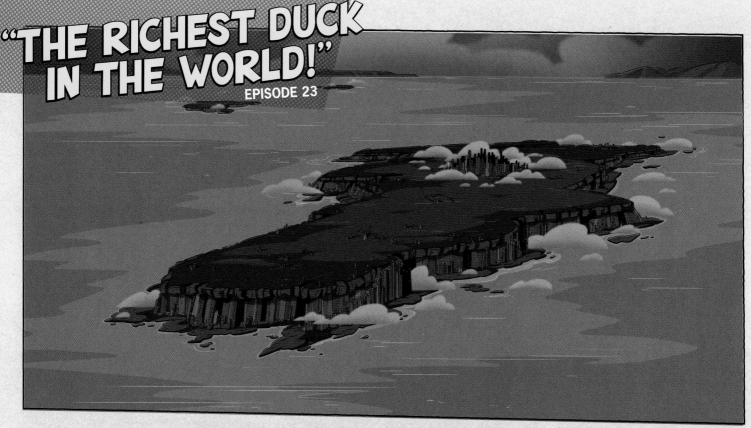

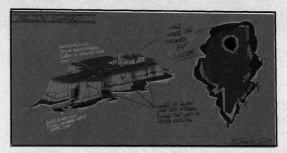

B

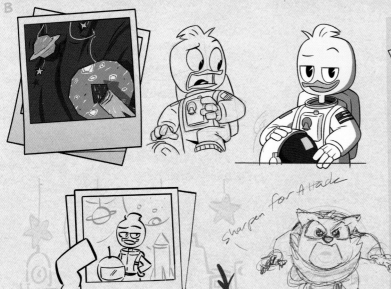

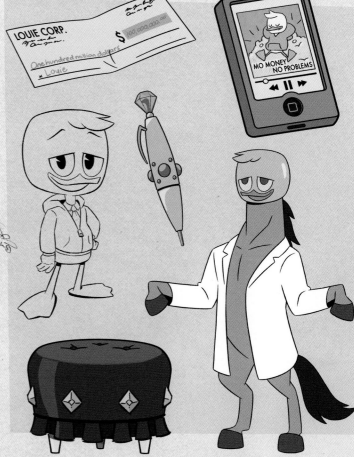

FRANK ANGONES: It seemed like the most obvious thing in the world to do a "Louie becomes the richest duck in the world and everything is great and he loves it" story. And the most *DuckTales* thing in the world would be to undercut that by having him realize, "Oh, this is a ton of hard work. This is not actually what I want at all." Because we had the big finale coming up, this needed to be the big personal payoff to the Louie Inc. story. I really liked the fact that Louie gains knowledge in this episode so that his arc isn't resolved in the finale; it's actually resolved here but provides him knowledge for the finale.

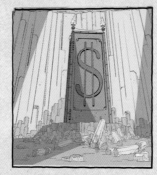

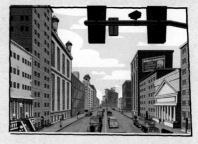

SEAN JIMENEZ: Bombie's island was based on another actual location in Scotland, called the Giant's Causeway. It's really strange, because it has these naturally hexagonal rocks. Matt Humphreys wanted to be able to go into a cavern, so we punched a hole in the top of the island and stuck Bombie's cell down on the bottom.

FRANK ANGONES: We wanted Bombie to be a mystical karmic force that will always hunt down the richest duck in the world. He's the literalization of the pressure, the responsibility, the danger, and the fear that comes along with being so greedy that you would want to be the richest duck in the world.

"MOONVASION! PART ONE"

EPISODE 24

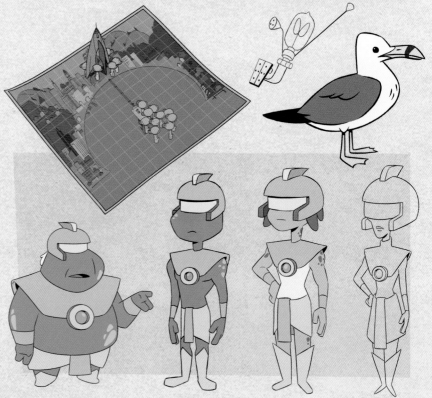

FRANK ANGONES: If you settle on your themes at the beginning of the season, and if you know where your stories are going for these characters at the beginning of the season, then—if you've done your job and laid the groundwork well enough—you find that all of those themes come to a head. Besides the scale of the episode, the real miracle of "Moonvasion!" is that all of the different arcs came to a head. If you look at season two from a Louie perspective, it's about schemes. I always used to refer to the theme of this season as "The Best-Laid Plans of Ducks and Moon Men Are Torn Asunder in the End." Della had this plan about how her life was going to go as the mom to Huey, Dewey, and Louie, and it got completely thrown off track. Louie had this plan to become the richest duck in the world, and it got completely thrown off track. Glomgold has nothing but schemes, and his plans are always foolhardy and insane and ridiculous.

It all comes back to that Scrooge theme of being sharper than the sharpies, and that's how we built Lunaris—as this guy who had been crafting and finding every angle of this plan since he was a kid. You see in "What Ever Happened to Donald Duck?!" that he's been prepping this in the background for forever, and he's insanely overly prepared. And so you can see where the Lunaris story, the Louie story, the Della story, and the Glomgold story that we had been telling all the way through season two all tie together. There was so much joy in the writers' room when we decided that it was Glomgold's cockamamie scheme that would save the Earth. And within that ridiculous scheme, Glomgold manages to get his fortune and his company back and come off as the hero of Earth.

And finally, we got the reunion of Donald and Della Duck. We felt like we had enough real estate in this episode to do it right and to introduce onscreen, for the first time, Donald Duck to his twin sister, Della.

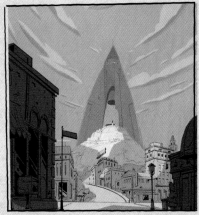

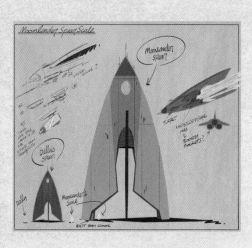

SEAN JIMENEZ: Once we had the *Spear of Selene* designed, we had the Moonlander ships, as well. The issue became how to handle the shift in scale from the regular *Spear* to the combat versions, the hologram version, and then to the monstrous planetary-engine version. Placing the hologram version on top of an existing image of Killmotor Hill, above the mansion, is what gave us the size and scale for the first of the massive ships. But then there was the planetary-engine mother ship out in the ocean, which is even bigger.

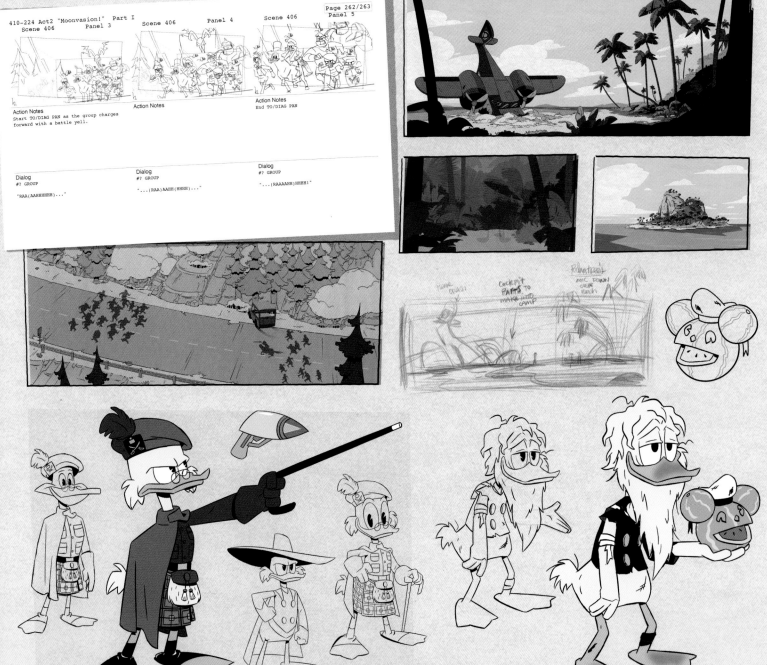

"MOONVASION! PART TWO"

EPISODE 25

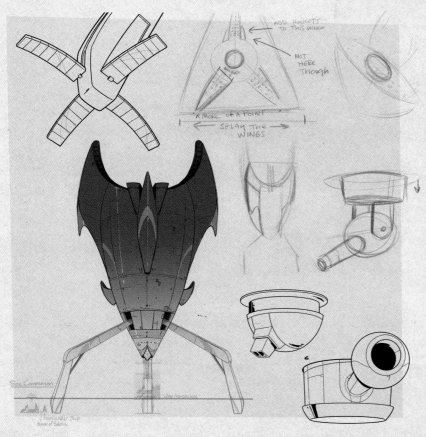

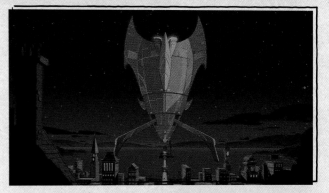

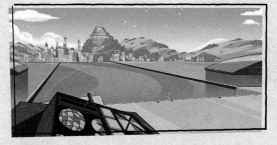

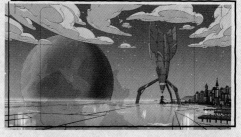

SEAN JIMENEZ: To achieve Lunaris's plan, his ship needed to be upside down, so the engines could push the Earth out of orbit. But that would mean that Lunaris's command bridge in the ship would also be upside down. Because this is *DuckTales*, we worked in a logistical solution which most people won't notice: that the bridge is actually designed to rotate.

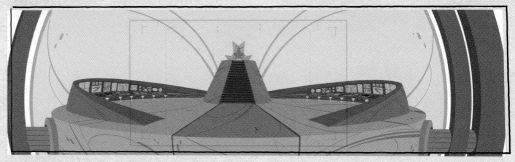

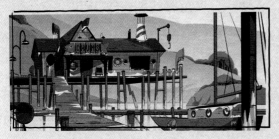

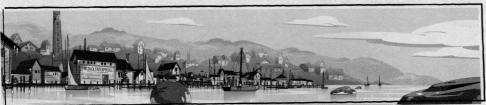

SEAN JIMENEZ: The choice of everything getting cold and being frozen came out of a functional issue with where the mother ship was going to be. It makes sense to put it out in the bay, because we didn't want the production difficulties of a big fight happening in the streets of Duckburg. But then how are you going to have a giant fight taking place out in the bay? On boats? But then if you freeze the bay, you have this big open space. And then Frank and the writers were able to tie it in to the story and Lunaris's plan of putting the Earth off its normal course, which causes everything to freeze over.

MATT YOUNGBERG: We approached this whole episode knowing that we wanted to do a really epic CG dogfight.

SUZANNA OLSON: I had experience working with Rough Draft on *Gravity Falls*, with the Shacktron, so when it came time to do a CG space battle, I reached out to them again.

TANNER JOHNSON: Rough Draft also did all of the spaceship stuff for *Futurama*. Getting to work with them was terrific, and I think the proof is in the pudding.

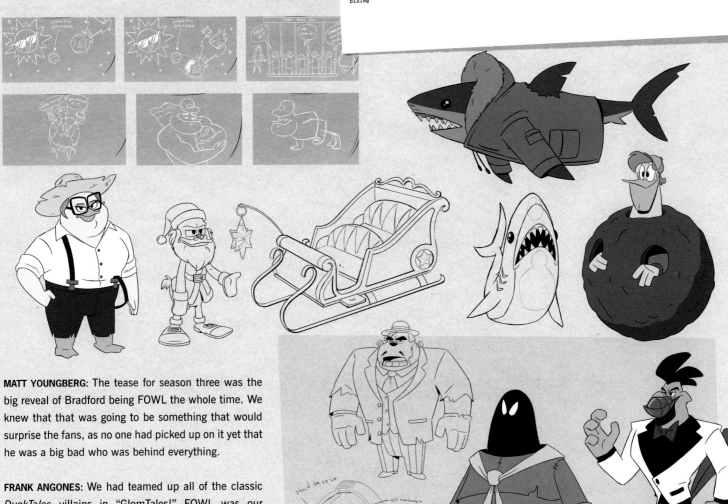

MATT YOUNGBERG: The tease for season three was the big reveal of Bradford being FOWL the whole time. We knew that that was going to be something that would surprise the fans, as no one had picked up on it yet that he was a big bad who was behind everything.

FRANK ANGONES: We had teamed up all of the classic *DuckTales* villains in "GlomTales!" FOWL was our opportunity to put together all of the villains that we had come up with that we really liked. We brought Rockerduck and Jeeves back, and Black Heron in, because we liked them so much. And then we added surprises, like Phantom Blot and Steelbeak.

"CHALLENGE OF THE SENIOR JUNIOR WOODCHUCKS!"
EPISODE 1

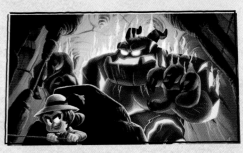

FRANK ANGONES: Because we knew this was the season of Huey, we talked a lot in the writers' room—and Madison Bateman led the charge—about the idea of Huey learning that it was okay to fail. In that realm of kids' show morals that you don't see often, but you feel are important for kids to learn, is that it's okay to not be the best at something. Having Huey come to accept that maybe he's not the best Junior Woodchuck was about knocking him off of his footing, which was a place that we were going to get him to by the end of the season. A lot of this season was about having Huey question things that he assumed to be true.

MATT YOUNGBERG: And then we had to pair the Huey story with the thrust of this season's big adventure, which was the hunt for the missing mysteries, which were these things that Isabella Finch had been looking for but hadn't discovered.

FRANK ANGONES: We knew that we were going to reveal that Isabella Finch was the source of Bradford's hatred of adventure, in the same way that she was also a person who inspired Scrooge to adventure. We like the idea of saying, "When Scrooge was a kid, who was his Scrooge?" Who was the adventurer that Scrooge would read about and say, "I love this"? And so this was to establish her in an interesting way—that Scrooge and Bradford had parallel origin points for the one's love and the other's hatred of adventure, both stemming from Isabella Finch. And also having the relationship between Isabella and Bradford mirror the relationship between Scrooge and the kids.

This is where we established that Lena was adopted by the Sabrewings, and this is where we established Violet's dads. I liked the reveal that Violet has also won several failure merit badges—that she's tried this challenge before and lost, and Huey hadn't clocked that.

VALERIE SCHWARZ: All these backgrounds have so much specificity to them that is referenced from all the material pulled from Camp Woodchuck, especially in the lodge.

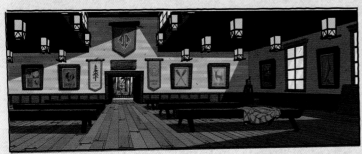

SEAN JIMENEZ: When the writers were breaking this story, we were looking at a lot of Junior Woodchuck material. While visiting the WDI library to do research, I found out that there was a whole area in Tokyo Disneyland themed around the Junior Woodchucks, called Camp Woodchuck. Imagineering had done quite a bit of research in order to put loads of Easter eggs in their designs, so it seemed like a cool idea to work together and bring some of those elements from Camp Woodchuck into our episode. I had worked at Imagineering, so there was a lot of rapport there. Madison Bateman was so excited that this episode could tie into Camp Woodchuck, and then there was tons of logistics once we started baking these locations from the park into the narrative.

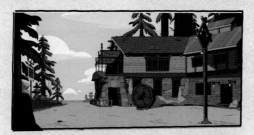

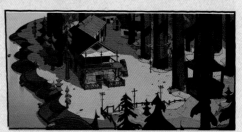

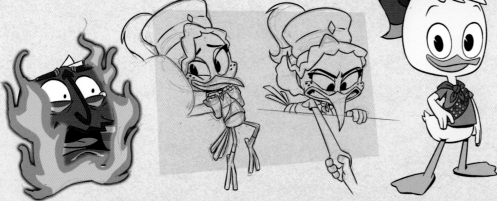

FRANK ANGONES: We pulled in a lot of the Junior Woodchuck lore from both Barks and Rosa, in terms of the tittertwill and the Junior Woodchucks logo, upside down, being the tittertwill.

"QUACK PACK!"
EPISODE 2

MATT YOUNGBERG: Since we needed something that was a little more simple for the design team, we designed the episode using a few mansion "sets," and then the board artists reused those sets over and over.

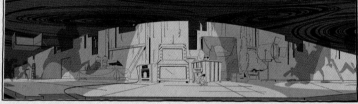

FRANK ANGONES: We had tried on several occasions to do what is traditionally called a "bottle episode," which, as we've mentioned before, simply doesn't exist in animation. So I went over to Matt's office, and I asked him what would actually be a production saver that would actually be easy to pull off. And Matt was like, "Something with just three backgrounds, and only ever shooting those backgrounds, like, from two different angles." And off of that, we were like, "Oh. So let's do a multicamera-sitcom episode of *DuckTales*, as a production saver." And then we just worked backwards from that idea, necessity being the mother of invention.

Then it was us figuring out what a traditional-sitcom version of this family was versus the adventure-family version. Then we remembered, "Oh. Right. There was a sitcom version of the show. It was called *Quack Pack*." It was the follow-up to *DuckTales* and was way more about Donald and teenage versions of Huey, Dewey, and Louie having antics. It was way more of a silly comedy than a thrilling adventure-based show. It was building off of that, and then immediately turning it into a *Twilight Zone*–type thing. There's nothing more fun than a classic Danny Pudi Huey spinout, having Huey panic as he notices that everything about the sitcom world feels wrong. Driving Huey just a little nutty was always super fun.

Once we knew that this was a juxtaposition of what a traditional sitcom would be like versus what the *DuckTales* version would be like, we then pinned the story on Donald having made a wish that his life would be normal. So it was Della never having been lost in space, and nobody getting hurt, and all these wonderful things. It's actually a huge episode for Donald and him coming to terms with his panicky arc of the past. We knew we were going to set him up for his Daisy romance this season, and that was going to be his arc. So before that could happen, this was him coming to accept that his family is, and always will be, an adventure family.

SEAN JIMENEZ: When they said it was going to be like a sitcom with a three-camera setup, I got really excited. A lot of my development work was figuring out what would represent the audience point of view of our sets, and how those could also become the behind-the-scenes views. If you're in the three-camera setup, the camera is always trucked in enough that the world is filled up. But the minute you reveal the audience, the cameras are now seeing the stage and what's behind the stage. And what's behind the stage should be otherworldly. I think the fun part about this episode was that everything should just feel super unsettling.

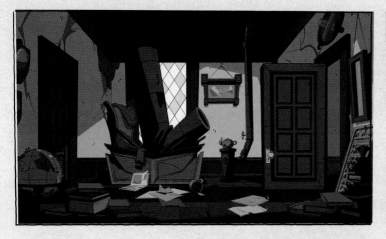

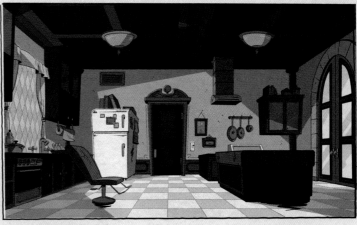

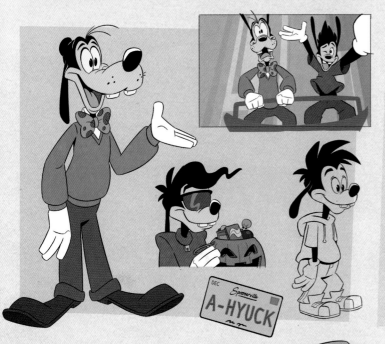

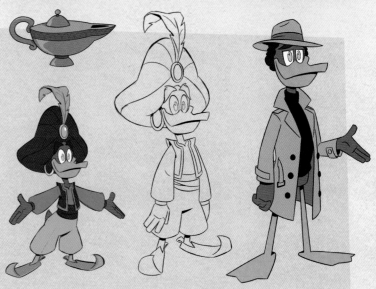

MATT YOUNGBERG: We pulled reference from *DuckTales the Movie* for Gene the Genie, and then we reimagined him to fit within our own universe.

MATT YOUNGBERG: Initially in the script, the audience characters were written as bigmouthed monsters. They were just supposed to be these giant lips with teeth, laughing in the darkness. I was trying to wrap my head around that and then, looking at the original *Quack Pack* series, they had these humans—and the designs of the humans in that world looked horrifying to me. And so we went to the old *Quack Pack* designs, pulled them in, and then gave them these rictus grins to make them even scarier.

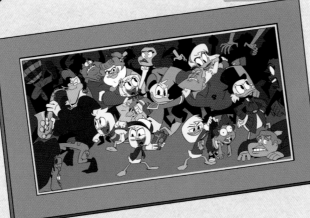

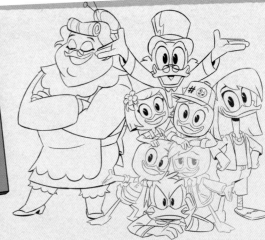

"DOUBLE-O-DUCK IN YOU ONLY CRASH TWICE!"
EPISODE 3

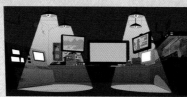

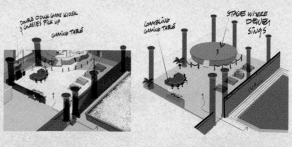

MATT YOUNGBERG: For Frank, his most important episode was getting Darkwing. But for me, it was doing a "Double-O-Duck" episode. It was one of the episodes of the original series I remember most fondly from when I was a kid, because it was like bringing adult spy movies into a kids' TV show. And so this was a spiritual sequel to that episode. We even gave it a fancy sequel name and everything. It was hard to break the story on this one, it was so big.

FRANK ANGONES: We wanted to do a riff on "Double-O-Duck" that was more of a traditional Bond riff than our *Avengers* riff in "From the Confidential Casefiles of Agent 22!," which was more like a sixties swinging-spy pastiche, as opposed to a suave-spy riff.

MATT YOUNGBERG: We needed to get into FOWL a little bit more than we had previously, since we were setting them up to be the big bad of the season. We hit on the idea of giving Launchpad super smarts, and he becomes fully aware of FOWL's master plan. So this was a good opportunity to show the audience what FOWL's up to but then erase it from Launchpad's memory. The fun thing about this episode was leaning into a bunch of the tropes that we love from spy movies.

Of course, it being a Dewey and Launchpad episode, we leaned in super hard to their friendship. Launchpad has insisted that Dewey is his best friend. For a couple of seasons, Dewey just kind of went along with it, like, "Yeah, sure. We're best friends." But in this episode, we solidified that friendship in the most beautiful way.

FRANK ANGONES: It was taking a line that was a joke in the first season, where Launchpad tells Dewey that he's his best friend, and that's a gag, but then imbuing it with sincerity down the line. To have Dewey say that Launchpad was his best friend back was all that Launchpad wanted.

MATT YOUNGBERG: This episode was a challenge because it was one of the bigger action episodes that we'd done, but we still leaned into the comedy. Having Launchpad realize he needs to be dumb to save the world is inherently funny.

SEAN JIMENEZ: Tackling the logistics of the space where the AR game was going to take place posed a particular challenge, which is where my initial problem-solving designs came from. It was a really hard solve to make it work for the action.

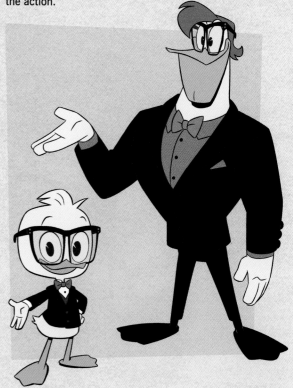

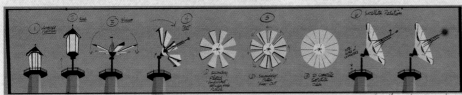

SEAN JIMENEZ: There was going to be a big fight at the lighthouse, so we used our existing Duckburg lighthouse location, but I had to figure out how they could be fighting on a satellite dish. I wanted to make sure that the reveal of the satellite dish felt compatible with the lighthouse design, like it had been hidden there all along.

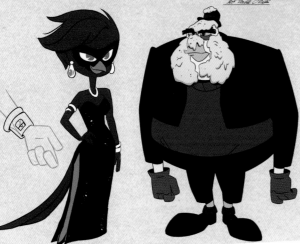

410D-305 ACT 3 "Double-O-Duck in You Only Crash Twice!"

| Scene 725 | Scene 725 | Scene 726 | Page 231/299 |
| Panel 2 | Panel 3 | Panel 1 | |

Action Notes
SP opens one eye

Action Notes
SP sadly watches Dewey

Action Notes
CUT TO: Dewey looking helpless as SP falls.

TO

Dialog

Dialog

Dialog

MATT YOUNGBERG: Since the whole theme of this season was about legacy, we also thought a lot about the legacy of the Disney Afternoon. So we just went for it. "Okay, we've got this smart ray that makes people smarter, they're experimenting on rodents, and those rodents are the Rescue Rangers, then they get together to help each other escape, and then they end up helping Launchpad at the end."

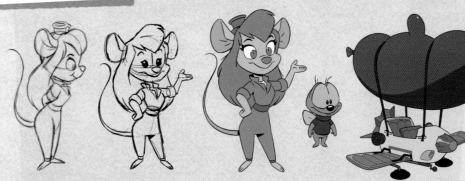

"THE LOST HARP OF MERVANA!"
EPISODE 4

FRANK ANGONES: This started out as a Fethry Duck episode. We wanted to do a Beakley and Webby story that involved the Harp of Mervana to start tipping where the Beakley story was going for the finale. The main reason that they came across a hippie commune of mermaids was because it would make sense that Fethry would hang out with these guys, but having Fethry was just one of those things where it just wasn't working. It was one element too much.

MATT YOUNGBERG: We gave most of Fethry's beats to Donald, so Donald gets there and then becomes very Zen-like, as this is the one place where he's found peace, with these hippies. But it did give us an opportunity to have Scrooge be very Scrooge. He had such disdain for a lifestyle that does not involve hard work. This episode did a couple of really important things, including furthering the missing-mysteries idea, as this was one of their first outings to find the missing mysteries. Having it be the harp was a throwback to the original *DuckTales* series, which had this truth-telling harp who would declare in a singsongy fashion if you were "fibbing, fibbing, fibbing."

FRANK ANGONES: We wanted to do another Webby and Louie pairing, because we hadn't done one in a long time. And this is actually the inverse of their first pairing, in "Toth-Ra," where it was Webby being worried that there's some kind of danger in that temple, and Louie thinking it's a con, and Louie being wrong. And here, Louie thinks it's a con, and Louie's right. And that destroys Webby. Louie's cynicism beating out Webby's optimism was a big deal. But to add in that Beakley element of, like, "Yeah, sometimes we don't tell you everything, so that you can be happier. And maybe we should." There were larger implications to doing a story about Webby finding out that sometimes grandparents lie to you to maintain your worldview. It's not a clear-cut, typical moral that you get on many shows, where you can have a grandmother yell at her children, "Sometimes I lie to you to protect you from the hard truths of the world." The hint towards a bigger lie, with the harp calling out Beakley's fibbing at the end, was a huge foreshadowing of the series finale.

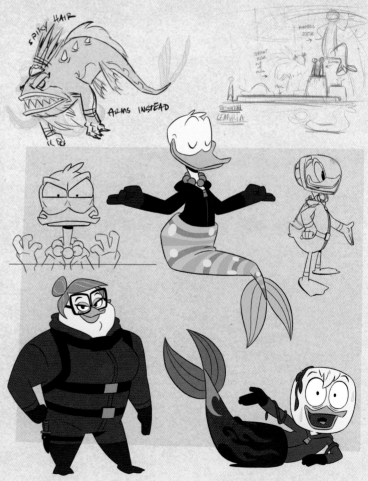

MATT YOUNGBERG: This was a hard one. Turns out, when you do water-heavy episodes, they are very difficult. Especially coming in and out of water all the time. And monsters. We had done underwater episodes before, but fully underwater stuff ended up being a bit easier. But we didn't want to have our characters just be in scuba masks the entire time, so we had to come up with the lagoon.

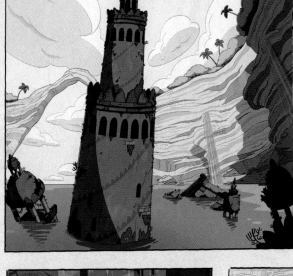

MATT YOUNGBERG: When we got to the castle, we wanted to make sure we weren't doing the classic European-castle type of thing. We wanted it to be different. So we leaned more into Asian influences to give it a different feel.

VALERIE SCHWARZ: A lot of inspiration for the tunnels and caves came from the Saint Louis City Museum, which is made completely out of recycled materials. It's a mishmash of textures and patterns and craziness, and it feels like one big piece of art. But one of the rooms is themed like an underwater-feeling place, and that's what I drew upon.

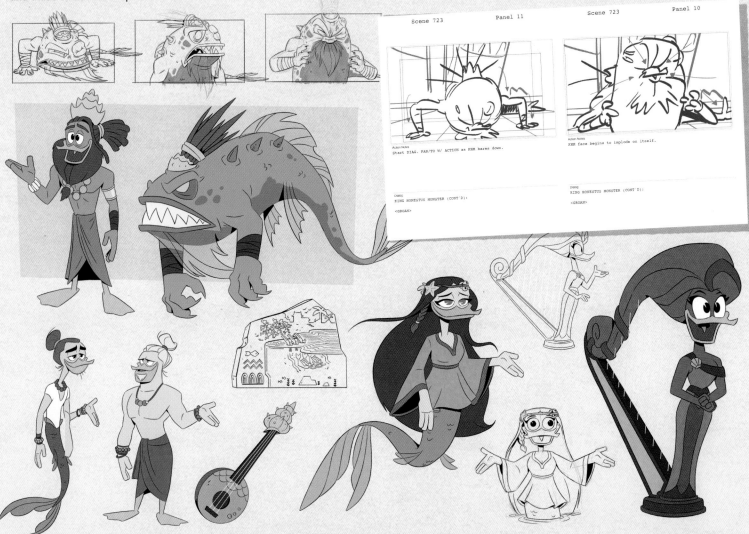

"LOUIE'S ELEVEN!"
EPISODE 5

FRANK ANGONES: This episode came from a pitch that Tanner Johnson had, which was the idea of a heist story where Louie had to team up with the Beagle Boys to break into the Money Bin. We had already done a "Louie teams up with villains story" in season two, but Tanner's basic heist idea stuck around. We wanted to introduce Daisy as part of Donald's arc, in that now that Della was back, Donald could maybe worry a little less about the boys. Now he had the opportunity to have things for himself that weren't just about taking care of kids. And so we got him to get the band back together by bringing in the Three Caballeros, which was something we always loved doing, and we brought in Daisy Duck.

MATT YOUNGBERG: From a writing perspective, a heist is not an easy thing to pull off, because you have to be a step ahead of your audience, and that is not an easy thing to do.

FRANK ANGONES: It sounds great to do a riff on a heist movie, until you realize you have twenty-two minutes to execute a heist movie. And you've promised eleven members of this heist team. And so it became "Yep! Just any random person." No one has to do two jobs in this. Everyone can just do one thing. And we bring them in and then that brings up the total a little bit.

MATT YOUNGBERG: Usually, as a filmmaker, you want your audience to be with you, but in heist stories, you need to be ahead of them—not so far ahead that it won't work, but far enough ahead that they don't see. It's very complicated. But I feel our reveal of Mark Beaks is a great twist on it—that he's behind the whole heist.

MATT YOUNGBERG: The main thing about this episode was introducing Daisy into our show. We had some different ideas at the beginning about how to bring her in—either as a documentary filmmaker or a reporter or as Glomgold's assistant. But finally, we decided to introduce her organically, as her own character in her own existence, instead of being supporting to our cast. That felt like the right thing to do. We leaned into some of the things that are classic about her, like the fashion thing. In designing her, we referenced the Tom Oreb designs from the 1950s of a very stylized Daisy. I wanted to lean into that and get away from the classic animated-shorts version of her, just because she needed to be elevated a little bit in terms of fashion and style. She's a fashion designer. We needed something more elegant than a frilly dress. She turned out to be one of my favorite designs of the series.

SUZANNA OLSON: During one of the art reviews, I suggested we look at Audrey Hepburn as inspiration for the hair, with the headband.

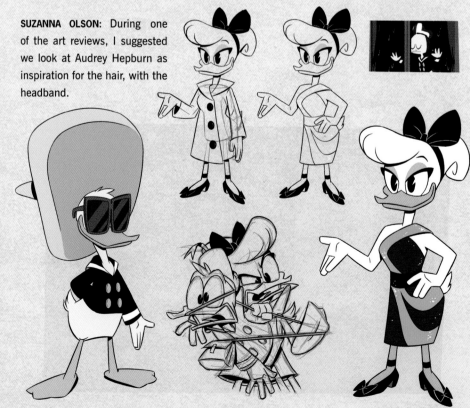

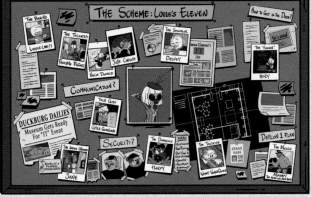

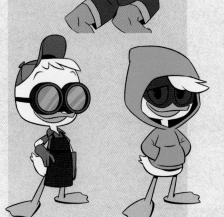

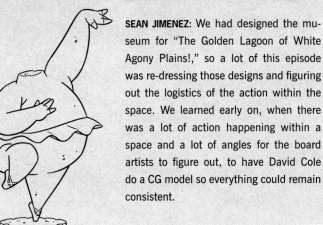

SEAN JIMENEZ: We had designed the museum for "The Golden Lagoon of White Agony Plains!," so a lot of this episode was re-dressing those designs and figuring out the logistics of the action within the space. We learned early on, when there was a lot of action happening within a space and a lot of angles for the board artists to figure out, to have David Cole do a CG model so everything could remain consistent.

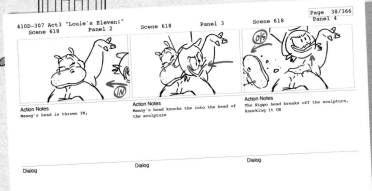

"ASTRO B.O.Y.D.!"
EPISODE 6

FRANK ANGONES: Between seasons one and two, I took a trip to Japan, and I walked around desperately looking for Astro Boy stuff, because I loved the original Astro Boy. Astro Boy's creator, Osamu Tezuka, was inspired by Carl Barks comics.

MATT YOUNGBERG: Frank had this idea about how BOYD was our homage to Astro Boy, and I was like, "Yep, there we go." That's all I needed to know.

FRANK ANGONES: Up to that point, BOYD was a funny joke character that turned up in "Happy Birthday, Doofus Drake!" for a gag—and as a threat. We had also been wanting to do a Gyro Gearloose story for two seasons and change, and take the least likable character from our main heroes gallery and explain why our Gyro was so different from the version of Gyro in the original *DuckTales* and what had happened to him.

MATT YOUNGBERG: This was our love letter to Japanese animation. It's an episode where everything—from writing to directing to color design to design—every single thing came together so beautifully. It gave Gyro one of the most heartfelt moments of the entire series, and that ending of BOYD choosing to overcome his programming and to truly be a real boy was just a beautiful moment. We've also got Huey and BOYD going off on their own adventure and becoming best friends.

FRANK ANGONES: At its core, it's about a kid who's just wired a little differently. And that's okay. It's a story about what is expected of you. And even Gizmoduck is wrong in this. BOYD doesn't want to be a heroic robot. He doesn't want to be an evil robot. He just wants to be a kid.

SEAN JIMENEZ: If we normally treated every episode as a love letter to Carl Barks, this episode was a love letter to Osamu Tezuka. It wasn't as big a swing in terms of style as it might seem, other than the fact that visually, it does look very different than all the episodes, simply because we colored the black lines out in the backgrounds. Usually when we colored the line out, it meant the color is almost the same as the shapes, so it doesn't act as an accent. It just sort of gets out of the way, so the shapes can look good against each other. For this episode, I had this idea that we flare the line, making it an accent, so it feels heightened. It ended up looking really cool. This was the only episode that I color scripted. For the color script, it was Valerie who suggested *Sailor Moon* backgrounds as an inspiration. I also riffed on some of the desaturated color of 1960s Toho *Godzilla* movies.

VALERIE SCHWARZ: The backgrounds in *Sailor Moon* are so gorgeous, and the palette is super limited. They're very pastelly. Pastels were not something we'd do in *DuckTales* a lot. I feel like we found a really cool blend of the two styles.

SEAN JIMENEZ: Tokyo is incredibly busy and filled with massive amounts of signage.

VALERIE SCHWARZ: This episode was a beast. There are so many backgrounds. We tried to make it easier by having the background artists draw flat versions of different assets, like a generic sign or a generic box, just to populate the environments and to make it feel more lived in and lively. Especially in those alleyways in Japan, they feel really busy and full of stuff. And so we just created a bunch of assets to give our overseas studio so that they could plop them in, like a puzzle, and not have to focus so much on the detail.

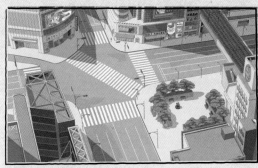

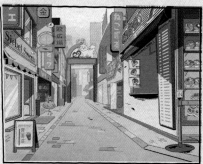

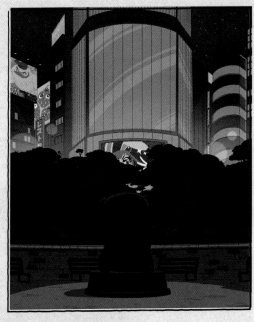

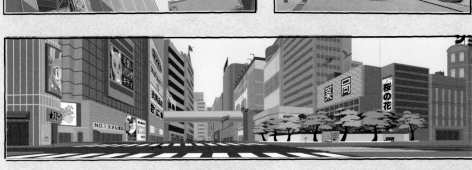

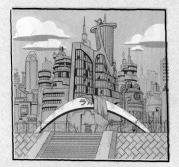

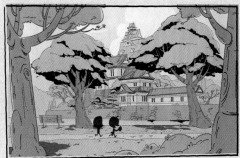

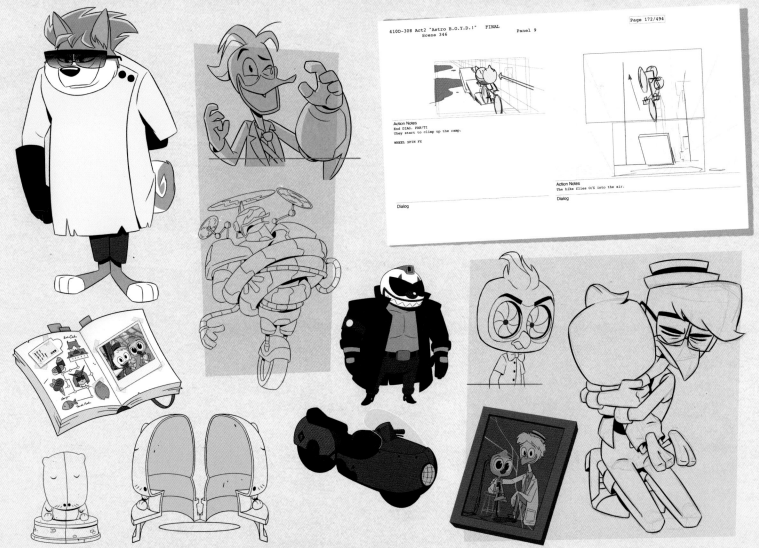

"THE RUMBLE FOR RAGNAROK!"
EPISODE 7

FRANK ANGONES: In "Last Christmas!," Scrooge talked to Dewey about all of the various responsibilities that take up his time, and he lists them as "my company, my family, keeping the world-eating serpent Jörmungandr at bay . . ." And then we had that in our back pocket for whatever we might need it for later, and it turned out to be this episode.

MATT YOUNGBERG: The director of this episode, Tanner Johnson, loves wrestling. And not only does Tanner love wrestling, but the writers' room started getting really into the indie wrestling scene in Los Angeles. So we went to a few wrestling matches and met wrestlers. We just all got into wrestling, it was super fun, and then this episode gave us a great excuse to go watch more. This episode was Tanner's milieu, and so a lot of this was relying on his expertise. The writers even brought him in to talk about specific wrestling things, and because of that, I feel like it's a very accurate representation of wrestling. We did our homework. I mean, yeah, it's fantastical and fun and ridiculous. And it's in Valhalla.

TANNER JOHNSON: It became important to the writers that this episode not be a huge pro wrestling–style event but instead be a smaller show where the stakes are high because we're dealing with the end of the world.

MATT YOUNGBERG: Dewey is so obsessed with being loved and everyone adoring him all the time that his brain can't wrap around the audience not liking him. He thinks he has the best character in the world, Champ Popular, and that he's super cool. And nobody loves him, because Jörmungandr is the hero. Everyone loves Jörmungandr. And so it's Dewey having to learn to embrace being a heel, because sometimes doing the right thing means that people aren't going to love you. That was a great lesson for him to learn.

FRANK ANGONES: And this was part of Dewey's growth arc in season three. He had to learn that sometimes being the hero isn't about the glory. Since season three was about legacy, a more general theme was setting these characters up for the future. This was the first time Scrooge was admitting that one day, he's going to be passing on his responsibilities of being an epic adventurer-slash-hero to the kids, and that they have to be ready for it.

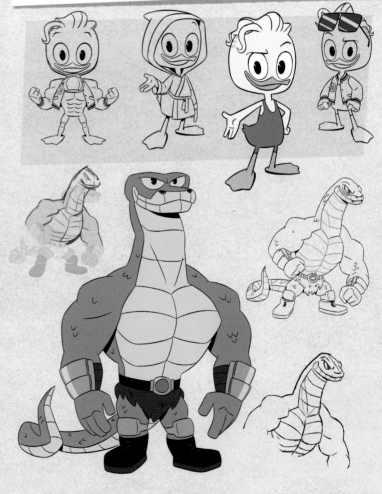

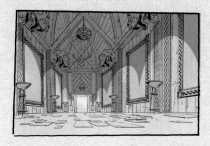

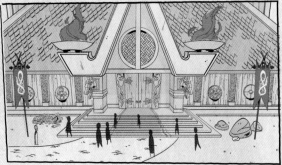

VALERIE SCHWARZ: The architecture is very Nordic, with arched roofs and lots of wood. The artist who did the predesign for this episode was Luciano Herrera, and it really set the mood for the look.

SUZANNA OLSON: From a production standpoint, you're trying to problem solve the crowd size and how to make it big and exciting and feel like a crowd but not add that extra line mileage to the animators. So we used lighting very strategically to have the front of the crowd lit, so you could see those acting characters, but the deeper you got into the crowd, it got darker and more silhouette based.

MATT YOUNGBERG: When we were in the ring, we decided to be extra stylized, with just the light coming from above, and if you're looking out, all you'd see is black. You don't really see the audience or anything.

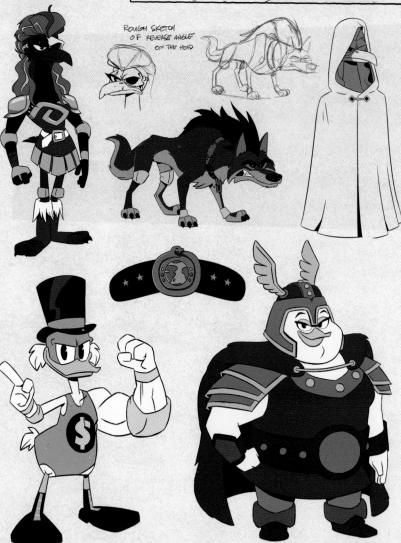

"THE PHANTOM AND THE SORCERESS!"
EPISODE 8

FRANK ANGONES: Lena had come so far with her relationship to her past, and herself, and her magic, that the big idea here was that she was independent and she renounced the De Spell name. It was important to have Lena own her legacy.

MATT YOUNGBERG: Lena had already overcome her fear of Magica in "A Nightmare on Killmotor Hill!," but this was where she became truly independent of her. She had self-doubt at the beginning of the episode—her magic kept ruining things and was uncontrollable—but by the end, she has control over it, and that gives her the confidence and power to not worry anymore.

FRANK ANGONES: To have a character using magic for good is almost never a thing that we had done, so this was setting Lena up for the future as being the protector of all things magical in the world of Duckburg.

MATT YOUNGBERG: We also wanted Magica to get her powers back. Up to this point, we had de-magicked Magica, so the fun with this episode was playing with the idea that she doesn't have magic, and she's teaching Lena how to use her magic. By the end, Magica's got magic again, but we wanted to show that, thanks to the training and thanks to her confidence, Lena is now able to stand up to Magica and is a more powerful magical being than her, so Magica shouldn't mess with Lena.

FRANK ANGONES: This was our formal introduction of the Phantom Blot, who's a classic Mickey Mouse villain.

MATT YOUNGBERG: He's trying to remove all magic, which set up a very specific threat to Lena, because Lena was created by magic. She is a completely magical being. And then that also gave us a real fun chance to bring in Gladstone, whose luck powers are magical.

FRANK ANGONES: Tying him to magic was an opportunity to get him as a comic-relief character throughout this episode, which was going to be pretty intense. Whenever we had a heavy story, especially a heavy Magica and Lena story, we wanted to have something really silly to leaven it.

VALERIE SCHWARZ: We looked at different swamps with these tendril-like tree roots running throughout the landscape. Add a thick fog, and it's the spookiest place, perfect for Magica's hideaway in the woods. In my predesign sketches, I was exploring how the swamp could look and trying to find a simplified solution to having a very dense and crazy-looking forest, because having a lot of tendrilly roots and organic shapes can get kind of busy and chaotic. Our background artist, Janie Lee, did such a good job with all of the foliage and gnarly-looking trees. She's just a beast when it comes to organic shapes and nature.

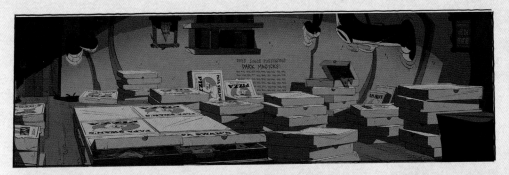

VALERIE SCHWARZ: Magica's whole house is full of pizza boxes, and all of the furniture is made out of them. Even her bed is pizza boxes, and the pillows are just open ones.

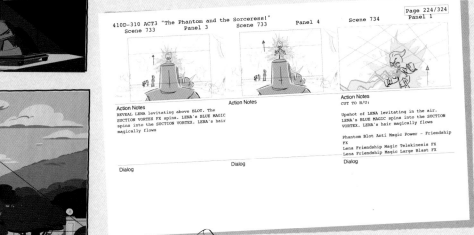

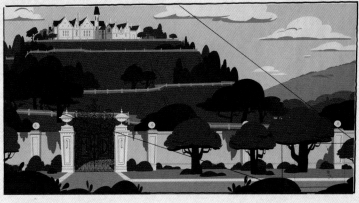

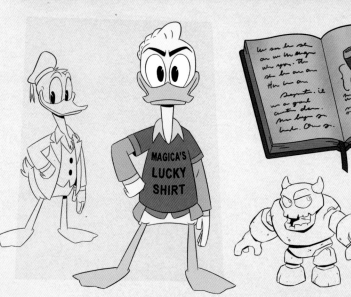

"THEY PUT A MOONLANDER ON THE EARTH!"

EPISODE 9

FRANK ANGONES: This is an episode that was entirely inspired by Sam King doing fan comics of Penumbra, and our continued effort to lift up new and interesting voices amongst our crew and give them opportunities both in the writing room and directing.

SAM KING: *DuckTales* was full of really awesome female characters. But I noticed that characters like Launchpad, Glomgold, and Storkules were really physical, and we got comedy out of how far we could push them physically. We hadn't really been doing that with any of the female characters. I thought that Penny would be such a fun way to do that: to have a character who was basically indestructible, so we could get a ton of slapstick out of her.

MATT YOUNGBERG: Sam really fell in love with Penumbra. She just had a great time riffing on what Penumbra and Della's relationship was like by making these funny side comics that were the continuing adventures of the two, and they were really charming and funny. Sam was a storyboard artist, but with a really great writer's sensibility.

SAM KING: The *DuckTales* crew was really great about looking for what people were really passionate about and trying to give them opportunities to bring that forward on the show and bring them to the table. I had known early on in season three that I would be codirecting an episode, because I had talked about wanting to become a director. But they had seen ideas in my Penumbra comics that they liked, and Frank asked me how I would feel about cowriting this episode, as well. He was like, "You seem to have such specific ideas and thoughts about this. We want you to have your voice in the room." And it was great.

FRANK ANGONES: We weren't going to be dealing with a lot of Moonlander stuff in season three, because of all of the focus on Bradford and FOWL, but we thought the best way to touch upon them would be to focus an entire episode on the Moonlanders and how Penumbra felt as the only one who wanted to go back home. She was feeling really, really lost without her role and was trying to figure out her role here on Earth. She had been set up as the only Moonlander who was not taken with Earth, so the fact that she was now living on Earth was perfect and seemed like a perfect engine for comedy.

MATT YOUNGBERG: It's one of the funniest episodes of the season and a charming slice-of-life episode about Penumbra's character and her relationship with Webby and the family.

SAM KING: I wanted the Moonlanders' outfits to be eighties and nineties themed, because Bob had already set up that everything they know about Earth culture came from Della, who grew up in the eighties and nineties.

MATT YOUNGBERG: Sam has a great eye for design and fashion for characters and a really funny sensibility.

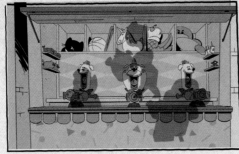

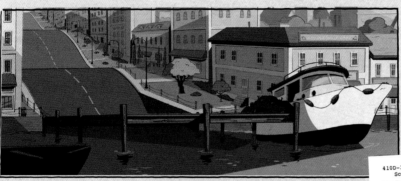

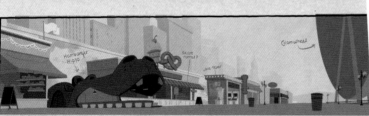

410D-311 ACT3 "They Put a Moonlander on the Earth!"
Scene 663 Panel 2 Scene 664 Panel 1 Scene 664 Page 105/219
 Panel 2

Dialog Dialog Dialog

Action Notes Action Notes Action Notes
GG stands up and CUT TO End HORIZ. PAN W/ ACTION
looks up.
 Start HORIZ. PAN W/ ACTION as P flies in
 slowmo.

SAM KING: I redesigned a bunch of Moonlanders for this shot. In the middle row, from left to right, are Jason Zurek, Bob Snow, and me.

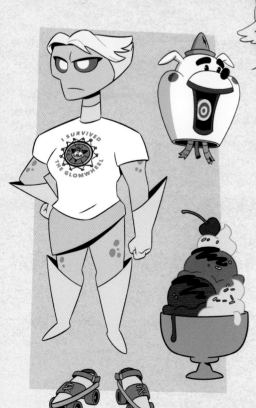

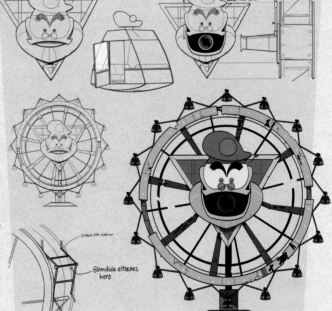

VALERIE SCHWARZ: Because we needed to see so many different angles of the Glomwheel, we did a 3D model of it. It's a circular shape that moves in perspective with all of these components on it, so it would get really complicated otherwise.

"THE TRICKENING!"

EPISODE 10

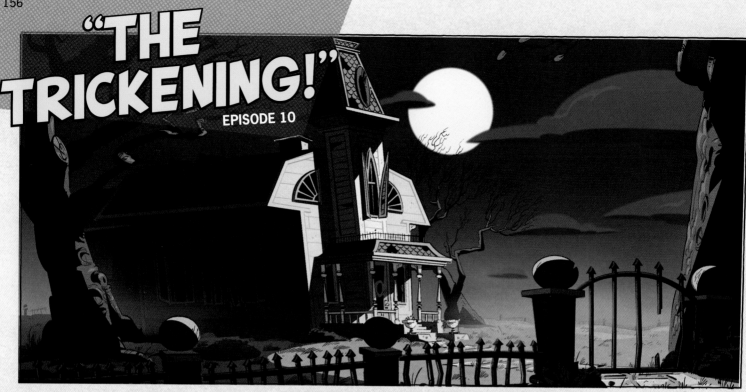

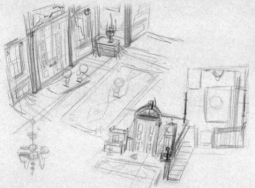

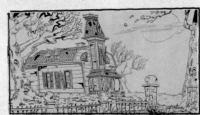

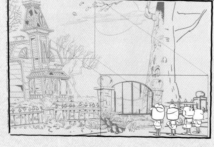

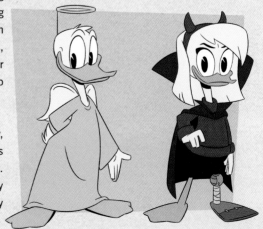

FRANK ANGONES: The Halloween episode of *DuckTales* was a very difficult proposition. A Halloween episode of a typical show is its spooky or scary episode with a monster in it. We had so many monsters on our show all the time that we couldn't really lean into the spookiness of it, so we leaned into the more kid angle of getting candy and having that be the main thing. In the process of realizing what the heck is a spooky episode of *DuckTales*, we landed on the Huey of it. This being the Huey season, it's seeing Huey being so meticulous and excited about his candy route. In the script, it got to this really interesting place that Christian Magalhaes hit: that when the kids were still living on the houseboat, Halloween was the biggest adventure they had. And now they're all growing and moving on to different things, and they've faced real mummies and all of these other crazy monsters. It fit in nicely with our larger conversation in season three, which was the theme of legacy, and the theme of these kids growing up and growing out, but still wanting to hold on to something from their childhood.

MATT YOUNGBERG: Halloween episodes are hard, but they're fun. It's usually a full redesign of a show, because every single main character is in a new outfit, there are a bunch of new incidentals, everyone's in costumes, and the backgrounds are all changed, because they have to have a Halloween theme. But we wanted to do a cool Halloween episode. It's a fun way to mix it up a little bit. We threw every horror trope that we could come up with into it, including classic monsters, new monsters, and a scary haunted house at the end of the street.

SEAN JIMENEZ: I thought it would be cool to merge the *Psycho* house, the house from *Halloween*, and the *Amityville Horror* house. I actually put a lot of energy into designing the house in development.

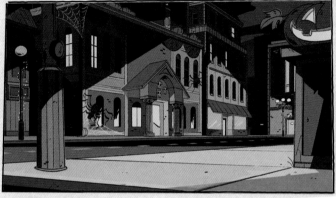

410D-301 Act2 "THE TRICKENING!" FINAL Page 131/293
Scene 370 Panel 4 Scene 370 Panel REF Scene 371 Panel 1

Action Notes

Action Notes

Action Notes
CUT TO H/U of the kids backing up away
from the monsters

BG TI

Dialog Dialog Dialog
#? MONSTERS 98 WEBBY

... "Our costumes..."

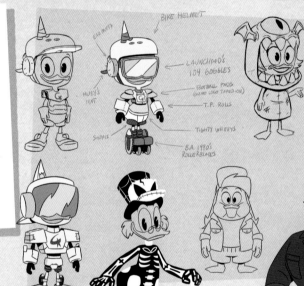

SEAN JIMENEZ: When we were talking about it being a Halloween episode, I was thinking in terms of color and what could be a good guide for it. We wanted it to feel like a classic. So we were talking about the Donald cartoon *Trick or Treat*, because there's something classic and wonderful about that, in terms of tone and mood. We were also talking about *The Haunted Mansion* and the artwork that came in the booklet of the LP. There are these crazy greens that are super seventies, smashing against these blues.

"THE FORBIDDEN FOUNTAIN OF THE FOREVERGLADES!"
EPISODE 11

VALERIE SCHWARZ: The resort is supposed to feel a tiny bit gaudy and fake. Scrooge went to the cheapest place he could find in the Everglades, because he's on this mission and didn't want to spend too much money. So he found this weird hotel in the middle of nowhere. From a distance, the hotel seems grand, but when you get closer, it's cracked and shoddy. It just exists as a means to an end for Ponce de León's scheme.

MATT YOUNGBERG: As an overall adventure episode, this felt very classic in terms of *DuckTales*, but also very much our own show, and the twist was really interesting. The idea that the water from the Fountain of Youth actually drains people's youth so that other people can steal it is an interesting twist. It's a fun, bonkers idea that Ponce de León is still alive and is using the Fountain of Youth to retain his youth by stealing it from spring breakers who come and party at his resort's pool.

We brought Goldie back to explore what Scrooge's life means to him. Youth is exciting, but his life is about lived experience. It's not necessary to be young to have a good life. And then FOWL is chasing after another missing mystery, the Fountain of Youth, so they send John Rockerduck.

FRANK ANGONES: Scrooge and Goldie, through adventure, get young and get to live forever. And because he doesn't put in any work, Rockerduck gets to live forever in the worst way possible: as a decrepit, old unfrozen creature in a baby carrier. He found a way to be even less mobile and more dependent on Jeeves, now Frankenjeeves.

VALERIE SCHWARZ: Doing the flashbacks in a stylized way using the stained glass was a creative means to keep the animation limited, because too many flashbacks gets really heavy on design. Stylization is always the best, because then you keep it contained to a couple of design theories and don't have to create brand-new environments and backgrounds. They're just a very graphic representation of what's happening.

MATT YOUNGBERG: The Everglades are a very visually dense and rich area, especially when it comes to lighting.

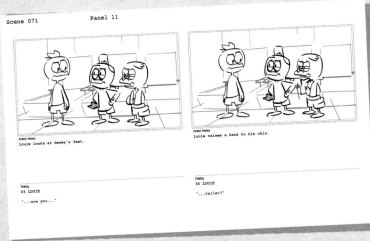

MATT YOUNGBERG: Aging Dewey up was hard to pull off visually, because the difference was really subtle. So we had to do a little bit of work to make it feel right. If his proportions were too close to the original, then we had to stretch and pull and redraw sometimes just to get him to work proportionally, because otherwise he just didn't look very different.

FRANK ANGONES: Having Webby slowly turn into Scrooge over the course of having one bad day is the least subtle foreshadowing we've ever done. And nobody got it!

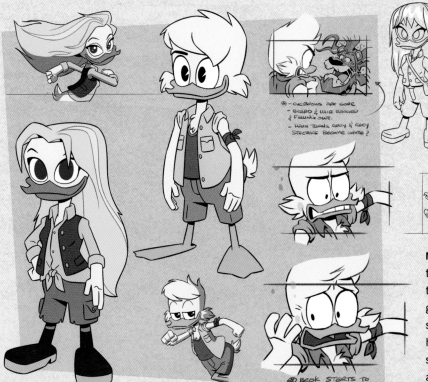

MATT YOUNGBERG: It was tough to figure out how best to show the reverse aging, when Scrooge starts getting old again, because there's not a whole lot of detail in these ducks. So when they're getting old, they're not really changing that much. Some of the head shapes or placement of hair is changing, but it's so subtle that we had to add wrinkles as Scrooge was getting older just to show that something was happening. There isn't a ton different between old and young Goldie, other than her hair.

"LET'S GET DANGEROUS! PART ONE" EPISODE 12

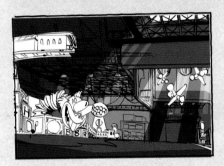

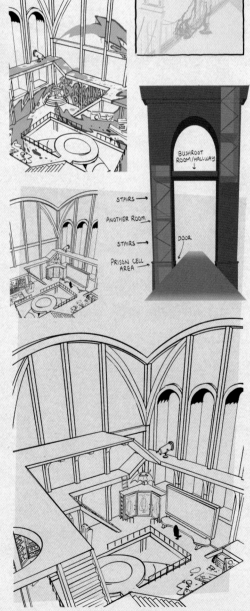

FRANK ANGONES: *Darkwing Duck* is the story of a father, a daughter, and a Launchpad, and how they come together to fight crime and fight for each other. Darkwing had been a big part of the DNA of our *DuckTales*. Because I obviously love this character, and I loved working with him so much in "Duck Knight Returns," we wanted to honor the legacy of Darkwing in this season. We had to follow through on the premise of a father, a daughter, and a Launchpad by introducing Gosalyn into the mix.

MATT YOUNGBERG: This episode is the payoff of years of planning and obsession. I made the joke, but it's one hundred percent true, that *DuckTales* was the steppingstone for Frank to get Darkwing onto TV. It was the long game, and he played it. This episode is the culmination of that long game, giving us the Darkwing that we had been setting up this entire time, the adoptive father of Gosalyn and best friend of Launchpad, and them starting their own little family unit. That's what we had set out to do with this character—to get him to this point, where he's his own hero with his own crime-fighting family.

FRANK ANGONES: And because *Darkwing Duck*, the show, was also a huge part of Launchpad's legacy, this also became part of Launchpad's legacy story. It's about Launchpad finding a family, based on all the things that he really knows and he really loves. It became a very interesting challenge of how to, essentially, remake the *Darkwing Duck* pilot in a *DuckTales* world. How do you push the action? How do you push the design? How do you push all these things to still feel like an episode of *DuckTales*? That was Matt's main marching order. And he kept us honest.

MATT YOUNGBERG: This episode was our midseason tent pole, so it wasn't just setting up Darkwing; it also needed to set up the rest of the season for our *DuckTales* characters or family. We needed to make sure that it tied into our overall FOWL story line, and that was setting up Taurus Bulba to be working with Bradford, and Bradford being revealed to Scrooge at the end as the big bad who has been manipulating everything.

FRANK ANGONES: This episode was about finding a way to tie in Darkwing's origin story with Gosalyn's origin story, and to tie those in with *DuckTales*, Bradford, Taurus Bulba, and the missing mysteries. It was such a dream to essentially do a *Darkwing Duck* pilot in the middle of a series and know that we had been able to set ourselves up to get to that place. There was a little drop of our Darkwing in "Duck Knight Returns," which was a very meta way to bring him in, but this was us going full Darkwing. As we always said with everything in *DuckTales*, "You can be canceled tomorrow, so don't hold back."

MATT YOUNGBERG: For Darkwing's tower, we thought of it in terms of an industrial loft kind of living and work space.

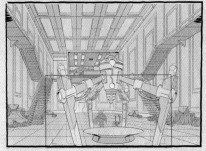
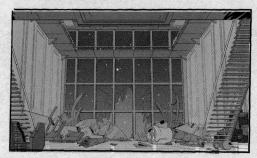
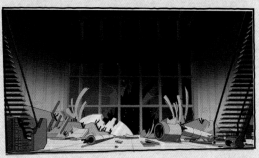

MATT YOUNGBERG: The console that controls the Ramrod was pulled from the original series, and it had that curved lip over the top of it. We took that idea and then built a more modern-looking console out of it, but it's definitely a nod to the original.

VALERIE SCHWARZ: Background paint in this episode is so beautiful. Emily Cole had to do numerous versions of the lighting effects for the Ramrod, and they're all gorgeous.

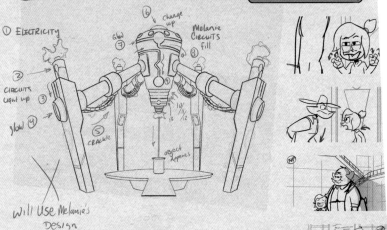

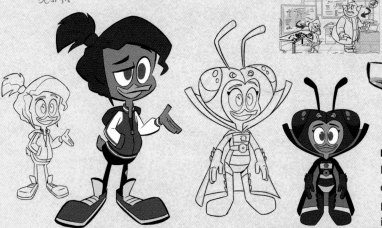

MATT YOUNGBERG: The Ratcatcher was a really difficult design to figure out—how to update it but keep some of its iconic look. It turned out to be one of the most difficult things about this episode, visually, because I'm super particular about cool tech and vehicles. There were a lot of fingers on it, and it was tough to pull off, but I think it looked pretty cool by the end.

"LET'S GET DANGEROUS! PART TWO" EPISODE 13

 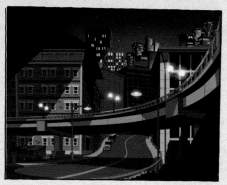 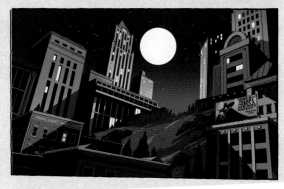

VALERIE SCHWARZ: This was a major episode to design, just because it's a huge city. It's classic *Darkwing*, but in the *DuckTales* style—which is a challenge. St. Canard was a mix of gothic architecture. It's an East Coast city in the way that Duckburg feels like a West Coast city. Designers Miles Schlenker, Janie Lee, and Sean Kenny did such a good job with the backgrounds in this episode. Because these were all entirely new locations, we couldn't get away with any reuse. The lighting was very dramatic and intense, but with limited colors.

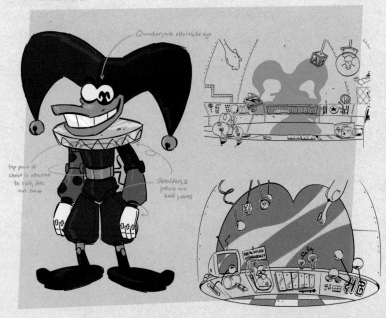

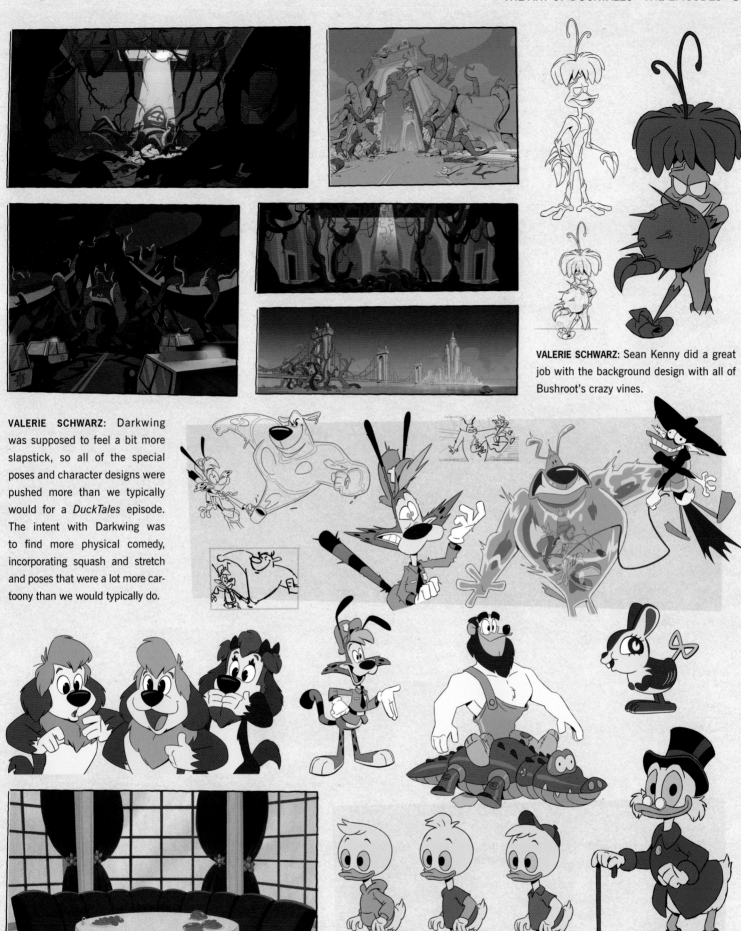

VALERIE SCHWARZ: Sean Kenny did a great job with the background design with all of Bushroot's crazy vines.

VALERIE SCHWARZ: Darkwing was supposed to feel a bit more slapstick, so all of the special poses and character designs were pushed more than we typically would for a *DuckTales* episode. The intent with Darkwing was to find more physical comedy, incorporating squash and stretch and poses that were a lot more cartoony than we would typically do.

VALERIE SCHWARZ: Designing a background that was supposed to look like the original *DuckTales* was cool. It's a bit less in perspective, and a bit more rendered, in terms of the background paint. It doesn't have the bold ink line that we have in our *DuckTales*. Classic *DuckTales* had a wash look to it, which was very different from what we did.

FRANK ANGONES: I want to give a tremendous amount of credit to Tim Moen, Tapan Gandhi, and Sarah Craig, our character designers, who were able to take all of the different styles of these original Disney shows and figure out how to incorporate them into a unified style so that each of these characters is still recognizable but feels very much like they're a part of our show.

"ESCAPE FROM THE IMPOSSIBIN!"

EPISODE 14

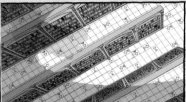

FRANK ANGONES: "Let's Get Dangerous!" was so big in its scale and scope. This was our chance to check in with our characters after the huge revelation that FOWL is back and that Bradford is running it—and had been doing so under Scrooge's nose the whole time.

MATT YOUNGBERG: This episode is all about the fallout from that reveal. They're on edge, and Scrooge, especially, is feeling vulnerable in a way that he usually does not, knowing that Bradford has been behind things for so long. Scrooge wants to make sure everything is safe, so he gets the Money Bin ready. This is our "Somebody's trying to break into the bin" story, which is something that you always want out of *DuckTales*. But it's not the regular take of the Beagle Boys trying to break in; it's the family trying to overcome all of the traps in Scrooge's new security system. It's not an outside force—it's an inside force. But then Bradford takes over the traps, so it's the family versus the bin.

FRANK ANGONES: We had a lot of fun with figuring out all of the traps. Two people that we've established are the sharpest sharpies in the family are Della and Louie, and it was a great team-up to have them dealing with the traps.

MATT YOUNGBERG: Meanwhile, Webby and Beakley are at home, and Beakley is trying to prepare Webby, because she knows the danger FOWL poses. We'd been setting up Webby throughout the whole series. Beakley's push to prepare Webby is because she knows what Webby means to FOWL, and she's harboring this fear that FOWL is going to get Webby, and so she's pushing Webby harder than Webby feels like she should be pushed. Webby pushes back, and so we have that amazing fight between Beakley and Webby.

Huey is used to order. He wants to be able to prepare for the things that he can understand but realizes he doesn't know how to prepare for this. He thinks he's not prepared for the challenges ahead. By the end of the episode, though, they all feel prepared, because they're adventurers who overcome obstacles. The doubt that the family is having throughout the episode is mirroring the doubt that they're having about their ability to take on FOWL, but by the end, they're ready to go on the offensive and beat FOWL to the missing mysteries.

FRANK ANGONES: This episode is Scrooge overreacting to the fact that someone got one over on him. But at the end, Bradford lets them all know that while they were having these family moments, he was out there stealing all of the magical mysteries they had found.

TANNER JOHNSON: We had a hard time figuring out the library, with the Rosa Runes, because you had to think very spatially about how best to use the space.

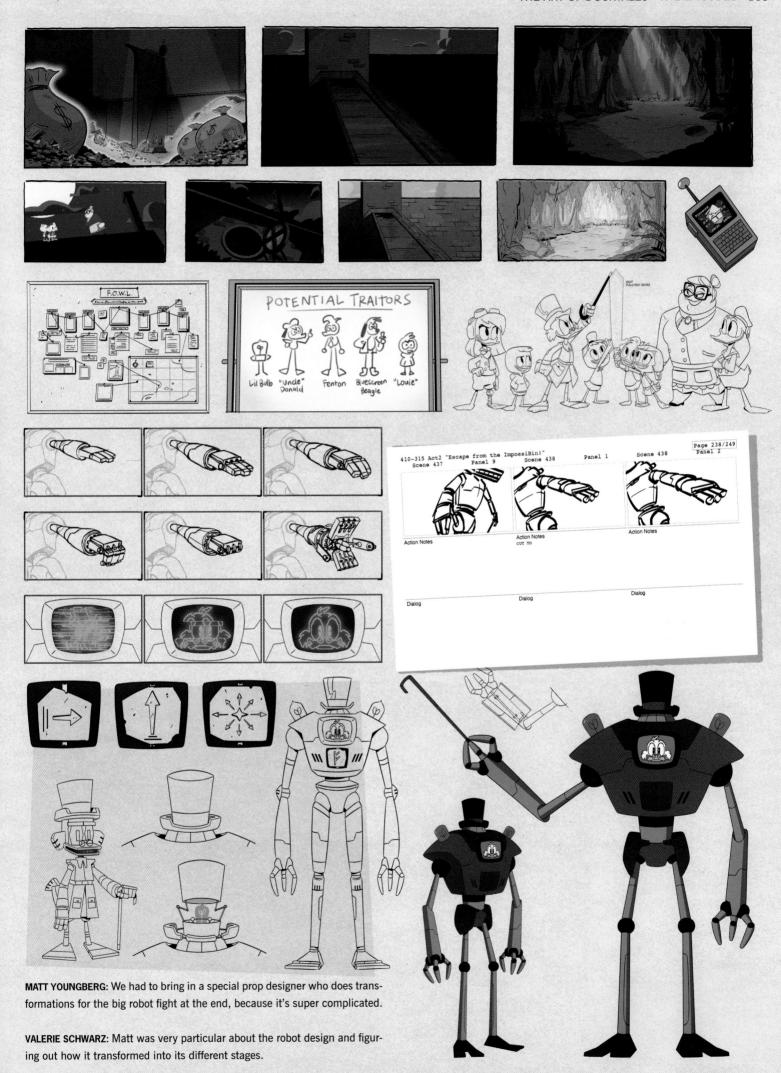

MATT YOUNGBERG: We had to bring in a special prop designer who does transformations for the big robot fight at the end, because it's super complicated.

VALERIE SCHWARZ: Matt was very particular about the robot design and figuring out how it transformed into its different stages.

"THE SPLIT SWORD OF SWANSTANTINE!"
EPISODE 15

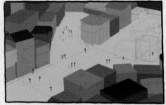
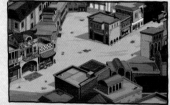

FRANK ANGONES: We wanted to showcase two things: FOWL working together as agents in FOWL, and the kids as adventurers. We really liked the idea of mixing up the kids into unconventional groups that we hadn't seen.

MATT YOUNGBERG: Each act in this episode is a different short that all fits into one larger narrative. It was fun splitting our characters into three different groups, and then having them go on three different adventures with their own story lines that all fit together into one cohesive whole. The FOWL race to the missing mysteries continues with the Sword of Swanstantine.

FRANK ANGONES: Any opportunity I could take for Scrooge to have a big fight, I would, so I liked the idea of keeping him busy with Black Heron. They are so evenly matched that their fight runs through the background of the entirety of this episode.

MATT YOUNGBERG: The first story line has Webby and Dewey team up as they go after Gandra Dee and have to do so without their sense of sight, so they have to adventure using their other senses. It turns out that Dewey is really good at using his other senses, because he doesn't worry much and just goes for it. And then Louie and Violet go off and have a game of wits in this underground spice den against Rockerduck. It became a mix of James Bond and Indiana Jones, and Rockerduck is always a good time.

FRANK ANGONES: It's so rare, especially in our show, and in kid shows in general, where you get to have an entire ten-minute block that is a single scene of people talking. There's lots of crazy stuff going on, obviously, but it's mostly a scene of people talking.

VALERIE SCHWARZ: We wanted to get really specific with the architecture and the colors. I took a lot of inspiration from Istanbul, which has beautifully colored buildings everywhere, with very pastel hues.

MATT YOUNGBERG: We had researched large markets, some fully inside and some outside, trying to find the right one. We made sure we referenced a lot of things that brought in the color of the life of these places, to lend a little authenticity. Even though we're a crazy cartoon duck world, we wanted it to feel grounded and lived in and appropriate.

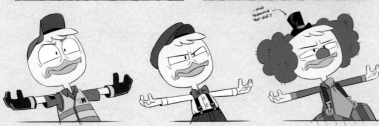

VALERIE SCHWARZ: When we enter Huey's mindscape, we simplified the backgrounds. It's really cool, because it broke the style of what we typically do. It's just the black-and-white watercolor version of the backgrounds, and it's black and white to reflect Huey's usual way of thinking. We only see color when he confronts the Duke.

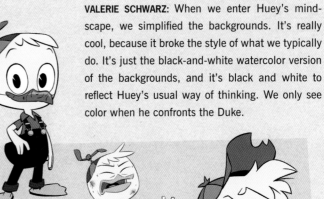

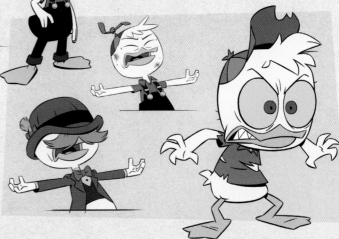

MATT YOUNGBERG: The third story is Huey and Lena taking on Steelbeak, and Lena using her magic to bring them into Huey's mindscape, accidentally unleashing the Duke of Making a Mess. When Huey is at his limit and can't handle it anymore, he goes berserk. He's a lot like Donald, in that his rage can overtake him, and it becomes almost like a superpower. In this episode, he finally connects with that rage and learns how to control it and embrace both parts of himself. When they come out of his mindscape, Huey is able to use that new connection to his rage to defeat Steelbeak. And at the end, we furthered the story line of Webby and the clones, as Black Heron revealed that FOWL's real goal was to get a feather from Webby.

"NEW GODS ON THE BLOCK!"

EPISODE 16

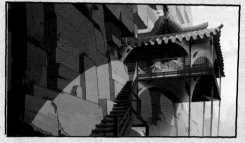

MATT YOUNGBERG: Scrooge decided to put together another adventure team, which was a thing that was going to spin the kids into feeling a lot of self-doubt, so we needed to figure out a way to make Scrooge have to put together this alternate adventure team. The story difficulty was figuring out how to do it in an absent-minded way that wasn't pointed at the kids at all. It was just that Scrooge was up against a challenge, he didn't solve it, and he's so focused on figuring out how to solve it that he's like, "Oh, right, if we put together a team of people like this, it's going to help us." In his mind, he was never excluding the kids. But what came out of his mouth and what the kids were hearing was "I'm excluding you from my team." And they took that really hard.

FRANK ANGONES: We liked addressing Scrooge not realizing that he is withholding of praise and how much his approval means to the kids. And also having Della call him out on it, because he raised her, too.

MATT YOUNGBERG: It became an opportunity for Della to become a great mom, where she sees these kids hurting for recognition and feeling down, and she wants to do something for them to give them an opportunity to show what they're worth. And so when this opportunity to become gods comes up, where Selene is like, "Della, you should be the god," Della instead looks at her kids and, feeling sad that they were overlooked yet again, is like, "No, give the kids a chance. I think the kids would be great gods." And so each of the kids has their own little trial. And they all fail. But then they rally at the end to save Scrooge by harnessing each other's specific powers.

FRANK ANGONES: It was a tremendous joy to come up with what the kids' powers would be. Huey's made sense and was also a reference to the series *Quack Pack*, where Huey got an upsettingly large head from getting brain powers. Louie's golden touch was something that we had played with for the pilot, when originally it was going to be a Midas Gauntlet instead of a Medusa Gauntlet. Webby's is even more foreshadowing, pointing out that it would be very easy for Webby to go evil and just fall apart, with the best of intentions. I can't tell you the amount of joy in the room when we settled on Dewey and we just said, "This is an audition. Dewey is a theater kid. He has one hundred percent forgotten the stakes and the context of the competition, and he is just going to do the audition scene from *Flashdance*."

MATT YOUNGBERG: We also furthered the relationship between Daisy and Donald.

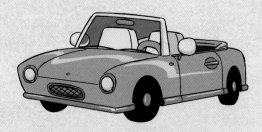

FRANK ANGONES: I would have loved to have done more Daisy and Donald stories, as they're possibly the most functional romantic relationship in the show, and they are supportive of each other.

VALERIE SCHWARZ: Melanie Atwater designed Daisy's car, and I love it. I want that car.

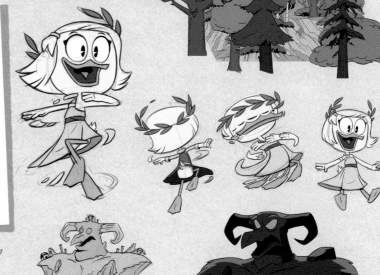

VALERIE SCHWARZ: Because we spent a lot of time in the forest, Janie Lee drew every single tree on a separate layer, so that we could mix and match and reuse them, and build out the forest that way.

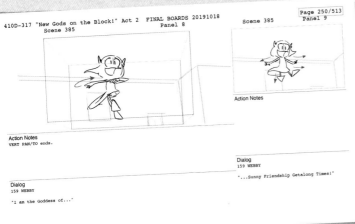

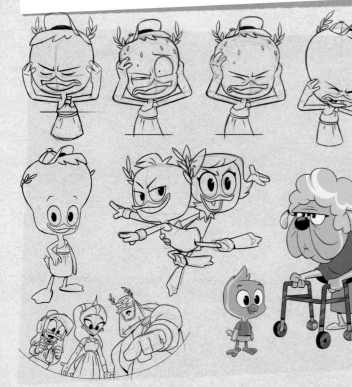

VALERIE SCHWARZ: Crownus was a challenge, because he's a giant creature, and he's moving. But we also have our characters in close-up shots against him, where he's a background element, so he wound up being a joint effort between backgrounds and character design.

"THE FIRST ADVENTURE!"

EPISODE 17

MATT YOUNGBERG: This is a very classic *DuckTales* adventure, just instead of the nephews, it's Della and Donald. We always talked about how they were the original adventure team, and it was fun to see how they became that.

FRANK ANGONES: We talked so much in season one about how much Scrooge loved his time adventuring with Donald and Della, and how grand that was, that it was such a joy to see that in this episode and for it to be their first one. Scrooge didn't consider anything that he did before this to be adventures. It was all scraping by, struggling, making his name, and earning a fortune. But this was adventure for the sake of adventure, and he kind of eased off the wheel a little bit and started to discover this thing. So you get to see a little bit of what he lost when Della was lost in space.

MATT YOUNGBERG: This feels like a standalone episode when you watch it, as there's not anything that really indicates that it's tied into the larger arc of the season, but it is hugely significant due to the introduction of the Papyrus of Binding. A lot of the treasures that we've gone after are MacGuffins: they're there to be a thing that the characters are going after. The papyrus is another artifact, so it feels like a MacGuffin to get us to the next step. But in reality, this is the big thing. This is the artifact that comes into play in the finale, in the most important way, as it becomes the contract that Scrooge is going to sign, barring him from all adventure. But in this episode, the audience doesn't know that yet.

FRANK ANGONES: The first thing that I pitched to Matt about season three was the scene with Black Heron and Bradford, and the core of that dynamic became the core of the villain arc in season three. Bradford works at SHUSH, and he recommends getting rid of anything adventurous, because it would make their jobs easier and help their bottom line. He wants to start the Organization for World Larceny. Having Black Heron add the "Fiendish," to make it "FOWL," told you everything you needed to know about this relationship and about Bradford as a character. But to see Heron drag Bradford along on this adventure, and to see Bradford's evolution from not wanting to get involved in trying to prevent as much adventure as humanly possible to the moment that he signs the Papyrus of Binding—in that moment, he's already gone. He's already a villain. And he's going to spend the next few decades of his life pretending like he didn't do that.

MATT YOUNGBERG: Bradford using the papyrus to erase Scrooge's memory of his existence, so when he meets him at the end, he seems like the perfect candidate to work for Scrooge, was the moment where Scrooge's world began being manipulated by Bradford.

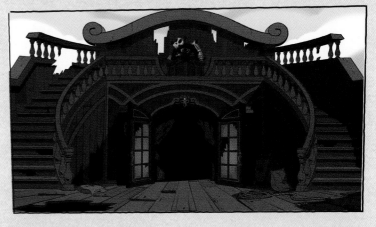

MATT YOUNGBERG: The ship on top of the mountain peak was a nod to the centerpiece of Typhoon Lagoon, in Walt Disney World. It's not exactly the same, but it was definitely inspired by it.

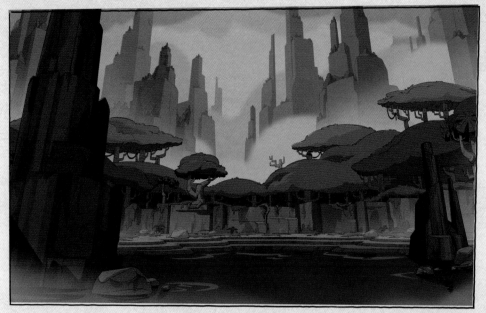

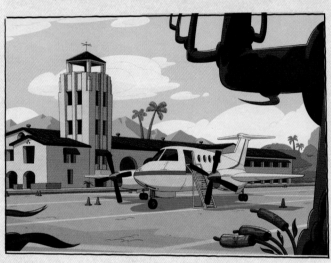

410D-318 Act 3 "The First Adventure!"
Scene 614 Panel 3 Scene 614 Panel 4 Scene 614 Page 24/212
 Panel 5

Action Notes
YB antics to swing.

Action Notes
Start TO W/ ACTION as YB swings the
cutlass.

Action Notes
End TO W/ ACTION

Dialog
192 YELLOW BEAK

"...Yel(low)..."

Dialog
192 YELLOW BEAK

"...(Yel)lo(w)..."

Dialog
192 YELLOW BEAK

"...(Yello)w..."

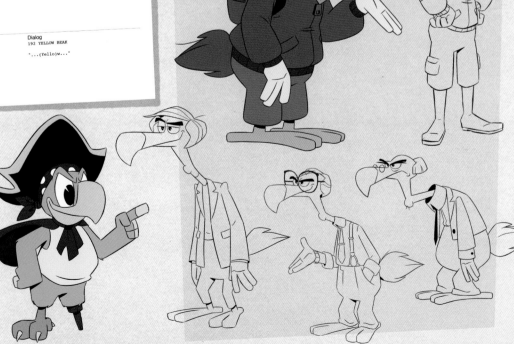

FRANK ANGONES: Captain Yellow Beak is a reference to the very first Donald Duck adventure story by Carl Barks, "Donald Duck Finds Pirate Gold." Because we were telling the story of their first adventure, it felt appropriate to tie him to the papyrus.

"THE FIGHT FOR CASTLE McDUCK!"
EPISODE 18

MATT YOUNGBERG: Back to Castle McDuck. We wanted to include as much historical McDuck family as we could, including Scrooge's sister, Matilda McDuck. Having them go back to the family castle was the best way to dig into his family history and see more of it. But with our rule that the castle only appears every five years, we had to come up with a reason that it's appeared again. We had a Phantom Blot episode earlier in the season, and we wanted to bring him back to get our family closer to the endgame.

FRANK ANGONES: We wanted to make sure that every FOWL agent had at least two episodes: one in the first half, before they were fully working for FOWL and knew what their goal was, and one in the second half, where we knew what the stakes were. It was a gift that Phantom Blot had a magic-sucking device that could bring back Castle McDuck early. And then to explain that away, not as a devastating magical crisis but as the equivalent of when your parents can't get the Wi-Fi to work, and Scrooge is called in and has to come back.

MATT YOUNGBERG: Huey wants to go through this very methodical process of figuring out where the missing mystery is hidden, and Louie does not want to go along with it. He just wants the treasure at the end and is trying to shortcut everything, putting him at odds with Huey.

FRANK ANGONES: Foreshadowing for the finale, this is a whole episode about Webby worried that she's broken Clan McDuck and that she doesn't fit in with its legacy. It's emotionally priming her for the finale. The last time Webby was at Castle McDuck, she just kind of zoned out, and she did not get engaged in the adventure. But this time, she's going to do everything she can. It's the story of a kid who thinks that it's their job to fix a family.

MATT YOUNGBERG: Emotionally, Webby continued to be the centerpiece hiding in plain sight. In this one, it was her feeling of connection to Clan McDuck and wanting so badly to be a part of it and do right by it, and then her fear that she's responsible for breaking it. It put a lot of emotional stakes on her. By the end, all she wanted to do was fix everything and make sure that the family loved each other, but it's not up to her to fix it, because it's not her fault. She didn't break anything—it's just how families are. It was another means to have her connect with the McDuck family in a very personal way.

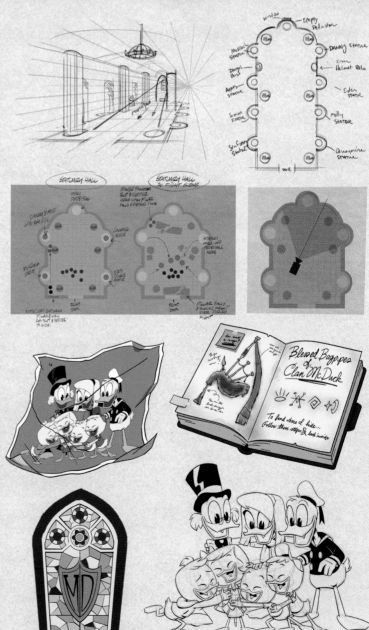

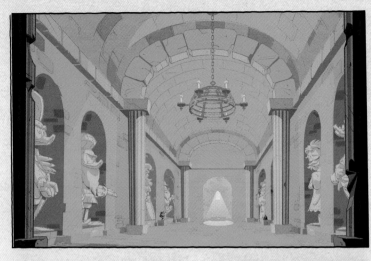

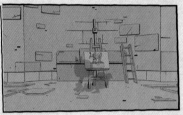

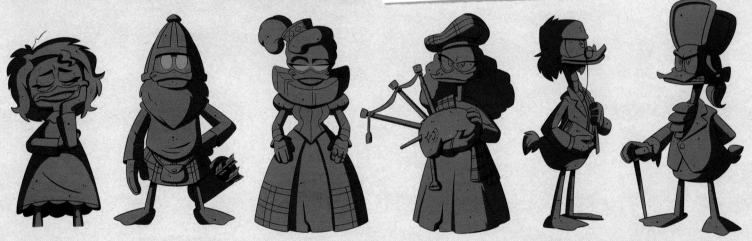

FRANK ANGONES: This was a hard episode, because a lot of these rooms were not built. Hats off to director Matt Humphreys and his team, because the staging of the final fight is a marvel. It is something to behold, to be tracking multiple kids and having multiple characters having multiple arguments, plus multiple giant statues fighting in the background of a room that is slowly coming apart. Sean Jimenez came back to help out on this episode, because he had so much institutional knowledge of Castle McDuck.

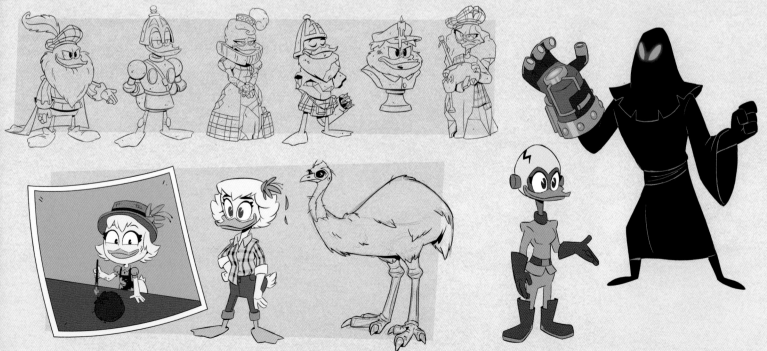

174

"HOW SANTA STOLE CHRISTMAS!"
EPISODE 19

MATT YOUNGBERG: Even though this episode was a standalone, it also tied into some of the things that we had set up throughout the series, especially the idea that Scrooge loves Christmas but hates Santa Claus. We had set that gag up for a couple of seasons, and we knew we needed to pay it off. We knew it wasn't just a gag.

FRANK ANGONES: This was one of those happy accidents, where we had these throwaway jokes about Santa not being allowed in Scrooge's house because of some bitter feud, but I eventually began to wonder about what the source of that falling-out could be. We had done the *Christmas Carol* thing in our first Christmas episode, and the inspiration for this came from all those classic Rankin/Bass specials where Santa Claus was a protagonist, and me realizing that Scrooge McDuck could very easily be the villain of a Rankin/Bass special. Scrooge has so many enemies, but he seems like he hates Santa more than all of them. And this episode was finding out why. What could that have been? It was because it was the first time that Scrooge had a business deal go wrong on him. He'd never had a business deal go wrong on him before. And he felt like he was betrayed by a business partner, and it made him, like, fundamentally untrusting. And it hurt even more because it was also the first time Scrooge had a friend.

MATT YOUNGBERG: Scrooge and Santa were best friends. Scrooge doesn't have very many. Especially in the time period when he meets Santa, Scrooge is a loner trying to make it in the world and make his fortune. And then Scrooge runs into this goodhearted guy who just loves hanging out with him and wants to do best by him, and they had this great relationship and had fun adventures together. We built their friendship to be something that was really important, and then reveal that it died because of this philosophical difference between the two of them, where Santa only wanted to do things out of the goodness of his heart, because it just made him feel good, and Scrooge didn't quite understand that. Scrooge is not a bad guy. He views it as "We spent time building this business together, and you want to just give it away? That's a completely ineffective use of our time." And so Scrooge has to give up what he'd been working towards for Christmas, and Santa takes over. There's this heartbreaking moment between the two of them, from the realization that they can't do this together. Webby says, "Christmas is a sad story." I love that idea that there's this kind of real heart behind the reality of the Christmas within this universe. Scrooge is tied to these mythological creatures and these amazing beings, so let's find the *DuckTales* reason for it. We didn't want it to feel like a classically Christmas episode of something where it was "We have to save Christmas!" It is about saving Christmas, but we wanted to do it as a *DuckTales* adventure within the context of Christmas. Santa was willing to risk Christmas so that he could have his friend back. That's the heart of the episode and why it makes it a classically Christmas episode: because it's about finding the heart behind the holiday. I'm really proud of this episode. It was a lot of work to get it there, but it was a lot of fun.

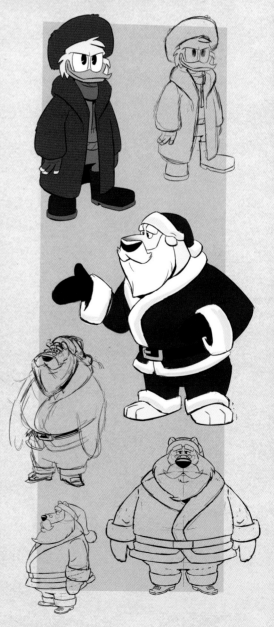

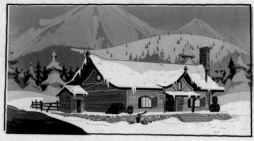

VALERIE SCHWARZ: I was trying to make the backgrounds look like vintage Christmas card illustrations, like Currier and Ives.

"BEAKS IN THE SHELL!"
EPISODE 20

MATT YOUNGBERG: I'm not a big fanboy of many things, but the closest I come is *Ghost in the Shell*, and so when they told me the name of the episode, I was like, "Yeah, okay, we're doing it." The pitch of the premise was very easy for me to say yes to, and the concept was super fun. It's always tough to do a Gizmoduck episode, because you want it to be about Gizmoduck, and certain people want it to be about the kids. And so you have to make sure that you are finding good kid content within the episode, and the fun thing with Gizmoduck is his relationship with Huey. Being able to lean into Huey and Fenton as a comedy duo was really fun.

FRANK ANGONES: We usually liked to do a Gizmoduck-focused episode in the middle of the season, and this was the latest we ever had one, but because of her setup, we didn't want to tip that Gandra Dee was good too early. Ben Siemon came up with the idea of the GizmoCloud standing in for their relationship and not going public, because Gandra's worried that people will judge her. She's not fundamentally a bad person; she just got forced into this series of circumstances that made her make a lot of bad choices, and that's how she ended up with FOWL.

FRANK ANGONES: We had always tried to track the progression of Fenton's ambitions, and the GizmoCloud is something that fully represents who Fenton is. It's his magnum opus, because it's taking science and giving it to everyone. Science should not belong to the super-rich people. It's Fenton and Gandra having this really noble aim, and then seeing how easily it would be corrupted by someone like Beaks coming in, trying to monetize it and make it something dirty. Beaks and Fenton are the exact opposites of each other. They're both brilliant fast talkers, but Beaks does not have an original idea in his head—he can only promote ideas. He can't come up with anything.

Our favorite thing in the world is making Huey neurotic and really pushing him to have to keep a secret. It cemented the friendship between Huey and Fenton to have them be allies. They're the equivalent of Dewey and Launchpad, in terms of the adult friend who they're probably going to grow up to be.

Knowing that this was the last big Gizmoduck episode, you want to have everyone say "blathering blatherskite" and be in their own Gizmoduck armor. You want to have the return of tall Huey!

MATT YOUNGBERG: It's a pretty simple standalone episode, except for the twist at the end, where we start alluding to our endgame when Bradford comes in and orders that Gandra be taken to the Lost Library.

VALERIE SCHWARZ: The look of the virtual world was a mixture of vaporwave, which was my idea, and the colors in the works of Maxfield Parrish, which was Sean Jimenez's idea. Sean came in and did some freelance work on this episode. Because this was supposed to be a virtual dreamscape that Gizmoduck created, and it's his romantic retreat where he hangs out with a secret lover, we were going for a blend of high-tech VR technology and beautiful classical paintings. So it feels very dreamy.

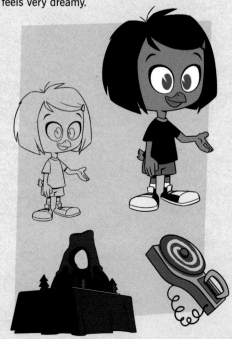

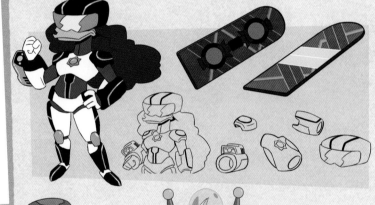
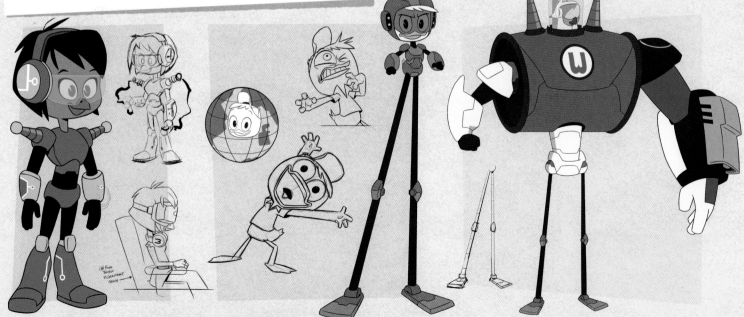

"THE LOST CARGO OF KIT CLOUDKICKER!"
EPISODE 21

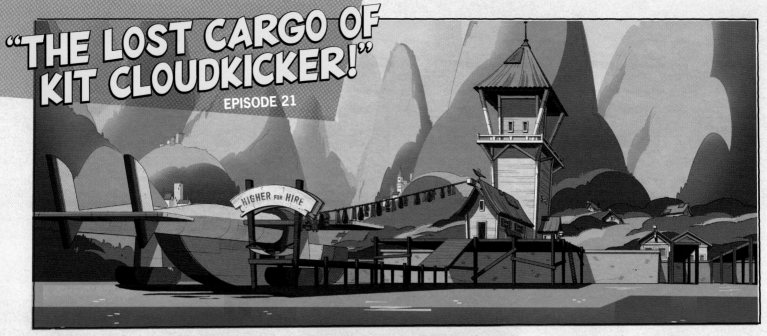

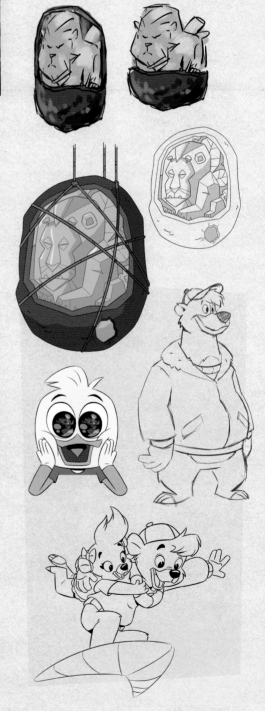

MATT YOUNGBERG: Frank really wanted to do *Darkwing*, and I really wanted to do *TaleSpin*.

FRANK ANGONES: We had introduced Don Karnage in season one, and we wanted to pay that off by introducing the rest of Cape Suzette and the *TaleSpin* world. Tanner Johnson directed this episode, as well as cowrote it with Colleen Evanson.

TANNER JOHNSON: I had a take on *TaleSpin* that I wanted to do, and Frank and Matt felt that it was a good opportunity to incorporate it into the overall arc of the season. I had always assumed that *TaleSpin* happened concurrently with the other Disney Afternoon shows, but it was just in a different part of the world. I was surprised to learn that it was a period show, happening during the 1930s. After I learned that, I thought, if I were to do *TaleSpin*, I would bring it into the current day. And I would have Kit Cloudkicker be the main character, all grown up. And since he idolized and loved Baloo, a grown-up Kit would be just like Baloo.

FRANK ANGONES: If Kit Cloudkicker grew up idolizing Baloo with all of his heart and soul, then this is who he would turn out to be. Kit is ambitious, but maybe Baloo didn't set him right. Kit is eager to prove himself. And then Dewey desperately wants to be the prototypical cool nineties-kid sidekick, with a skyfoil and catch phrases, hanging with Kit, who used to be that cool kid sidekick, but who's now trying really hard to be an ace pilot. It gave us an interesting opportunity to tell a story about not being ashamed of the thing that you're good at, just because you feel you should be good at something else.

MATT YOUNGBERG: This was about giving Dewey his superpower. Basically, the thing that Dewey is great at, it turns out, is being a pilot. This was our chance to kind of really set that up before he gets his big moment in the finale against Don Karnage in the dogfight. It was also fun to play with the idea of Della knowing Kit from flight school and connecting those universes. Kit isn't known for being a good pilot—he's known for his cloudkicking.

FRANK ANGONES: It was tremendous fun to put Huey and Della on a rollicking adventure, with Della being the overly supportive mom, and giving her some history with Kit.

This episode also featured the introduction of the final missing mystery. We knew the Stone of What Was was necessary for the finale, as the creation of Webby involved the merging of DNA with robotics and all kinds of bananas Black Heron technology. In order to create May and June, we had to come up with a reason as to why FOWL had not created them sooner. That's why the Stone of What Was had to be the cargo that Kit had lost in the past and needed to be recovered by FOWL in the present.

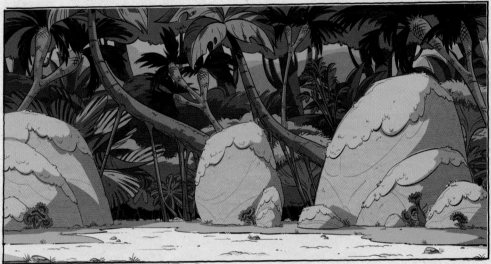

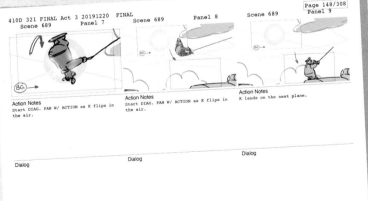

VALERIE SCHWARZ: Since this was another island episode, we wanted it to feel very different, so we gave it giant hilly mountains that look kind of ridiculous. The idea is that even the plants on this island are weird looking, because they've merged together.

The fun thing about this episode was that the colors were really different. On the original *TaleSpin*, the colors were very vibrant, and the background art was so beautiful. So to make it more like that show, we saturated the colors on this episode more than we typically do. The sky was very purple and yellow, which we've never done.

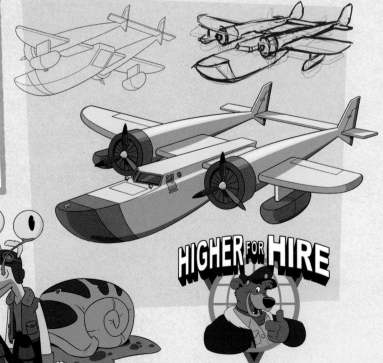

"THE LIFE AND CRIMES OF SCROOGE McDUCK!"
EPISODE 22

FRANK ANGONES: This felt like a really important story to tell at this juncture in the series, because we'd never absolved Scrooge. Scrooge is not a great guy. Scrooge has done a lot of questionable things in his past. It was important for us to show that he'd grown as a person.

In terms of *DuckTales* villains, the big three are the Beagle Boys, Magica, and Glomgold. We wanted to have a progression in the flashbacks, where the first one's not that bad. The second one is a little worse, but Scrooge is still in the clear. And then the third one is pretty bad. We had already done so much of Glomgold's backstory in "Duke Baloney," so his segment was a flashback to him in the eighties, at his height, when he's the new, fun, charismatic billionaire on the scene. This isn't the origin of Duke Baloney—this is the origin of Flintheart Glomgold, the man who's obsessed with sharks and bombs, who went from trying to seem like a good guy to being a straight-up bad guy.

The Beagle Boy segment goes back to our desire to do an episode that showed where Scrooge swindled Duckburg away from Blackheart Beagle—or Pappy Beagle, as Ma calls him. Here, Scrooge is cocky, swaggering, and feeling his oats with not a care in the world. He's going to con con men out of their hard-stolen money. But even that's not that bad, because then you see that Ma Beagle was really the brains behind the outfit all along, even when she was only five.

The last flashback was the big one . . . "Why does Magica hate Scrooge?" In a show that loves triplets and twins, we wanted to have Magica's brother, Poe. Scrooge is coming to face the bad guys, but he's not doing it to save the town. He's doing it for his own profit. Magica was already evil, but we really wanted to get across that her unending ire towards Scrooge was deserved. You have to believe that, in that moment, if Scrooge had been decent, maybe it could have fixed things, and maybe people would have been spared a century's worth of Magica De Spell.

Louie learns that he doesn't want to be someone who creates this many villains. He sees that he was gearing up to have a lifelong enemy in Doofus, who had acquired magical means and recruited other villains in a case of petty revenge. The important thing was to give Scrooge some kind of emotional closure and to really show that he's grown as a person. It was also leaning into the idea of the next generation learning lessons about what not to do, as well as that generation teaching lessons to the older generation. We wanted to show, in as clear a way as possible, that Scrooge has become a better person specifically from his association with his family.

VALERIE SCHWARZ: Sean Kenny did all of the courtroom backgrounds. I felt like the space was so simple that it wouldn't feel as dreamy if it were just in black and white, so we needed to give it some weird color to make it feel more like they're going to be judged in this karmic court. I was specifically referencing an artist named Helen Lundeberg, because she had such a great sense of color. We looked at a lot of surrealist artwork. The space feels very abstract.

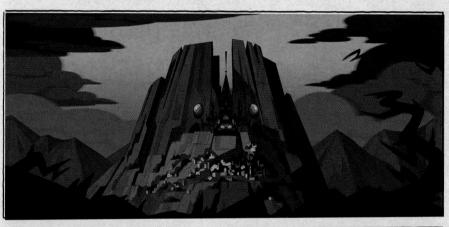

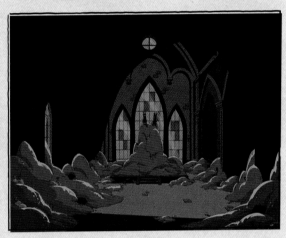

VALERIE SCHWARZ: Miles Schlenker did such a good job with Castle De Spell. In season two, we saw a nightmare version of it, but this is the first time we designed the actual castle. We wanted to firm up the details and have it be more grounded in our show's reality while still feeling like the one we had seen previously.

410D-322 Act 3 "The Life and Crimes of Scrooge McDuck!" Page 204/257

Scene 729 Scene 729 Scene 730
Panel 5 Panel 6 Panel 1

Action Notes
DIAG PAN to Magica

Action Notes
Magica is surprised.

Action Notes
CUT TO H/U:
MED SHOT on VILLAINS as they look down
shocked with their victory

Dialog
198 BAILIFF (CONT)

"...and Magica DeSpell..."

Dialog
198 BAILIFF (CONT)

"...and Magica DeSpell..."

Dialog
198 BAILIFF (CONT)

"...Are respectfully entitled to Scrooge's
fortune,..."

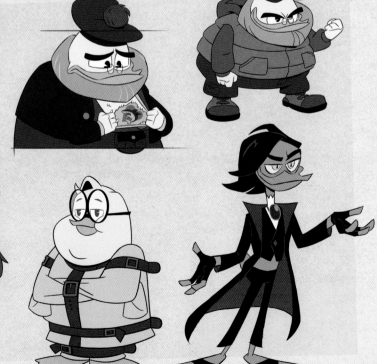

"THE LAST ADVENTURE! PART ONE: A TALE OF THREE WEBBYS!"
EPISODE 23

FRANK ANGONES: This was the endgame. That Webby would be a clone of Scrooge, and therefore his daughter, Matt was shockingly excited about. We didn't talk big plans in the early days, but the fact that he was so gung ho about it made me realize that it was a good idea, as long as we were laying references throughout the entire series that fed into that history. Huey's main drive in this season was to figure out the mystery of the missing mysteries of Isabella Finch, which evolved into figuring out FOWL's plan. But the greatest mystery of our show is "Who is Webby?"

MATT YOUNGBERG: And then the other focus of this episode was "Who are May and June? And who are they to Webby?" They basically go through their own arc in this episode, and we wanted to make sure they weren't just villains. In Webby's eyes, they're her sisters. They had to be fully fledged characters, because if there had been another season, they would have been a part of it. For three seasons, we've been developing Webby into her place in the family, so starting out on her birthday seemed like a really perfect way of solidifying her place, when the whole family is celebrating her.

FRANK ANGONES: Knowing the epic action and depths of craziness that this three-parter was going to go to, we wanted to start in a more intimate place. We had to put a lot of emotional character work in the first part, particularly with Webby, and having her questioning herself for the first time. Webby was so excited to have this surrogate family that she never stopped to wonder what it would be like for her to have her own family. So what happens when someone comes in and says, "No, we are your family as well," and challenges those preconceived notions?

MATT YOUNGBERG: Beakley had been lying to Webby her whole life, knowing that she had been a creation of FOWL, but for the later reveal of the truth to have impact, Beakley's story needed to feel real. When the twist happens, Webby really needs to feel it hit hard, along with the audience. If Beakley didn't say it convincingly to the audience, basically, then the audience is going to see through it right away, and we didn't want that to be the case.

FRANK ANGONES: The big question April and June presented is: "Where does biological family enter into it?" At the end of this episode, it was important that it was Webby's decision not to abandon her family, but instead to go undercover to figure out what's going on. That is very much in her grandmother's training. Taking June's place, tying her up, and then also bringing Huey along for that ride really cements the two of them as the kind of co-leads of this episode. But no matter what, the McDucks are her family.

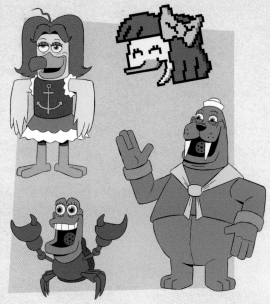

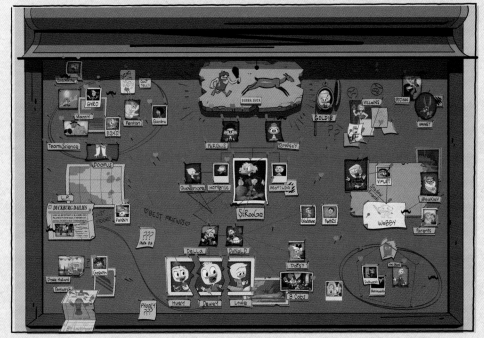

FRANK ANGONES: It was nice to bring back Webby's mystery board and see how it had evolved over the course of our series. It really became our version of the expanded family tree. In a show that is about found family, this is who Webby considered her family.

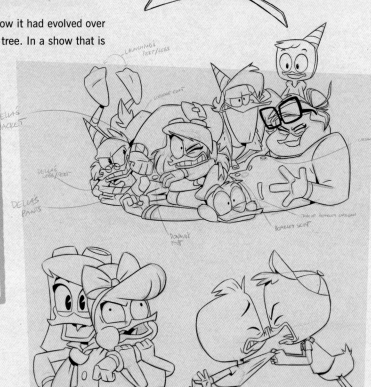

VALERIE SCHWARZ: As these were the final episodes, Matt told the storyboard artists and directors to go more crazy than usual and use more dynamic shots, interesting cinematography, and action. That posed a huge challenge for design, because that's a lot more information to provide to our overseas studios, in order to draw those things in crazy perspective with all that detail. It's a big task. But everyone did such a good job.

"THE LAST ADVENTURE! PART TWO: THE LOST LIBRARY OF ISABELLA FINCH!"

EPISODE 24

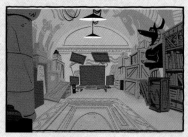

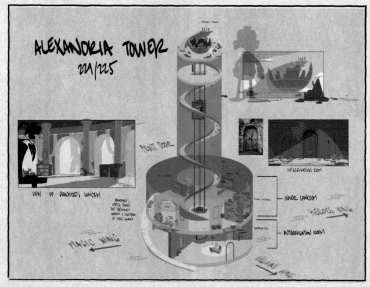

MATT YOUNGBERG: Taken as the second part of our three-part finale, by the end of this one, we needed to get to our lowest emotional point, which is Webby finding out the truth of her past and that Beakley had been lying to her. And we had to deliver it in a way where Webby, upon hearing it, would choose to help Bradford, just because she'd been hurt so bad by the revelation. It's been a build going all the way back to "Mervana," where Beakley promised not to lie to her, and it turns out that was a lie. She thought she was a daughter of someone, raised by her grandmother, but now she's had all of that torn away, and she needs to know the truth—at whatever cost.

FRANK ANGONES: This was even more ambitious than "Moonvasion" in terms of tracking so many different stories, fights, and arcs. Luckily, on our big board of characters, we had laid out which villains were specifically calibrated to fight which heroes, and then defeat those heroes, and then which kids would stand up to those villains. This is where FOWL is at their most competent, so all of our greatest heroes get completely obliterated in the most fun, ridiculous way. It was such an elaborate puzzle, because we knew that we wanted to use every missing mystery in the finale, so they either had to tie into how Webby, May, and June were constructed, or they had to be a weapon that could be used to fight.

MATT YOUNGBERG: This episode really does feel like a big, epic adventure. That's the promise of *DuckTales*: it's a family show, a comedy show, and a globetrotting adventure show. This is our big one. We see Bradford's plan coming together; we understand it more, and get the backstory of Bradford. He was a Junior Woodchuck, he hated doing it, and he despised his grandmother for taking him on all of her adventures. He hated the chaos of the adventures.

FRANK ANGONES: This was the opportunity to split all of our characters off and have them do the thing you've always wanted them to do and give them their last hurrah. We knew that we were tying up all the threads, because the next episode really had to be about family, so this episode had to be about the promise of getting all of these characters in a big blockbuster action movie.

VALERIE SCHWARZ: Designing the Library of Alexandria was a challenge. It was a lot to plan, especially to get the scale right, because it was so massive. It's a big building, but it could easily look small. We needed it to feel massive and intense, because this was the site of the ultimate adventure. Nobody knows what the actual Library of Alexandria looked like, so we went with a blend of Egyptian, Greek, and Roman architecture. It needed to feel extremely old, and everything's crumbling because it's so ancient, but at the same time, Bradford has turned it into his own thing. So his additions are the dark metal ironwork. He's not a designer, and he doesn't care about history; he's just trying to house everything. It's a very stark contrast between the earthy historical architecture and his thick middle Gothic architecture.

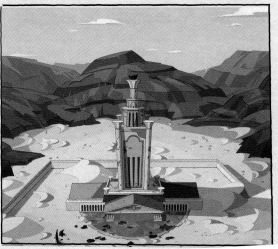
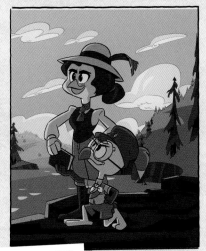

VALERIE SCHWARZ: We originally saw the paintings of Isabella Finch in "Challenge of the Senior Junior Woodchucks!," which were done by Rachel Yung and Tim Artz, and for the reveal in the finale, we had them go back and expand them out to include young Bradford.

410D_324_The_Lost_Library_of_Isabella_Finch1_Act3_20200204 CHECKING
Page 224/405
Panel 1
Scene 717 Panel 4 Scene 717 Panel 5 Scene 718

Action Notes

The Egghead punches with the other fist.

Action Notes

J punches. The Egghead ducks.

Action Notes

CUT TO H/U

Dialog

Dialog

Dialog

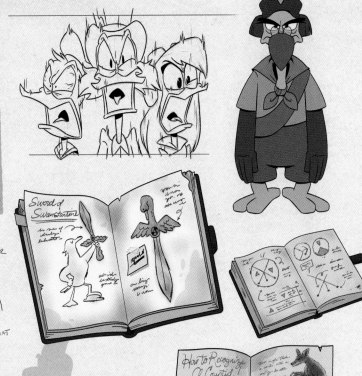

"THE LAST ADVENTURE! PART THREE: TALE'S END!"

EPISODE 25

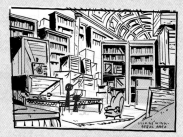

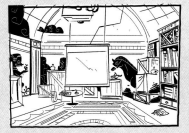

MATT YOUNGBERG: Everything comes to a head. Webby goes along with Bradford, and she finds the Papyrus of Binding, not even realizing what it is. She just thought it was a thing that was going to tell her why she was created. But it's yet another act of betrayal by Bradford, who only created her to get the papyrus. Bradford's ultimate plan is just to get rid of everything fun and adventurous. He doesn't get it, so no one else should get it. It's closed-minded thinking like Bradford's that keeps the world from being interesting. But once he gets the Sword of Swanstantine, it brings out his inner villain.

Scrooge, the nephews, and Donald all exist outside the show, but the two characters that truly make it *DuckTales* are Webby and Launchpad. The whole series was about Webby, but the fight in this episode gave Launchpad his big moment to show why he's important.

FRANK ANGONES: Launchpad is just a dude who flies planes—and doesn't do that well. And he's surrounded by epic myths and superheroes and monsters and clones and secret organizations, and he's feeling really out of his depth. We've established that Launchpad is the patron saint of heroes in the world of *DuckTales*, and so it really gets you when Launchpad puts on the Gizmoduck armor.

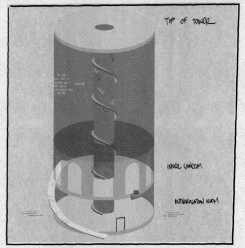

MATT YOUNGBERG: On the roof of the library, Scrooge is at his lowest point as Bradford's plan is laid bare, and he's threatened by the loss of his family. It was a pretty big swing, and a cool thing to do, where the choice was to no longer adventure and have a contract to bind him to it. We took him off the table at the end of this, so that he had to rely on his family, and his family had to rely on the strength of their adventuring spirit that they'd developed through the series.

FRANK ANGONES: Huey is smarter than the smarties. Dewey is tougher than the toughies. Louie is sharper than the sharpies. Our whole point at the end is that Webby earned her way into the family, square. One of the defining moments of the entire series is that after Webby finds out that she is actually related to Scrooge in this insane way, it does not change a single thing, because she already considered all of them family, and vice versa. It's not that she's blood related now, all of a sudden—it's that she earned her place into that family with every step along the way.

The most *DuckTales* way to defeat a villain was to have the villain say, "That's the stupidest thing I've ever heard," and have it work. In the pilot, we made a joke of Launchpad saying, "Family truly is the greatest adventure." We seeded that in all the way through. When we pitched the series, we said, "Look, we will never actually say, 'Family is the greatest adventure of all,' because that's corny." But that was what the show was actually about, and by the end, we earned not only being able to say it, but that it would be the Excalibur that runs through the ultimate villain.

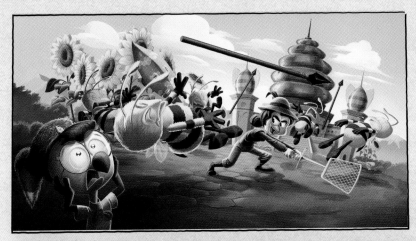

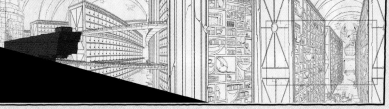

VALERIE SCHWARZ: A banana pan is a camera pan that warps in the shape of a banana, kind of like a fisheye lens. They're really difficult to do, especially in such a rigid environment with so many details in the background. I think it took Miles Schlenker a week to paint this, but it turned out gorgeous.

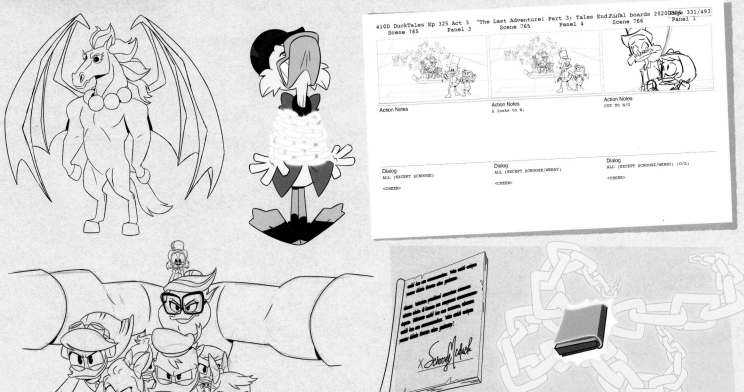

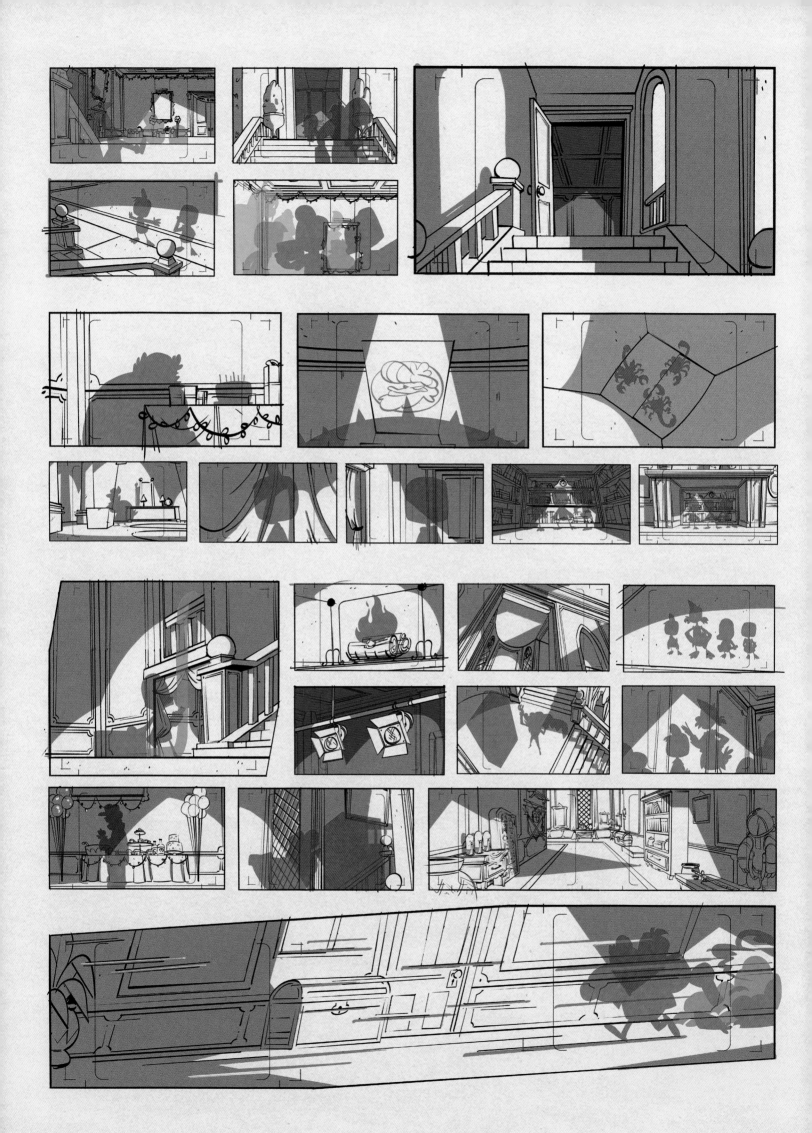

BEYOND DUCKTALES!

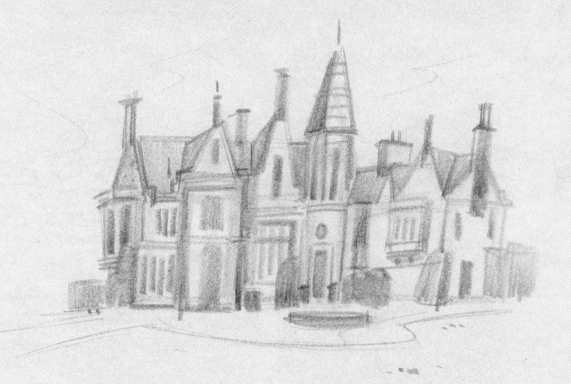

EPCOT: DUCKTALES WORLD SHOWCASE ADVENTURE!

MATT YOUNGBERG: The DuckTales World Showcase Adventure is a scavenger hunt where you get clues and puzzles to solve in the different countries within Epcot's World Showcase. As with all things *DuckTales*, we really wanted it to be something special. It's as close to a show experience as you can get, and we're really proud of it.

FRANK ANGONES: It is tremendously flattering, and I'm very excited that families are able to continue to experience *DuckTales* in Epcot. It's an honor that very few animated series from Disney Television Animation get,

and it was a joy to take one last adventure with everybody. It's a greatest hits, with all of the main family and some of our craziest villains, in a very exciting interactive framework. It was just a natural fit—we're a globetrotting adventure show, Epcot encompasses the globe, and there's an adventure that we can have there. It was plotted with Imagineering, written by our staff, and performed by our amazing cast. I hope that it's an extra little bonus gift when you experience the DuckTales World Showcase Adventure, and you get the feeling that you are on an actual adventure with our duck family.

IT'S A DUCK BLUR!
REFLECTIONS ON MAKING DUCKTALES

FRANK ANGONES (Co–Executive Producer, Story Editor): Before *DuckTales*—creatively, personally, professionally—I wasn't sure who I was. I knew what I was trying to be. I knew the types of stories that it would be great if I could tell. I wasn't sure if I knew how to get there. I was kind of grasping at straws. In the process of making *DuckTales*, we all agreed that the show was fundamentally about family. And so I was able to take my own experiences, my own feelings about my family, my parents, my wife, my kids, my dogs, my friends, and put them into this show, because that was the theme. That's what made sense. And what I didn't know was that by doing that, I was putting everything that I was into the show. Other people did the same thing. Matt did it. The writers did it. Sean did it. Suzanna did it. Every board artist and every director didn't just bring their best—they brought themselves. And in that process, the show became about who each of us were. Over the course of the five years I worked on *DuckTales*—the three seasons—it was the best creative experience of my life. It's the creative experience that I feel like more than a few of us will be constantly comparing all future creative experiences to. I figured out who I was, I figured out the type of thing I wanted to do and the type of show I want to make—which was to take a thing that had been formative to me as a kid, to infuse it with everything that I had learned and everything that mattered to me, and to share that—not just with audiences, obviously, but also with the rest of this crew and cast. It was a tremendous gift. The story of the *DuckTales* production is about found family. This crew became a kind of ramshackle found family who cared about the adventure above all else. The tremendous amount of respect and joy that everyone had for each other came from the top, from Matt, and Matt's willingness to collaborate, to hear ideas, and to encourage people to give their absolute best. We all fed off of that.

It's the happiest thing in the world to say that this show was an adventure. There's truly no other way to explain it. These characters have been around a long time before us, and they'll be around a long time after us. Hopefully, these adventures will live on for viewers, and for ourselves. It's not just being proud of a thing; it's being able to look at a thing and say, "Yeah, that's who I am."

JOHN AOSHIMA (Director): *DuckTales* was something that had been part of my childhood. Being part of this was truly a passion project, where the whole crew was really present and full of encouragement and support. I felt I had a voice in the creative process. There was enough there that I could really allow my imagination to expand out and explore how I could shape an episode. Pulling from the scripts—it allowed me to expand out of a standard kids' show into making it a true adventure show. As a director, I had to live up to the level of attention and detail that was put in the writing and the art. There was a level of character, emotions, and pathos that was missing in other shows. Matt's showrunning style was different than I anticipated, in that he really did give a lot of trust. Most of my directing career was about the animation director aspect of it, and not so much creative, collaborative participation, but *DuckTales* offered that to me and allowed me to stretch my legs in a way where I was able to take everything I'd learned in my career up to that point and put it into my work. I wanted to honor the writing on the screen.

MADISON BATEMAN (Writer): The writers' room chemistry was like lightning in a bottle. Everyone had their own strengths, and everyone's skills just meshed really well together, elevating the stories we told. And personally, we all got along really well. Colleen is the Lena to my Webby, and I'm so grateful for the lifelong friends we made on the show. It made everything more fun. One day in the writers' room we played Carly Rae Jepsen's "Call Me Maybe" fifty-one times in a row. Did it ever get old? Absolutely not. It's the world's most perfect song. Did it drive one of our writers to the brink of madness? Maybe. But, eh, just channel that into writing for Glomgold! I can't believe the number of musical episodes I got to write on *DuckTales*, and I can't believe Matt Youngberg let us do them. He always said he hated musical episodes, and yet every time we pitched one, he just went, "Okay, you sold me. Let's do it!" I feel like if you didn't come into *DuckTales* a musical fan, you were leaving as one, whether you wanted to or not. And hey! We were ahead of the sea shanty craze!

BECK BENNETT (Launchpad McQuack): I was so, so happy to be Launchpad. I feel truly honored to be connected to the legacy of that character. At first, it was like, "Oh, I get to be a part of my childhood." And in the same way that Terry McGovern's Launchpad was passed down to me, my Launchpad will be passed on down to whoever may play Launchpad next. It's really

exciting to be cemented like that. This is something that has been around for a long time and will continue to be around for a long time, so it is kind of unbelievable that I have a stamp on that. Along with *Saturday Night Live*, I've definitely thought about how lucky I am to be part of these huge institutions and have a place in them. The work I've done has a place and a community. I think I was expecting the end of my time on the show to feel more dramatic, and then it was just kind of like, that was it. The sentiment of family at the end of the series stuck with me more than any of the heroic stuff. I really don't know if my Launchpad is going to be coming back, but I could definitely see him coming back. He's a part of the Disney universe, so he'll be around. It's this immortalized feeling—that there's something out there that is me. I feel so lucky. When I think about it—maybe because it's an animated show, but I see this colorful world that includes all the people who created it and were a part of it. I really feel like I was thrown into a group of experts, and I learned a lot while doing it. I don't think I've said this to them before, but a lot of the time, I was just trying to keep up with everybody. I don't think that they would say that it ever felt like I was keeping up, because they liked my Launchpad from the beginning, but I respected everybody so much. I respected what they were doing with the series, with the writing, and even the way that Sam Riegel would direct my voice. I felt like I was with the sweetest, smartest, funniest, hardest-working people. I've done some other animated shows, and it's not always that experience. Even if it's wonderful people, it's not the level of expertise and execution that I experienced working on *DuckTales*. I'll take *DuckTales* with me wherever I go, because I feel like it's the highest bar and helped prepare me for anything I do after.

JASMINE BOCZ (Animation Editor): When I was a little girl, I couldn't wait to get home from school and watch the original *DuckTales*. It allowed me to escape into a world full of adventure, and I often imagined myself being part of the McDuck family. (I believed I was the long-lost sister of Huey, Dewey, and Louie. Unfortunately, Matt and Frank didn't buy into that part of my childhood story!) The original series inspired me to pursue the arts and create my own adventures to share with audiences when I grew up. Little did I know, many years later, my path would lead me to become an editor on the reboot of the very show that started it all for me. I was fortunate to be on the show from the very beginning—cutting the animation test, the first episode, and even the first-look trailer—all the way through to the very last day delivering the series finale (in the middle of a pandemic!). My editorial team also got nominated for an Emmy! It was quite the ride. In the beginning, I was

incredibly nervous that I would fail or that the show would not live up to the expectations I had as a fan. But what transpired over the five years helping to make the new *DuckTales* couldn't have been more opposite. It challenged and pushed me in ways that made me grow professionally, finally allowing me to trust myself as an editor. I was surrounded by incredibly creative and talented artists, writers, and a production team who loved the show. Because so many of us were fans of the original, we poured all of ourselves into our version, wanting to make it better for a new generation. To say those five years were a highlight in my career would be an understatement. I will forever hold that experience, and the people, close to my heart. They will always be my Duckburg family.

PAGET BREWSTER (Della Duck): The people making this show were a happy group of people. They loved it and enjoyed it, and no one there seemed to feel like, "Oh, this is a job. I've got to get the hell out of here." And I was just so thrilled to be a part of it that I would spend hours there, making sure they got whatever they needed and asking if I could do another one, because I just wanted them to be happy. When they told me at my last recording that it was the last episode of the series, I burst into tears. It still makes me sad to think about it. It was so upsetting that we didn't get to do more. It was just such a validating, exciting, fun group of people and a part of my life that I'm so proud of. I love that Della made it back. I love that she would go on adventures. There's something beautiful about the idea that these characters, whether you see them on TV or not, they're still out there together, adventuring.

DON CHEADLE (Donald Duck): I think what's really evident for me was how much of an art form animation voice acting is, and how important it is to have the right people guiding you through that experience—especially someone like me, who was pretty much a novice to it. Really trying to be in the

pocket and understand that you're going to be animated to, and then having an idea of what that's going to require, is totally not something to do in the blind. I was very happy to have them there and willing to trust when they said, "You can go bigger" or "This needs to be modulated in this way" or any of the guidance that they gave me. I was really happy about it, because I needed every note. They wanted it to be a fun experience, and it was. It's a lot of fun to be a part of that legacy, to be only the fourth person who's voiced Donald Duck, and to be on another show, in another form, with my good friend Ben Schwartz.

EMMY CICIEREGA (Storyboard Artist): Working on *DuckTales* felt like I made it and that I could be really proud of myself. I was so scared all the time, and I didn't need to be. That, to me, was a huge revelation. The fear isn't gone, but *DuckTales* got me from a really intense fear to a small fear that I can stamp

out. And that was very important to me. Everything I learned on *DuckTales* set me up for going forward in a way I never thought I would be able to. I'll always remember everyone's enthusiasm. Everybody was fantastic to work with. When you work isolated, like I do, you get lost in your head a lot, and after every time that I would touch base with the crew, I'd be like, "Okay, now I know what I'm doing is right, and they appreciate it."

CHRIS DIAMANTOPOULOS (Drake Mallard / Darkwing Duck, Storkules): There were many things that made *DuckTales* unique. For me, just from the standpoint of the characters I got to play—from Storkules to Mikey Melon to Darkwing—it really gave me a chance to try out different angles of my vocal range and personalities. There was also something really beautiful in the fact

that they entrusted me with these characters. I felt very, very honored to lend my voice to this universe. I think that it was just a great collaborative spirit there. Every session was one of those sessions that I just didn't want to end. One of the later sessions that we did was after COVID hit, and having to do it while not actually in the room with them was so challenging, because they give so much great energy that the performance comes out easily. In all honesty, I pinch myself. I feel so fortunate and grateful to be able to work with these really brilliant, lovely people who give me gold on a platter, with such great material, artwork, animation, and beloved characters, and allow me the license to play with them.

COLLEEN EVANSON (Writer): Back in May of 2019, we were wrapping up the season three writers' room when the hashtag #WhyILoveDuckTales started trending. It wasn't anything started by some Disney marketing strategy or anyone on the crew; it was fully fan generated, and my succinct addition to it still stands today. *DuckTales* gave me my first credit as a staff writer. It's crazy to me how silly ideas from my brain got written down, approved by executives, drawn by talented artists, and voiced by an all-star cast. Life there truly was like a hurricane.

JOHN HODGMAN (John D. Rockerduck): It's a strange thing, because I was too old to get into the original *DuckTales* when it came out. So I was unaware for a long time of what a rich extended universe existed around Carl Barks's whole duck family, and how much smart social satire it engaged in. I just thought it was a kids' cartoon. Once I rediscovered it and the comics it was based on while researching Rockerduck, I began to realize, "Oh, this is really something very special." And then when I got to see the show that Matt and Frank made, I was like, "Oh, this is something incredibly special," because it explored and deepened that world. The humor was so sharp, and so funny, and the characters were so well drawn, and the acting was so incredible. I am very, very proud to be part of this extended universe. I love that I get to play this little character who can come back. I felt very honored. I think that this is something really, really special that they made, and I know these characters will return someday.

MATT HUMPHREYS (Director): Ironically, right before I got on *DuckTales*, all I had worked on almost my entire career were reboots of old properties that I grew up with. And I told myself, "I don't think I want to ever work

on a reboot again." And then Tanner Johnson told me about the impending *DuckTales* reboot, and it was such a huge part of my childhood that I said, "I guess I have to do it, but it's never going to be as good as the original." And then every day, walking into work and seeing how much love and heart was put into every single bit of this show—it made me feel like we were going beyond the original. Being a part of this changed my entire life. I learned a lot about myself as a creator. I'd always been a workhorse, but this was the show that made me realize there is love in creating. Matt Youngberg gave me that opportunity by promoting me to director, and Frank offered me that by allowing me to collaborate on script notes. His writers' room made me realize I wanted to write, as well. I watched every season of this show be about our characters' journey of growth and coming together as a family, and that was reflected in our crew. We all grew as creators, we all grew as people, and we all changed from who we were at the very beginning of this show, on a fundamental level. This group of people gave every bit of themselves to this show and to each other. Our show ended up having just the perfect collaborative crew, in that everybody supported everyone. It was ridiculous. You always waited for the other shoe to drop, but everybody was just there for everyone else. It was a show of a lifetime. Every show after this is going to be compared to it. It's going to be hard to gather this exact group of people again, but knowing that you will eventually work with one or two of them again here and there just really warms my heart, knowing that this family is going to endure.

MARC EVAN JACKSON (Bradford Buzzard): Being part of *DuckTales* was meaningful to me. I don't know if I can say that it was formative, but *DuckTales* was on at four and four thirty, Monday through Friday, in my junior and senior years at college, and I watched it all the time. So for a wallflower C student from Buffalo, New York, to later be able to connect those dots and go, "That universe that I spent so much time living in, in my early twenties, I now get to be a part of," is remarkable and feels very cool. I feel the same way about the cast, which is such a powerhouse of cool and accomplished people from different neighborhoods of entertainment—from comedy to legit movie stars. It's an honor to be a part of that group, and to be allowed to come and play in that playground, and to work with that material written by those writers. *DuckTales* is such a flagship project for Disney that it's not just a gig. It's something that you care about. I do plenty of work where you kind of go in and do it, and they say, "Thanks, I think we got it." *DuckTales* was a job where you'd go in, and you'd say, "Show me everything you have, like, as much of the animatic as you want to show me." It's an entire universe. And its notion of family and adventure was meaningful. It's not about greed. It's not about money. It's about what it means to be a family and to experience things together.

SEAN JIMENEZ (Art Director): *DuckTales* was the greatest opportunity that I've had in my career. It's not super easy to become an art director. I've worked with tons of people in my career, but I don't think about any of them in the way I think about Matt, Frank, Suzanna, and Laura. As you get older, you start realizing how there's an alchemy to getting the right people together, or a thing doesn't work. For me, my life changed the moment that Suzanna probably said, "I know somebody who's great, and I think you should meet him." And then I met Frank and Matt, and I had an instinct that this was a great team. And now I know for a fact that it was a great team. It's always easier to look back on the work you've done when it looks as though that's

the way it was always meant to be. But when you're in it, doing the work, it could be a million different ways. And it was always really nerve-racking to guide it into the direction that we now see as the finished show. I look back on all this art with fondness, and when I look back on *DuckTales*, I remember the joyous camaraderie. It was a family. And that's what's most important to me. Our entire team of artists was just so great, and it made everything we did deeply satisfying, to know we were doing something special.

TANNER JOHNSON (Director): *DuckTales* was a once-in-a-lifetime experience that I will spend the rest of my career trying to duplicate. It was a crew becoming friends and becoming family. I truly look back on everybody that worked on the show as a dear friend, and some are as close as family. One of the things that was great about this show was we weren't siloed away from each other like a lot of productions. There was a lot of free exchange between departments, and I think everybody brought their best ideas. And that's why the show ended up being as great as it is. It was an immense creative satisfaction and creative fulfillment working on this show, and I will never forget it.

SAM KING (Storyboard Artist): This was the first time that I felt free to be really passionate about the work. Frank and Matt cared so much about the show that it gave me permission to care. And because of that, stuff that was important to me that might not have been on Frank or Matt's radar, I felt safe telling them, "Hey, I have an idea about this." And even if it didn't end up going anywhere, I always felt heard. And because I was allowed to be passionate and to care about my job without feeling embarrassed about it, that pushed me to continually get better. And they did that for everyone on the crew. It's clichéd to say, but I wouldn't have believed in myself in the same way if I didn't have these people in my corner, who gave me room to grow but also were there to help me if I stumbled. Everyone was there to make a good show, everyone really loved *DuckTales*, and I think that comes through in the final product.

DOMINIC LEWIS (Composer): Matt and Frank were a dream to work with, and I hadn't had as pleasant an experience with anyone else. They're just awesome. It takes very special people and a very, very special understanding of the characters on the show to create something as wonderful as what they did. You can reboot whatever you want, but if the wrong person is at the helm, it wouldn't be the same. I hope we get to work together again. It's actually quite upsetting to think that I'm not able

to come into work and be like, "Okay, well, I get to hang out with Scrooge today." I didn't want to let it go. You love it, and you live for writing it, and then it finishes. The show was the amazing people behind it: from the top on down, every single person involved was so passionate and wanted to do the very best, and it really shows. It's a real testament to how much people care, and it's very rare to be part of a project like that. It had a humanity. I feel extremely lucky and emotional about being part of this awesome show.

YURI LOWENTHAL (Mr. Drake): And the scripts were fall-down funny!

CHRISTIAN MAGALHAES (Writer): The great thing about working on *DuckTales* was that it was just such a group of nerds—especially in the writing room, with Frank as head writer. Because at some point, it became more than just "How do we reboot this show?" It became "How do we pay homage to the entire canon of both *DuckTales* and *Uncle Scrooge* comics, but also the Disney Afternoon that we grew up on, that introduced us to *DuckTales*?" And suddenly, the world expanded, to where we could find ourselves exploring tidbits from the *DuckTales* video game to the comic books. It became an endless well for us. The reference points were not just cartoons but cinematic and literary, and we had a staff that was really open to that. It starts from the top, with Matt and Frank. It was a tough show to produce, because it was tremendously ambitious. There were times where we handed in scripts, and I was just like, "I'm sorry. I don't really know how you're going to pull this off. It's so dense." But then someone like Sean will look at that and go, "Let's figure out how to pull this off." As writers, we spend a lot of time thinking of these stories, but then you have to actually make it. And the *DuckTales* team would find a way. The writers on *DuckTales* had a really great chemistry. We were really close. There was not a lot of competition, which is a problem with a lot of writers' rooms, where there can be a lot of edginess in the room. We were a united front as a writing group, trying to get our ideas across as a unit. If you're going to make a show like this, which is a reboot with such a long legacy and a lot of expectations, you'd better really love it. We got away with so much more than I think anyone thought we could, and it's because there was so much passion behind it. What allowed it to succeed, by any metric, is the passion and love to do something special with this property.

KATE MICUCCI (Webby Vanderquack): The thing about *DuckTales* that made it such a success is that each character, in the way that they wrote them, you saw their heart. There was so much heart to this whole show. It was so much fun to bring these characters to life, because the show was so well written. It was a really fun thing to get to act out. The years with this project and this crew and cast—it was very much a family feeling. That's not always the case with animated shows, especially ones that you don't get to record with the rest of the cast, but we all really felt connected. The recordings for *DuckTales* were just so fun, because of everyone involved. Sam Riegel was such an incredible director. I wish that we all could have recorded together, but when you have such a successful cast, it's just impossible. It's a genuinely good group of people, and I feel so lucky to be a part of it and to get to do a character that's so cool. It was really special, and I'm really going to miss it.

Disney Television Animation OPENING CREDITS

PANEL 1 PANEL 2

Action Notes Action Notes

Dialog Dialog

Revision Notes Revision Notes

LIN-MANUEL MIRANDA (Fenton Crackshell-Cabrera / Gizmoduck): Every time I was in the recording booth for *DuckTales*, it was the most fun part of my month. It wasn't that much of a time commitment, probably four hours every couple months, but they were remarkably consistent in the way they approached their actors. I've done voice-over work before. Sometimes a project stays consistent, but whoever's on the other side of the camera can change a lot. But on *DuckTales*, it was always Frank and the great Sam Riegel, who was directing me every time I was up to the microphone. We had a great shorthand, and it was an incredibly funny room. You were allowed to play with and improve on things and try things. There was a lot of liberty in what we were able to bring to it. And I got to yell "Blathering blatherskite!" at the top of my lungs . . . But we did learn to save those to the end of every recording session, so I wouldn't blow out my voice!

TIM MOEN (Lead Character Designer): When I think of my time working on *DuckTales*, the word that comes to mind is *special*. I had the opportunity to be on the show for five years, and they were all awesome. Right from the start, I knew that the caliber of my work had to be higher than anything I had ever done before. I was being entrusted to help redesign legendary, internationally renowned characters. It was not a time to slack off! To be honest, I simply needed to learn how to become a better character designer. Alex Kirwan, who had been the lead character designer through the development phase of *DuckTales*, graciously handed the baton to me with great encouragement and was a fine example. I learned a lot from him in those early days, and I also learned a lot from the talented character designers who worked on my team. They all brought something unique and special to the show, and if I'm lucky, I'll remember the techniques I stole from them for the rest of my career! It was a great team, an exciting challenge, and a lot of prayer that got me through those three wonderful seasons in Duckburg. Even after my time on the show was up, I had the opportunity to design promotional images for the *DuckTales* podcast, and I hope I get to say hello to Scrooge 'n' the fam from time to time with little assignments like that. There are a lot of forgotten cartoons out there in the ether, but I somehow doubt our show will be one of them. It will always be an honor to say, "I worked on *DuckTales*."

BOBBY MOYNIHAN (Louie Duck): I'm not an amazing voice-over artist like some people out there that have mastered the craft, but I've been on enough shows to know *DuckTales* had crazy-good writing. It was amazing comedy to perform. There was a lot of adventure, but then these heart-wrenching moments. It's crazy to have a young daughter and, for the first time in my life, not be selfish, like, "I can't wait to show her Louie," but instead be like, "Oh, I can't wait to show her Webby, because that's the coolest character ever." She's going to grow up with Kate Micucci's Webby as a role model, and that's the best. Frank and Matt did that. As a cast, we had so many amazing experiences together, like the day we were in the Disneyland

parade. Here are these people that I've spent years doing comedy with, and it's this reward of "Now you're in a parade. Oh, and by the way, you're Louie Duck and a part of Disney history." That is not lost on me at all. I've been lucky enough to follow the things that I have loved since I was a kid, keep following them, meet people who have that same love, and get to work with those people. That's the best part of this whole thing.

TOKS OLAGUNDOYE (Mrs. Beakley): Sometimes, when I leave a job, there was somebody that I didn't get along with, or there's an episode I didn't do the way I wanted to, and there'll be a feeling that sticks with me that I didn't really enjoy the experience. I don't have that with *DuckTales*. I don't have any regrets about any of it. I enjoyed working with everybody, hanging out with everybody, and everything that I got to do for the character. I just really enjoyed all of it.

SUZANNA OLSON (Producer): The moment Matt, Frank, Sean, and I sat down in my office to blue-sky what kind of series and production we hoped to create, I had a thrilling feeling that this team and series would be something uniquely special. That feeling only continued as our incredible crew and voice talent came onboard and made this show what it is. We were all keenly aware and humbly honored to be a part of the Duck and McDuck legacy, and I hope we have inspired others through the characters, stories, and artwork. We left it all on the screen, and I couldn't be more proud to have been a part of this incredible family of humans . . . and ducks.

TARA PLATT (Mrs. Drake): I remember we laughed a lot. When you're recording, you're behind a glass wall, and you can see other people, but you can't hear them. As we would finish recording a scene, we would look, and the director and producers would be sprawled out, laughing hysterically.

DANNY PUDI (Huey Duck): When I was cast and I heard about the world that they were building, it was tremendously exciting. Then I heard about the cast itself, with Kate, Ben, Bobby, David, Toks, and Beck, and felt like they were creating such a special world of people who were true fans of this show as

Disney Television Animation OPENING CREDITS PANEL 1 PANEL 2

Action Notes

Dialog Dialog

Revision Notes Revision Notes

kids. We felt like a true TV ensemble. It was a group of tremendously talented actors, and everyone brought their own spirit and energy to this project in a different way. And then it just kept building from there, whether it was Jim Rash or Lin-Manuel Miranda or Don Cheadle, and then ultimately with Paget, who was just the perfect person to inhabit our mom. Even though we would record separately, we felt like a true ensemble, despite being all over the world. I loved hearing everyone's lines of dialogue, because they all inhabited such fun characters. And then ultimately seeing the episodes on TV with my kids—and seeing how the animation came to be and how Frank and Matt crafted this world—was such a treat. From the beginning,

it didn't feel like a typical project to me. It felt like something that everyone wanted to do for fun. Everyone on this show made things better, whether it was the animation, the writing, or the cast. I always felt like each layer made the show special. It felt like everyone was really having fun doing this show, across all levels. This was such a fulfilling job as an actor and as a person. This was the first show that I could truly celebrate and watch with my kids, and that felt really special. My kids were included in this process from the beginning, they were always welcomed into the fold, and that felt really cool. I was sad this show ended, but I was thankful that I was able to be with this great group of people, as a little piece in this beautiful, funny puzzle. I cherish just being part of this legacy and these stories.

JIM RASH (Gyro Gearloose): I love doing animation. It's one thing to do live action, but there's something about animation and being a part of that and watching it come alive that is a very special thing. I'm very grateful to have been a part of *DuckTales*, quite honestly, because it was just a smart and entertaining show for a full scale of ages. I always had a blast at recording sessions. They were so fun and supportive.

JASON REICHER (Storyboard Artist): My time working in Duckburg was a total education in filmmaking. As a storyboard artist, I expected my duties to consist of drawing flat, wide, cartoony compositions—like the only other full-time job I had before. *DuckTales* was different. Under the guidance of Matt Youngberg and Frank Angones, we were encouraged to draw dynamic, cinematic, thrilling, and emotional storyboards to support the vision of the show thought up in the writers' room. Oh yeah, and there was space for comedy, too. Our references were classic cinema and anime more than classic American cartoons. As someone who expected to only draw the classic Disney characters they grew up loving, this was a huge learning experience. I'd like to thank my directors—Dana Terrace, Tanner Johnson, John Aoshima, and Jason Zurek—for their passionate leadership and the skills they passed down to me that I still use today. I'll always remember walking to get coffee with my cube neighbor, Ben Holm, where we'd talk story, help each other out with tough scenes, and—most importantly—motivate each other to do work we'd be proud of and that the show deserved. Life felt like a hurricane on this show, but now that we're done, I'm pleased to admit that we all definitely rewrote history.

LAURA LEGANZA REYNOLDS (Line Producer): I come from being at Pixar for twelve years. I drank the Kool-Aid and firmly believe in a director-driven studio show. And when I joined *DuckTales*, I brought that with me. Our job as production people is to make space for the creative. Matt Youngberg reminded me very much of Brad Bird and Pete Docter, both of whom I worked with at Pixar very closely. They know what's important to them and what's important to telling the story—and if they have to, what they can let go of, because it's not going to push the story forward. Matt Youngberg was very much that kind of person. It was really about laying out a plan and then being able to shift that plan, sort of moment by moment, depending on what the creative needed. I call it "the Zen of production"—you make a plan, you throw out the plan . . . You can never be attached to the plan. It's our job to support the creative, and if the plan doesn't work for the creative, you make a new plan. *DuckTales* was the best thing I ever did. I've had a great career. I'm very proud of my career. I've worked on some great projects, from

The Iron Giant to *Up*, and *DuckTales* was the best adventure I've had in my career. The stories were as well written as any movie I ever worked on at Pixar. The creatives were as brilliant as anybody I've ever worked with, and it was the place where I felt most valued for who I am and what I brought to the table. So I was very sad to see it end but very grateful for the experience.

SAM RIEGEL (Dialogue Director): *DuckTales* evokes nostalgia in some, but for me, the thrill of this show was assembling a dream team of comedic geniuses and just kinda . . . letting them do their thing. And I don't only mean the main cast. Of course, Bobby, Danny, Ben, Kate, David, Beck, and Toks are tremendously talented actors and comedy pros. Watching them riff was a spectacular, sidesplitting experience. But our little reboot also attracted hands down the best guest cast I've ever seen. Paget Brewster, Jim Rash, Marc Evan Jackson, Jaime Camil, Josh Brener, Lin-Manuel Miranda, Paul F. Tompkins, Stephanie Beatriz, Allison Janney—I mean, these people are *hilarious*. As the voice director, I had a front-row seat to three seasons of the best comedy I will ever witness. For all those laughs, I'm truly grateful.

BEN SCHWARTZ (Dewey Duck): Being part of this show was an honor and a privilege. It's something that I feel very, very fortunate about. The idea that kids may watch ours and then watch the original makes me even happier. Both Bobby and I would fanboy all the time that we had lines with Donald Duck. I'm like, "Oh my god, I'm talking to Donald Duck." Me and Darkwing Duck was another huge one. Bobby and I always relished those little moments. And I always loved reading the scripts. When you do voice-over, you learn that a lot of people don't really read the script, because you can just go in there and do your lines. But I always read all the scripts, because coming from a writing background, I was always so excited by the *DuckTales* scripts. If you look at the casting on this show, it's unbelievable. From the top to the bottom of this cast, it's crazy. We had so many all-stars, not only in our main, but our guest cast is ludicrous. And Sam Riegel was an incredible voice director. I don't think animation voice directors get enough credit. I've been around many of them now, and when you get a good one, you can flow. He's so calm and so smart. We didn't really get to spend that much time together as a cast, except at conventions. Once, we all went to Disneyland, which was one of the most fun things we'd ever done. We did the parade, and it was crazy to realize, "Oh, right. We're part of this whole legacy." After hours and hours of press, I remember the fun thing about Disneyland was that we could hang out in the park and go on the rides with a guide, which was a huge bonus for someone who loves Disneyland. I remember texting Frank and Matt and some of the folks from the show and finding a way to grab them into our group, so all of us could do these things together. It was so fun and so special that we all got

to play together. It was special to be in Disneyland and going on rides and just be happy with people that you've been creative with but haven't been able to be around. I think we're all very proud to be part of *DuckTales*, because the show was so good.

VALERIE SCHWARZ (Assistant Art Director): *DuckTales* was my first gig ever in the industry, and I couldn't have asked for a better first experience with a better crew. I know it's easy to say that, but it's true. Everyone was just so inspiring. To have someone like Sean Jimenez as a boss was the coolest thing.

Working on a property that's so big and so special and so close to people's hearts was such an honor. It was a home for almost five years, and it's pretty rare in animation to have a gig for that long, especially your first one, but it had such great leadership, and I had a team that strongly believed in me.

BOB SNOW (Writer): As a kid watching the original *DuckTales* show, I knew, in the intuitive way kids do, that there was something special about it. It wasn't just that the characters and the stories and the art were so delightful and fun. There was something extra about it, some ineffable quality that I couldn't quite put my finger on. Later, when I discovered the Carl Barks comics that the show was based on, I noticed that same quality. And when I was granted the incredible opportunity to write for the new *DuckTales*, I began to wonder if we could possibly re-create whatever that special something was in our version of the show. Of course, I wanted our version of the show to be as special to new audiences as the original was for me. But eventually, as the show got going, I stopped worrying about achieving that magical, mysterious quality and simply focused on doing my best with our incredible team of collaborators. And what an amazing collaborative experience it was. It was as if every artist, writer, executive, and producer was not just making a show but working for some higher purpose that was bigger than any of us. And with that spirit, we all worked tirelessly to make something that I am truly proud of. Only now, looking back, does it finally occur to me what that special something was. It was love—the love Carl Barks had for the characters and the world he created that was carried on in the '87 show and finally in ours. I only hope that young audiences watching now feel that same special something that I did when I was a kid: the love we put into it.

DAVID TENNANT (Scrooge McDuck): I feel hugely fortunate to have slightly stumbled into something that is so great, frankly. And this is on me, but I didn't get how important this show was to people until I was part of it. To have been chosen to be part of it is a wonderful thing, especially as the show was so joyously received and so enthusiastically welcomed back. They managed to pull off that really difficult trick of doing something which works for the fans of the show who are now adults and have it be as fulfilling for them as for the new generation for whom the show was really being made. Kids enjoyed it and were excited by it and went on that same kind of journey of wonder that the people who made the show went on, way back when, thanks to these wonderful stories. When they put us in a car and chugged us down Disneyland's Main Street, I thought it was wonderful and lovely to be part of that, but I couldn't help thinking, "We're the voices! Nobody knows who we are!" Those little kids are going, "Why are those people not dressed up?" There were lots of quite extraordinary moments to do with *DuckTales*. I kept being surprised by how enthusiastic people were about it—not because it didn't deserve people to be, but when you're just a voice in a booth on your own, in London, it's quite hard to imagine it impacting the world in the way that clearly it has. It's lovely to be in Disneyland and there's Scrooge, and to go, "Yeah, that's me these days." I'm carrying that torch for a while, and it's a very nice place to be. To be part of an ongoing legacy of a character that is certainly bigger than any one of us who have carried the flame for a while is very humbling. To get to be Scrooge, for now, is something I'm very proud of and very chuffed about.

DANA TERRACE (Director): I remember my first week directing on *DuckTales*—I was so nervous I would shut my office door just so I could panic in peace. I had a lot of respect for Matt and Frank, I loved the way they reimagined the triplets, and I wanted to do a good job! I was only on the show for a year, but it remains to this day one of my most rewarding experiences in animation. The episodes were fun, the team was skilled as heck, and I'm forever thankful to have been a part of that crew. Woo-oo!

PAUL F. TOMPKINS (Gladstone Gander): Anytime I walked into that booth, I was greeted with so much positivity. Beyond everyone just being incredibly warm and welcoming, you could tell that everyone was happy to be there, and that they enjoyed what they were making. That's the best vibe to walk into. I am so grateful to have been a part of this world, which I know is so meaningful to so many people.

MATT YOUNGBERG (Executive Producer): Working on *DuckTales* was the highlight of my career. For all the challenges and expectations that went into making *DuckTales*, I couldn't have asked for a better experience. The crew was fantastic, and it really was a family. I love the crew and the people who worked on the show and the heart that they put into it. I made lifelong friends on this show. I didn't know Frank prior to *DuckTales*, and now I'd say that Frank is one of my best friends, and I hope to work with him again and forever, because he's so good. The whole production team was amazing, particularly Suzanna Olson and Laura Reynolds. It was just a world-class crew, all the way around. I couldn't have made the show without them. It came during a very chaotic time in my personal life, but *DuckTales* was always a home away from home. It was the found family that I needed in my life. I'd done a lot of action-adventure shows before and was always coming off of somebody else's take on them. *DuckTales* was truest to what I wanted to make. When you're work for hire, sometimes you just make things for people. But I felt we made *DuckTales* for ourselves, and it felt good to have such a personal touch on it.

JASON ZUREK (Director): As directors, I've come to realize that we had a lot of creative control over our episodes on *DuckTales*. There's a lot more of a director's personality stamped onto each episode, more so than you might have on a different show. It's really unique, and it's something I definitely appreciated at the time. And I was lucky to have a really awesome board team throughout. The work was definitely hard at times, but even at the hardest times, this show was an amazing experience.

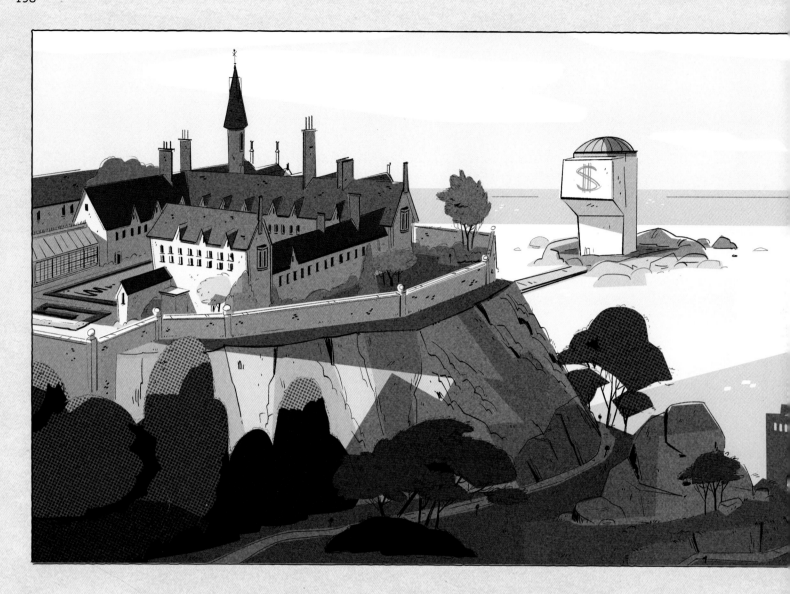

CREW CONTRIBUTOR CREDITS

& SPECIAL THANKS

CREW CONTRIBUTOR CREDITS

Matt Youngberg

Francisco Angones

Suzanna Olson

Sean Jimenez

Laura Leganza Reynolds

Timothy A. Moen

Valerie Schwarz

David Christopher Cole

Chris Hooten

Kat Kosmala

Jeremiah Alcorn

Cameron Butler

Leila Tilghman

Amy Rocchio

Morgan McManus

DARK HORSE SPECIAL THANKS

David Tennant	Chris Diamantopoulos	Tanner Johnson
Kate Micucci	Yuri Lowenthal	Dana Terrace
Danny Pudi	Tara Platt	Jason Zurek
Ben Schwartz	John Hodgman	Jason Reicher
Bobby Moynihan	Don Cheadle	Sam Riegel
Beck Bennett	Madison Bateman	Jasmine Bocz
Toks Olagundoye	Colleen Evanson	Dominic Lewis
Paget Brewster	Christian Magalhaes	Chris Troise
Lin-Manuel Miranda	Bob Snow	Eugene Paraszczuk
Jim Rash	Emmy Cicierega	Nick McWhorter
Paul F. Tompkins	Sam King	Annie Gullion
Marc Evan Jackson	John Aoshima	Jemiah Jefferson
	Matt Humphreys	

This book is the product of the hard work of hundreds of individuals who contributed in ways big, small, visible, and invisible. To all who worked on aspects of this book and to those who created the show that it celebrates, thank you, from the bottom of our hearts.

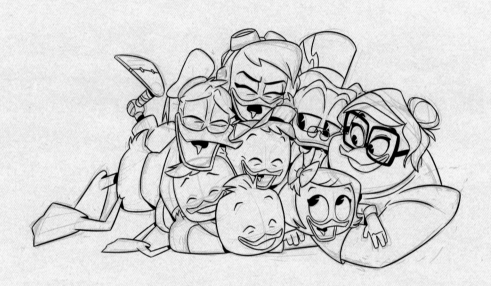

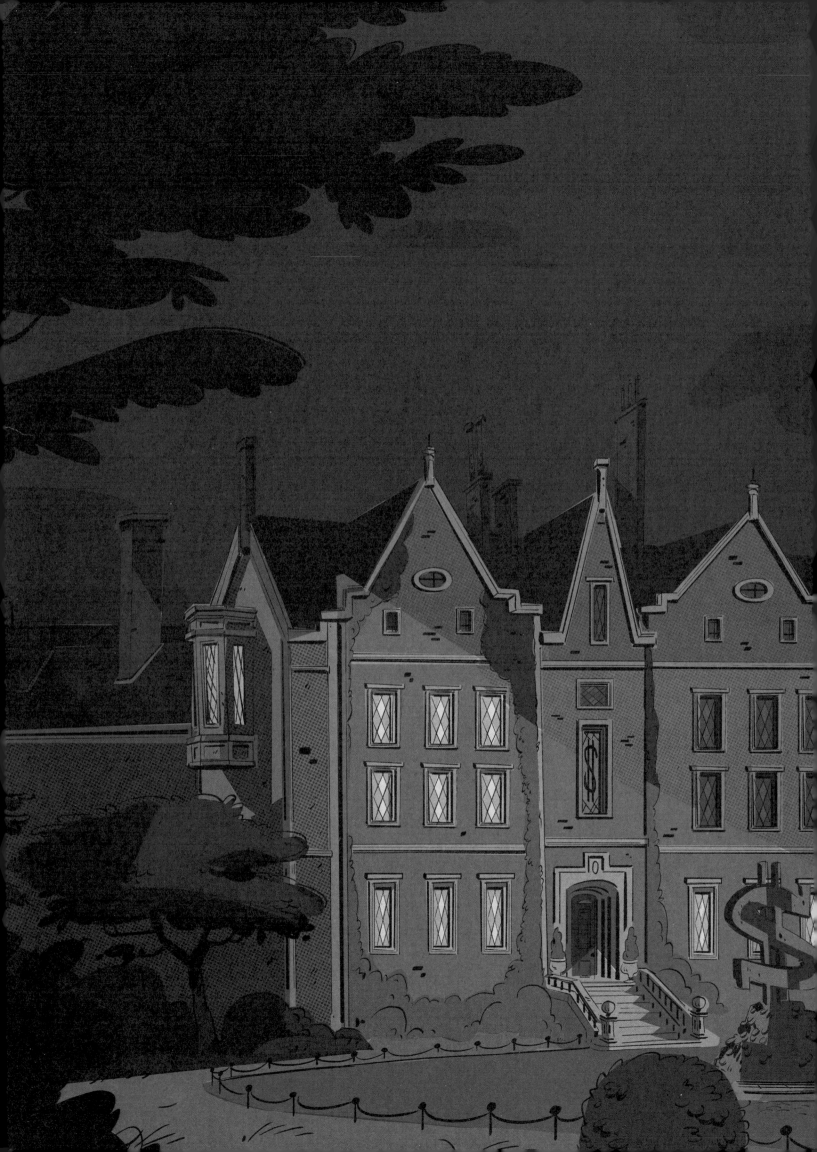